MATERIAL RELATIONS

MANCHESTER
1824

Manchester University Press

GENERAL EDITOR:
Christopher Breward

FOUNDING EDITOR:
Paul Greenhalgh

Material Relations

DOMESTIC INTERIORS AND MIDDLE-CLASS FAMILIES IN ENGLAND, 1850–1910

Jane Hamlett

Manchester University Press

Manchester and New York

distributed in the United States exclusively by Palgrave Macmillan

Published by Manchester University Press
Oxford Road, Manchester M13 9NR, UK
and Room 400, 175 Fifth Avenue, New York, NY 10010, USA
www.manchesteruniversitypress.co.uk

Distributed in the United States exclusively by
Palgrave Macmillan, 175 Fifth Avenue, New York,
NY 10010, USA

Distributed in Canada exclusively by
UBC Press, University of British Columbia, 2029 West Mall,
Vancouver, BC, Canada V6T 1Z2

British Library Cataloguing-in-Publication Data
A catalogue record for this book is available from the British Library

Library of Congress Cataloging-in-Publication Data applied for

ISBN 978 0 7190 7863 7 hardback

First published 2010

Typeset
by Servis Filmsetting Ltd, Stockport, Cheshire
Printed in Great Britain
by TJ International

For Ian, Jenny and Jon Hamlett

Contents

Figures

Abbreviations

B&L	Bedford and Luton Archives and Local Studies Centre
BL	British Library
BRO	Berkshire Record Office
BRL	Buckinghamshire Records and Local Studies Centre
CKS	Centre for Kentish Studies
CROB	Cumbria Record Office Barrow
CROW	Cumbria Record Office Whitehaven
DCA	Downing College Archives
DRO	Durham Record Office
ERO	Essex Record Office, Chelmsford branch
ERY	East Riding of Yorkshire Archives
ESRO	East Sussex Record Office
GCA	Girton College Archives
GCCA	Gonville and Caius College Archives
GMCRO DPA	Greater Manchester County Record Office, Documentary Photography Archive
GRO	Gloucestershire Record Office
HAL	Hertfordshire Archives and Local Studies
HCO	St Hilda's College Archives
HRO	Hampshire Record Office
IHC	Islington Local History Centre
JCL	St John's College Library, Cambridge
LA	Lewisham Local Archives
LCA	Lincoln College Archives
LLS	Lambeth Local Studies Library
LRO	Lancaster County Record Office
LMA	London Metropolitan Archives
MCAC	Magdalene College Cambridge Archives
MCA	Magdalene College Oxford Archives
NCA	Newnham College Archives

RHCA	Royal Holloway College Archives
SCA	Somerville College Archives
SECA	Selwyn College Archives
SLS	Southwark Local Studies Library
SHC	Surrey History Centre
SHRO	Shropshire Record Office
SRO	Suffolk Record Office, Ipswich branch
TCA	Trinity College Archives, Oxford
TWAS	Tyne and Wear Archives Service
UCA	University College Archives
WSRO	West Sussex Record Office
WYAS Bradford	West Yorkshire Archives Service, Bradford branch
WYAS Calderdale	West Yorkshire Archives Service, Calderdale branch
WYAS Leeds	West Yorkshire Archives Service, Leeds Branch

Acknowledgements

During the ten years I have spent on this project, I have incurred a number of debts. The largest intellectual debt is owed to Amanda Vickery, who supervised the thesis on which this book is based. Her imagination and incisive criticism were crucial. Deborah Cohen, Penelope Corfield, Olwen Hufton, Ruth Livesey, Alastair Owens, Nicola Phillips and Alex Windscheffel all commented usefully on the thesis, while Matthew Grimley, my adviser at Royal Holloway, untiringly read drafts. Guidance from Margot Finn and Lynda Nead, my PhD examiners, shaped the subsequent book. Michele Cohen, Lucy Delap, Kathryn Eccles, Kate Ferris, Leonie Hannan, Lesley Hoskins and Rebecca Preston and Julie Marie Strange generously read book chapters, sometimes more than once. The anonymous readers for Manchester University Press provided some useful comments, and I owe Megan Doolittle particular thanks for her thorough reading of the final manuscript.

Institutional and financial support were also essential. My PhD was funded by an AHRC Doctoral Award, and expanded for publication while I held an ESRC Postgraduate Fellowship (Ref: PTA-026-27–1337) at the University of Manchester, where Janet Wolff was a supportive research mentor. I have been lucky enough to participate in a rich interdisciplinary research culture focused on the domestic interior – and a series of events hosted by the AHRC Centre for the Study of the Domestic Interior based at the Royal College of Art, The Modern Interiors Research Centre hosted by Kingston University and, most recently, the Geffrye Museum's histories of Home Subject Specialist Network. Over the past four years I have worked with the Geffrye Museum, first as a researcher and then as a guest curator. There, conversations with David Dewing, Kathy Haslam, Eleanor John, Christine Lalumina and Rebecca Preston, and later with Lesley Hoskins and Alex Corney, helped clarify my arguments. The publication of this book was supported by an award provided by the Scouloudi Foundation in Association with the Institute of Historical Research, University of London. This book would also not have been possible without support provided by a series of jobs. These included lectureships at Balliol College and the University of Manchester, and research posts with Andrew Alexander at the University of

Surrey and Hannah Barker at Manchester, in addition to my current post at Royal Holloway University of London.

I would also like to thank the archivists of the following institutions: Bedford and Luton Archives and Local Studies Centre; The British Library; Berkshire Record Office; Buckinghamshire Records and Local Studies Centre; Centre for Kentish Studies; Cumbria Record Office Barrow; Cumbria Record Office Whitehaven; Downing College Archives; Durham Record Office; Essex Record Office, Chelmsford branch; East Riding of Yorkshire Archives; East Sussex Record Office; Girton College Archives; Gonville and Caius College Archives; Greater Manchester County Record Office, Documentary Photography Archive; Gloucestershire Record Office; Hertfordshire Archives and Local Studies; St Hilda's College Archives; Hampshire Record Office; Islington Local History Centre; St John's College Library, Cambridge; Lewisham Local Archives; Lincoln College Archives; Lambeth Local Studies Library; Lancaster County Record Office; London Metropolitan Archives; Magdalene College Cambridge Archives; Magdalene College Oxford Archives; Newnham College Archives; Royal Holloway College Archives; Somerville College Archives; Selwyn College Archives; Southwark Local Studies Library; Surrey History Centre; Shropshire Record Office; Suffolk Record Office, Ipswich branch; Trinity College Archives, Oxford; Tyne and Wear Archives Service; University College Archives; West Sussex Record Office; West Yorkshire Archives Service, Bradford branch; West Yorkshire Archives Service, Calderdale branch and West Yorkshire Archives Service, Leeds Branch. Archivists at these institutions played a vital role in helping me to find material for this book, and in many cases generously waived or reduced fees for the reproduction of images.

A portion of this research material draws on the UK Data Archive collection: the original data creators and the UK data archive bear no responsibility for their further analysis or interpretation here. All possible efforts have been made to trace the copyright holders of the images reproduced here. The publisher would be happy to hear from copyright holders not acknowledged here, or acknowledged incorrectly. Some parts of this research have previously been published elsewhere. Parts of Chapter 3 have appeared in the essay '"Tiresome trips downstairs": middle-class domestic space and family relationships', in L. Delap, B. Griffin and A. Wills (eds), *The Politics of Domestic Authority in Britain since 1800* (Basingstoke: Palgrave Macmillan, 2009), pp. 111–131. Material from Chapters 1 and 3 also appears in '"The dining room should be the man's paradise, as the drawing room is the woman's": gender and middle-class domestic space in England, 1850–1910', *Gender & History*, 21:3 (2009), 576–591. A revised form of section II of the introduction appeared in 'Review essay: the British domestic interior and social and cultural history', *Cultural and Social History*, 6:1 (2009), 97–101.

The greatest debt of all is to my family, to my parents Ian and Jenny Hamlett and Jon Hamlett, whom I would like to thank very much for their love and support, both material and emotional, over the past years. I would also like

to thank a number of friends who have supported this work over the past ten years by generously spending time with me in the pub and at rock festivals: Nick Ashwell, Kate Bradley, Matthew Cunningham, Rishi Dastidar, Colin Fairweather, Kate Ferris, Leonie Hannan, Martin Harvey, Paul Hickin, Emma Jones, Simon Kennedy, Carolyn Kohl, Matt and Becky McClaren, John McEwan, Lindsay McKean, Paul Micklethwaite, Annabelle O'Connell, Sile O'Connor, Jeremy Opperer, Dhara Ranasinghe, Paula Rycroft, Florian Scheding, Lindsay Starbuck, Melanie Towers, Iain Wilson and Tony Wilson. And finally I thank my marvellous boyfriend David Wilson for everything he has been to me over the past ten years – for his love, support and boundless patience.

Introduction

CLERGYMAN'S DAUGHTER Winifred Peck (formerly Knox) grew up in a Leicestershire vicarage in the 1880s, and published a memoir of her childhood in 1952.[1] Looking back on her Victorian home, her strongest memories were of the way in which the rooms in the house were organised, and the powerful effect this had on her as she grew up. In the Knox home, as in many other middle-class households of this era, the children were segregated in the nursery and rarely allowed to enter the parental drawing room: 'Grown ups were more a race apart . . . we lived on a different plane.'[2] Although Peck felt that modern children had the advantage, she also thought that the nineteenth-century system had some merit: 'the change of atmosphere from nursery to schoolroom, from schoolroom to drawing room, was perhaps a little more stimulating than our modern ways, and invested a parent with the mystery and enchantment of a certain distance'.[3]

Peck believed that arranging the home in this way created a set of family relationships – intimacies and distances – that was unique to the nineteenth-century middle classes. The domestic spaces that people create and the objects they choose for them can both reflect and shape their identity, emotions and relationships. So it follows that by looking closely at the way objects are used we can learn, not only about past physical structures, but about the thoughts and feelings of those who used them.

This book explores the domestic material culture of the English middle classes in the second half of the nineteenth century and the first decade of the twentieth. It considers how middle-class families imagined, described and used rooms, furnishings and domestic ephemera, and the role these objects played in family life. By opening the doors of the middle-class home, and peering into drawing rooms and dining rooms, marital bedrooms with dressing rooms attached, nurseries, attics and basements, we can learn how husbands and wives bonded

or perhaps avoided each other, how children formed their first ideas of identity, and how servants and mistresses might forge relationships that could cross class boundaries. The following introduction shows what studying the material world means for our understanding of Victorian middle-class families.

The sixty-year period this book encompasses saw significant change in the world of domestic goods. This study begins in 1850, when the middle classes were expanding in wealth and power, and had more money to lavish on the home. In England, the number of people who fell into the middle-income bracket of £200–500 a year doubled between 1851 and 1871.[4] This growth in wealth brought an increasing demand for material things, and helped create the mass market.[5] The Great Exhibition of 1851 revealed the huge range of goods available to consumers in the mid-nineteenth century.[6] Indeed, some writers have heralded it as the beginning of commodity culture in Britain.[7]

A new range of furniture shops were opened in the West End of London, offering shoppers an array of furniture in a variety of styles,[8] and the mid-Victorian interior acquired the dense decoration that would be heavily criticised by modernist writers.[9] Parlours and drawing rooms were crammed with ornaments and draperies.[10] Partly in reaction to this, from the 1860s, the upper classes were offered household goods that embodied a new idea of craftsmanship by firms such as Morris & Co.[11] By the early 1880s, 'artistic furnishing' had been adopted and developed for a middle and lower-middle class market.[12] Technological changes, including the introduction of plumbing, gas and, from the 1900s, electric light, made the middle-class domestic interior recognisably modern.[13] We know a great deal about how domestic technologies and styles of home decoration changed during this sixty-year period, yet the role played by domestic spaces and objects in middle-class family life has been relatively unexplored.[14] Rather than looking at the meaning of changing styles and technology per se, this book considers the functions of room space and furnishing in family life. It ends in 1910, four years before the First World War changed the character of English domestic life,[15] and the style of living and set of family relationships of the nineteenth-century middle-class home began to slip away.

In the second half of the nineteenth century, the population of the town outstripped the countryside for the first time[16] and many newly-built homes were positioned on the fringes of the city. Suburban London expanded in this period, as the population of the 'outer ring' beyond the administrative county increased from 414,000 in 1861 to 2,045,000 in 1901.[17] Yet the growth of the suburbs was uneven. As the industrial revolution that drove this varied geographically and temporally, so too did middle-class housing.[18] Nineteenth-century English housing had a

distinctive character. As Stefan Muthesius demonstrates, by 1911 only about 3 per cent of all dwellings in England and Wales were flats, and the vast majority of houses were built in rows, as they had been since the eighteenth century.[19] However, the size of terraced houses, and their external decoration varied, as speculative builders targeted particular sections of the middle classes.[20] Moreover, the new terraces existed alongside a large body of older middle-class housing. Clergymen, for example, often occupied homes built during the late eighteenth and early nineteenth-century vicarage building boom.[21]

At the top end of the social group, minor gentry and country squires often dwelt in homes that had been in their families for some generations. In contrast to the opulent villas of the wealthy and rambling gentry manors, many new urban middle-class homes were quite small. Most newly built middle-class homes had only two reception rooms, a large living room/kitchen, four bedrooms and maybe a small conservatory.[22] Middle-class families were likely to employ live-in servants. The domestic servant population in England peaked in 1871, and after the turn of the century numbers began to decline.[23] Yet there was also a gulf between upper middle-class households that might employ four servants or more, and the average servant-employing household lower down the social scale with only one or two servants.[24] The availability of space, and the way it was organised, mattered deeply for the creation of family relationships in middle-class homes. The rooms were used in a way that allowed social separation and the construction of household hierarchies and, to a certain extent, reinforced ideas of class and gender. However, as this book shows, the use of space could also subvert the status quo.

The possessions of the Victorian middle classes have long been viewed as emissaries of their social status. But while middle-class people sometimes bought things to impress their neighbours, this book argues that taste was not automatically emulative. Most studies of nineteenth-century consumption to date have focused on the act of shopping, rather than the meaning of goods when brought home.[25] The self-made man of questionable taste has frequently appeared in popular histories of mid-century middle-class decoration.[26] Amanda Girling-Budd's thoughtful study of the consumption of Gillows furniture suggests that emulation was complicated, but still central to the meaning of things.[27] John Tosh's brief mention of furnishing, in his study of nineteenth-century men, links it to status anxiety.[28] However, as Bourdieu has shown, the relationship between the distribution of economic capital and cultural status was complex.[29] Moreover, class identity was often not the most important meaning attached to domestic objects. Moving away from the moment of consumption, this book examines the life cycle of the object as it was used in the home after it was purchased. Social standing jostled

with the many other meanings, including age and gender identities, personal associations, kinship ties and religious affiliations.

This book does not use class as a purposive, all-embracing category that can be seen as the source of all nineteenth-century historical change. Rather than taking a broad brush, meta-narrative approach it uses the middle-class interior as a vehicle for assessing the many different types of mentality and expressions of material culture for those of middle incomes. The idea that the middle class was a coherent and clearly defined social group has been questioned by historians. The story of the middle classes rising to prominence in the early nineteenth century, on the back of the industrial revolution, has been increasingly qualified. The industrial revolution is now seen to have varied over centuries,[30] both in terms of its geographical reach and the pace at which it occurred. Historians of the early modern period have identified a 'middling sort' that emerged well before the industrial revolution.[31] During the 1970s and early 1980s, historians refined their view of the social composition of the middle class, noting differences of stratification and occupation.[32] More recently, post-modernist analyses of the representation of class in contemporary language have concluded that the middle class had little actual basis in social reality: 'If the middle class arose as anything during these years it was as a rhetorical formation.'[33] Historians of class have also become aware of the importance of other categories: 'social identity is now understood to be a construct in which class is one of a constellation of meanings'.[34] Increasingly, social historical studies have sought to take account of the operation of both class and gender.[35] *Material Relations* questions the extent to which this broad social group was united by a shared material culture. As John Field's study of Portsmouth's middle class from 1800 to 1875 demonstrates, even groups within a relatively narrow economic spectrum could have different world views that were manifested in lifestyle choice.[36]

If our understanding of the meaning of Victorian things has been dominated by the idea of social status, the organisation of the middle-class home has been seen as driven by a middle-class desire for privacy. This book moves away from this idea, and seeks new ways of understanding the meaning of family spaces in middle-class homes. The industrial revolution and urban expansion are held to have brought about a physical separation of the private and public worlds of home and work as middle-class families moved out of cities to the suburbs.[37] The evangelical revival of the early nineteenth century also placed an increased emphasis on the virtues of home life, and the separate roles of men and women. This is most fully elaborated in Leonore Davidoff and Catherine Hall's study of the middle classes in the eighteenth and early nineteenth centuries, although they also stress the many interconnections between

the two worlds.[38] This separation of both physical and mental worlds into public and private spheres is thought to have shaped home life in two ways.

First, the home itself became increasingly separate from the public world, as home and work moved apart. Second, the desire for privacy is thought to have driven the internal organisation of the home, through increased segregation and the devotion of rooms to single uses.[39] Helen Long argues that the distinction between public and private was also manifest in the division of the home between masters and servants.[40] The absolute division between public and private has not gone unchallenged.[41] However, this idea has continued to provide the major theoretical framework for recent social historical studies of the domestic interior.[42] The question of how the inhabitants of the home experienced privacy is important. Yet privacy was only one aspect of the emotional experiences that the middle-class home was designed to create. Rather than securing individual privacies, the division of space in the home was often relational – that is, designed either to separate or to bring members of the household together – as much as to ensure the privacy of the individual.

This book focuses on the family relationships that developed among the permanent residents of middle-class households: husbands and wives, parents and children, and masters and live-in servants. Historians argue over the extent to which we can generalise over family experience, suggesting that it might be more apposite to refer to families, rather than the family.[43] Certainly, middle-class families were very diverse.[44] Many households fell outside the norms associated with the nuclear family. As Gordon and Nair have shown for middle-class Glasgow, many households included extra members, or were headed by widows or widowers, to the extent that between 1851 and 1891 only between a half and a third of all households were composed of a 'nuclear family', that is a husband, wife and children.[45] The experiences of these families are addressed through the analysis of the homes of widows and widowers, and of young people living alone. As Davidoff, Doolittle, Fink and Holden have discussed, the nineteenth-century family also needs to be considered in terms of wider kinship and social networks: aunts, uncles, cousins and relations by marriage were often all important players in family life.[46] These relationships could be important. The focus of this book is the main residential relationships in the home, and from the sources studied here these emerge as between husbands and wives, parents and children, and family and servants. But the influence of wider kin on shared house space is a subject that merits further research. As Gordon and Nair have shown for the Glasgow middle classes, visits from kin were common, particularly during illness or at celebrations, such as

weddings.[47] The presence of wider kin on visits could transform domestic space. This is discussed in Chapter 5 in relation to death and dying, but this is an area that historians could discuss in more detail.

Live-in servants occupied an equivocal position in the nineteenth-century family. According to Naomi Tadmor, in the eighteenth century, linguistically at least, servants were constructed as part of the family and the term referred to the household rather than a kinship group.[48] Theresa McBride argues that in the early nineteenth century the master–servant relationship altered, becoming that of employer and employee.[49] However, it is possible to overstate this divide.

As Siân Pooley has shown, in a study of domestic servants and their employers in late nineteenth-century Lancashire, there could be considerable overlap in the socio-economic background of masters and servants.[50] Resident servants remained an integral part of the nineteenth-century household and relationships between them and the family might in some cases be as important as the blood-ties of kinship. Examining the rooms that were set aside for servants helps us to understand their relationship with the nineteenth-century family. Often, servants were excluded from family spaces in theory, but in small middle-class homes, they could be pulled into the heart of family life.

Material Relations offers a new way of seeing nineteenth-century middle-class couples, through the significance of domestic objects and the arrangement of rooms in the everyday rites and rituals of marriage. Setting up and maintaining a home were closely linked to the distribution of power between the sexes. Nineteenth-century marital relationships have been defined in a variety of ways, from patriarchal to romantic and companionate.[51] Many historians have argued that mid-Victorian women's association with the domestic made the decoration of the home their responsibility.[52] Taking a controversial new stance, Deborah Cohen contends that it was only at the end of the century that women were able to take control of the furnishing of their homes.[53] During this period, women's legal relationship with goods changed dramatically in the eyes of the law. The 1882 Married Women's Property Act was an important victory for the women's movement, and allowed married women to hold separate property and to will away their own goods. There was certainly a strong connection between the rise of feminism and the growing number of women working as professional interior decorators.[54] Secondary and higher education for women expanded, creating more opportunities for women outside the home, and stimulating a growth in female white-collar workers.[55] Cultural anxieties over women's new roles were manifest in the emerging stereotype of the 'New Woman' who, it was feared, shunned homemaking and even marriage.[56]

Yet although the cultural profile of the 'New Woman' was high, real life new women may have struggled to create new domestic spaces for themselves. Moreover, it does not necessarily follow that these improvements for women meant that men dominated mid-nineteenth-century decorative choice.[57] A male purchaser might determine furniture, but its meaning could be steadily eroded by a build-up of female handicrafts.[58] The plethora of things in the densely draped mid-Victorian drawing room or parlour could be reinterpreted as the product of female frustrations.[59] From the mid-century, there was a tacit cultural assumption that home decoration was predominantly a woman's role, as an extension of domestic management. In practice, while men often retained overall control of household finances, women's domestic responsibilities led to an intimate involvement with the arrangement and maintenance of home.

This book explores the male engagement with home from childhood to adulthood, and questions the idea that the later decades of the century saw a male 'flight from domesticity'. Mid-Victorian men have recently been reinstated as pivotal figures within the home.[60] As Margot Finn's work has shown, eighteenth-century men could be active consumers, searching out both basic and luxury goods.[61] John Tosh's influential analysis of masculinity and domesticity argues that men were heavily emotionally involved in the mid-century home.[62] And Cohen also argues that male control of the domestic interior at this time has been substantially underestimated.[63] *Material Relations* concurs with these findings, although suggesting that men's relationship with household things often denoted love as much as control. There was an expectation that Victorian men would be closely engaged with the marital home, an emotional investment that was often expressed through the purchase of domestic goods. In the final decades of the nineteenth century, it has been widely argued that middle-class men turned away from the home, in a 'flight from domesticity'.[64] Male control of the home is held to have diminished in the face of an increasing demand for women's rights, which brought about a 'feminisation' of the home, increasingly subjecting men to female-dominated rites and rituals. Men are thought have sought solace at the club or even further afield in the empire. This male rejection of home life has also been linked to the polarisation of gender divisions within the late nineteenth-century middle-class home. Tosh posits that men fled to the newly-created den and smoking room.[65] John MacKenzie argues that male spaces were marked out by a distinctive material culture, with studies, smoking rooms and billiard rooms dominated by stags' heads and other images of the hunt.[66]

Yet, as this book shows, these masculine spaces were few, and were often not used to separate men from their families. As Martin Francis

has argued, it may be more useful to see late nineteenth-century men's relationship with domesticity as complex and contested.[67] There was a clear material culture of masculinity, marked out by the writers of advice manuals and, to a lesser extent, recreated in middle-class homes. Yet the material things chosen by men often celebrated home as much as they rejected it. Male student rooms and the studies of public school boys, examined in Chapter 4, demonstrate the extent to which young men were able to recreate the domesticity they found in their mothers' parlours and drawing rooms.

Studying the material culture of the nursery allows us to explore relationships between parents and children, and to see the home from a child's perspective. The experience of childhood changed in the final decades of the nineteenth century, as families became smaller. The average number of children per family dropped from six to between three and four.[68] These changes are thought to have occurred first in middle-class professional families.[69] The fall in family size was accompanied by a shift in ideas about how children should be brought up. The mid-nineteenth century saw a falling away of the strict codes of evangelicalism that had dominated England in the early part of the century.[70] Linda Pollock suggests that parental discipline became less strict, as the state began to intervene more in the upbringing of children through education.[71] Megan Doolittle has argued that nineteenth-century fatherhood was increasingly characterised by the expectation that the father would provide protection.[72] Siân Pooley has shown that moral concerns over inadequate parenting were strongly expressed in advice literature from the 1840s.[73] There was a marked change in perceptions of good parenting in the early twentieth century, as commentators reflected on the evils of physical separation between mother and child.[74]

Of course, parenting varied from family to family and most recently, historians have moved away from a single characterisation of the nineteenth-century family, stressing the diversity of parental roles.[75] *Material Relations* explores how these changes were played out in the material life of the family, how space divided parents and children and the impact of this on their relationships. Ideas of parenting were manifest in the material instructions communicated to children through domestic objects, but as the investigation of the physical world of the nursery here shows, children could be impervious to such messages, co-opting objects into their own imaginative worlds through play.

Chapter 1 asks whether it was possible to find privacy in the middle-class home, how the public world entered the private house, in particular through the presence of men who worked from home and the frequent entrance of visitors. The ways in which the home was internally divided are explored – and the extent to which it was possible to enforce a

public/private divide between masters and servants. But the rest of the book moves away from this paradigm. The arrangement of space within the home was designed to create not just individual privacies but relationships between family members. Space was used to construct intimacies and distances. Therefore, the rest of the book is structured, loosely, around the life cycle of the Victorian family.

Chapter 2 shows how domestic goods were used to build relationships between prospective spouses, and how home decoration could express marital dynamics. Chapter 3 examines childhood experience of the home, revealing the impact of the nursery system on children's relationships with their parents, and how the material culture of home could fashion early gendered identities. Chapter 4 steps outside the conventional family home by exploring the domestic spaces occupied by young single men and women when they left the home. The question of whether young people sought to escape or recreate the domesticity of the Victorian home when they left it for the first time is examined, through an analysis of the domestic interiors of schools, universities and lodgings. Finally, Chapter 5 returns to the home in the final stage of the life course when it was often dismantled on the death of its owner. A survey of domestic objects in wills and bequest lists examines how bequests transmitted family identities to the next generation, but the chapter also considers how widows and widowers remade the home after the death of a spouse.

Approaches to the material world

This book draws on a number of different disciplinary approaches. The study of the domestic interior is built on early art historical studies that explored the decoration and layout of the home and stylistic change. Mario Praz, whose book *An Illustrated History of Interior Decoration: From Pompeii to Art Nouveau* (1964), was the first art historian to treat the domestic interior as a whole: a room and its contents were perceived as a form of artistic expression.[76] Charlotte Gere has taken a lead in developing the art history of the nineteenth-century interior. This, together the diversification of Victorian style, has been the subject of extensive discussion, which tends to focus on leading figures such as Morris and Pugin, rather than examining popular taste.[77] The drive to document aesthetic achievement has also shaped architectural studies, which tend to concentrate on the houses of the great.[78] These histories provide the bedrock for this study, although it takes a different tack, exploring the meanings of goods in family life rather than stylistic change. A more populist approach to objects, developed by some design historians, is also important here. This was most fully articulated by Judy Attfield, who

insisted that design history should consider not just 'good design' but the vast array of goods that make up the fabrics of everyday life.[79] The idea of 'use' is now central to much new design history.[80] But no study to date has considered the significance of the arrangement of space and the distribution of objects in nineteenth-century everyday rituals and family life.

Social anthropology has been crucial in developing the way we understand the social meaning of things and, in particular, the role of objects in rites and rituals. Mary Douglas and Baron Isherwood's *The World of Goods* (1996) defined consumption as 'a system of reciprocal rituals'.[81] Consumption takes on a new symbolic importance, as 'it is the very arena in which culture is fought over and licked into shape'.[82] An exploration of the social life of things, by Arjun Appadurai, showed how the biography of a thing could have a wider cultural meaning.[83] Recent work has highlighted the sentimental and emotional meanings of goods.[84] Anthropologists such as Irene Cieraad have discovered a variety of meanings that have eluded historians. This focus on ritual shows how, while the physical structure of houses might not change for decades, the inhabitants' behaviour would change, altering the meaning related to the material structure.[85] Anthropological work has emphasised the importance of meanings of the domestic interior related to family.[86] This perspective, which highlights the symbolic and ritual role of the home, shows how the home functions as a theatre for the expression of identity. *Material Relations* draws on these approaches, focusing on the relationship between material culture and behaviour, and viewing the home as stage for the performance of family relationships. In particular, the consideration of the exchange of engagement and wedding gifts draws on the way the circulation of goods has been perceived in anthropological studies.

This book also draws on the notion of material culture, that is, the understanding that objects can reveal the core values and relationships of society and culture.[87] The cultural representation of the relationship between home and family is explored, and the ways in which everyday experiences fell short of such ideals or indeed ignored or bypassed them. The significance of domestic material culture was first revealed by North American scholars. Katherine Grier's study of middle-class American interiors placed the parlour at the centre of cultural production: 'the parlors . . .were constant reminders of what Victorian culture valued highly: the principles of gentility and domesticity, along with the material refinement that inevitably accompanied civilised progress'.[88] Grier argues that furnishing worked like manners, as a system for communicating a set of cultural values.[89] Richard Bushman's cultural history also suggests that the parlour was the ultimate sign of refinement in early nineteenth-century America.[90]

The idea that the interior was culturally significant has also been developed in British studies. Thad Logan has read the Victorian parlour as a series of cultural signs and signifiers.[91] Juliet Kinchin has analysed gendered goods and spaces in nineteenth-century decorative advice, arguing that these symbolised a cultural system that emphasised women's 'objectification within the interior'.[92] These studies reveal the potential of domestic interior studies to tell broader cultural historical stories. However, Grier argues that cultural experience of the interior is not recoverable from records of individual experience.[93] This book argues that we can, indeed, uncover how the domestic interior was used and experienced in everyday life through a range of historical sources. This is achieved through the analysis of nineteenth-century cultural representation through a range of advice literature, novels and magazines, but also a variety of sources that can tell us how the home was used on an everyday basis, including sale catalogues and advice manuals, autobiographies and diaries, and photographs and snapshots.

The social meaning of space, from the planners' point of view, has been examined by architectural historians. These have also been shaped by the drive to document aesthetic achievement, and often concentrate on the houses of the great.[94] Mark Girouard's *Life in the English Country House* (1978) paved the way for the socio-historical study of architecture, making a direct link between the design and layout of the home and the social practices that took place within its walls.[95] Helen Long's study of the late Victorian and Edwardian middle-class house also considers the social function of the plan.[96] Interdisciplinary theoretical studies have also emphasised the role of space and material structures in the creation of power. Michel Foucault's study of the birth of the prison demonstrated the capacity of spatial organisation to work as an aspect of discipline and a technology of power.[97] But as Foucault later acknowledged, the intentions of architects are rarely entirely fulfilled.[98] In a post-structuralist retreat from the author, recent architectural studies have focused less on the architect and considered the interior from the point of the user.[99] Feminist historical geographers have also theorised space more flexibly. Jane Rendell, for example, sees space as a product of exchange between individuals.[100] Doreen Massey argues that every place is individual, and subject to differing social interactions.[101] The idea that we can learn more about the social and cultural values of society by examining the way space is arranged has influenced a number of studies of the early modern period.[102] By exploring the way the middle classes divided, labelled and inhabited rooms in the home, we can learn more about their social values. The Victorian middle-class house, with its carefully segregated nursery and servants' quarters, was a spatial manifestation of contemporary hierarchies of power. Spatial boundaries were,

however, never absolute. Above all, the social meaning of space and objects was flexible, and could play an important role in individual self-fashioning and agency.

Material Relations argues that acts of consumption need to be seen within the context of the household and the lifecycle. During the 1980s, interest in the industrial revolution stimulated the study of the eighteenth-century consumer revolution.[103] Early studies of consumption recognised the importance of the consumer to economic growth, but saw consumer motivation in basic terms.[104] Initial interpretations relied heavily on Thorstein Veblen's *Theory of the Leisure Class* (1899), which argued that consumption was motivated by emulation.[105] But a second generation of consumption historians questioned this,[106] and the quest for a more complex understanding of consumption led to widespread criticism of the emulation thesis.[107] Historians of the eighteenth century have also considered the impact of gender on consumption.[108]

Asking questions about how and why people chose to acquire material things has pushed consumer studies towards an analysis of the use of everyday objects in domestic spaces and domestic practices. John Styles reconsiders the relationship between the individual and consumption in his study of lodging in the eighteenth century, which reveals the limited power of lodgers over their material worlds, and thus the broader 'indirect relationship with material things familiar to working men and women'.[109] Louise Purbrick also argues that the receipt of wedding gifts problematises the notion of consumption as an act of individual choice.[110] Consumption might be a joint, as much as an individual, act: marital homes were created by negotiations between husbands and wives, wedding gifts assembled through the shared efforts of family and friends. Control over the immediate material environment through purchase was limited by age and financial position: this was clearly the case for school children and lodgers. Moreover, as the analysis of bequests in Chapter 5 will show, the long-term significance of domestic things to nineteenth-century families often lay in their role in the transition between generations, as much as their meaning at the moment of purchase.

Much of this book responds to questions set up by historical studies of women and gender. From the medieval to the modern, the work of the home has been seen as woman's responsibility.[111] The nature of that burden, with its possibilities for empowerment or confinement, has long exercised historians. Indeed, the concern to understand female empowerment lies behind some of the fullest historical investigations of the social and cultural uses of the domestic material world to date.[112] The first studies of women and domesticity, inspired by second wave feminism, showed that home could be a 'gilded cage', a source

of restraint. Martha Vicinus's analysis of the Victorian 'perfect lady', for example, 'combined sexual innocence, conspicuous consumption and the worship of the family hearth'.[113] This vision was revised in a later collection of essays that looked at the expanding possibilities for Victorian women.[114] Yet later writers built on the idea that that men and women occupied separate spheres: the public sphere was a male world while the home belonged to women.[115] Some historians of women's lives have found the vocabulary offered by separate spheres thesis inadequate.[116] Yet the influence of this thesis is still considerable. This book also responds to the way in which women's historians have approached chronology: Judith Bennett calls for a consideration of the continuities in women's history as well as the changes.[117] By studying male and female relationships with the domestic interior, we can thus consider the relationship between these roles and responsibilities and long-term change, demonstrating both transition and continuity.

Since 2000, there has been a growing recognition of the importance of the domestic interior in social and cultural history, and this subject has also moved to the forefront of British scholarship, largely thanks to the work of the Arts and Humanities Research Council Centre for the Study of the Domestic Interior.[118] The Modern Interiors Research Centre, based at the University of Kingston, has also been influential in promoting a variety of research on the interior.[119] An impressive body of scholarship on the nineteenth-century interior has emerged, including the analysis of retailing and consumption, the relationship between taste and identity and the suburban garden.[120] The work of Emma Ferry and Judith Neiswander has considerably broadened our understanding of the motivation and meaning of nineteenth-century domestic advice literature.[121]

Two recent works are particularly important for this study. Margaret Ponsonby's *Stories from Home* (2007) draws on personal documents to demonstrate the distinctiveness of provincial consumption in the first half of the nineteenth century.[122] The book is also insightful in its depiction of the emotional meanings of household things by showing the distress suffered through the destruction of homes.[123] Deborah Cohen's provocative and groundbreaking *Household Gods* (2006) has shown the Victorians and their possessions in a new light, demonstrating the connection between the use and valuation of objects and shifts in morality and religion.[124] Cohen also reveals how the increasing emphasis on individuality in home decoration reflected a new idea of the self, embodying personality rather than character.[125] While these studies have moved the field forward considerably, we still know very little about how material things were used in the daily lives of Victorian middle-class families, or the relationship between the organisation of domestic space and the

structuring of contemporary social relations. *Material Relations* attempts to remedy this lack, exploring the role of everyday things in the social and emotional life of the nineteenth-century middle-class family at home.

Sources and methodology

This book is premised on a flexible, practical definition of the Victorian middle classes. Historians have considered three factors as markers of middle-class status: income, occupation and servant keeping. Income determined middle-class lifestyle,[126] but there are problems with drawing rigid lines between income groups, and contemporaries disagreed over where the line should be drawn.[127] Income was also temporally variable and determined by family size.[128] Nor did wealth necessarily reflect social position: struggling gentry families would have been out-earned by successful businessmen. Occupation has been seen as central to class identity, with professional groups defining themselves in opposition to commerce.[129] Certain occupations, such as curate, or nonconformist minister, might earn less than one hundred pounds a year but define themselves as middle class. Yet, in some cases, family status was defined by the position of the mother.[130] While middle-class homes were clearly marked out by the practice of keeping residential servants, some families who might define themselves as middle class in other ways could not afford to do so.[131] This book adopts an elastic definition of this broad and ambiguous social group. Households that employed one servant or more are viewed as middle class, yet occupational identity and self-definition are also considered. Rather more controversially, this study also includes minor gentry families. This material has been included because studying the families who fall between conventional class definitions, that is, between the aristocracy and the middle class, can help us to understand how boundaries of class were perceived and maintained.

This book departs from previous histories of goods that have focused on records of immediate purchase, such as archives of the department store, trade catalogues and furniture shop accounts.[132] Instead, it examines sources that reveal the role of objects in everyday practices. This is achieved through the way in which domestic goods and spaces were imagined in advice manuals, magazines and novels, but also through a new large-scale survey of records of individual experience, incorporating printed memoirs, a survey of manuscript sources and some oral history transcripts. Archival sources for the nineteenth-century middle-class domestic interior (i.e. diaries, letters, inventories, sale catalogues and wills), survive in small collections of family papers or solicitors' papers.[133] The manuscript survey for this project is nationwide. London

and the upper middle classes are strongly represented in autobiographies of the period.[134] In order to re-dress this imbalance, the survey of sale catalogues and inventories focuses on areas outside London, in particular the north east, north west and the south, the object being to reveal the contents of the homes of rural and small-town dwellers, as well as those who lived in urban homes and the expanding suburbs. These sources also allow a glimpse into the homes of those on the fringes of the middle classes, such as farmers and small shopkeepers.

Although this book is principally concerned with lived experience of everyday domestic interiors, the representation of the interior was also an important part of that experience. As Jeremy Aynsley and Charlotte Grant have shown, the imagined interior, while never entirely separate from everyday life, often differed from it and was shaped by genres of representation.[135] During the second half of the nineteenth century, representations of the domestic interior proliferated. There was a change in the nature of the advice offered to women, away from guidance on morality and religious behaviour, towards the production of compendiums of practical advice for the home.[136] The growth of the population and improving literacy rates in the nineteenth century contributed to a growing market for books.[137] While moral instruction for women had seldom dealt with material things, mid-century women, who faced the upheavals of industrialisation, urbanisation and shifting class structure, were held to be sorely in need of practical advice on domestic matters.[138] Thirty-two domestic and decorative advice manuals are surveyed here, including classic design reform texts such as Charles Eastlake's *Hints on Household Taste* (1868),[139] and books with a more everyday domestic focus such as *Cassell's Household Guide* (1869).[140] The book also explores the representation of home in the new magazines that emerged in the second half of the century for women of different social classes and age groups including *The Girl's Own Paper, The Gentlewoman, Home Chat,* and *The House: An Artistic Monthly for Those Who Manage and Beautify the Home.*

The novel also flourished in this period, with a sharp increase in the number of novels for adults produced after 1886.[141] While historians have been wary of the novel as a historical source, acceptance of the use of novels as a source for social and cultural history is growing.[142] This book uses the novel in conjunction with other sources, while retaining a sense of the novel's status as a cultural product. Peter Mandler has argued that to fully understand the process of representation it is necessary to consider 'not only the meanings of a text but also its relationship to other texts, its significance in wider discursive fields, its "throw"'.[143] It is virtually impossible to find direct textual evidence of the application of domestic advice.[144] Rather than tracking direct reception of these texts,

this book often refers to advice manuals, novels and magazines as examples of the way in which the relationship between home and material culture was imagined, before moving to discuss everyday practices established in records of individual experience. This allows a consideration of the 'throw' of these texts in nineteenth-century culture and society. It also permits an exploration of the tensions between the way in which domestic interiors and family relations were imagined and the way they were lived.

The rest of the book draws on sources that have been more conventionally associated with everyday practices. The most detailed records for the objects nineteenth-century men and women kept in their homes are lists. These were often made informally and survive in family papers: the wedding list and the informal bequest list are two notable examples. Lists of domestic objects were also produced as a part of legal and commercial processes, appearing in wills and in probate inventories, and from the eighteenth century onwards, in printed sale catalogues advertising the sale of house contents. The inventory has been the key source for historians of home material culture of earlier periods.[145] However, while thousands of inventories survive from the early modern period owing to probate, far fewer survive for the period 1850 to 1910.[146] Moreover, they tend to be occasional survivals separately preserved in collections of family or legal papers, unlike earlier material.[147]

Recent work has focused on the possible circumstances in which inventories were produced, questioning whether we can use the source to tell the position of goods in the home.[148] Although the presence of objects on these lists shows us the way in which things act in everyday cultural processes, as many historians have pointed out, there is a limit to the meaning that can be read from the inclusion of an object in an inventory.[149] Despite these problems, inventories and sale catalogues survive in large enough numbers to make a small-scale quantitative survey of approximately two hundred lists from the north west, north east and south of England possible.[150] In addition, Chapter 2 draws on a nationwide survey of surviving wedding lists from family papers. Chapter 5 investigates bequeathing practices through the analysis of sixty wills and informal bequest lists from the south east.

Personal texts, such as diaries and autobiographies, reveal more about the link between objects and identity. These texts provide the best source of deep reflection on the meaning and use of domestic objects, but are subject to certain complications, as much so as the 'representation' texts previously discussed. The pool of available texts is, of course, shaped by the social conditions under which they were produced. Diarists and the writers of autobiographies tend to come from the upper middle classes. Generally fewer personal written accounts emerge from

those lower down the social scale, perhaps reflecting greater restrictions on leisure time and personal space. Occupation had a crucial impact on diary keeping: clergymen frequently kept diaries, which present themselves as semi-public documents.[151] Autobiographies were more likely to be written by certain types of people: writers or poets, or those with successful public careers. Female diarists tended to deal more with domestic issues than men, although these were not completely absent from male accounts. The gendering of the content of autobiographies is more striking. Men tend to provide sparse accounts of their early home lives, which are frequently subordinate to a central narrative of career.[152] As male autobiographies give less space to domestic matters, it has been necessary to survey just over twice as many autobiographies by men as by women. In order to cover the experience of servants within the home, existing oral history transcripts that relate to the period before 1910 have been consulted.[153] Bound by the limits of the questioner and restricted to the late nineteenth century, these sources can be frustrating but also offer an unparalleled insight into the working-class world.

Visual sources for everyday home life are harder to come by. The home was extensively represented in nineteenth-century visual culture. Lynda Nead argues that the development of domestic genre painting in this period 'should be recognised as part of the formation of domestic ideology'.[154] Yet the significance of these images of the middle-class home has been extensively worked over, both in Cohen's survey of paintings and Neiswander's detailed analysis.[155] This book moves away from these sources, instead exploring previously unseen everyday photographs of the home, unearthed from family albums and papers.

Photographing the inside of the home was technically difficult in this period, which accounts for the comparative rarity of shots of the interior.[156] However, developments in photography meant that, in the final years of the nineteenth century, domestic interiors were widely photographed for the first time. In particular, technical improvements allowed photographs to be taken outside the studio in the late 1880s. Professional photographers occasionally produced images of the interior, but the interior was also subject to the efforts of amateur photographers as the camera became increasingly embedded in the processes of everyday life.

In addition to mining the resources of large collections of photography, such as the Manchester Documentary Photography Archive, this book brings together the fruits of a nationwide trawl of the holdings of local archives and record offices, where chance survivals of rare images of the interior can sometimes be found. Drawing attention to the lack of sustained historical analysis of the photograph, Raphael Samuel argues that photographs should be subjected to the same kind of historical

criticism as any other 'text', and contextualised within a body of other sources.[157] The selection of images for this book was ultimately determined by their survival in the context of other interpretative material. Large, professionally-made collections of interior photographs do exist for this period: the Victoria and Albert Museum's Bedford Lemere collection is one example. However, these images are rarely peopled and often lack complementary archival material. Rather than focusing on larger, formal collections of interior photography, the emphasis is on occasional survivals of photographs in local record offices, preserved in family albums or amid clusters of family papers. The presentation and arrangement of images in family photograph albums is also suggestive.[158] While less technically competent and frequently badly exposed, such snaps were often produced by family members, and offer greater scope for a discussion of the social meaning of domestic objects.

In summary, this book offers a new study of the role of domestic spaces and material goods in nineteenth-century middle-class family life. It links material and emotional worlds, shedding new light on the meaning of domestic goods, but also on relations between husbands and wives, parents and children and masters and servants. The field of domestic interior studies has grown rapidly since the end of the twentieth century, and has been influenced by a number of different disciplines and approaches. This book is underpinned by work in art and design history, anthropology, material culture studies, and scholarship on consumption and the history of women and gender. The book surveys the cultural representation of the family and the interior and the ideas that material things were thought to carry through advice manuals, novels and magazines. Throughout, these representations are used to illuminate how the relationship between home and family was imagined, and contrasted with sources that show how homes were experienced and used on an everyday basis. The result is a new story of the nineteenth-century middle-class family, told through the rooms they created and the material goods that they prized.

Notes

1 Winifred Peck, *A Little Learning or A Victorian Childhood* (Faber & Faber, London, 1952).

2 Ibid., p. 30.

3 Ibid., p. 31.

4 T. McBride, *The Domestic Revolution: The Modernisation of Household Service in England and France 1820–1920* (London: Croom Helm, 1976), p. 19.

5 W. Hamish Fraser, *The Coming of the Mass Market 1850–1914* (London: Macmillan, 1981), p. 133. Also, see Deborah Cohen, *Household Gods: the British and their Possessions* (London: Yale, 2006), p. 13.

6 Charlotte Gere, *Nineteenth-Century Decoration: The Art of the Interior* (London: Weidenfeld & Nicolson, 1989), p. 222.

7 For a discussion of this see Louise Purbrick, 'Introduction', in Louise Purbrick (ed.), *The Great Exhibition of 1851: New Interdisciplinary Essays* (Manchester: Manchester University Press, 2001), pp. 14–17.

8 Clive Edwards, *Turning Houses in Homes: A History of the Retailing and Consumption of Domestic Furnishings* (Aldershot: Ashgate, 2005), p. 108; S. Fagence Cooper, 'The Battle of the Styles', in M. Snodin and J. Styles (eds), *Design and the Decorative Arts Britain 1500–1900* (London: V&A, 2001), pp. 354–355.

9 See John Gloag, *Victorian Comfort: A Social History of Design 1830–1900* (London: Adam and Charles Black, 1961), p. 33; J. Marshall and I. Willox, *The Victorian House* (London: Sidgwick & Jackson, 1986), p. 68.

10 S. Calloway, *Twentieth-Century Decoration: The Domestic Interior from 1900 to the Present Day* (London: Weidenfeld & Nicolson, 1988), p. 32.

11 Gere, *Nineteenth-Century Decoration*, p. 276.

12 Charlotte Gere and Lesley Hoskins, *The House Beautiful: Oscar Wilde and the Aesthetic Interior* (London: Lund Humphries, 2000), p. 109. Also see Sonia Ashmore, 'Liberty and Lifestyle: Shopping for Art and Luxury in Nineteenth Century London', in David Hussey and Margaret Ponsonby (eds), *Buying for the Home: Shopping for the Domestic from the Seventeenth Century to the Present* (Aldershot: Ashgate, 2008), pp. 73–90.

13 J. Styles, 'Victorian Britain, 1837–1901: What Was New', in Snodin and Styles (eds), *Design and the Decorative Arts*, pp. 440–441, p. 452. Gas lighting was first introduced in the 1830s, and by 1885 there were two million consumers of gas in England and Wales. Ibid., p. 89. Electric light was slow to take off as it was expensive and difficult to install, but this too increased in the 1900s. Ibid., p. 91. On plumbing see K. Theodore Hoppen, *The Mid-Victorian Generation 1846–1886* (Oxford: Oxford University Press, 1998), p. 388.

14 Aside from Asa Briggs's ground breaking study, Asa Briggs, *Victorian Things* (London: Batsford, 1988), the fullest examples to date include R. Rich, 'Designing the Dinner Party: Advice On Dining and Décor in London and Paris 1860–1914', *Journal of Design History*, 16:1 (2003), 49–61; Eleanor Gordon and Gwyneth Nair, *Public Lives: Women, Family and Society in Victorian Britain* (London: Yale University Press, 2003), chapter four.

15 See S. Kingsley Kent, *Making Peace: The Reconstruction of Gender in Interwar Britain* (Chichester: Princeton University Press, 1993), p. 3.

16 Hoppen, *The Mid-Victorian Generation*, p. 12.

17 Asa Briggs, *Victorian Cities* (London: Odhams Press, 1963), p. 324.

18 Charles More, *Understanding the Industrial Revolution* (London: Routledge, 2000), p. 132.

19 Stefan Muthesius, *The English Terraced House* (London: Yale University Press, 1982), p. 1.

20 Ibid., p. 242.

21 F. Knight, *The Nineteenth-Century Church and English Society* (Cambridge: Cambridge University Press, 1995), p. 141.

22 Helen Long, *The Edwardian House: The Middle-Class Home in Britain 1880–1914* (Manchester: Manchester University Press, 1993), p. 31.

23 M. Ebery and B. Preston, *Domestic Service in late Victorian and Edwardian England 1871–1914* (Reading: University of Reading, 1976), p. 20. Leonard Schwarz has recently argued, however, that numbers of domestic servants in the eighteenth century may have been underestimated. Leonard Schwarz, 'English Servants and their Employers

during the Eighteenth and Nineteenth Centuries', *Economic History Review*, 52:2 (1999), 238.

24 McBride, *The Domestic Revolution*, p. 21.

25 E.D. Rappaport, *Shopping for Pleasure: Women in the Making of London's West End* (Chichester: Princeton, 2000); G. Crossick and S. Jaumain, 'The World of the Department Store: Distribution, Culture and Social Change', in G. Crossick and S. Jaumain (eds), *Cathedrals of Consumption: The European Department Store 1850–1939* (Aldershot: Ashgate, 1999), pp. 1–45. On men see: C. Breward, *The Hidden Consumer: Masculinities, Fashion and City Life 1860–1914* (Manchester: Manchester University Press, 1999), p. 10.

26 See Gloag, *Victorian Comfort*, p. 33; Marshall and Willox, *The Victorian House*, p. 68; Gere and Hoskins, *The House Beautiful*, p. 40; Briggs, *Victorian Things*, p. 1.

27 P. Sparke and S. McKellar, 'Introduction', in P. Sparke and S. McKellar (eds), *Interior Design and Identity* (Manchester: Manchester University Press, 2004), p. 4. A. Girling-Budd, 'Comfort and Gentility: Furnishings by Gillows, Lancaster 1840–55', in Sparke and McKellar, *Interior Design*, p. 37. Q. Colville, 'The Role of the Interior in Constructing Notions of Class and Status: Case Study of Britannia Royal Naval College Dartmouth, 1905–39', in Sparke and McKellar, *Interior Design*, p. 125. On clothes see Catherine Horwood, *Keeping up Appearances: Fashion and Class between the Wars* (Stroud: Sutton, 2005).

28 J. Tosh, *A Man's Place: Masculinity and the Middle-Class Home in Victorian England* (London: Yale University Press, 1999), pp. 23–24.

29 P. Bourdieu, *Distinction: A Social Critique of the Judgement of Taste* (London: Routledge, 1984), p. 260.

30 More, *Understanding the Industrial Revolution*, pp. 132–135.

31 M.R. Hunt, *The Middling Sort: Commerce, Gender, and the Family in England 1680–1780* (London: University of California Press, 1996), p. 15.

32 Geoffrey Crossick first explored the stratification of the lower middle class. G. Crossick, 'The Labour Aristocracy and its Values: A Study of Mid-Victorian London Kentish town', *Victorian Studies*, 19:3 (1976), 301–328. Crossick's emphasis on occupation has been questioned. A. Reid, 'Intelligent Artisans and Autocrats of Labour: The Essays of Thomas Wright', in J. Winter (ed.), *The Working Class in Modern British History* (Cambridge: Cambridge University Press, 1983), p. 184. Recent work has looked more closely at the lower middle class as a social group. A. James Hammerton, 'Pooterism or Partnership? Marriage and Masculine Identity in the Lower Middle Class 1870–1920', *Journal of British Studies*, 38:1 (1999), 291–321; C. Bailey, 'White Collars, Gray Lives? The Lower Middle Class Revisited', *Journal of British Studies*, 38:1 (1999), 273–290.

33 D. Cannadine, *Class in Britain* (London: Yale University Press, 1998), p. 72. The cultural approach is outlined in A. Kidd and D. Nicholls, 'Introduction: History, Culture and the Middle Classes', in A. Kidd and D. Nicholls (eds), *Gender, Civic Culture and Consumerism: Middle-Class Identity in Britain 1800–1940* (Manchester: Manchester University Press, 1999), pp. 5–6. Although some historians criticise this departure. See F.M.L. Thompson, *Gentrification and Enterprise Culture: Britain 1780–1980* (Oxford: Oxford University Press, 2001), p. 160.

34 Kidd and Nicholls, 'Introduction', p. 6.

35 Leonore Davidoff and Catherine Hall, *Family Fortunes: Men and Women of the English Middle Class 1780–1850* (London: Hutchinson, 1987), p. 13; Kidd and Nicholls, 'Introduction', p. 7.

36 J. Field, 'Wealth, Styles of Life and Social Tone amongst Portsmouth's Middle Class 1800–75', in R.J. Morris (ed.), *Class, Power and Social Structure in British Nineteenth-Century Towns* (Leicester: Leicester University Press, 1986), p. 93.

37 Tamara K. Hareven, 'Recent Research on the History of the Family', in Michael Drake (ed.), *Time, Family and Community: Perspectives on Family and Community History* (Oxford: Blackwell, 1994), p. 35. For a challenge to this see Gordon and Nair, *Public Lives*, pp. 46–47.

38 Davidoff and Hall, *Family Fortunes*, p. 32. Also see C. Hall, 'Gender Divisions and Class Formation in the Birmingham Middle Class 1780–1850', in R. Samuel (ed.), *People's History and Socialist Theory* (London: Routledge & Kegan Paul, 1981), p. 166.

39 Muthesius, *The English Terraced House*, p. 39; Jill Franklin, *The Gentleman's Country House and Its Plan 1835–1914* (London: Routledge & Kegan Paul, 1981), p. 39; Mark Girouard, *Life in the English Country House: A Social and Architectural History* (London: Yale University Press, 1978), p. 285.

40 Long, *The Edwardian House*, p. 169.

41 See T. Meldrum, *Domestic Service and Gender 1660–1750: Life and Work in the London Household* (Harlow: Longman, 2000), p. 78; A. Vickery, 'An Englishman's Home is his Castle? Thresholds, Boundaries and Privacies in the Eighteenth-century London House', *Past and Present* 199 (2008), 147–173.

42 But in many cases these studies show inconsistencies within the theory rather than working towards a new theoretical framework for the study of the domestic interior. For example see, Long, *The Edwardian House*; Amanda Flather, *Gender and Space in Early Modern England* (Woodbridge: Boydell Press, 2007); Margaret Ponsonby, *Stories from Home: English Domestic Interiors, 1750–1850* (Aldershot: Ashgate, 2007).

43 Diana Gittins, *The Family in Question: Changing Households and Familier Ideologies* (London: Macmillan, 1985), p. 2.

44 Gordon and Nair, *Public Lives*, p. 46.

45 Ibid., pp. 38 and 46–47.

46 L. Davidoff, M. Doolittle, J. Fink and K. Holden, *The Family Story: Blood, Contract and Intimacy 1830–1960* (London: Longman, 1999), pp. 77–83, 126.

47 Gordon and Nair, *Public Lives*, pp. 53–54.

48 Gittins, *The Family in Question*, p. 15; Naomi Tadmor, *Family and Friends in Eighteenth-century England* (Cambridge: Cambridge University Press, 2000), p. 272.

49 McBride, *The Domestic Revolution*, p. 33.

50 Siân Pooley, 'Domestic Servants and their Urban Employers: A Case Study of Lancaster, 1880–1914', *Economic History Review* 62:2 (2009), p. 412.

51 A. James Hammerton, *Cruelty and Companionship: Conflict in Nineteenth-Century Married Life* (London: Routledge, 1992), p. 169; B. Caine, *Destined to be Wives: The Sisters of Beatrice Webb* (Oxford: Clarendon, 1986), p. 92.

52 Davidoff and Hall, *Family Fortunes*, p. 362; Thad Logan, *The Victorian Parlour* (Cambridge: Cambridge University Press, 2001), p. 26; Gordon and Nair, *Public Lives*, p. 6; Edwards, *Turning Houses into Homes*, p. 163.

53 Cohen, *Household Gods*, p. 90; Davidoff and Hall, *Family Fortunes*, p. 362; Logan, *The Victorian Parlour*, p. 26; Gordon and Nair, *Public Lives*, p. 6; Edwards, *Turning Houses into Homes*, p. 163.

54 Cohen, *Household Gods*, p. 109. E. Ferry, '"Decorators may be Compared to Doctors": an analysis of Rhoda and Agnes Garrett's Suggestions for House Decoration in Painting, Woodwork and Furniture (1876)', *Journal of Design History* 16:1 (2003), 49–61.

55 Gregory Anderson, 'The White Blouse Revolution', in Gregory Anderson (ed.), *The White-Blouse Revolution: Female Office Workers since 1870* (Manchester: Manchester University Press, 1988), p. 4.

56 Sally Ledger, *The New Woman: Fiction and Feminism at the Fin de Siecle* (Manchester: Manchester University Press, 1997), p. 10.

57 A. Vickery, 'His and Hers: Gender, Consumption and Household Accounting in Eighteenth-century England', *Past and Present*, 1 (supplement 1) (2006), p. 2; Girling-Budd, 'Comfort and Gentility', p. 33.

58 K. Sharp, 'Women's Creativity and Display in the Eighteenth-Century British Domestic Interior', in Sparke and McKellar, *Interior Design and Identity*, p. 10; Logan, *The Victorian Parlour*, p. 176; C. Edwards, '"Home is where the Art is": Women, Handicraft and Home Improvements 1750–1900', *Journal of Design History*, 19:1 (2006), 11–21.

59 T. Logan, 'Decorating Domestic Space: Middle-Class Women and Victorian Interiors', in V.D. Dickerson (ed.), *Keeping the Victorian House: A Collection of Essays* (London: Garland Publishing, 1995), p. 217.

60 Tosh, *A Man's Place*, passim.

61 M. Finn, 'Men's Things: Masculine Possession in the Consumer Revolution', *Social History*, 25:2 (2000), 135. Also see David Hussey, 'Guns, Horses and Stylish Waistcoats? Male Consumer Activity and Domestic Shopping in Late-Eighteenth- and Early-Nineteenth-Century England', in Hussey and Ponsonby, *Buying for the Home*, pp. 66–67.

62 Tosh, *A Man's Place*, pp. 179–180. Tosh's chronology has recently been questioned by Martin Francis. M. Francis, 'The Domestication of the Male? Recent Research on Nineteenth- and Early Twentieth-Century British Masculinity', *The Historical Journal*, 45:3 (2002), p. 643.

63 Cohen, *Household Gods*, p. 90.

64 A. Milne-Smith, 'A Flight to Domesticity? Making a Home in the Gentleman's Clubs of London, 1880–1914', *Journal of British Studies* 45:4 (2006), 796–818.

65 Tosh, *A Man's Place*, p. 182.

66 J.M. Mackenzie, 'The Imperial Pioneer and Hunter and the British Masculine Stereotype in Late Victorian and Edwardian Times', in J.A. Mangan and J. Walvin (eds), *Manliness and Morality: Middle-Class Masculinity in Britain and America 1800–1940* (Manchester: Manchester University Press, 1987), pp. 180–181.

67 Francis, 'The Domestication of the Male', p. 643.

68 Davidoff, Doolittle, Fink and Holden, *The Family Story*, p. 128.

69 Michael Anderson, 'The Social Implications of Demographic Change', in F.M.L. Thompson (ed.), *The Cambridge Social History of Britain 1750–1950, Vol. 2, People and their Environment* (Cambridge: Cambridge University Press, 1990), pp. 42–44. This has been problematised by Simon Szreter, *Fertility, Class and Gender in Britain, 1860–1940* (Cambridge: Cambridge University Press, 1996), pp. 58–59.

70 L. Stone, *The Family, Sex and Marriage in England 1500–1800* (London: Penguin, 1979), p. 423; L. Pollock, *Forgotten Children: Parent-Child Relations from 1500 to 1900* (Cambridge: Cambridge University Press, 1983), pp. 269–270.

71 Pollock, *Forgotten Children*, pp. 269–270. Annemarie Adams has also argued that the decline of evangelicalism allowed women to spend time away from children and nursery. Annemarie Adams, *Architecture in the Family Way: Doctors, Houses and Women 1870–1900* (London: McGill-Queen's University Press, 1996), p. 139.

72 Megan Doolittle, 'Fatherhood, Religious Belief and the Protection of Children in Nineteenth-Century English Families', in Trev Lynn Broughton and Helen Rogers (eds), *Gender and Fatherhood in the Nineteenth Century* (Basingstoke: Palgrave Macmillan, 2007), p. 31.

73 Siân Pooley, 'Child Care and Neglect: A Comparative Local Study of Late Nineteenth Century Parental Authority', in L. Delap, B. Griffin and A. Wills (eds), *The Politics of Domestic Authority in Britain since 1800* (Basingstoke: Palgrave Macmillan, 2009), p. 226.

74 Leonore Davidoff, Megan Doolittle, Janet Fink and Katherine Holden, *The Family Story: Blood, Contract and Intimacy 1830–1960* (London: Longman, 1999), pp. 208–211.

75 Tosh, *A Man's Place*, p. 195; Gordon and Nair, *Public Lives*, p. 63, p. 145.

76 M. Praz, *An Illustrated History of Interior Decoration: From Pompeii to Art Nouveau* (London: Thames & Hudson, 1964).

77 See J. Cooper, *Victorian and Edwardian Furniture and Interiors: From the Gothic Revival to Art Nouveau* (London: Thames and Hudson, 1987). Decorative difference between countries has also been explored, but these studies remain focused on aesthetic meaning. S. Forge, *Victorian Splendour: Australian Interior Decoration 1837–1901* (Oxford: Oxford University Press, 1981) and I. Gow, *The Scottish Interior: Georgian and Victorian Décor* (Edinburgh: Edinburgh University Press, 1992).

78 M. Girouard, *Life in the English Country House*; P. Davey, *Arts and Crafts Architecture: The Search for the Earthly Paradise* (London: Architectural Press, 1980); J. Mordaunt Crook, *The Rise of the Nouveaux Riches: Style and Status in Victorian and Edwardian Architecture* (London: John Murray, 1999).

79 J. Attfield, *Wild Things: The Material Culture of Everyday Life* (Oxford: Berg, 2000), p. 5. For a further, more direct consideration of 'use', see P. Sparke and S. McKellar, 'Introduction', p. 1. The essays in the book have all been written by recent graduates of the joint Royal College of Art/Victoria and Albert Museum design history MA.

80 See collection of work in Sparke and McKellar, *Interior Design and Identity*. And for a good example of how this works in recent design history see L. Purbrick, *The Wedding Present: Domestic Life Beyond Consumption* (Aldershot: Ashgate, 2007).

81 M. Douglas and B. Isherwood, *The World of Goods: Towards an Anthropology of Consumption* (London: Routledge, 1996), p. xxii.

82 Ibid., p. 37.

83 A. Appadurai, 'Introduction: Commodities and the Politics of Value', in A. Appadurai (ed.), *The Social Life of Things: Commodities in Cultural Perspective* (Cambridge: Cambridge University Press, 1986), p. 17. I. Koptytoff, 'The Cultural Biography of Things: Commoditization as a Process', in Appadurai, *The Social Life of Things*, p. 67.

84 D. Miller, 'Why Some Things Matter', in D. Miller (ed.), *Material Cultures: Why Some Things Matter* (London: UCL Press, 1997), p. 11.

85 I. Cieraad, 'Introduction: Anthropology at Home', in I. Cieraad (ed.), *At Home: An Anthropology of Domestic Space* (New York: Syracuse, 1999), p. 5.

86 S. Chevalier, 'The French Two-home Project: The Materialisation of Family Identity', in Cieraad, *At Home*, p. 91.

87 Outlined in Lou Taylor, *The Study of Dress History* (Manchester: Manchester University Press, 2002), p. 72. Also see Ann Smart Martin and J. Ritchie Garrison, 'Shaping the Field: The Multidisciplinary Perspectives of Material Culture', in Ann Smart Martin and J. Ritchie Garrison (eds), *American Material Culture: The Shape of the Field* (Delaware: Henry Francis Du Pont Winterthur Museum, 1997), pp. 1–21.

88 K.C. Grier, *Culture and Comfort: Parlor Making and Middle-Class Identity 1850–1930* (Massachusetts: Massachusetts University Press, 1997), p. vii.

89 Ibid., 154.

90 R.L. Bushman, *The Refinement of America: Persons, Cities, Houses* (New York: Knopf, 1992), p. 274. The parlour as an expression of personality has also been discussed by Karen Halttunen. K. Halttunen, 'From Parlour to Living Room: Domestic Space, Interior Decoration and the Culture of Personality', in S. J. Bronner (ed.), *Consuming Visions: Accumulation and Display of Goods in America 1880–1920* (New York: Henry Francis du Pont Winterthur Museum, 1989), pp. 157–189. Bushman and Grier both produced their work in association with the Henry Francis du Pont Winterthur Museum. The Winterthur school of material culture studies has fostered a wide range of work on North American gender and material culture. See K. Martinez and K.L. Ames (eds), *The Material Culture of Gender: The Gender of Material Culture* (New York: Henry Francis du Pont Winterthur Museum, 1997).

91 Logan, *Victorian Parlour*.

92 J. Kinchin, 'Interiors: Nineteenth-Century Essays on the 'Masculine' and the 'Feminine' Room', in P. Kirkham (ed.), *The Gendered Object* (Manchester: Manchester University Press, 1996), pp. 18–20.

93 Grier, *Culture and Comfort*, p. 172.

94 Girouard, *Life in the English Country House*; Davey, *Arts and Crafts Architecture*; Mordaunt Crook, *The Rise of the Nouveaux Riches*. In comparison, Victorian middle-class homes have been neglected. Two notable exceptions are R. Dixon and S. Muthesius, *Victorian Architecture* (London: Thames & Hudson, 1978) and Long, *The Edwardian House*.

95 Girouard, *Life in the English Country House*, particularly chapters 7 and 10. Also see Franklin, *The Gentleman's Country House*; Long, *The Edwardian House*; J. Bold, 'Privacy and the Plan', in J. Bold and E. Chaney (eds), *English Architecture: Public and Private Essays for Kerry Downes* (London: Hambledon, 1993), pp. 107–119.

96 Long, *The Edwardian House*, p. 32.

97 M. Foucault, *Discipline and Punish: The Birth of the Prison* (London: Penguin, 1991), pp. 141–148.

98 M. Foucault, 'Space, Knowledge and Power', in James D. Faubion (ed.), *Michel Foucault, Power: Essential Works of Foucault 1954–1984*, vol. 3 (London: Penguin, 2002), p. 352.

99 I. Borden, J.Kerr, J. Rendell with A. Pivaro, 'Things, Flows, Filters, Tactics', in I. Borden et al. (eds), *The Unknown City: Contesting Architecture and Social Space* (Massachusetts: MIT Press, 2001), p. 11.

100 J. Rendell, *The Pursuit of Pleasure: Gender, Space and Architecture in Regency London* (London: Athlone Press, 2002), p. 4.

101 D. Massey, *Space, Place and Gender* (Cambridge: Polity, 1994), p. 168.

102 Flather, *Gender and Space*; J. Melville, 'The Use and Organisation of Domestic Space in Late Seventeenth-Century London' (PhD Thesis, University of Cambridge, 1999); R. Blair St George, 'Reading Spaces in Eighteenth-Century New England', in John Styles and Amanda Vickery (eds), *Gender, Taste and Material Culture in Britain and North America 1700–1830* (London: Yale, 2006), pp. 81–106; K. Lipsedge, '"Enter into Thy Closet": Women, Closet Culture, and the Eighteenth-Century English Novel', in Styles and Vickery, *Gender, Taste and Material Culture*, pp. 107–124.

103 N. McKendrick, J. Brewer and J.H. Plumb, *The Birth of a Consumer Society: The Commercialisation of Eighteenth-Century England* (London: Europa, 1982), p. 9. Also strongly influenced by interdisciplinary study of the consumer – see ESRC Cultures

of Consumption Project website for a full outline of this extensive literature. www. consume.bbk.ac.uk/index.html (accessed 17 March 2008).

104 McKendrick, *Birth*, p. 11.

105 T. Veblen, *The Theory of the Leisure Class: An Economic Study in the Evolution of Institutions* (New York: Macmillan Co., 1899), p. 25.

106 See J. Lears, 'Beyond Veblen: Rethinking Consumer Culture in America', in S. J. Bronner (ed.), *Consuming Visions: Accumulation and Display of Goods in America 1880–1920* (New York: Henry Francis du Pont Winterthur Museum, 1989), p. 75; A. Bermingham, 'Introduction The Consumption of Culture: Image, Object, Text', in A. Bermingham and J. Brewer (eds), *The Consumption of Culture 1600–1800: Image, Object, Text* (London: Routledge, 1995), p. 14; T. Breen, 'The Meaning of Things: Interpreting the Consumer Economy in the Eighteenth Century', in J. Brewer and R. Porter (eds), *Consumption and the World of Goods* (London: Routledge, 1993), pp. 257–258; J. Styles, 'Involuntary Consumers? Servants and their Clothes in Eighteenth-century England', *Textile History*, 33 (2002), p. 18.

107 L. Weatherill, *Consumer Behaviour and Material Culture in Britain 1660–1760* (London: Routledge, 1996), p. 185. For similar conclusions see M. Overton, J. Whittle, D. Dean and A. Hann, *Production and Consumption in English Households 1600–1750* (London: Routledge, 2004), p. 120.

108 A. Vickery, 'Women and the World of Goods: A Lancashire Consumer and her Possessions 1751–81', in Brewer, *Consumption*, pp. 274–301; L. Weatherill, 'A Possession of One's Own: Women and Consumer Behaviour in England 1660–1740', *Journal of British Studies*, 25 (1986), 131–156, 155–156; Finn, 'Men's Things', 135.

109 Styles, 'Lodging at the Old Bailey', in Styles and Vickery, *Gender, Taste and Material Culture*, p. 63.

110 Purbrick, *Wedding Present*, p. 20.

111 On medieval roles see H. Leyser, *Medieval Women: A Social History of Women in England, 450–1500* (London: Phoenix Giant, 1996), p. 151.

112 A. Vickery, *The Gentleman's Daughter: Women's Lives in Georgian England* (London: Yale University Press, 1998); Logan, *The Victorian Parlour*; Gordon and Nair, *Public Lives*.

113 Martha Vicinus, 'Introduction: the Perfect Victorian Lady', in M. Vicinus (ed.), *Suffer and be Still: Women in the Victorian Age* (1972), p. ix.

114 M. Vicinus, 'Introduction: New Trends in the Study of the Victorian Woman', in M. Vicinus (ed.), *A Widening Sphere: Changing Roles of Victorian Women* (Bloomington: Indiana University Press, 1977), p. xix.

115 The thesis continued to inform principal works on women's history in the 1980s. See J. Lewis, 'Introduction: Reconstructing Women's Experience of Home and Family', in J. Lewis (ed.), *Labour and Love: Women's Experience of Home and Family 1850–1940* (Oxford: Blackwell, 1986), p. 9. Also C. Dyhouse, 'Mothers and Daughters in the Middle-Class Home *c.*1870–1914', in Lewis, *Labour and Love*, pp. 28–29. The thesis in its most complex form is put forward by Leonore Davidoff and Catherine Hall who posit that in the first half of the nineteenth century, conduct literature in combination with the rise of a new evangelical doctrine, created a new climate in which 'a woman's femininity was best expressed in her dependence'. Davidoff and Hall, *Family Fortunes*, p. 114.

116 A. Vickery, 'Golden Age to Separate Spheres? A Review of the Categories and Chronology of English Women's History', *Historical Journal*, 36:2 (1993), 401. Also M. Jeanne Peterson, *Family, Love and Work in the Lives of Victorian Gentlewomen* (Bloomington: Indiana University Press, 1989), p. 188. And more recently: Gordon and Nair, *Public Lives*, pp. 2–3.

117 Judith M. Bennett, *History Matters: Patriarchy and the Challenge of Feminism* (Manchester: Manchester University Press, 2006), pp. 60–65.

118 For more details see the Centre for the Study of the Domestic Interior website. http://csdi.rca.ac.uk/ (accessed 25 August 2009).

119 For more details see the Modern Interiors Research Centre website. www.kingston.ac.uk/design/MIRC/ (accessed 25 August 2009).

120 Including Edwards, *Turning Houses into Homes*. And the following dissertations are in development for publication: E. Ferry, 'Advice, Authorship and the Domestic Interior: An Inter-disciplinary Study of Macmillan's "Art at Home Series" 1876–1833' (PhD thesis, Kingston University, 2004); T. Keeble, 'The Domestic Moment: Design, Taste and Identity in the Late Victorian interior' (PhD Thesis, Royal College of Art, 2004); R. Preston, 'Home Landscapes: Amateur Gardening and Popular Horticulture in the Making of Personal, National and Imperial Identities 1815–1914' (PhD thesis, University of London, 1999). Also see the essays in Elizabeth Darling and Lesley Whitworth (eds), *Women and the Making of Built Space in England, 1870–1950* (Aldershot: Ashgate, 2007).

121 E. Ferry, '"Decorators May be Compared to Doctors"'; Judith A. Neiswander, *The Cosmopolitan Interior: Liberalism and the British Home 1870–1914* (London: Yale University Press, 2008).

122 Ponsonby, *Stories from Home*, chapter 1, 'Provincial Homes'.

123 Ponsonby, *Stories from Home*, chapter 2, 'Transient Homes'.

124 Cohen, *Household Gods*, chapter 1.

125 Cohen, *Household Gods*, p. 125.

126 Theresa McBride defines the middle income bracket as £200 to £500 a year. McBride, *The Domestic Revolution*, p. 19.

127 R. McKibbin, *Classes and Cultures: England 1918–1951* (Oxford: Oxford University Press, 1998), p. 45.

128 Philip Gibbs comments on the difficulty his parents had in providing for seven children on an income of £400–500, at the top of McBride's middle-class scale. Phillip Gibbs, *The Pageant of the Years: An Autobiography* (London: William Heinemann, 1946), p. 6.

129 McKibbin, *Classes and Cultures*, p. 45; P. J. Corfield, *Power and the Professions in Britain 1700–1850* (London: Routledge, 1995), p. 8. The idea of 'craft' could be as important as profession. J. Garrard and V. Parrott, 'Craft, Professional and Middle-Class Identity: Solicitors and Gas Engineers c.1850–1914', in Alan Kidd and David Nicholls, *The Making of the British Middle Class? Studies of Regional and Cultural Diversity since the Eighteenth Century* (Sutton: Stroud, 1998), p. 149.

130 Family status could be defined by the mother's position. Owen Berkeley-Hill, *All Too Human: An Unconventional Autobiography* (London: Peter Davies, 1939), p. 11.

131 McBride, *The Domestic Revolution*, p. 20.

132 See *Stories from Home*; *Turning Houses into Homes*.

133 For a full list of sources consulted see Bibliography.

134 Just over a third of the autobiographies used in this book refer to homes in inner or suburban London.

135 C. Grant, 'Reading the House of Fiction: From Object to Interior 1720–1920', *Home Cultures*, 2 (2005), 233–249. For a broader exploration of the 'representation' of the domestic interior see J. Aynsley and C. Grant (eds) *Imagined Interiors: Representing the Domestic Interior since the Renaissance* (London: V&A, 2006).

136 Dena Attar, *A Bibliography of Household Books Published in Britain 1800–1914* (London: Prospect Books, 1987), pp. 12–13; Margaret Beetham, 'Of Recipe Books and Reading in the Nineteenth Century: Mrs Beeton and her Cultural Consequences', in Janet Floyd and Laurel Foster (eds), *The Recipe Reader: Narratives, Contexts, Traditions* (Aldershot: Ashgate, 2003), p. 20.

137 A. Weedon, *Victorian Publishing: The Economics of Book Production for a Mass Market 1836–1916* (Aldershot: Ashgate, 2003), p. 52.

138 Attar, *A Bibliography of Household Books*, p. 12.

139 C.L. Eastlake, *Hints on Household Taste in Furniture, Upholstery and Other Details* (London: Longmans Green, 1878 fourth edition first published in 1868).

140 [Anon.], *Cassell's Household Guide: Being a Complete Encyclopaedia of Domestic and Social Economy* (London: Cassell & Co., 1869).

141 P. Keating, *The Haunted Study: A Social History of the English Novel 1875–1914* (London: Fontana, 1991), p. 32.

142 Recent uses of the novel include R.J. Morris, *Men, Women and Property in England, 1780–1870: A Social and Economic History of Family Strategies Amongst the Leeds Middle Classes* (Cambridge: Cambridge University Press, 2005), p. 90. For an example of the complex overlap between fact and fiction, see M. Finn, 'Being in Debt in Dickens' London: Fact, Fictional Representation and the Nineteenth-Century Prison', *Journal of Victorian Culture*, 1:2 (1996), 203–226.

143 Peter Mandler, 'The Problem with Cultural History', *Cultural and Social History*, 1:1 (2004), 96.

144 Domestic advice is rarely mentioned in autobiographies, in contrast to novels and other reading matter. K. Flint, *The Woman Reader 1837–1914* (Oxford: Oxford University Press, 1993).

145 See Weatherill, *Consumer Behaviour and Material Culture*, p. 3. M. Overton, J. Whittle, D. Dean and A. Hann's recent study of Kent and Cornwall in the early modern period is based on 8103 inventories. Overton et al., *Production and Consumption*, p. 9.

146 A new survey of London inventories held at the National Archive is currently being conducted by Lesley Hoskins at Queen Mary University of London. Far fewer inventories survive for the late eighteenth and early nineteenth centuries, as the custom of exhibiting inventories in court and retaining them in the administrative records, if not of making inventories themselves, declined from the 1720s. Jeff and Nancy Cox, 'Probate 1500–1800: A System in Transition', in Tom Arkell, Esta Evans and Nigel Goose (eds), *When Death Do Us Part: Understanding and Intepreting the Probate Records of Early Modern England* (Oxford: Leopard's Head, 2000), p. 27; John S. Moore, 'Probate Inventories: Problems and Prospects', in Philip Riden (ed.), *Probate Records and the Local Community* (Stroud: Sutton, 1985), p. 27. Giorgio Riello, ''Things Seen and Unseen': Inventories and the Representation of the Domestic Interior in Early Modern Europe', Unpublished paper, May 2009, pp. 37–44. Quoted with the author's permission.

147 Large collections of inventories survive for the early modern period. For instance, The Orphans Court Records at the Corporation of London Record Office hold thousands of inventories.

148 Riello, 'Things Seen and Unseen', p. 19, p. 31.

149 Whittle et al., *Production and Consumption*, p. 9.

150 See Bibliography for a list of material consulted.

151 Richard Hooper, the incumbent of Upton and Aston-Upthorpe in southeast Oxfordshire, for example, noted, 'I ought to have noted that my wife always prepares the girls for confirmation.' Diary of Richard Hooper, 31 Jan. 1881, BRO, D/P 20C/28/5.

152 Male autobiographies that step beyond this conventional structure were usually written by a-typical men, poets and others who made their living by words. C. Wrey Gardiner, *The Colonies of Heaven: The Autobiography of a Poet* (Essex: Grey Walls Press, 1941); R. Graves, *Good-bye to All That: An Autobiography* (London: Jonathan Cape, 1929).

153 Most interviews used here were conducted by Paul Thompson and Trevor Lummis and accessed through the UK Data Archive. P. Thompson and T. Lummis, *Family Life and Work Experience Before 1918, 1870–1973* [computer file], 7th edition. Colchester, Essex: UK Data Archive [distributor], May 2009. SN: 2000.

154 L. Nead, *Myths of Sexuality: Representations of Women in Victorian Britain* (Oxford: Basil Blackwell, 1988), p. 18.

155 Cohen, *Household Gods*; Neiswander, *The Cosmopolitan Interior*, pp. 2–3.

156 Instruction for amateur photographers suggests that in the period before 1900 at least, photographing the domestic interior required considerable skill. A. Black, 'The Amateur Photographer', in B. Newhall (ed.), *Photography: Essays and Images, Illustrated Readings in the History of Photography* (London: Secker & Warburg, 1980), p. 151.

157 R. Samuel, *Theatres of Memory: vol. 1 Past and Present Contemporary Culture* (London: Verso, 1994), pp. 329–330.

158 See P. Holland, 'Introduction: History, Memory and the Family Album', in J. Spence and P. Holland (eds), *Family Snaps: The Meanings of Domestic Photography* (London: Virago, 1991), p. 7.

1 ✧ Inside middle-class homes: the limits of privacy

FRANK KENDON was brought up in a schoolhouse, near Goudhurst in Kent, in the 1890s. As his home was also the location of his father's school for boys, it was inevitably permeated by the public world of work. Kendon writes: 'Because we lived at a school, our home, like the stage house, had no fourth wall. If you entered by the front door, at once the chilly formality of politeness to visitors met you.'[1] The presence of work, of pupils and their parents, was an inescapable part of Kendon's experience of home. All rooms were not equally public, however. The drawing room, in particular, was an 'unfriendly piece of the outside world shut into our home by mistake'.[2] Used mainly for the reception of visitors, Kendon perceived this as a dead, cold space, in contrast to 'the live and echoing building beyond'.[3] Kendon's dislike of the drawing room was based not on a yearning for privacy, the desire to shut out the public world, but rather a longing for the restorative warmth of family relations. The drawing room only became bearable when occupied by the family on winter evenings, sitting around the fire or playing the American organ: 'Peopled like this with a fire and a song the place was quite transformed.'[4]

The Kendon family home, like many other nineteenth-century middle-class homes, cannot be neatly defined as a private space in opposition to the public world outside. Public and private were often inseparable, linked through objects and images, through visitors in the drawing room and below stairs, and through by the presence of male work. Although the middle-class house became increasingly segregated in the nineteenth century, internal divisions were not necessarily designed to secure individual privacy. As in the Kendon home, domestic spaces were often significant in that they brought the family together, while also keeping them apart. This chapter also examines the division between servants and masters in the home. This was designed to protect the privacy of the family and, to a lesser extent, the servants themselves, but varied between households.

During the nineteenth century, the relationship between the physical worlds of work and home, the public and the private, was transformed by urbanisation and industrialisation, yet the results were complex and uneven. Industrialisation and the growth of the cities greatly altered Britain's urban landscapes.[5] Widespread change took place in middle-class housing, mainly through the movement of the middle classes from town centres to the suburbs, which brought about a separation of home and work.[6] Suburban growth peaked in the late nineteenth century.[7] Yet, as Jerry White points out, while the main phase of suburban building in London took place in the final decades of the nineteenth century, this was also the period in which a new generation, tired of suburban living, sought to return to the centre.[8] Suburbs were not necessarily free from commercial activity, as middle-class homes might attract small businesses.[9] And while some family lives were transformed by a move to the suburbs, others continued to live in villages, small towns and older-build houses.[10] Nationwide, the growth of the suburbs varied. In fast-growing Manchester and Birmingham, this kept pace with industrial growth.[11] In some areas, such as Exeter and north Oxford, new building was stimulated by causes other than industrialisation and so did not occur on the same timescale.[12] Physical divides were also constantly crossed. Movement between centre and suburb increased with the development of the railways.[13] Travel for work, for the acquisition of necessities, but also for pleasure, became more frequent.[14]

Even before the growth of the department stores in the late nineteenth century, women frequently crossed supposed boundaries and engaged in the public world and were a notable physical presence on the street.[15] So even while the worlds of home and work became apparently more physically separate, this was accompanied by a growth in the movement of people – in ways of traversing or crossing these spaces.

This physical separation is often thought to have been accompanied by an ideological compartmentalisation of the world into public and private spheres: the domestic, and that which lay outside it. Jürgen Habermas, in his influential analysis of eighteenth-century society, argued that a public sphere developed with the formation of a bourgeois reading public. While this public sphere reinforced the idea of a separate, private world, these spheres were ultimately inseparable as reading itself took place in the private family home.[16] Early nineteenth-century Britain saw the rise of a new evangelical ideology of domesticity, which marked out the home as a private sphere of female activity and explicitly excluded women from the public realm. This notion was promoted by popular evangelical writers such as Hannah More.[17]

Yet how far nineteenth-century middle-class women took these prescriptions to heart is unclear.[18] Mid-Victorian middle-class women

often led physically and sexually active lives, suggesting that that they did not feel constricted within a private sphere.[19] While men dominated the public world, the exclusion of women was contested on many levels. Women could play an important, but not equal, role in contemporary politics.[20] Almost as quickly as male power institutionalised the nineteenth-century professional and public world, female pioneers emerged to challenge this.[21] The boundaries between public and private life in the nineteenth-century social world, then, both physical and ideological, were permeable and frequently transgressed. The home, supposedly the heart of the private world, was no exception to this. It was influenced and entered by 'the public' in a number of ways, as the first section of this chapter shows.

Public world, private home?

The ways in which the public world entered the home were myriad. The physical structure of the home itself had a dual function, providing a frame through which to view the outside world and allowing the domestic interior to be viewed by the outside world. The home and the wider world were connected in a variety of ways. In urban houses the balcony could expose the house and its occupants to the gaze of passers-by in the street. Advice manuals recommended balconies as a means of urban and suburban gardening, and illustrations suggest that it was considered acceptable for the lady of the house to appear, watering her plants.[22] A humorous illustration by John Leech, published in 1857 in a collection of work that had previously appeared in *Punch*, shown in figure 1.1, satirises the revelatory possibilities of the balcony, showing a bevy of beauties on display, open to the admiration of passing male spectators.[23] The window often appears in autobiographical descriptions of the childhood home. Windows looked out on to streets, and those with time to look out learned about the wider world from within domestic space. Children, in particular, often looked out.[24] London-based children were likely to recall their impressions of the outside world. H.A.L. Fisher remembers:

> Was it not from those windows that we were taught to look out for Mr. Justice Byles riding to the Law Courts every morning in his white hack Bills, that we watched, being waked up specially by the nurse, the glorious conflagration of the Pantechnicon, and enjoyed over and over again the unending enchantment of Punch and Judy?[25]

Philip Gibbs also evocatively described the London of his childhood, experienced through the nursery window:

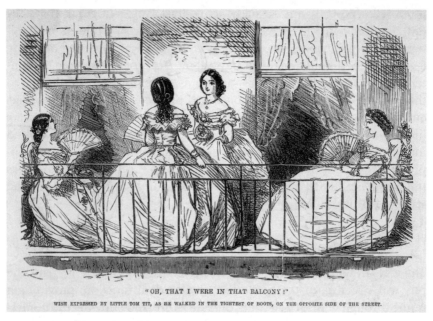

"OH, THAT I WERE IN THAT BALCONY!"

WISH EXPRESSED BY LITTLE TOM TIT, AS HE WALKED IN THE TIGHTEST OF BOOTS, ON THE OPPOSITE SIDE OF THE STREET.

1.1 J. Leech, 'Little Tom'

> Out of the nursery windows we children of the eighties looked into the glamorous dusk of the London streets, and watched the lamplighter making his magic at the end of a long pole, until all the lamp-posts in the street were shining on wet pavements or made a golden haze through a night of fog.[26]

Autobiographers often used the interior as the frame for their first experiences of the outside world. Robert Graves's first recollection was being held up at a window to watch a carnival procession for the Diamond Jubilee in 1897.[27] Those in central London homes looked out on to the public world of the bustling street, but the view from quieter suburbs or even rural homes could also be full of activity. Kendon, whose father's schoolhouse was deep in the countryside of the Kentish Weald, looked out of the windows of his home on to the school playground.[28] Where windows were too high, children might be helped to see the view. Guy Nickalls from Kent remembers that 'the nursery window was too high for a mite to see out of doors, so a sort of miniature grand stand was provided with four tiers of steps to enable us to look out'.[29] So rather than isolating the home from the public world, the physical structure of the home often framed children's early perceptions of it.

The material culture of the home also embodied the public world, through a wealth of imagery displayed on its walls and in its ornaments. Ceramic figures relating to political themes had been manufactured for domestic display from at least the eighteenth century.[30] The significance

of the consumption of objects and the building of ideas of nationhood has been highlighted by Linda Colley, who shows that material culture was employed to express patriotic fervour in new ways at the end of the eighteenth century.[31] Lynne Walker and Vron Ware have shown how early nineteenth-century domestic images expressed the desire for abolitionism, and although political meaning cannot be read from these goods in a straightforward fashion, they were certainly capable of carrying powerful subversive messages.[32]

Inventories and sale catalogues show that in the second half of the nineteenth century the home continued to display an iconography that related to the public world. Twenty-two per cent of the material examined from the north east featured images connected to a historical figure,[33] while 32 per cent of the sale catalogues and inventories from the south east included such items. The display of literary figures was quite common: such as representations of Tennyson, Ruskin and Scott.[34] Shakespeare and Milton were favourites. These figures brought the public literary world into the home. Their presence, and of course the many books that were often present in middle-class homes, hinted at an enthusiasm for reading – a private, domestic act, but one that could simultaneously involve engagement with an intellectual world far beyond the four walls of the home.[35] British nationalism is also suggested by the title of an engraving owned by Mrs M.A. Purchase, 'The Intellect and Valour of Britain'[36] and also in Thomas Roberts's 'Clemency of Coeur de Lion'.[37] In addition to images on walls, inventories show that middle-class homes were often filled with books, magazines and artefacts that brought the public world into the home. It is unclear exactly what these goods meant to their owners, yet we can certainly see the public world on the walls and in the artefacts of the home.

A major way in which the outside world entered the home was through the presence of visitors. From the point of view of the middle-class family the most important visitors were those from their own social class, who were generally received in the drawing room. Trevor Keeble has recently used the diaries of two Victorian women to show how the process of visiting and viewing the houses of others could subvert the dichotomy between public and private.[38] Drawing room decoration was seem as synonymous with social display, and was often heavily criticised by advice writers for socially ambitious ostentation.[39] While the contents of the drawing room had many meanings beyond simple social emulation, inventories and sale catalogues show a concentration of ornaments and furnishings in the drawing room. Figure 1.2 shows a family tea at Durham Rise, a smart Manchester house, in the late nineteenth century. The two women leading the ritual have serious faces, suggesting formal family ritual carefully staged for the camera. The act of photographing

1.2 The drawing room at Durham Rise

the home, which often involved a professional photographer, opened the home to public view. The drawing room was the most photographed space in the middle-class home: approximately 60 per cent of the images of domestic interiors from before 1910 held at the Greater Manchester Record Office were of a drawing room or sitting room.[40]

At certain times of the week, a middle-class home might be packed with visitors. The dining room, as a family space, might provide a private retreat from the round of public visitors that besieged the drawing room.[41] But equally, the dining room itself was often used for entertaining, and for dinner parties.[42] Gordon and Nair use probate inventories from Glaswegian middle-class homes, to stress the importance of dining room furnishings that catered for a minimum of twelve guests.[43] Sociability could transform space, as shown in the lively drawing room at the Rectory at West Meon, in figure 1.3. Many households subscribed to a formal system of visiting that included a weekly 'At Home', in which the lady of the house would be at home to visitors in the drawing room.[44] An overambitious 'At Home' might transform a quiet house into a bustling thoroughfare. The design reform writer Charles Eastlake remembered:

> In our younger days, when we followed the practice of our betters and attempted an occasional 'At Home', I am ashamed to remember how many guests we invited to assemble in that room – how they overflowed down the staircase on to the balconies and even into the dining room below.[45]

1.3 The family in the drawing room at West Meon Vicarage

1.4 A musical evening at the Wilkinson's

Figure 1.4 shows a group photograph taken in the drawing room of the Wilkinson family in Manchester. Titled 'A Musical Evening' the photograph, although more formal, suggests how the middle-class drawing room might look when crammed full of bodies for social events.

The 'At Home' ritual remained popular in the 1900s. Celia Davies who grew up in a small middle-class home at Woodford Green near Epping Forest, disliked being presented to guests at her mother's weekly 'At Home' immensely, remembering it as 'a dreary event for us

children'.[46] Robert Graves, whose father was an inspector of schools in Southwark, also had a hatred of Wednesdays in his Wimbledon home when he and his sisters were paraded in front of guests: 'We were called down in our Sunday clothes to eat cakes, be kissed, and be polite.'[47]

Less prestigious and, sometimes unwelcome, visitors might also enter the home via the servants' quarters or the basement. Moira Donald, writing of domestic servants, notes that: 'The domestic Victorian space, then, was elaborately segregated . . . Yet when individuals crossed boundaries, their reading of the same space would have been very different.'[48] In larger homes, the public entered the private through a vibrant world below stairs. Tradesmen could visit the home, bringing news and exchanging gossip and pleasantries with the household servants. Edith Mabel Hanran, who worked as a housemaid for a Jewish family in Harley Street in the early twentieth century, recalled how she met her husband, Jim, there, as he was a tradesman who often visited the house.[49]

Visitors for servants, who might be 'followers' or love interests, were perceived as a potential threat to the middle-class household, and figured heavily in contemporary representations. In Mrs Henry Wood's *East Lynne* (1861), a servant criticises her master for denying her the opportunity to meet her 'follower', and uses this as an excuse for her presence in the household garden where she overhears her employer's daughter in illicit conversation.[50] Figure 1.5 shows another John Leech cartoon, in which a stern mistress surprises a follower in the kitchen. Being allowed to receive friends was seen by servants themselves as the sign of a good 'place'.[51] But advice writers regarded followers with suspicion, and urged mistresses to monitor them closely. The anonymous author of *Home Difficulties* (1866), for example, stressed that ladies should discuss their servants' love lives openly with them, as they might otherwise be duped into allowing unscrupulous individuals into their homes: 'Under pretence of Ellen seeing her lover, all kinds of men were admitted to my kitchen.'[52] Another approach, advocated by an American writer, was to restrict such visits to a certain hour each day.[53] While the middle classes sought to protect their homes against these visitors, they were often inseparable from the servants themselves and ensured that the middle-class home was frequently entered by a range of individuals from the outside world.

Perhaps the most pervasive way in which the outside world entered the home was through the presence of a large number of middle-class men who worked at home. Davidoff and Hall note that the separation of home from work was far from universal. Bankers, lawyers, doctors and schoolmasters are all offered as exceptions to the rule.[54] Tosh also mentions the clergy.[55] Merchants, industrialists, those who ran small family businesses or shops might also bring trade home. Finn highlights the

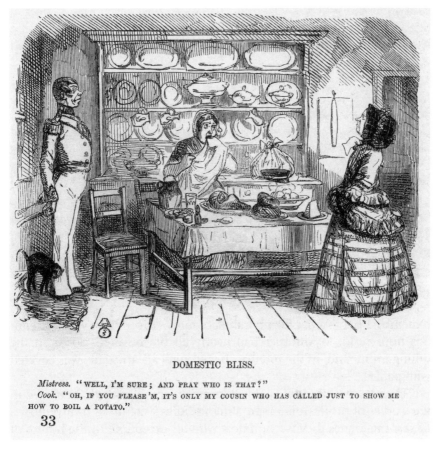

DOMESTIC BLISS.

Mistress. "WELL, I'M SURE; AND PRAY WHO IS THAT?"
Cook. "OH, IF YOU PLEASE 'M, IT'S ONLY MY COUSIN WHO HAS CALLED JUST TO SHOW ME
HOW TO BOIL A POTATO."

33

1.5 J. Leech, 'Domestic Bliss'

'continued centrality of retailers' homes and shops as sites of consumption' in the late nineteenth century.[56] Autobiographies suggest that men who ran a shop or business were likely to base themselves in the home. In the 1880s, Gilbert Thomas' parents, who had been head assistants in an outfitting and drapery department in Gloucester, married and opened a small shop in Coventry, which was also their home.[57] Ernst Rhys's father was a wine merchant, and the family lived in Newcastle in the 1860s. Their house was split in two: 'the lower storeys for offices and wine vaults, the upper for living-rooms'.[58] Rhys's father's office was a powerful presence in the home: 'when one spied him through the glass window that opened out of the parlour into his office, one dared not make any noise that he could hear.'[59]

If a family business was run from home, this was likely to seep into the rest of the household. Oliver Lodge, who grew up in the 1860s, in a family that owned a business for the sale of blue clay in Stoke on Trent,

1.6 Study at Stoke Vicarage belonging to Rev. Cleave Warne, 1909

remembers his mother keeping the accounts: 'It certainly was a strenu-
ous household. My mother had nearly all the business books in the
dining-room; and, in the intervals between meals, the table was covered
with papers.'[60]

 The presence of public work at home was most strongly expressed in
the studies of professional men. When studies were listed in inventories
or sale catalogues they were, almost without exception, in the homes of
professional families: the majority were in clergymen's homes,[61] with two
in doctors' homes,[62] one in the home of a Quaker schoolmaster and one
in the home of an East Sussex widow.[63] In the homes of clergymen the
study became more important in this period as the public emphasis on
the clergyman's pastoral responsibility increased.[64] Clerical studies were
often impressively furnished.[65] The two photographs displayed here (see
figures 1.6 and 1.7) show the study of the Rev. Canon Vaughan from
Droxford Rectory in Hampshire, and the study of the Rev. Cleave Warne
from Stoke Vicarage near Rochester: both desks are workmanlike, and
the study from Stoke has some expensive looking candlesticks and an ink
pot. To a certain extent, the study internalised the divide between public
and private. Tosh argues: 'Reserved for the husband's exclusive use and
out of bounds for the rest of the family, it conformed to the principle of
separate spheres by removing his work from the domestic atmosphere.'[66]

 Yet, professional spaces in the home were not necessarily inacces-
sible to the rest of the family. For doctors' sons in particular, such spaces
often transmitted the mysteries of the profession to young men. Bernard
M. Allen described his six young male cousins as 'all initiated by their

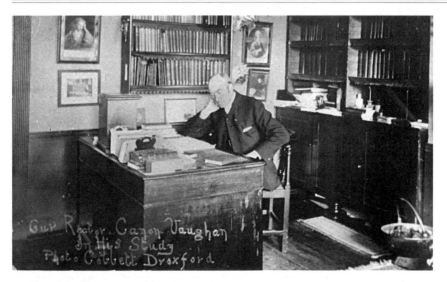

1.7 Rev. Canon Vaughan in his study, Droxford, Hants, undated,

father into the mysteries of the surgery attached to the house, and four of them became practising doctors in after life'.[67] Owen Berkeley Hill, who went on to become a psychologist, had a particularly strong relationship with his father's consulting room: 'I was always welcome in his consulting-room, provided, of course, there were no patients with him . . . I would polish his surgical instruments, the number and shapes of which evoked in me a feeling of awe.'[68] In these cases, access to the father's professional space was gendered: young men were privileged entrants to these rooms, in the expectations that they might follow in their father's professional footsteps.

Rather than being restricted to a professional enclave, work could have an important impact on the atmosphere of the home. It was common for schoolmasters to live on their premises in this period. As shown in the Kendon household, in schoolhouses the world of work very clearly altered the nature of home. Thomas Wright, who, with the help of his wife, ran a private school in Olney, built an extra wing onto his house, in 1898, to accommodate a larger schoolroom.[69] Air Vice-Marshal Sir David Munro, whose father ran a boarding school for boys at Boreham Wood in Sussex, recalled 'the stabling and yards . . . were on a colonial scale. They were mostly used as playgrounds, workshops, and gymnasium.'[70] Families who lived in domestic spaces that had a professional purpose experienced a difference in the atmosphere of the home. Some spaces in the home were associated with its function as a school, and some with the family. A.A. Milne, whose father ran a school in Kilburn, recalls: 'Henley House was two houses. On the Family Side

you entered the front door, and found yourself in a small lobby.'[71] Such domestic division could create a dual atmosphere, as in the case of Kendon, who also distinguished between space for the family and space for the school. Gender could make a difference to this experience: while wives may have assisted husbands, daughters are unlikely to have attended the school. Sons of schoolmasters, however, were both pupils and sons. Milne recalls:

> Beneath the sitting-room was what the rest of the school called The Kids' Room. Here we ate, lived, worked, played with our governess, until we had left Miss Budd's, and here, when we were part of the school, as still our home from home . . . We were undoubtedly part of the school, but we still had long hair, and one foot in the Family Side of the house.[72]

Family life in homes where men worked from home, then, was often infused by the world of work, which could transform the atmosphere of home. The public world frequently permeated the private – and any distinction between the two was highly complex. The home was not always a haven or privacy for the family as a whole from the outside world, nor was it necessarily directed to securing individual privacy – as the examination of internal divisions in domestic space in the second half of this chapter shows.

Internal privacies: the family and spatial hierarchy

Inside the home, individual privacy might be achieved through internal segregation. However, as this section shows, the division and use of rooms were not necessarily geared towards securing the privacy of the individual in isolation – rather, they were about negotiating the relationships between family members, and constructing gendered roles. Throughout the nineteenth century, middle-class homes were divided with increasing rigour and there was a shift towards greater segregation and specificity in house planning.[73] Late seventeenth and eighteenth-century inventories from middling London homes sometimes labelled dining rooms, drawing rooms and parlours, but many rooms were simply referred to as 'chambers'.[74] By the mid-nineteenth century rooms were increasingly named after a specific function.[75] This shift was not absolute: valuers and appraisers in East Sussex in the 1840s and 1850s, for example, continued to use 'chamber' rather than 'bedroom'.[76]

It has been argued that this increasing specificity was driven by the middle classes' desire for privacy.[77] Stefan Muthesius writes: 'the private sphere of the family – increasingly the nuclear family – and the individual became much more carefully demarcated . . . In short, there was a

relentless process of differentiation and segregation. One might say the home became more specialised.'[78] Overall, there was a greater tendency to give a room a name and to associate it with a specific kind of use. One of the most important consequences of these divisions was their function in family life. This chapter considers how domestic spaces were imagined in the pages of advice manuals (often a complex process in itself) and how they were arranged and presented in middle-class homes through inventories, sale catalogues and photographs. While there was a strong association between rooms, material cultures and imagined gendered hierarchies, the everyday use of rooms and goods could be chaotic, and was often quite far away from the idealised representations of advice manuals.

The organisation of the home both reflected and reinforced contemporary gender hierarchies, through the creation of male and female spaces. In the late eighteenth and early nineteenth centuries, rooms and goods had been associated with masculine and feminine styles of decoration and modes of behaviour,[79] but domestic advice writers increasingly emphasised these distinctions in the second half of the nineteenth century.[80] In particular, the drawing room and dining room were designated feminine and masculine, respectively.[81] In his treatise on planning, *The Gentleman's House*, first published in 1864, Robert Kerr noted that the drawing room should be 'entirely ladylike'.[82] The distinction reached its zenith in the 1880s and 1890s.[83] In contrast, advice writers viewed the dining room as a masculine space, to be decorated in dark colours and sombre oak. Figures 1.8 and 1.9, from H.J. Jennings' *Our Homes* (1902) show the contrast between the delicate furniture thought suitable for the drawing room and an ideal dining room, furnished in oak. The name 'drawing room' came from the idea that the room would be used by the ladies of the house for 'withdrawing' after dinner.[84] In *House Architecture* (1880) J.J. Stevenson describes this use of the room: 'in accordance with our custom, which Continental nations consider barbarous, of the ladies retiring to it after dinner, and leaving the gentlemen to drink by themselves'.[85] Figure 1.10 shows John Leech's humorous illustration of the reversal of conventional drawing room and dining room behaviours. Leech, although known for his enthusiasm for home life, was no stranger to the dining tables of the well-off London literary set.[86] It is likely that this satirical depiction of gendered conventions refers to common behaviour among the mid-Victorian upper middle classes.

Many middle-class families had a drawing room and a dining room. Approximately 67 per cent of the inventories and sale catalogues analysed included both these rooms. Lesley Hoskins's new survey suggests that the drawing room was particularly common at the upper end of the middle classes, although she finds that parlours were in use across

AND HOW TO BEAUTIFY THEM.

WOMAN'S REALM—THE DRAWING ROOM.

FIG. 72. GILT LOUIS XV. SETTEE, COVERED IN FINE TAPESTRY.

DRAWING rooms are of all kinds and sizes, varying from the stately salon to the small " best-room " of the cottage *ornée*; but one feature and one purpose are common to all of them. The drawing, or "withdraw "-ing room, is essentially and pre-eminently the ladies' room ; as sacred to their influence and rule as the smoking room is to the regnancy of the men. It is there that the ladies of the house "receive"; there that they preside and enthrone themselves. The whole atmosphere of the apartment is charged with the gracious refinement of woman's subtle spell. It is thither that you adjourn from the dinner-table to listen to music, or to play cards, or to indulge in the lighter intellectual *causeries* to which all can contribute their share. The inferior sex have cast off, for the time, the habiliments of their daily calling, and donned the dress jackets and the varnished boots of the masculine *demi-toilette*. The grace and elegance of the surroundings, no less than the fact that it is the ladies' audience chamber, would exact this concession even were it not convenient and comfortable in itself. You are in a room which expresses a quality *sui generis*—a quality of rest, sociability, and comfort in an artistic framework.

173

1.8 The ideal furnishing for the drawing room

the social group.[87] The sale catalogues and inventories consulted here suggest that parlours were more likely to be listed lower down the social scale: in the north west they appeared in the homes of farmers, engineers and electricians.[88] Across the country, 'sitting room' was often used to describe rooms in the homes of farmers or shopkeepers.[89] There were, of course, exceptions: the house of the farmer J. Earwaker, near Basingstoke,

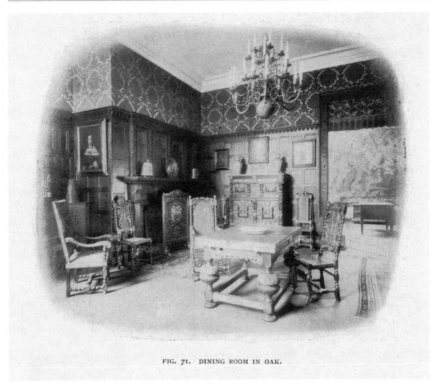

FIG. 71. DINING ROOM IN OAK.

1.9 The ideal dining room

for example, boasted an impressively furnished drawing room and dining room.[90] There was also some variation in the local availability of furnishings.[91] However, the evidence suggests that across England the middle classes developed shared domestic practices for labelling and using these spaces.

But it is harder to tell whether advice writers' prescriptions for the gendered use of these rooms were followed. The size of small middle-class homes meant that it was difficult to designate any one room for individual or separate use. The dining room, while frequently decorated in 'masculine style', often had to serve many purposes. Robert Edis, in his widely sold guide to the furnishing of the town house, published in 1881, recommends that the dining room be set up for the use of professional men during the day.[92] Mrs Loftie's *The Dining Room* (1878), noted that in many smaller homes, this room would have to be used as a sitting room for the family, as well as its named purpose: 'The eating room, perhaps the best in the house, must in large families often serve as parlour, study or schoolroom. This entails a considerable amount of inconvenience.'[93] Figure 1.11, from the manual, shows a man seated in his dining room. The contents of dining rooms, listed in inventories and

THE DRAWING ROOM.

THE DINING ROOM.

Lady of the House. "NOW THEN, GIRLS! FILL YOUR GLASSES! BUMPERS! HERE'S JUST ONE TOAST WHICH I AM SURE YOU WILL ALL DRINK WITH PLEASURE. THE GENTLEMEN!!"

1.10 J. Leech, 'The Ladies of Creation'

sale catalogues, also suggest many different uses. In both small and larger middle-class homes, easy chairs, sofas and ottomans were ubiquitous in the dining room.[94] Easy chairs, and smoking paraphernalia, suggest that the dining room could function as a space for male relaxation.[95] But writing equipment[96] and book collections[97] also suggest a possible work-space. Surprisingly, the dining room also contained a range of goods associated with female occupation: work boxes[98] and sewing machines[99] were often present.

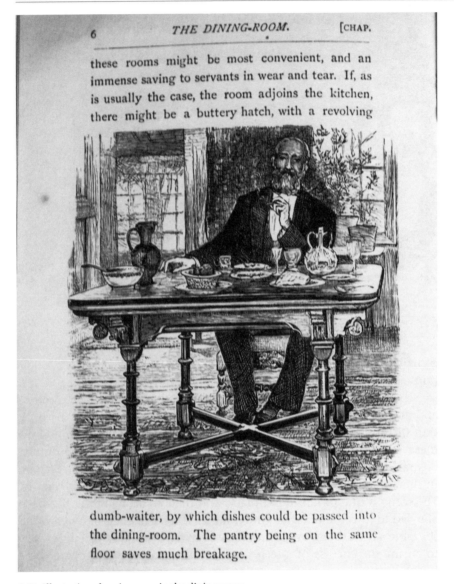

6 *THE DINING-ROOM.* [CHAP.

these rooms might be most convenient, and an immense saving to servants in wear and tear. If, as is usually the case, the room adjoins the kitchen, there might be a buttery hatch, with a revolving

dumb-waiter, by which dishes could be passed into the dining-room. The pantry being on the same floor saves much breakage.

1.11 Illustration showing man in the dining room

The dining room at 'Cornikeraium', a four-bedroom house on Oxford Avenue in Southampton, inventoried between 1907 and 1908, reveals the large range of activities this room might be expected to host.[100] Alongside the obligatory dining room suite, the room included 'lady and gent's easy chairs', 'a smoker's companion fitted with 3 pots and combined ash-tray and cigar cutter' and 'a walnut wood inkstand with two moulded bottles and a pen bowl'. Other goods included books, a cribbage board, dominoes, a pair of flat-nosed pliers and two pairs

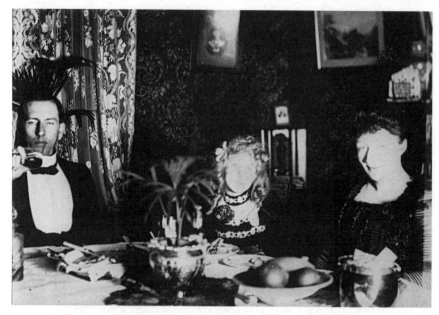

1.12 Dr and Mrs McBain at dinner

of nail scissors, which suggest a wealth of activity rather than a single purpose.

The individual experience of privacy or otherwise in dining rooms and drawing rooms varied, depending on the time of day and the position of the individual in the household. Two photographs show how these rooms might be set up for dining, during breakfast or dinner. Figure 1.12 shows a rare photograph of the family of Dr and Mrs McBain in their small Manchester dining room in the late nineteenth century. The scene is one of family intimacy, and their small daughter has been allowed to join them at the dinner table. The family is grouped around the table, and although they may have been positioned unusually closely to ensure the success of a technically difficult interior photograph, the image leaves an evocative sense of the impossibility of privacy at such times, especially for a child required to perform table manners. Yet at certain times of day the room offered an escape from the demands of family life. Amy Barlow, the seventh child of a hard-pressed middle-class family recalled: 'This room was my Mecca. I repaired here whenever I could escape from the family and household jobs and curled myself up in an old armchair just to read and read.'[101] Photographs also often show the drawing room as a space for quiet introspection.[102] Figure 1.13 shows a woman seated in the drawing room of a small home in Botley in Hampshire. She is posed reading with a book in her lap, gazing towards a window as if rapt in thought. Figure 1.14 also shows a photograph

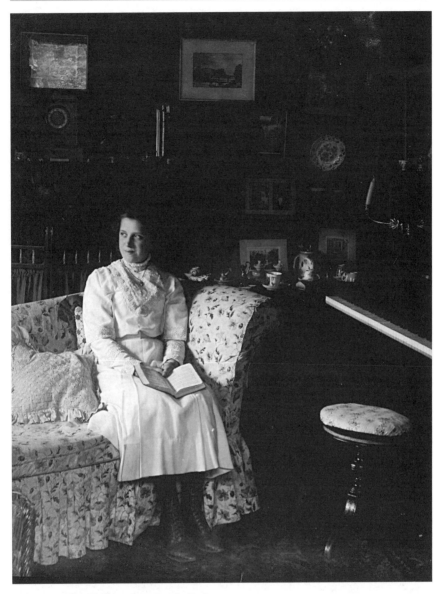

1.13 An unidentified drawing room in Botley

that constructs the drawing room as a space of solitude and personal introspection.

In larger homes, whether the privacy of the master or the mistress should take precedence was a matter for debate. Most middle-class homes were expected to contain not only a dining room and a drawing room, but an additional reception room.[103] For professional men who worked from home, it was expected that this room would be a study or

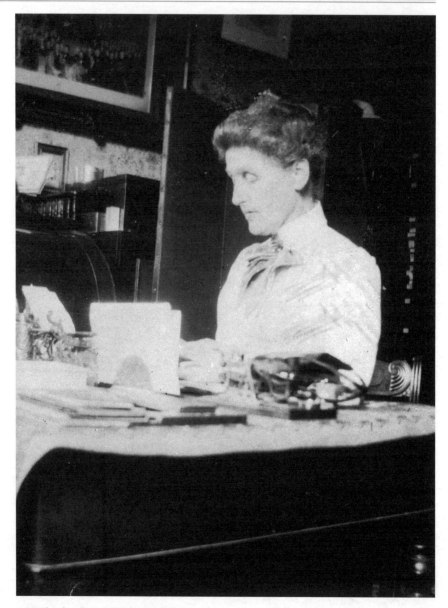

1.14 The drawing room at Frondeg

library.[104] Otherwise, advice writers argued over who should have own-
ership of the third sitting room.

Towards the end of the century, with the expansion of smoking and
the manufacture of cheap cigarettes from the 1880s, a smoking room was
a possibility.[105] Smoking in the home was, however, controversial. Kerr
gives the male side of the argument, pleading: 'The pitiable resources to

PLATE XXXVI. A SMOKING ROOM CHIMNEY CORNER. *Photographed at Warings.*

1.15 The ideal smoking room

which some gentlemen are driven, even in their own houses, in order to be able to enjoy the pestiferous luxury of a cigar, have given rise to the occasional introduction of an apartment specially dedicated to the use of Tobacco.'[106] Jennings presents the smoking room as the man's retreat from the world: 'The room should at once convey a feeling of retirement from the throb and tumult of the hurry-scurrying world'[107] (see figure 1.15). Panton, however (writing shortly before Jennings), argued that smoking should not be allowed in the home at all, except, perhaps, in the conservatory.[108] Instead, Panton and Mrs Peel argued that in small middle-class houses the third sitting room should be a female morning room, rather than a male study or smoking room.[109] Panton and Peel both viewed the room as highly feminine.[110] But they also marked it out as a female workspace, where the mistress of the house could pursue household management (and perhaps a writing career) unhampered by children, servants or visitors.[111]

But few middle-class homes had the resources to implement the 'third sitting room' that advice writers argued over. Overall, only approximately 30 per cent of the inventories and sale catalogues included a specifically 'male' space, that is, a study, library, smoking room or billiard room. Female domestic spaces, such as the boudoir and the morning room, were even thinner on the ground. A few women were able to realise the morning room: Mrs Greenwell, of Clonavon in Barrow, for example, had a morning room that included books, a writing table and writing equipment.[112] But overall, only approximately 15 per cent of the inventories and sale catalogues included a morning room or a boudoir. Other sources also suggest that the provision of private spaces

for individual family members was limited by lack of space. Newly built suburban homes in London, Manchester and Birmingham had only two reception rooms, a large living room/kitchen, four bedrooms and maybe a small conservatory.[113] Older houses with a special purpose, such as vicarages, might be more spacious, and gentry manors were of course much larger. But it was more usual for space to be at a premium. Hubert Nicholson remembered the pressures of family life in a small space in his early twentieth-century childhood home in London: 'We were packed tightly into a box too small for us.'[114]

Even in larger homes where increased segregation through a wider number of rooms was possible, additional rooms were not necessarily used to secure greater privacy. Rather than creating individual privacy by separating family members, the library and breakfast room were often set up to ensure their coming together. In the case of these rooms, it was the desire for intimacy – rather than privacy – that drove their establishment and arrangement. Those families that did have the resources for a third sitting room often did not devote this to the exclusive use of either husband or wife, instead opting for the breakfast room, a shared space used for the morning meal and as a sitting room later in the day. In the north and south east of England, breakfast rooms outnumbered morning rooms and smoking rooms listed in sale catalogues and inventories.[115] The breakfast room was also relatively common in the north west.[116] This ambiguous space was clearly used for a range of purposes, besides breakfast.

Figure 1.16 shows the breakfast room at Brentwood, a large upper-middle-class house in Manchester. It has no obvious purpose, but the covered table and chairs suggest a variety of possible uses. The morning and breakfast rooms in the south were clearly intended for female work, containing work tables and writing tables. Some of the northern rooms were similar. The Blackett household in Leeds, catalogued in 1875, contained a 'breakfast room' that included a sewing machine and work box, and several north-western breakfast rooms also contained sewing machines.[117] The contents of these rooms suggest a flexible space that was used by both sexes. The breakfast room in Greenscoe House included 'a tapestry pile table cover, superior four foot six inch knee hole walnut writing table, inlaid with dark blue leather, a revolving office chair, a rocking chair, two tobacco jars, a hand sewing machine by Singer & Co., and a lady's work basket'.[118]

Advice writers often emphasised that the library should be a sacred male preserve, undisturbed by the rest of the family and only to be dusted by the mistress of the house.[119] Inventories and sale catalogues, however, show that libraries often contained goods that suggest family sociability as much as solitary male occupancy. The

1.16 The breakfast room at Brentwood

library at 'Crosslands', for example, the home of James White, a general manager of an iron steel works, and his wife and three children, included both bookcases and a pianoforte and piano stool.[120] Many libraries contained a large number of seats, suggesting that they could accommodate groups.[121] Unlike the study, the library was not necessarily used as a quiet space for male work, and a significant number of libraries included pianos.[122] Clearly, libraries were often used as additional family sitting rooms in addition to their perceived role as male territories.

Upstairs, downstairs? Privacy for masters and servants

Middle-class and upper-class homes were organised to protect the privacy of families from their working-class staff whose presence was necessary to maintain them.[123] Large country house plans sharply divided servant and family space, although as Jill Franklin has shown this declined towards the end of the nineteenth century.[124] Such distinctions were also pronounced in upper-middle-class houses, where more than two servants were employed. The 'otherness' of the servants' world was emphasised most strongly by upper middle-class writers, such as Sonia Keppel, who likened the servants' area of her family's London town house to the world of 'Pluto and Proserpine'.[125] Robert Graves

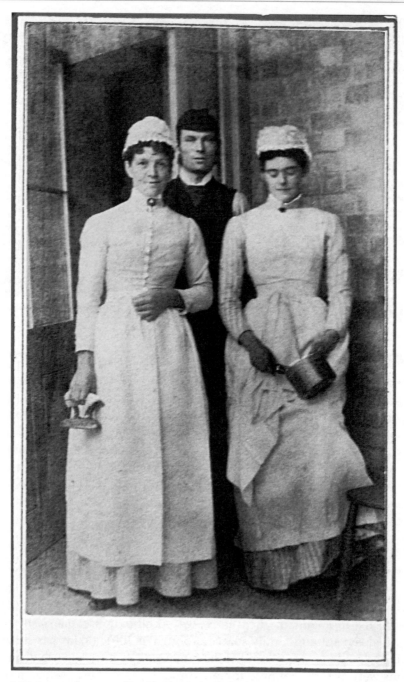

1.17 Servants from an unidentified house in Cheltenham

1.18 Servant from an unidentified house in Cheltenham

recalled that: 'By a convention of the times they were the only rooms in the house that had no carpet or linoleum . . . gaunt, unfriendly-looking beds, and hanging cupboards with faded cotton curtains.'[126] Virginia Woolf remembered that in her childhood home at 22 Hyde Park Gate 'the basement was a dark unsanitary place for seven maids to live in'.[127] However, the average servant-employing household included only one or two live-in servants, and some middle-class homes did not employ servants at all, especially early in the life cycle when couples were first married and money was short.[128] There was thus a vast difference between the division of masters and servants in gentry and some upper middle-class homes, and the rest of the middle classes. The former might have separate servant wings and staircases.[129] But it was more usual for servant bedrooms to be separated by vertical space, in small rooms at the top of the house.

The desire to distance the family from the servants was complicated by the need to keep a close check on their activities. Proximity to, and surveillance of, the kitchen were presented as essential to the authority of mistresses. *Domestic Servants: as they are and as they ought to be*, published in 1859, warned of uppity cooks who would brook no interference in kitchen affairs: 'as for going beyond the kitchen table, the mistress dare not, for she would be looked on by some cooks as trespassing on a territory not her own'.[130] An advice manual for mistresses, *Home Difficulties*, published in 1866, recommended that servants should not be left in the home unsupervised over holiday periods.[131] Anxieties over what went on in the kitchen beyond the eyes of the mistress continued into the twentieth century. *The Servant Problem* (1899) remarks, for many servants, 'the ideal mistress being one who enters her kitchen once a day, sometimes not even that, who takes everything for granted, and who allows the servants to do what they like'.[132] The author also cites the problem of over dominant cooks: 'They look upon the kitchen as their domain, and the mistress as an interloper there, and they certainly do pretty much as they like in it.'[133]

The extent to which mistresses kept watch over their servants varied according to inclination and practical constraints. The diaries of Mary Ann Turner, the daughter of a middle-class family in Beverley, include a list of tasks for the servants of the house, suggesting that some mistresses were careful to penetrate all areas of domestic space: 'to mention to the cook that no perquisites are allowed and that I shall occasionally look over everything under her care closets included'.[134] But despite advice manual writers' exhortations, upper middle-class mistresses could be wary of conflict in the kitchen. Esther Stokes, a barrister's daughter, recalled that her mother was reluctant to enter the kitchen of their large Streatham home:

Mother would go down and see her cook in the morning, to give orders and that sort of thing. And thereafter, if she wanted to speak to her for any reason or other bells were rung and the cook would come. No mistress would ever go downstairs. She wouldn't impinge on their privacy and what they were doing after ten in the morning, whenever it was she went.[135]

In households with more than two or three servants there was a greater sense of distance between maid and mistress than in smaller households. In a house with a number of servants, it was possible for the mistress to not even see the housemaid or kitchen maid on a regular basis, as they would receive their instructions from the cook. Florence Davis, whose first full-time job was in the house of a banker in the 1900s, recalled that she did not see much of the lady of the house: 'Didn't see much of her, because I was kitchen maid then you see – the lady of the house always made it a rule to give their orders to the cook or the housekeeper by nine in the morning.'[136] In these larger houses, relations between servants and the wider family might well be more formal. Edith Mabel Hanran, who went into service aged 16, in 1910, worked in a family house in Harley Street with a staff of about six servants. When asked about contact with members of the family, she commented:

Oh we very seldom saw them. And then if we met them in the hall or anything we used to say good morning and they said good morning – they always called you by your surname then – yes – Tyler – so they'd say good morning Tyler and you'd say good morning, Madam or good morning Sir, whatever it might be and that was that.[137]

The maintenance of the privacy of the family required an elaborate and tightly organised timetable, in which servants and family members performed tasks at set times, skirting around each other but never meeting in the same room. In gentry or upper middle-class homes, planners recommended a separate staircase for servants, ensuring that they did not meet the family.[138] A.M. Sargeant's *The Housemaid's Complete Guide* (revised edn 1854), reveals the lengths a housemaid was expected to go to avoid disturbing the family. When waiting on the family, servants were instructed to be unobtrusive: 'Let everything be done quietly and neatly.'[139] The drawing room was to be cleaned in the family's absence.[140] The maid's entry to the bedroom was governed by a complex gendered etiquette. Under normal circumstances, warm water for washing would be left outside the bedrooms of ladies and gentleman at an appointed hour in the morning: 'When you take this up, tap at the door, and as soon as the person within answers put the jug down close to the door, and leave it.'[141] However, in the event of illness, breakfast was to be taken up:

If the lady rings, and she is alone in her bed room, you must knock, and on receiving an answer, go in and do what may be required; but if the gentleman is there, you must knock and not go in, but deliver at the door, or put down at it, after knocking, whatever may have been rung for.[142]

Domestic advice manuals often mapped out daily and weekly plans for housemaids, designating when to rise, and carefully timing particular tasks in certain areas in the home. Commentators thus viewed the disposition of domestic space as a means of ensuring that masters and servants remained separate, and inappropriate intimacies did not arise between them.

Oral histories suggest that while mistresses attempted to implement these spatial and temporal rules, strict timekeeping could be a challenge. Certain areas were out of bounds at some time during the day. Mavis Thompson recalled: 'We didn't go in [the drawing room] when they were having tea because it was a sort of private talk for the mistress you see.'[143] Even in quite small houses elaborate arrangements could be made to achieve spatial separation. Jeannie Williams recalled: 'Well I ate with the children, afterwards. In order that they had peace with their breakfast – I'd be in the study with the children. And then the children and I would have breakfast – afterwards. You see, as they had – peace to have breakfast then I'd have peace as well, because she'd be in the kitchen while I was having my breakfast.'[144] While protecting the privacy of the parents, this arrangement would have brought Jeannie Williams into closer contact with the children of the family.

Of course, rules were not always followed. Advice writers acknowledged the frequent failure of their stipulations. Mrs Haweis remarked: 'Servants generally rise at 7 (they call it 6), they breakfast at 8, they lunch at 11, they dine at 2 or before, they have tea at 4.30, and they have supper at 9.'[145] The author of *The Servant Problem* stated: 'You may tell them they must be down at six o'clock, and instead they come down close upon seven, the consequence being noise and scramble and rush and hurry to get the work crowded into half the time.'[146] Edith Hanran remembered that she was often late for her mistress in the mornings at Harley Street, although her mistress did not reprimand her for this.[147] Many servants may have found it difficult to follow such elaborate spatial rules, and any separation achieved would have been partial at best.

In single servant households, where mistress and maid occupied the same workspace daily, it was almost impossible to avoid each other. Irene Thompson was employed as the single general domestic servant in a Market Harborough home in the early twentieth century; she recalled that this allowed her mistress to supervise her work to an uncomfortable degree.[148] Siân Pooley has recently shown that in late nineteenth-century

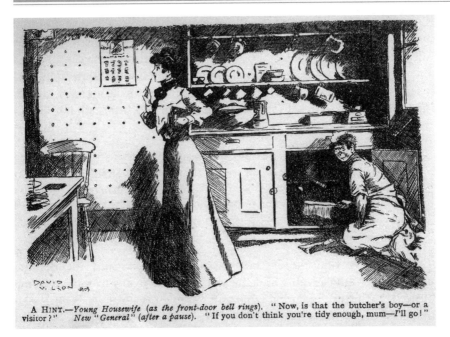

A HINT.—*Young Housewife (as the front-door bell rings).* " Now, is that the butcher's boy—or a visitor ? " *New " General " (after a pause).* " If you don't think you're tidy enough, mum—*I'll go !* "

1.19 David Wilson, 'A Hint', 1903

Lancashire the division of household tasks between maid and mistress could be fluid, although she also notes that such practical closeness did not necessarily mean greater warmth or intimacy between the two.[149] Mrs Hallam worked as a single servant for a family in Highgate, where spatial segregation was enforced to the point of abuse: 'I was scared stiff because I was always kept in the scullery.'[150]

Yet the relationship between master and servant in the small middle-class home was not necessarily dominated by exploitation or petty surveillance. Representations from the period did not portray servants as vulnerable victims. Kitchen subversion was a common theme of *Punch* cartoons. Figure 1.18 shows a cartoon by David Wilson, drawn in 1903, in which a 'general' servant ignores the commands of her young mistress. In contrast, servant oral histories often recall the warmth that grew up between maids and mistresses in small homes.[151] As Leonore Davidoff, Megan Doolittle, Janet Fink and Katherine Holden show, in smaller households, servants were often very young, and might well be kin or the daughter of a neighbour or friend.[152] Elsie Thompson from Chelmsford had her first job working as a help to the local schoolmaster's wife: 'Mrs Marsh used to work along with me, sort of worked with her as though she was me own mother.'[153] Visitors to the house helped her with the washing up, and her own children were later welcomed by her mistress.[154] The 'family' connection between some employers and

their servants was, in some cases, cemented by the practice of employ-ing sisters from the same family in succession.[155] In a few households (although of course not all) a bond could be built up between mistress and servant, which cut across the relationship between the mistress and master of the house. Jeannie Williams built up an intimacy with her mistress when working alongside her in the kitchen, although her master remained an intimidating presence:

> Well – except that I do remember him reading a sort of a – family sermon and I – in the evening and you see the thing was that Mrs Griffiths and I'd been in the kitchen and we'd been having fun in the kitchen and I couldn't stop myself laughing. And he stopped the sermon, and he said, I'm prepared to wait for you Jeannie, until you're ready – ready to listen. I was frightened out of my life.[156]

In smaller households, both spatial divisions and the distinc-tion between the servants and the family often seems to have become blurred. Sitting at the family table and sharing the meal was a clear sign that class distinctions were muddied. In Mrs Warren's *My Lady-Help and What she Taught Me* (reprint 1889), the fictional husband's main objec-tion to the introduction of a 'lady-help', a servant from the same class as the family, is the social awkwardness presented by her waiting at table: 'My dear, you outrage all manly feeling in proposing such a scheme! Am I to have a lady, a gentlewoman, to wait upon me at the dinner table, and to bring me this, that and the other?'[157] However, the book went on to suggest that middle-class families in need of domestic assistance would benefit if these scruples could be overcome. Some lower middle-class families were clearly quite comfortable with this. Servants who had particularly close relationships with their employers might well eat in the same spaces. Elsie Thompson ate at the same table as her mistress, Mrs Marsh, and this contributed to her feeling of being 'just like one of the family'.[158]

This may have been more likely to occur in farming households, in which it was both more practical for the staff and family to eat at once and group endeavour might militate against class boundaries. Nora Blewett, who worked on a farm at Ladock near Boswidiel in Cornwall in 1913, remembered that her master and mistress 'treat us all just like themselves, had meals with us and – did everything as – it should be done in working-class people's area'.[159] In this household, however, Blewett remembered that there were two spatial orders. The master and mistress adopted middle-class practices when visitors came to the house, eating separately in the dining room and using the best china.[160]

Servants' penetration of their masters' most personal spaces in their absence was a source of considerable cultural anxiety, and was perceived

as a direct threat to privacy. Lawrence Stone has shown that servants in the eighteenth and first half of the nineteenth centuries were often witnesses in trials for separation and adultery.[161] As Brian McCuskey has demonstrated, nineteenth-century novels often dealt with the issue of servants' surveillance of their masters, although he notes that this was shown to work both ways.[162] From the middle of the century, novels expressed fears over servants' intimate knowledge of their masters, gleaned through contact with domestic goods. In *The Moonstone* (1868), Wilkie Collins draws a disturbing portrait of Rosanna Spearman, the erring servant girl given a second chance, only to wreak havoc inadvertently through concealing her knowledge of events surrounding the theft of a jewel. Spearman's privileged access to her master's personal goods during her cleaning duties is crucial in enabling her to obtain this knowledge.[163] Middle-class fears of servants mishandling intimate objects were also expressed in didactic novels produced in the late nineteenth century. These books were probably intended for a servant readership. Heavy with moral messages, they reinforced the idea that there were certain material boundaries that servants should not cross.

Miss Poole's *Without a Character: A Tale of Servant Life* was published by the Christian Knowledge Society in 1870. The tale focuses on the life of Lydia Bennett, a young housemaid taken on without a character (i.e. reference) by her mistress. Lydia gives in to the desire of the other servants to see her mistress's diamond ring, and removes it from its rightful setting and displays it in the kitchen. Her transgression is later punished, as she is the first to be suspected when the ring goes missing.[164] The threat posed by the bad servant, who makes illicit uses of her mistress's goods, reappears in Helen Briston's *Lottie: Servant and Heroine*, published in 1898.[165] The character flaws of a maidservant called Kate are demonstrated when she tampers with her mistress's goods, actually having a mantle altered by a dressmaker so that she can wear it to a trip to the theatre.[166] Anxieties over servants' potential destruction of their masters' property also figured in *Punch* cartoons.[167]

Could servants hope for privacy in the middle-class home? Novels and advice literature suggest that although servants' powers were limited, there was an expectation that they would be entitled to some privacy. There was a material line that a master or mistress could not cross without forfeiting a servant's trust. Mistresses were encouraged to regularly monitor their servants' bedrooms and even their personal possessions.[168] But it was acknowledged that servants were entitled to keys to wardrobes and drawers or, at the very least, a box of their own.[169]

Amanda Vickery has shown that this was also the case in the eighteenth-century home.[170] Boxes and locked trunks, servants' hidden spaces, often inspired suspicion in their masters. In *The Servant Problem*

(1899) a cook's box is used to conceal goods and food that have been stolen from the home of her employers: 'She worked fairly well for a fortnight or so, but during the latter part of the month I observed her box had become a dead weight, almost too heavy to be moved. It was always fast locked, her door frequently so, and the window always wide open.'[171] Yet it was not acceptable to traverse these spaces. In the novel the act of searching a servant's box was constructed as a serious step, infringing servants' rights, which only occurred when circumstances had cast definite suspicion on a member of the household. In *Without a Character* (1870) the innocent servant under suspicion reverses the normal procedure, demanding that her boxes be searched as a testament to her honesty.[172] Once open, the boxes reveal more than just innocence, but also virtue and frugality: 'Nothing was to be discovered from her boxes except – poor girl! – the unmistakeable evidence of her poverty. There was a small scanty wardrobe arranged with great neatness, but no small personal possessions beyond what was absolutely needful, except a few presents that she had received since coming to Worcester.'[173]

Servant–master relationships in the nineteenth century basically relied on trust: masters trusted servants with their most valuable and intimate objects, and in return servants expected a modicum of privacy of their own. Once the box had been opened, that trust was broken, and good relations between the two were often at an end.

In practice, servants' privacy was often limited. The power of mistresses over servants, mediated in their own domains, in some ways bordered on the absolute: servants often had to work long hours with little leisure, and were accorded few afternoons or evenings away from the household. Visitors were also sometimes forbidden. Employers might pry into their servants' things: the diary of the Rev. Cleave Warne notes that a servant was dismissed on the spot for 'immorality imputed in certain letters I discovered'.[174] For some servants, however, the middle-class house actually offered more privacy than their own homes. It was not unusual for servants to be given their own bedrooms and these were remembered as a perk.[175] Mrs Jaggard recalled that one of the best things about her job was a bedroom of her own: 'Well one thing I had a nice bedroom to myself – nothing elaborate, but . . .'[176] Mrs Radford remembered feeling isolated in her first situation, as the sole servant of a butcher's family: 'I cried the first night. 'Cos I – I had to go right in the attic to sleep away from them, oh lonely I was.'[177] But in later posts she came to prize having a room of her own. Even a shared room might be an improvement as, at the very least, it would mean a single bed to oneself. Mrs F Thompson recalled that one of the attractions of her first job was that 'they had a lovely big bedroom with single beds'.[178] A partial privacy, then, was achievable for some servants.

Conclusion

Despite the changes in the physical and mental world, public and private remained intermingled in the nineteenth-century middle-class home. The extent to which the middle classes embraced privacy can be questioned. It has been argued that the private world of the home became increasingly divorced from the public in this period. But while the rise of suburbia saw the removal of some sectors of the middle classes from the city, the physical structure and design of houses continued to link the interior to the outside world. Domestic consumption brought a flow of objects into the home, and the home was often decorated with objects and images that symbolised the public world outside. The steady patter of visitors, both above and below stairs, also connected the home with many other spaces around it. Moreover, in many middle-class houses, work remained very much in the home. The arrangement and atmosphere of many households was conditioned by the presence of men who worked from home. Clergymen, doctors, businessmen, shop owners all worked from home and made a crucial difference to domestic space. The example of the vicarage shows just how far the private world of the home could be pressed into public use. Professional spaces in the home were profoundly influential, particularly for young boys in the formation of their first ideas of self and masculinity.

Nor did the middle classes necessarily seek individual privacy through internal division. While rooms were labelled more precisely from the early nineteenth century, inventories and sale catalogues show just how little space was on offer in many middle-class homes, which were often simply too small to include the elaborate suites of gendered spaces recommended in advice literature. A degree of segregation was achieved in most middle-class homes through the division between the drawing room and dining room. Indeed, the use of these two reception rooms emerges as a shared domestic practice across the English middle classes. Their contents, however, suggest that the dining room in particular was often multifunctional. The preference for the breakfast room, and the clustering of male and female objects in it, also suggests that these spaces continued to be characterised by a number of different uses rather than a single function. Moreover, the objects in larger upper middle-class homes suggest that even where the spatial potential for elaborate segregation existed, prescription for usage was not always followed. The widespread presence of the piano in the library, for example, suggests female performance and sociability in a space that advice manuals linked with men.

Servants and masters were separated to a degree, but with some limitations. Servant bedrooms were located at the top of the house in

the attic, while servant workspaces were usually in the kitchen and basement. However, sale catalogues and inventories reveal the limits of such segregation: few homes had an additional staircase for servants, and housemaids' closets were often located amid family spaces. Moreover, while masters and servants remained distant in upper middle-class homes with four or more servants, this was not the experience of the majority of the middle classes. Far more frequently, middle-class homes included only one or two servants, necessitating greater spatial contact between maid and mistress and leading to long hours spent together in the kitchen. It would have been difficult to maintain privacy in these circumstances and, in some cases, intimacy between maid and mistress could transcend the spatial divisions that the middle-class home set up.

Even in large-scale establishments, the separation of master and servant relied on servants making elaborate movements around the home at certain times to avoid encountering their masters. As servant oral histories attest, these instructions were not always fulfilled. Moreover, in lower middle-class homes at least, it seems that masters and mistresses were often comfortable to mingle quite closely with the servants, unworried by the need for privacy or class boundaries.

The home, then, could be simultaneously public and private in complex ways. If 'public' and 'private' are not the best terms to use to describe nineteenth-century middle-class domestic space, what should we replace them with? Rather than emphasising the need to secure individual privacy, autobiographies and oral histories often focus on the way the home was structured to create family relationships. The workspaces of professional men, particularly the clergyman's study, ensured that men could perform public functions, but were also hugely influential on the wider home. Boys, in particular, often venerated these spaces.

Children remembered being dragged into the drawing room for the uncomfortable weekly 'At Home', but often also made strong associations between these spaces and their relationships with their parents. The presence of servants could play a crucial part in determining the behaviour of the family, and the intimacies that were forged in the home. In addition to considering the relationship between the home and the outside world, and the possibilities that separation offered for individual privacy, we also need to consider how the spatial structure of the home was set up to create intimacies and distances in family relations. The following chapters in this book explore this concept further.

Notes

1 F. Kendon, *The Small Years* (Cambridge: Cambridge University Press, 1930), p. 49.

2 Ibid., p. 52.

3 Ibid., p. 51.

4 Ibid., p. 51.

5 See A. Briggs, *Victorian Cities* (London: Odhams Press, 1963), pp. 1–58.

6 Donald J. Olsen, 'House upon House', in H.J. Dyos and Michael Wolff (eds), *The Victorian City: Images and Realities* (London: Routledge, 1973), vol. 1, pp. 333–358; H.J. Dyos and D.A. Reeder, 'Slums and Suburbs', in Dyos and Wolff (eds), *The Victorian City*, vol. 1, pp. 359–386; F.M.L. Thompson, 'Hampstead 1830–1914', in M.A. Simpson and T.H. Lloyd (eds), *Middle Class Housing in Britain* (Newton Abbott: David and Charles, 1977), pp. 87–113; H.J. Dyos, *Victorian Suburb: A Study of the Growth of Camberwell* (Leicester University Press: Leicester, 1961), p. 19. Davidoff and Hall have argued that the first half of the nineteenth century saw the separation of home and work as the suburban villa became 'physically, financially and socially removed from the enterprise'. Leonore Davidoff and Catherine Hall, *Family Fortunes: Men and Women of the English Middle Class 1780–1850* (London: Routledge, 1997, reprint), p. 359.

7 Helen Long, *The Edwardian House: The Middle-Class Home in Britain, 1880–1914* (Manchester: Manchester University Press, 1993), p. 49.

8 Jerry White, *London in the Nineteenth Century 'A Human Awful Wonder of God'* (London: Jonathan Cape, 2007), p. 97.

9 White, *London in the Nineteenth Century*, p. 82.

10 For example, clergymen frequently adapted vicarages. F. Knight, *The Nineteenth-Century Church and English Society* (Cambridge: Cambridge University Press, 1995), p. 141.

11 Briggs, *Victorian Cities*, p. 27; Alan Kidd, *Manchester* (Keele: Keele University Press, 1996), pp. 144–147.

12 R. Newton, 'Exeter 1770–1820', in Simpson and Lloyd (eds), *Middle Class Housing*, pp. 12–43; T. Hinchcliffe, *North Oxford* (London: Yale University Press, 1992), p. 211.

13 For a discussion of the times it took to reach central London from the suburbs see Alan A. Jackson, 'The London Railway Suburb 1850–1914', in A.K.B. Evans and J.V.Gough (eds), *The Impact of the Railway on Society in Britain* (Aldershot: Ashgate, 2003), pp. 169–180.

14 White, *London in the Nineteenth Century*, p. 78; Jim Cheshire, 'The Railways', in Michael Snodin and John Styles (eds), *Design and the Decorative Arts: Britain 1500–1900* (London: V&A Publications, 2001), pp. 424–425.

15 Erika Rappaport, *Shopping for Pleasure: Women in the Making of London's East End* (Princeton: Princeton University Press, 2000), p. 3; L. Nead, *Victorian Babylon: People, Streets and Images in Nineteenth-Century London* (London: Yale University Press, 2000), p. 67.

16 Jürgen Habermas, *The Structural Transformation of the Public Sphere: An Inquiry into a Category of Bourgeois Society* (trans. Thomas Burger) (Cambridge: Polity Press, 1996), p. 43.

17 Davidoff and Hall, *Family Fortunes*, pp. 167–171.

18 A. Vickery, 'Golden Age to Separate Spheres? A Review of the Categories and Chronology of English Women's History', *Historical Journal*, 36:2 (1993), 397–401.

19 This has been stated most recently by Gordon and Nair, who revisit the separate spheres debate. Eleanor Gordon and Gwyneth Nair, *Public Lives: Women, Family and Society in Victorian Britain* (London: Yale University Press, 2003), pp. 2–7.

20 P. Hollis, *Ladies Elect: Women in English Local Government 1865–1914* (Oxford: Clarendon, 1987), passim; K. Gleadle, '"Our Several Spheres": Middle-Class Women and the Feminisms of Early Victorian Radical Politics', in K. Gleadle and S. Richardson (eds), *Women in British Politics 1760–1860: The Power of the Petticoat* (London: Economic and Social Research Council, 2000), p. 147.

21 See section on 'New Professions', in Susie Steinbach, *Women in England 1760–1914: A Social History* (London: Orion Books, 2005), pp. 63–82.

22 S. Hibberd, *Rustic Adornments for Homes of Taste; And Recreations for Town Folk in the Study and Imitation of Nature* (London: Groombridge and Sons, 1857), p. 1.

23 J. Leech, *Pictures of Life and Character . . . from the Collection of Mr Punch* (London: Bradbury and Evans, 1863), p. 2.

24 H.E. Palmer, *The Mistletoe Child: An of Autobiography of Childhood* (London: J.M. Dent and Sons, 1935), p. 27.

25 H.A.L. Fisher, *An Unfinished Autobiography* (Oxford: Oxford University Press, 1940), p. 1.

26 Philip Gibbs, *The Pageant of the Years: An Autobiography* (London: William Heinemann, 1946), p. 2.

27 Robert Graves, *Good-bye to All That: An Autobiography* (London: Jonathan Cape, 1929), p. 14.

28 Kendon, *Small Years*, p. 2.

29 G. Nickalls, *Life's A Pudding: An Autobiography* (London: Faber & Faber, 1939), p. 24.

30 John Brewer has explored the exploitation of the cult of Wilkes by ceramics manufacturers. J. Brewer, 'Commercialisation and Politics', in N. McKendrick, J. Brewer and J.H. Plumb (eds), *The Birth of a Consumer Society: The Commercialisation of Eighteenth-Century England* (London: Hutchinson, 1983), pp. 238–240.

31 In particular, she notes the popularity of woodcuts of paintings of national heroes, such as Nelson, and associates this growth in consumption with a growth in patriotic feeling. L. Colley, *Britons: Forging the Nation 1707–1837* (London: Yale University Press, 1992), p. 180.

32 L. Walker and V. Ware, 'Political Pincushions: Decorating the Abolitionist Interior 1787–1865', in I. Bryden and J. Floyd (eds), *Domestic Space: Reading the Nineteenth-Century Interior* (Manchester: Manchester University Press, 1999), p. 70.

33 For a full list of the inventories and sale catalogues surveyed, see Bibliography.

34 16 Eldon Rd, Newcastle, 1886, T&WAS, DT/MSM/44; Bird Hill House, Gateshead, 1866, DRO, D/St/E5/9/33; Deanery of Durham, 1912, DRO, D/Ed 18/11/15, respectively.

35 A survey of the contents of middle-class bookshelves is beyond the scope of this study, but books were ubiquitous in inventories and sale catalogues, even in homes lower down the social scale. For example, books featured in the following: Inventory and Valuation of the Household Furniture and effects of Mr Jacob Ray, HRO 67M92W/16/2; Inventory and valuation of the late Thomas Hogget's furniture etc., 22 November 1871, DRO, D/SJ C103.

36 Abbotsford House, Romsey, 1918, HRO, 4M92/G16/5.

37 Inventory of Thomas Roberts, Twyford, 1887, HRO, 67M92W/8/10.

38 Trevor Keeble, '"Everything Whispers of Wealth and Luxury": Observation, Emulation and Display in the well-to-do-late-Victorian Home', in Elizabeth Darling and Lesley Whitworth (eds), *Women and the Making of Built Space in England 1870–1950* (Aldershot: Ashgate, 2007), pp. 69–84.

39 Judith Neiswander, *The Cosmopolitan Interior: Liberalism and the British Home, 1870–1914* (London: Yale University Press, 2008), pp. 28–30.

40 The Greater Manchester Record Office Documentary Photography Archive (GMCRO DPA) comprises the largest collection of family photographs in the UK, including 800,000 images.

41 Leonore Davidoff has demonstrated the importance of establishing initial contact through cards in aristocratic circles. Leonore Davidoff, *The Best Circles: Society, Etiquette and the Season* (London: Croom Helm, 1973), p. 43. Rigid rules could also govern middle-class calling practices. Jeanette Marshall's diary recalls a family contretemps over the failure of one branch to pay a courtesy call after a ball. Z. Shonfield, *The Precariously Privileged: A Professional Family in Victorian London* (Oxford: Oxford University Press, 1987), p. 90.

42 R. Rich, 'Designing the Dinner Party: Advice on Dining and Décor in London and Paris 1860–1914', *Journal of Design History*, 16:1 (2003), 50.

43 Gordon and Nair, *Public Lives*, p. 122.

44 Gibbs, *The Pageant of the Years*, p. 9; G. Rentoul, *This Is My Case: An Autobiography* (London: Hutchinson & Co, 1944), p. 11.

45 Jack Easel (pseud. Charles Eastlake), *Our Square and Circle: or, The Annals of a Little London House* (London: Smith, Elder & Co., 1895), p. 53.

46 Celia Davies, *Clean Clothes on Sunday* (Suffolk: Terrence Dalton, 1974), p. 17.

47 Graves, *Goodbye to All That*, p. 55.

48 M. Donald, 'Tranquil Havens? Critiquing the Idea of Home as a Middle-Class Sanctuary', in Bryden and Floyd, *Domestic Space*, p. 107.

49 Interview with Edith Hanran, from P. Thompson and T. Lummis, *Family Life and Work Experience Before 1918, 1870–1973* [computer file], 7th edition. Colchester, Essex: UK Data Archive [distributor], May 2009. SN: 2000. No. 53.

50 Mrs Henry Wood, *East Lynne* (London: Richard Bentley, 1861), vol. 1, pp. 265–266.

51 Interview with Mrs Eleanor Saunders, from Thompson and Lummis, *Family Life and Work Experience*, No. 231.

52 [Anon.], *Home Difficulties: Or, Whose Fault is it? A Few Words on the Servant Question* (London: Griffith and Farran, 1866), p. 24.

53 Christine Terhune Herrick, *The Expert Maid-Servant* (New York and London: Harper Brothers, 1904), p. 100.

54 Davidoff and Hall, *Family Fortunes*, p. 366; L. Davidoff, 'The Separation of Home and Work? Landladies and Lodgers in Nineteenth- and Twentieth-Century England', in S. Burman (ed.), *Fit Work for Women* (London: Croom Helm, 1979), pp. 64–97; C. Hall, 'Gender Divisions and Class Formation in the Birmingham Middle Class, 1780–1850', in R. Samuel (ed.), *People's History and Socialist Theory* (London, Routledge & Kegan Paul, 1981), p. 169.

55 J. Tosh, *A Man's Place: Masculinity and the Middle-Class Home in Victorian England* (London: Yale University Press, 1999), p. 17.

56 M. Finn, *The Character of Credit: Personal Debt in English Culture 1740–1914* (Cambridge: Cambridge University Press, 2003), p. 91.

57 G. Thomas, *Autobiography: 1891–1941* (London: Chapman and Hall, 1946), p. 22.

58 E. Rhys, *Wales England Wed* (London: J.M. Dent and Sons, 1940), p. 4.

59 Ibid., p. 7.

60 O. Lodge, *Past Years: An Autobiography* (London: Hodder & Stoughton, 1931), p. 25.

61 Sale catalogue in executorship papers of Rev. Abraham William Bullen of Great Baddow, 1887–1893, ERO, D/Dsu/F43; Catalogue of household furniture to be sold by Mr Paice at Winslade Rectory near Basingstoke, Hants, 1850, HRO, 10M57/SP747; Catalogue of the sale of household furniture from 'The Rectory', Upper Clatford, Andover, on behalf of the executors of the Rev. T. Child, 1881, HRO, 46M84/F94/1; Sale catalogue of contents of East Carleton Rectory belonging to the Rev. J.J. Cumming, 1907, DRO, D/Ed 18/11/11; Memorandum of Furniture at Curate's House, Pember, 1891, BRO, D/Eby Q 39; Bill of sale furniture and effects, Revd Philip Ahier, 1878, CROB, DBH/24/19/12.

62 Documents re. administration of will of Thomas Roberts of Twyford, surgeon 1878–1892, HRO, 67M92W/8/10; Inventory of household furniture taken at the residence of the late Dr J.P. Stephens, *c.*1897, HRO, 124M71/C18.

63 List of furniture for new home made by Amy Mounsey, 1909, DRO, D/Wa5/4/25; Sale catalogue of the household furniture, etc., to be sold by Mr T.P. Durrant by direction of the executors' of the late Mrs Hannah and Philadelphia Bakers of the Middle House, Mayfield, 1842, ESRO, AMS497.

64 B. Heeney, *A Different Kind of Gentleman: Parish Clergy as Professional Men in Early and Mid-Victorian England* (Connecticut: Archon Books, 1976), p. 5.

65 Catalogue of Household Furniture, West Hill Rectory, Buntingford, Herts, 1898, HRO, D/Ele/B25/3.

66 Tosh, *A Man's Place*, p. 60.

67 Bernard M. Allen, *Down the Stream of Life* (London: Lindsey Press, 1948), p. 14.

68 Owen Berkeley-Hill, *All Too Human: An Unconventional Autobiography* (London: Peter Davies, 1939), p. 3.

69 T. Wright, *Thomas Wright of Olney: An Autobiography* (London: Herbert Jenkins, 1936), p. 69.

70 D. Munro, *It Passed too Quickly: An Autobiography* (London: Routledge and Sons, 1941), p. 3.

71 A.A. Milne, *It's too Late Now: The Autobiography of a Writer* (London, Methuen & Co, 1939), p. 31.

72 Ibid., pp. 35–36.

73 Stefan Muthesius, *The English Terraced House* (London: Yale University Press, 1982), p. 45.

74 See J. Hamlett, Geffrye Museum report 3, Jul. 2004 and J. Hamlett, Geffrye Museum report 4, Aug. 2004.

75 Late eighteenth-century inventories and sale catalogues tended to list rooms on a basis of their position in the house, '2 pairs of stairs right hand' etc., rather than naming them by function. See J. Hamlett, Geffrye Museum report 5, Sep. 2004.

76 Sale catalogues for sale of Middleham, home of Frances Constable of Middleton, Ringmer, widow, 1866, ESRO, MOB 1639,1640; Inventory from Down House, Rottingdean, property of Charles Beard, 1844, ESRO, BRD 8/14/1; ESRO, AMS497.

77 Davidoff and Hall, *Family Fortunes*, p. 361; C. Hall, 'The Sweet Delights of Home', in M. Perrot (ed.), *A History of Private Life: From the Fires of Revolution to the Great War* (Massachusetts: Belknap Press, 1990), p. 72.

78 Muthesius, *The English Terraced House*, p. 39. Also see Tosh, *A Man's Place*, p. 21.

79 John Styles and Amanda Vickery, 'Introduction', in John Styles and Amanda Vickery (eds), *Gender, Taste and Material Culture in Britain and North America* (London: Yale, 2006), p. 11; Margaret Ponsonby, *Stories from Home: English Domestic Interiors 1750–1850* (Aldershot, Ashgate, 2007), p. 13; J. Kinchin, 'Interiors: Nineteenth-Century Essays on the 'Masculine' and the 'Feminine' Room', in P. Kirkham (ed.), *The Gendered Object* (Manchester: Manchester University Press, 1996), pp. 13–14.

80 Kinchin argues that although gendered divisions remained surprisingly consistent throughout the nineteenth century, they were less rigidly applied in the 'progressive' aesthetic schemes of the 1880s and 1890s. Kinchin, 'Interiors', pp. 24–25. Yet at the same time as these schemes were discussed other writers, such as Jennings and Panton, heavily stressed gendered division of the home, more so than previous commentators, so it is by no means clear that they were dropping away at this point. For discussion, see Jane Hamlett, '"The Dining Room should be the Man's Paradise, as the Drawing Room is the Woman's": Gender and Middle-class Domestic Space in England, 1850–1910', *Gender & History*, 21:3 (2009), 576–591.

81 Kinchin, 'Interiors', pp. 13–15.

82 Robert Kerr, *The Gentleman's House: Or, How to Plan English Residences, from the Parsonage to the Palace* (London: John Murray, 1864), p. 107.

83 Mrs Haweis, *The Art of Housekeeping: A Bridal Garland* (London: Sampson Low & Co., 1889), p. 29.

84 This was originally an aristocratic practice. M. Girouard, *Life in the English Country House: A Social and Architectural History* (London: Yale University Press, 1978), pp. 99–100.

85 John J. Stevenson, *House Architecture* (London: Macmillan & Co.), p. 57.

86 Simon Houfe, *John Leech and the Victorian Scene* (Antique Collectors' Club: Suffolk, 1984), p. 176.

87 Personal communication.

88 Valuation of the farming stock . . . household furniture and dairy utensils belonging to the estate of the late Mr George Robinson of Town End farm, Biggar, Walney, Barrow in Furness June 1915, CROB, BDB 17/1/9; Marriage settlement between William Simpson Ramsay Barrow in Furness in the county of Lancashire electrician and Mary Hannah Atkinson of Barrow in Furness, 26th 1901, CROB, BDB/17/T2/9/18; Probate copy of will of Frederick Arthur Bentall of Needham House, Maldon, engineer, 1893, ESRO, D/DCf/F566.

89 Valuation of the household furniture, plate, linen and other effects the property of the late Mr Joseph Beaumont of Brantingham Wold, 1860, ERY, DDBD 8 45; Inventory of Thomas Hogget, Gilesgate, 1871, DRO, D/SJ C103; Inventory of furniture and effects at 17 Oakfield Terrace, Gosforth occupied by John Greenwell, 1907, DRO, D/Gw 43; Catalogue of sale of wheelwright's and carpenters equipment at Mottisford, Romsey, sold by Mr James Jenvey, on behalf of late Mr Alfred Jewel, 1904, HRO, 4M92/N/186/12; Poster advertising household furniture, property and effects of Mr Dumper of Hyde

Street, Winchester, to be sold by auction 1862, HRO, 1M90/12; Sale poster for goods of Maria Pritchard of Winchester, spinster, 1888, HRO, 67M92W/19/18.

90 Sale catalogue for 'Tufton Warren Farm', property of Mr J. Earwaker, Whitchurch, 1882, HRO, 46M84/F91/1.

91 For a discussion of regional difference, see Ponsonby, *Stories from Home*, chapter 1.

92 R.W. Edis, *Decoration and Furniture of Town Houses* (London: Kegan, Paul & Co., 1881), p. 113.

93 Mrs Loftie, *The Dining-Room* (London: Macmillan & Co., 1878), p. 3.

94 Twenty inventories and sale catalogues of smaller homes listed easy chairs and sofas in the dining room. Eight inventories and sale catalogues from larger homes also included chairs and sofas in the dining room.

95 Auction of furniture at Deckham Hall, Gateshead, for Benjamin Bigger, 1874, DX951, DRO, DX951/1; Inventory of 'Villette', The Drive, Roundhay, belonging to Joseph Watson, insurance broker, 1898, WYAS Leeds, WAYS313.

96 WYAS Leeds, WYL 295 17 1 4; WYAS Halifax, FW 30/30; DRO, D/X 776/243; DRO, D/HH 6/15/32; Sale catalogue of contents of 8 Clare Hall Road, Halifax, belonging to Robert Edleston, Esq., 1858, DRO, D/Ed 18/11/3; Inventory and valuation of the household furniture, plate, linen and effects of Wintershill House near Bishops Waltham the property of the late Mrs Marianne Stares, 1888, HRO, 106M87/A11/21; Catalogue of furniture at Southfield Lodge, Christchurch Road, Winchester, by Messrs Gudgeon and Sons, 1892, HRO, 100/799/E21; Furniture sale catalogue for Abbotsford House, Market Place, Romsey, by order of the executors of Mrs M.A. Purchase deceased, 1918, HRO, 4M92/G16/5; Inventory of household furniture taken at the residence of the late Dr J.P. Stephens, *c.*1897, HRO, 124M71/C18; Bundle of documents relating to the estate of Mary Ann Bowker who died 1 Feb. 1885, including will, HRO, 11M70/D18.

97 CROB, BD/TB 8/5/1, BDB/17/SP3/12, BDB/17/SP3/8, BDB/17/SP3/23, BDB 17/3/5.

98 WYAS Leeds, WYL 295 17 1 4; DRO, D/X 776/243.

99 WYAS Halifax, FW 30/30.

100 Inventory of Cornikeraium, 1907–8, HRO, 4M92/N225/4.

101 A. Barlow, *The Seventh Child: The Autobiography of a Schoolmistress* (London: Gerald Duckworth & Co., 1969), p. 30.

102 GMRO Tunnicliffe's neighbour Styal 9/32 F13/5; Elizabeth Browne, 18 June 1890 Elliot and Fry 55 Baker St and 7 Gloucester Terrace SW 'At home' 355/35 C17/22; Mr Ogden in his house in Stretton, Moss Side, 810/13 M23/11; 'Mrs G.M Balshaw', photograph taken by father A.H. Williams of Manchester, 999/15 S41/16; Frondeg; the wife of Frederick Batho, studio photographer, in their home and studio at Westbourne Grove, Cheetham Hill, 2168/13.

103 Stevenson, *House Architecture*, p. 47.

104 J.E. Panton, *Nooks and Corners* (London: Ward & Downey, 1889), p. 94; Kerr, *The Gentleman's House*, p. 116; C.L. Eastlake, *Hints on Household Taste in Furniture, Upholstery and Other Details* (London: Longmans Green, 1878, fourth edition, first published in 1868), p. 126.

105 Matthew Hilton, *Smoking in British Popular Culture 1800–2000: Perfect Pleasures* (Manchester: Manchester University Press, 2000), p. 34.

106 Kerr, *The Gentleman's House*, p. 129.

107 H.J. Jennings, *Our Homes, and How to Beautify Them* (London: Harrison and Sons, 1902), p. 221.

108 J.E. Panton, *From Kitchen to Garret: Hints to Young Householders* (London: Ward & Downey, 1887), p. 80.

109 Ibid., p. 69.

110 Ibid., p. 69; Mrs C.S. Peel, *The New Home* (London: A. Constable & Co., 1898), p. 112.

111 Panton, *From Kitchen to Garret*, p. 70. Peel, *The New Home*, p. 121.

112 CROB, BDB 17/3/5.

113 Long, *The Edwardian House*, p. 31.

114 H. Nicholson, *Half My Days and Nights: Autobiography of a Reporter* (London: William Heinemann, 1941), p. 3.

115 Inventory of furniture belonging to Mrs Hebden, undated, WYAS Calderdale, FW31/56; List of silver and furniture belonging to Edith Binnington, 1861, ERY DDX 353 51; Inventory of the heirlooms the property of the late Colonel Warden Sergison, 1849, WSRO SERGISON/1/529; Settlement on the marriage of Maria Harvey with Nathaniel Hamer, 1867, ESRO ADD MSS 3406; Inventory from Down House, Rottingdean, property of Charles Beard, 1844, ESRO, BRD 8/14/1; Inventory and valuation of the furniture and effects at 'Cambrian Lodge', Shirley, the property of the late Mrs Flower, 1886, HRO, 4M92/F5/6; Catalogue of household furniture at Cliff Villa, Headingley, late the property of L.F. Blackett, Esq, dec., 875, WYAS Leeds, ACC 2363.

116 Bill of sale of furniture, chattels and effects in and about 'Littlebank', Settle, Yorkshire, May 1883, CROB, BD/HJ 12/2/1; Sale catalogue for 'The Guards', Kirkby, Ireleth, November 1895, CROB, BDB/17/SP3/20; Inventory for Oaklands, Grange over Sands, May 1906, CROB, BDB/17/SP3/18; Inventory of the household furniture at Risedale, Newbarns, Barrow in Furness, 1892, CROB, BDB 17/3/1; Sale catalogue for Greenscoe House, Askam in Furness, March 1891, CROB, BDB/17/SP3/2; Inventory of the household furniture and effects on the premises of Crake house, Sparke Bridge, Colton, November 1902, CROB, BD/HJ/256 2/13.

117 CROB, BD/HJ 12/2/1, BDB/17/SP3/2.

118 CROB, BDB/17/SP3/2.

119 Jennings, *Our Homes*, p. 207.

120 Sale Catalogue of Crosslands, Furness Abbey, January 1910, CROB, BDB/17/SP3/5.

121 Inventory of Clarence House, Dalton in Furness, July 1891, CROB, BDB/17/SP3/13; Sale catalogue for Broughton Lodge, Grange over Sands, April 1902, CROB, BDB/17/SP3/16; HRO, 46M84/F94/1; Schedule of books, furniture not dated, Gilfred William Hartley of Rosehill, Moresby 1876–1888, CROW, DBH 24/32/23.

122 CROB, BDB/17/SP3/5, CROB, BDB/17/SP3/8, BDB/17/SP3/16; CROW, DBH 24/32/23; Inventories of household furniture, ornaments, etc., belonging to Ellen Fisher 28 Bramham Gardens 1904, CROW, DBH 24/47/44; HRO, 11M70/D18.

123 Long, *The Edwardian House*, p. 169.

124 J. Franklin, 'Troops of Servants: Labour and Planning in the Country House 1840–1914', *Victorian Studies*, 19:2 (1975), 211–239.

125 Sonia Keppel, *Edwardian Daughter* (London: Hamish Hamilton, 1958), p. 11.

126 Graves, *Goodbye to All That*, pp. 31–32.

127 Virginia Woolf, 'A Sketch of the Past', in Jeanne Schulkind (ed.), *Moments of Being* (London: Pimlico Press, 2002), pp. 123–124.

128 Theresa M. McBride, *The Domestic Revolution: the Modernisation of Household Service in England and France 1820–1920* (London: Croom Helm, 1976), p. 21.

129 Only four of the inventories and sale catalogues from the north east and south showed these.

130 [Anon.], *Domestic Servants, As They Are & as They Ought To Be* (Brighton: W. Tweedie, 1859), p. 13.

131 [Anon.], *Home Difficulties*, p. 9.

132 Amara Veritas, *The Servant Problem: An Attempt at its Solution by an Experienced Mistress* (London: Simpkin, Marshall & Co., 1899), p. 41.

133 Ibid., p. 115.

134 Diary of Mary Ann Turner, Ery, DDX 857/2/5.

135 Thea Thompson, *Edwardian Childhoods* (London: Routledge, 1981), p. 179.

136 Interview with Mrs Florence Davis, from Thompson and Lummis, *Family Life and Work Experience*, No. 40.

137 Interview with Mrs Edith Mabel Hanran.

138 Jill Franklin, *The Gentleman's Country House and Its Plan 1835–1914* (London: Routledge & Kegan Paul), p. 39.

139 Anne Maria Sargeant, *The Housemaid's Complete Guide and Adviser* (London, Thomas Dean and Son, 1854), p. 44.

140 Sargeant, *The Housemaid's Complete Guide*, p. 13.

141 Ibid., p. 9.

142 Ibid., p. 17.

143 Interview with Mrs Elsie Thompson, from Thompson and Lummis, *Family Life and Work Experience*, No. 213.

144 Interview with Mrs Jeannie Williams, from Thompson and Lummis, *Family Life and Work Experience*, No. 212.

145 Mrs Haweis, *The Art of Housekeeping: A Bridal Garland* (London: Sampson Low, Marston, Searle and Rivington, 1889), p. 80.

146 [Anon.], *The Servant Problem*, p. 57.

147 Interview with Mrs Edith Mabel Hanran.

148 Samuel Mullins, *Cap and Apron: An Oral History of Domestic Service in the Shires 1880–1950* (Leciester: Leciester Museums Service, 1986), p. 30.

149 Siân Pooley, 'Domestic Servants and Their Urban Employers: A Case Study of Lancaster, 1880–1914', *Economic History Review* 62:2 (2009), p. 421.

150 Interview with Mrs Hallam, from Thompson and Lummis, *Family Life and Work Experience*, No. 317.

151 Interview with Mrs Jaggard, from Thompson and Lummis, *Family Life and Work Experience.*, No. 17; Interview with Mrs Edith Green, from Thompson and Lummis, *Family Life and Work Experience*, No. 268.

152 Leonore Davidoff, Megan Doolittle, Janet Fink and Katherine Holden, *The Family Story: Blood, Contract and Intimacy, 1830–1960* (Essex: Longman, 1999), p. 163.

153 Interview with Mrs Elsie Thompson.

154 Ibid.

155 Interview with Mrs Edith Mabel Hanran.

156 Interview with Mrs Jeannie Williams.

157 Mrs Warren, *My Lady Help and What She Taught Me* (London: Houlston and Sons, reprint 1889), pp. 1–2.

158 Interview with Mrs Elsie Thompson.

159 Interview with Mrs Nora Blewett, from Thompson and Lummis, *Family Life and Work Experience*, No. 408.

160 Ibid.

161 Lawrence Stone, *Road to Divorce: England 1530–1987* (Oxford: Oxford University Press, 1990), pp. 211–228.

162 Brian W. McCuskey, 'The Kitchen Police: Servant Surveillance and Middle-class Transgression', *Victorian Literature and Culture*, 28:2 (2000), 360.

163 W. Collins, *The Moonstone: A Romance* (London: Tinsley Bros., 1868), vol. 3, p. 13.

164 Miss Poole, *Without a Character: A Tale of Servant Life* (London: Christian Knowledge Society, 1870), p. 60.

165 Published by Robert Culley who produced books 'suitable for libraries, rewards and presents'. Briston was a prolific author of temperance literature. Other titles included Helen Briston, *Tell Me A Story: Yes, I Will* (London: T. Woolmer, 1889); Helen Briston, *The Poor Boy of the Class* (London: T. Woolmer, 1887); Helen Briston, *The Ladyboy's Story, and Other Temperance Sketches* (London: Robert Culley, 1897).

166 Helen Briston, *Lottie: Servant and Heroine* (London: Robert Culley, 1898), pp. 91–92.

167 See, for example, untitled cartoon by C.E. Brock in J.A. Hammerton (ed.), *Mr Punch at Home: The Comic Side of Domestic Life* (London, *c.*1907), p. 55.

168 Dorothy Constance Peel, *The New Home: Treating of the Arrangement, Decoration, Furnishing of a House of Medium Size* (London: Constable & Co., 1898), p. 227.

169 Panton, *From Kitchen to Garret*, p. 182.

170 A. Vickery, 'An Englishman's Home is his Castle? Thresholds, Boundaries and Privacies in the Eighteenth-century London House', *Past and Present* 199 (2008), 166.

171 Veritas, *The Servant Problem*, p. 144.

172 Poole, *Without a Character*, p. 67.

173 Ibid., p. 68.

174 20 Nov. 1893, CKS, U1390 F7.

175 Interview with Mrs Jaggard; interview with Jeannie Williams; interview with Mrs Radford from Thompson and Lummis, *Family Life and Work Experience*, No. 356;

interview with Miss Rosemary Nash from Thompson and Lummis, *Family Life and Work Experience*, No. 50.

176 Interview with Mrs Jaggard.

177 Interview with Mrs Radford.

178 Interview with Mrs F. Thompson, from Thompson and Lummis, *Family Life and Work Experience*, No. 117.

2 ✦ Material marriages: creating domestic interiors, defining marital relationships

FREDERICA ROUSE Boughton married Richard Orlebar, the eldest son of a minor Bedfordshire gentry family in 1861. On their marriage, the couple moved into Hinwick Hall, a manor house on the estate of Richard's family. For both husband and wife, this was a significant change in both their family position and their physical home life. The transition was more painful for Frederica Orlebar, who remarked in her diaries that: 'I felt a stranger amongst strangers, an inexplicably bitter feeling.'[1] Far removed from her family home at Larden Hall in Shropshire, Frederica Orlebar struggled to come to terms with her new surroundings. Her discomfort made itself felt in her criticisms of the fabric and furnishings of her new home, and in particular of her marital bedroom:

> Then the dressing table was a man's table, with a place for boots underneath, not an elegant muslin and glazed/glass calico affair covered with ivory backed brushes and silver things as I wished to see . . . As soon as Richard came home I told him all that was troubling me, & though it was unintelligible to him, he kindly gave way, & told me to get the carpenter down when I liked.[2]

Frederica Orlebar's understanding of the material world of home was closely bound up with her emotional response to her marriage. She saw the bedroom as a space that belonged to her, to be filled with feminine goods that would play an important role in constructing her identity. While the absence of such things was 'troubling' to Frederica Orlebar, her interest in these objects was 'unintelligible' to her husband. A complex negotiation between husband and wife often lay behind the creation of the domestic interior. In this case, the decoration of Hinwick Hall was determined by her desires and tastes, and his financial resources.

This chapter examines the relationship between middle-class domestic interiors and marriage, considering the role of objects in establishing relations between husband and wife and overcoming the anxieties involved in such unions. The second part of the chapter explores how responsibility for home furnishing expressed the gendered power relationship between husbands and wives. The final part turns to the way in which particular rooms in the house could shape marital behaviour, analysing the drawing room and the marital bedroom with dressing room attached.

For many middle-class Victorians, both family and material life were transformed on their wedding day. The majority of adults over the age of 45 in late nineteenth-century England were married.[3] Before marriage, men usually lived either at home or in bachelor establishments, and women at home. Marriage thus marked a crucial point in the life cycle when a new home was established and was also seen as synonymous with financial independence. Advice writer J.W. Kirton urged in 1882, 'No woman should consent to fix her wedding-day unless she is sure that she is to be taken to a home of her own, furnished and paid for.'[4] Often, the need to acquire sufficient resources to establish the home and support a wife and family would delay the wedding, sometimes by a number of years. Thus, many nineteenth-century couples had long engagements.

During the nineteenth century, the average age for marriage in England was 25 for women and 27 for men.[5] It was usual for wives to move into homes previously established by their husbands, although in a few cases, such as that of Jonathan Backhouse Hodgkin, who married into a wealthy Quaker family, husbands might move into the home of their brides.[6] Unless a family house was available, as was the case with some gentry couples, usually, a new home would be selected by the husband or the betrothed couple together, and furnished before the wedding.[7] For couples on a budget, extant bachelor premises might be converted for married life. It was assumed that marital and material unions would be permanent. While divorce through the common courts became possible after the reform of 1857, this was still the resort of a minority of couples and carried considerable shame and stigma.[8] Some couples, trapped in unworkable marriages, did resort to separation or 'self divorce', but they were a small minority.[9]

The nineteenth century saw a change in the emotional experience of marriage and a shift in marital behaviour. Mutuality in marriage was established long before the nineteenth century, yet this began to be expressed in different terms, with a new emphasis on romantic love. Judith Schneid Lewis argues that the ideal became important to the nineteenth-century British aristocracy: 'If being "reasonably happy" was

all that a young girl in 1780 expected of marriage, by 1860 she was in ardent pursuit of romantic love.'[10] The rise of companionate marriage – that is, the notion that couples began to place emotional satisfaction before the desire to move up the social ladder – is thought to have developed during the eighteenth century.[11] However, patriarchy remained a powerful force in some marriages, particularly in those unhappy unions that resulted in violence or breakdown.[12]

The last decades of the century saw a more quantifiable shift in marital behaviour. There was a steady fall in fertility across the population as a whole from the 1870s.[13] This was most marked among the middle classes. During the 1880s, professional groups such as lawyers, doctors and bank officials all tended to have families of fewer than four children.[14] Simon Szreter has argued that falling family size was the result of increased sexual restraint in marriage, and a 'culture of abstinence'.[15] Middle-class marriage was thus characterised by an increasing emphasis on love and companionship and, quite possibly, a rise in sexual restraint. These changing attitudes and behaviours influenced the way in which the home was arranged and decorated, most particularly in the areas of home where couples spent most of their time, such as the drawing room and marital bedroom. Marital relationships and the material world were thus mutually constitutive. The marital relationship drove the way the home was laid out but, once these arrangements were in place, they could shape emotional exchange.

Material engagement: gifts, the trousseau and the material culture of the wedding celebration

Before a couple created their new home materially, they imagined it on paper. While the nineteenth-century middle classes are notorious for their silence on sexual matters,[16] the description of the domestic interior was frequently employed in the love letter, as a strategy for imagining the intimate, for suggesting physical presence and closeness. Karen Lystra has shown that American lovers often used the description of the everyday to establish a context for their writing.[17] Richard Orlebar and Frederica Rouse Boughton corresponded before their marriage in 1864. He wrote: 'I don't believe you ever saw my room; it is at the top of the house, on the North side, very small.'[18] She responded in kind: 'I never saw your room, darling – I wish I had, that I might fancy you in it.'[19] Intimacy was heightened by the evocation of personal and private space, and its relationship to the body. Frederica Orlebar, when describing her room, also wrote of herself in it, on waking in the morning, an intensely private moment that no one but a future marital partner could share with her:

then is my little bed still in the corner with a chintz to match, white ground & coloured flowers in bunches . . . they met my eye on every side & looked so sunny and smiling down upon me – they entered so pleasantly into that dozing, dreamy 5 minutes that one generally takes to wake up in.[20]

When Quaker school teacher Anthony Wallis wrote to his fiancée Amy Mounsey fifty years later, he used a similar strategy: 'You must picture me in a bare little room, decorated with two texts, a candle wedged into a fold in the bed clothes, lying on my back very weary, very sleepy, very happy.'[21] He also pictures Amy in private and personal surroundings: 'it is hard to think of thee lying in thy nice new bed in thy charming room'.[22]

Engagement gifts were often the first domestic things that a betrothed couple acquired. As anthropologists have shown, the exchange of objects as gifts plays a crucial role in building relationships in many societies.[23] During the nineteenth century, the process of courtship and entry into marriage was a protracted one.[24] Ginger Frost has demonstrated that this was a particular problem for the lower middle classes, who might have to wait a number of years before the potential husband was able to generate enough income to wed.[25] The exchange of letters and objects could, therefore, be important in maintaining relationships, particularly if the couple lived some distance away from each other. Choosing the wrong spouse could carry a life-long penalty. Under these circumstances domestic objects could be emissaries, and the reception of gifts was viewed as the measure of the success of later mingling of goods and lives.

Ellen Ross has shown how working-class women might deliberately test their fiancés before marriage.[26] Middle-class women, with a greater range of goods at their command, were more able to use gifts to test the commitment of their betrothed. Gentleman's daughter Annie Dickinson gave a prayer book to her fiancé as a strategy to test his Nonconformist beliefs, attempting to lure him back to the Anglican fold. Its rejection left her bitter: 'I am unhappy for two reasons – the silly weak one of his not loving my book best – and the real and serious one of his being almost a dissenter . . . if I write bitterly, it is because I feel bitterly – I can never teach him as I have been taught.'[27]

Dickinson's diary, kept throughout the year of her engagement, betrays the anxiety and doubt that came with marital commitment. The diary swings from a profusion of love to embarrassed horror at her fiancé's habit of crunching damson stones at the dinner table: 'he made such a noise that Mama was obliged to ask him to desist'.[28] In moments of insecurity she offered gifts as a test to confirm love. After another row about religion she offered him some lilies, but speculated, 'I don't suppose he will care for them.'[29] Presumably, the olive branch was accepted as the next day's entry noted, 'Horace is kind.'[30]

Nineteenth-century women's role in the exchange of engagement gifts could thus be both active and subtle.

Men also used the power of the gift to direct their relationships, although there was a pressure on men to give that could lead to anxiety. The choice of such presents could be difficult, especially if religious orientation excluded jewellery. In 1872, the Quaker Jonathan Backhouse Hodgkin wrote in an anguished postscript to his mother: 'If I am accepted, what <u>can</u> I give her? She has no wants that I know of, and is too sensible to care for ornaments.'[31] Marrying into a rich and established Darlington family, Backhouse Hodgkin felt under pressure, quite literally, to come up with the goods.

However, some future husbands showed considerable foresight. Frederica Orlebar's diary reveals that, when on foreign excursions, Richard Orlebar had in fact stockpiled a range of goods for his future, then unknown wife, including 'a pair of slippers from Constantinople and a Lapis Lazuli brooch from Venice.'[32] Potential grooms could win the support of reluctant family members by proffering domestic gifts. Eleanor Farjeon recounts how, when her father proposed to her mother in the 1870s, he also brought her aunt Nell a teapot.[33] Lower down the scale, more modest presents were also exchanged between husband and wife. Herbert Twamley gave Mildred Butt the practical gift of a travelling bag, and she gave him a pocket book and silver card case.[34] Both men and women purchased goods to give, but women seem also to have produced them themselves, offering hand-worked tokens that suggested domestic skill.

Once the wedding date was set, a larger number of gifts, including many items for the home, arrived from the couple's friends and family. Beryl Lee Booker, a gentleman's daughter from London, who married in the 1900s, recalled that:

> now started the utterly unscrupulous but rapidly dying out custom of tapping all sources for wedding presents, an undignified racket then as now carried to unheard lengths. Hundreds of invitations were issued; and the harvest of thermos flasks, butter knives, silver ink pots, and, I'm glad to say, cheques began to pour in.[35]

The bride's receipt of some gifts from kinsmen and women and masters and mistresses (in addition to a dowry from her father and mother) shortly before her marriage, was a long-established practice that has taken place in England since the sixteenth century at least.[36] Yet, among the Victorian middle classes, the giving of wedding gifts seems to have flourished as never before. Brides often kept lists of both presents and givers, which survive among family papers. A national survey of

record offices in England revealed twenty such lists.[37] This evidence suggests that it was customary for a middle-class family to receive between 50 and 200 presents.[38] Even the least well off middle-class couples surveyed here received a substantial number.[39] The arriving objects could be too many to be practical or useful.

Domestic advice writer Mrs Haweis, in her 1889 instruction manual for young women, bemoaned the inappropriateness of many wedding presents, remarking that 'the tables on the wedding day groan with superfluities (chiefly salt-cellars, why I cannot imagine)'.[40] Such gift giving was fuelled in part by the increasing affluence of the middle classes, and the growth of a mass market for goods. Companies were certainly responding to this demand, with the firms such as H. Samuel producing catalogues of possible wedding gifts from the turn of the century.[41] (Although interestingly, the shop-produced wedding list in the sense we understand it today did not emerge until the mid-twentieth century).[42] For the twentieth century, Louise Purbrick has argued that giving and receiving wedding gifts complicates the understanding of consumption as the product of individual choice.[43] This also holds true for nineteenth-century middle class couples: these wedding lists demonstrate the extent to which domestic interiors were the composite investments of couple, family and friends.

The nature of the domestic goods recorded in wedding lists also demonstrates continuity in ritual gifting practices, not only throughout the nineteenth century but well into the twentieth. Finn argues that, 'Diaries and memoirs suggest that the scale and scope of gifting among friends and neighbours diminished, and that gift exchange became increasingly formalised, in the course of the nineteenth century.'[44] The increasing tendency to list wedding presents may have been part of this process of formalisation. However, middle-class wedding lists throughout the period also show continuity in gifting practices. New objects were often co-opted into existing practices of gift exchange. The nineteenth and early twentieth centuries were a time of change in the processes of manufacturing domestic goods.[45] The growth of the mass market and development of new technologies created an increasing abundance of new consumer goods, such as electro-plated cutlery and iron bedsteads.[46] The things recorded in these lists reflect changing fashions: lists from the 1870s include 'artistic' goods such as 'Chinese screens', and 'Japanese tea tables and trays'. Electro-plated cutlery begins to appear in later lists. But the kind of goods listed remained consistent throughout: wedding gifts tended to be small-scale domestic objects, such as ink stands, vases, dessert services and toast racks, of some use but also decorative. Many goods from women on the lists were also hand-worked, suggesting a female world of consumption and exchange in which handiwork was prized as a symbol of family

affection and personal links.[47] The creation of lists of wedding gifts on the formal occasion of middle-class marriage throughout the second half of the nineteenth century demonstrates continuity in gifting practice within an increasingly modern consumer society.

In addition to making a material contribution to the new home, the gifts were of symbolic value. It was customary to display presents in the home of the bride before and during the wedding.[48] In rural south-west France, the public display of the trousseau the day before the wedding was a long-standing tradition.[49] But the display of the wedding presents seems to have become particularly important among the nineteenth-century middle classes, perhaps understandably, given the volume of gifts.

The display of gifts was also common in nineteenth-century America.[50] Barbara Penner argues that the American gift arrangements mimicked displays in shops, and were part of an increasingly commercial consumer culture.[51] In Britain, social emulation may also have been important. Accounts of society weddings in women's magazines such as *Home and Hearth* and *The Gentlewoman*, in the 1890s and 1900s, were frequently rounded off with lists of wedding presents received, usually over two hundred, with special mentions of valuable items.[52] Advice literature encouraged those on smaller incomes to follow suit. An article directed to 'people on small incomes', published in 1890 in *The Girl's Own Paper*, suggests that a special 'present show room' should be put aside.[53] Figure 2.1 shows an array of wedding presents illustrated in the 1910 edition of *The Book of the Home*. Mary Hughes' account of her wedding, which took place in 1897, confirms that the custom of wedding present display was practised even among the more impoverished lower middle classes; 'the few wedding presents available had been spread out to make conversation'.[54] Wedding gifts were also an important statement of family pride: Hughes recounts that her brother Tom was unable to afford a gift so she added 'T.E. Thomas, cheque' to the list, assuming that 'no one will be so indelicate as to inquire about amounts'.[55] As Louise Purbrick has shown, the practice of displaying wedding gifts continued into the mid-twentieth century.[56]

A substantial proportion of new textiles for the home were provided by the trousseau, which was acquired by the wife-to-be and her mother. A number of families seem to have stockpiled goods, particularly linen, for daughters in a 'bottom drawer'.[57] Goods were also put aside for the marriage of sons.[58] Derived from the French word meaning bundle, the custom of the trousseau spanned both Europe and America and may be a descendant of the medieval English dowry – goods and cash contributed by the wife's family in return for which she would be endowed for rights in her groom's lands.[59] Traditionally, the trousseau consisted of both clothes for the bride and linen for her new household.

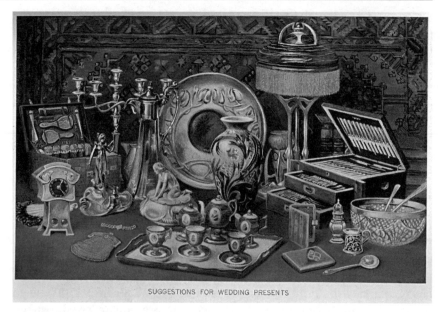

SUGGESTIONS FOR WEDDING PRESENTS

2.1 'Suggestions for Wedding Presents'

In the second half of the nineteenth century the practice of accumulating a trousseau was transformed by the growth of mass consumption. Shop sales catalogues and magazine advertisements show that the late-nineteenth century trousseau was an expanding industry. New wives and brides to be were a key advertising target, with companies such as The Old Bleach Linen Company and Maples advertising in women's magazines.[60] The new trousseau included not just traditional household linens but a large amount of underwear, and as machine-made lace was now widely available, the trousseau became increasingly frilly.[61]

These excesses inspired some disapproval. In February 1900 the penny weekly *Home Chat* sternly called for simplicity and modesty in the trousseau.[62] Discontent with the commercialised trousseau undoubtedly inspired the illustration shown in figure 2.2, published in the *Girl's Own Paper* in 1895. The nostalgic representation shows a young maiden of a previous age proudly displaying the contents of her well-stocked dowry chest to female onlookers. An accompanying poem lamented the decline of the hand-made trousseau, and made it clear that this was the fault of modern young women who failed to devote enough time to household cares:

> With needle and with thread,
> Through seams 'new women' dread,
> And they had furnished,
> A Bridal dower.[63]

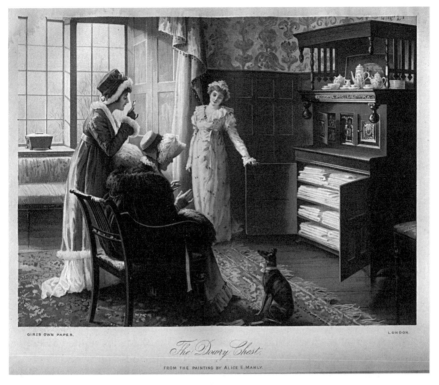

2.2 'The Dowry Chest'

The trousseau could also function as a generational link between mother and daughter, as they prepared it together. In the novel *The Mill on the Floss* (1860), George Eliot uses the disposal of a cherished trousseau to symbolise the loss of a wife's pride and her past family home. 'To think o' these cloths I spun myself . . . before I ever thought o' marrying your father! . . . And they're all to be sold – and go into strange people's houses, and perhaps be cut with knives, and wore out before I'm dead.'[64]

The preparation of the trousseau could have a strategic advantage – and allow a bride and her family to determine the date of the wedding. Celia Davies recounts how the engagement period of her grandparents in the 1860s was set by the six weeks it took to complete the trousseau.[65] Accounts of female family history often stress the symbolic importance of the trousseau as a link between mother and daughter,[66] and its preparation might help compensate upper-class mothers for the deep sense of loss they felt when their daughters left the family home.[67] In her study of France, Fine found a similar pattern: from a daughter's early teenage years, she would work on her trousseau together with her mother, sometimes for years before a potential groom had been found.[68] Motherless girls found it hard to accumulate trousseaux.[69] Agnes Maud Douton went to her first

party wrapped in a crimson shawl from her mother's trousseau: 'a relic of the handsome trousseau that had stood her in such good stead'.[70] When Mary Hughes went on her honeymoon with her husband in Salisbury she describes how 'I made a little show by spreading out my brilliant dressing-gown and a lovely embroidered night-dress marked "Mary Vivian", for it had been worked by my mother for her own trousseau.'[71] Even at this most intimate moment in the marital relationship, where the trousseau functions as a means of displaying the wife's body to her husband, Mary Hughes also articulated the presence of her dead mother, whose guidance she felt she had need of at this crucial stage in her life.

The accumulation and display of wedding gifts, the preparation of the trousseau, and the elaborate arrangements for the day itself could be exhausting and time consuming for the bride and her family. When the wedding day arrived, the home of the bride had an important part to play in the wedding ceremony. Advice literature from the later part of the period offered potential decorative schemes for the rooms that were to be used to host the wedding festivities. An article from *The House*, published in 1899, gave this description of a side table:

> The screen at the back should be covered with pink sateen, plaited as shown by lines, and decorated on the fold with tiny bunches of flowers. The heart in the background might be formed by any small blue flower, while the love birds could be cut in cardboard and covered with silver paper . . . white flowers . . . the ribbons which are festooned in several places must be pink . . .[72]

How far such elaborate decorative schemes were practised is open to question. Frost has found that the wedding breakfast was an almost universal practice from the working to upper middle classes.[73] The Rouse Boughton home was converted for the occasion: 'The dining room had long since been cleared of all its furniture, and a table of board put down in the shape of a horseshoe for the occasion.'[74] The 'chastely decorated' temporary room erected for a wedding between the Quaker Hodgkin and Pease families of 1873 reflected the religious orientation of the couple, but newspaper reports made it clear that no expense had been spared on decoration.[75]

A less expensive option was to hold the wedding celebration out of doors: a photograph of the wedding of Rev. T.J. and Fanny Cleave Warne in 1889, shown in figure 2.3, features a garden decorated for the occasion.[76] Decorations such as the welcome sign above the garden gate show that a cheaper option could also be rich in symbolic meaning. The Rev. John Coker and his bride were also welcomed home to Burwash with a wreath of evergreens over the porch and a motto reading 'God bless the

2.3 Wedding photograph for the Rev. Cleave Warne and Fanny Brice, 1890

happy pair' in the hall.[77] The ribbons and bunting could be seen as the visual embodiment of the rise of the romantic ideal in marriage. Schneid Lewis has noted the growth of sentimental wedding practices among the aristocracy in the mid-nineteenth century, and connects these to the rise of romance.[78] It has also recently been argued that the cutting and distribution of the wedding cake was a symbolic act, which demonstrated participation in and an acknowledgement of responsibility for the marriage itself.[79]

The elaborate decoration of the house and the bustle of preparation before the wedding may have helped ease or mask anxieties. John Gillis has argued that, for early twentieth-century working-class women, the growth in wedding celebrations was a ritual means of marking a transition of identity and soothing the fears of women when they embarked on married life.[80] Following Gillis' interpretation of the growth of signs and symbols around the working-class wedding, it could be argued that this elaborate middle-class ritual also marked a point of transition in the life of the middle-class wife, and worked to console her fears. Frederica Orlebar and Annie Dickinson stressed that the bustle of the wedding preparations helped conceal their sense of unease and loss at leaving the parental home.[81] The wedding would also have marked an important rite of passage: Frost's study suggests that both young men and women held this view.[82]

Parting from their own particular room in the family home could be

painful, and the stripping of that room could lead to feelings of lost identity. Annie Dickinson also waxed lyrical about the pain of leaving home for the first time: 'Oh what shall I do when this is my own room no longer – so happy have I been in it.'[83] Frederica Orlebar left her family home with strong feelings of regret: 'those four walls had witnessed so many ups and downs of my career and had become quite companionable to me, it almost seemed ungrateful to be leaving them so quietly, when I no longer needed their shelter, & really I did feel very strange and sad.'[84]

Choosing the furniture: gender, power and marital dynamics

Once husband and wife had moved into their new home, they sought to divide responsibility for its decoration. Recent research has equated the power to choose home decoration with patriarchal dominance.[85] In this story, mid-Victorian housewives played a muted role in the decoration of the home, as their husbands controlled purse strings, property and taste; and it is argued that decorative advice, formerly directed exclusively at men, began to address women only in the final decades of the century.[86] As Deborah Cohen has demonstrated, mid-nineteenth-century men had more to do with home decoration than previously thought, particularly in the selection of furniture.[87] However, it is important not to lose sight of the strong association between women and domestic management in mid-nineteenth century culture.

The selection of furniture and furnishings figured in domestic compendiums offering advice on household management, which were aimed at women.[88] *The Book of the Household of Family Dictionary of Everything Connected with Housekeeping and Domestic Medicine*, published in 1862, for example, was aimed at 'the daughters and wives of England'.[89] Within its pages, women could find advice on the selection of furniture, wallpaper and paints for the home.[90] The growing women's magazine market also demonstrates the expectation that women would consume household goods. In 1857, *The Englishwoman's Review and Drawing Room Journal* featured advertisements directed to 'ladies and housekeepers' by Thomas Metcalf, cabinet maker, upholsterer and decorator.[91] Furniture might figure alongside other fashionable consumables, as in *The Lady's Own Paper*, which first appeared in 1866.[92] The drawing room, the most public room in the house and often the most heavily decorated, was viewed as the wife's special responsibility, an expectation that was repeatedly stated in advice literature in the second half of the century.[93]

Moreover, throughout our period, women often had more day-to-day contact with the home than men and their engagement with its arrangement was more intense, as illustrated in Frederica Orlebar's diary, which describes her first home in the 1860s. When Richard and Frederica

Orlebar married, they moved into an already established home shared with Richard's uncle. Frederica Orlebar's diary shows that the responsibility for household management and some redecoration fell on her shoulders, but this was not necessarily a source of empowerment: 'This unpacking was a terrible affair . . . and oh the taking up and down stairs of those boxes that stood in the hall – what work it was!'[94] Frederica Orlebar's diaries show that her marriage was not one of oppressive patriarchal dominance, but nor was it necessarily companionate. She did not experience oppression at the hands of her husband, but felt the weight of patriarchal property structure. The rules of primogeniture that governed the gentry in this period required her to move far from her home on her marriage, into a space in which she was not at ease. She writes of the drawing room:

> it was also exceptionally stiff and proper in its lines – the effect was altogether too faded and washed out and pale – it wanted warming with rich red furniture and knick knacks – one never could live in such a precise room – it looked such a perfect essence of propriety that you could not but feel if you moved a chair out of its place, and omitted to put it back, it would of its own accord walk statelily [*sic*] home again and?resume its place – <u>back to the wall</u>.[95]

In her new environment, Frederica Orlebar felt like an outsider. The arrangement of the furniture expressed the distance she felt between her own family and the different taste and culture of the family that she had entered, so that 'the effect was aristocratic and old fashioned'.[96] She believed that the drawing room furniture had stayed in the same place for the last thirty years,[97] and she longed for 'modern elegancies'. Frederica Orlebar reacted to not the oppression of her marriage, but the difficulty that could be experienced by a woman when marriage shifted her position in the class structure. While Frederica Orlebar was also from a modest gentry background, the Hinwick estates were considerably larger than those of her family, and it took her a long time to find a role in this new home whose furniture she labelled aristocratic. Frederica Orlebar struggled to impose her own taste on the space: changes made to the drawing room were described as 'hard work'.[98] Only after an appeal was made to Richard for funds, and the arrival of the assistance of Frederica's sister Frances, was the redecoration possible.[99] Frederica Orlebar used goods to overcome her discomfort in a situation in which the patriarchal system of property relations had placed her. Using a number of wedding presents and goods from her old home, Frederica Orlebar was able to transform the drawing room into a space rich with sentimental meaning that symbolised her marriage:

The drawing room is changed, it is true, and looks with the new pianoforte (or rather the old friend from Larden) considerably more habitable than of yore – the blue (bird) screen of Aunt Fanny is a great addition, & our wedding writing table ornaments & all the wedding presents about the room give it a much more furnished effect – the three dear old cushions still hold the post of honour on the old sofa, but the sofa itself, being more useful than ornamental, has retired to a less conspicuous position than formerly – what a radical it must think me![100]

Other women's diaries, though less effusive, attest to the important and intense relationship between the middle-class wife and the domestic interior in this period. While men may have controlled the purse strings, women had a closer day-to-day relationship with the domestic interior, and exerted control through its maintenance. Diaries show that cleaning was a responsibility that women took seriously.[101] While cleaning could be an unpleasant labour, a large-scale cleaning campaign had the power to disrupt the normal social routine of the home.[102] The Rev. Cleave Warne's diaries show how frustrating the interruptions caused by cleaning could be for a man who worked at home.[103] Countless middle-class women sought to improve their homes through purchase (both new and second hand), exchange, painting and decorating. Margaret Ponsonby has recently demonstrated that the middle classes continued to buy second-hand furniture at auction well into the nineteenth century.[104] Women could dominate these events: the sale book of the auctioneer Porter Kitchin, recording a sale carried out at St Bees, near Whitehaven, in 1864, shows that women were the principal purchasers at this event.[105] Women could also purchase goods without leaving the home. Mrs Mary Maria Paine of 'Brooklands', Central Hill, Upper Norwood, the wife of a tea broker, acquired objects for her 1860s home by advertising for 'things in exchange' in the national press.[106]

Women also exercised a strong influence on the look of the home through the creation of hand-worked objects. Since the eighteenth century, women had been encouraged to embellish the home through handicrafts.[107] The nineteenth century saw a new emphasis on the moral properties of needlework and improvements in image reproduction in magazines and books combined to produce a plethora of patterns for hand-worked items for the home.[108] The social meaning of these goods is ambiguous – feminist historians have often interpreted them as a physical emblem of a slavish following of domestic ideology and confinement within domestic space.[109] Needlework would have taken up many hours of unstructured time, and for the lower-middle classes at least the production of clothes for the family was a vital necessity. Yet for some women, hand-worked goods, and particularly those made for the

domestic interior, were clearly a source of enthusiasm and pride. Diaries abound with references to needle crafts. Vicar's daughter Margaret Owen made her own curtains,[110] and painted a bookshelf green with paint ordered specially from Shoolbreds.[111] The diaries of Mrs Katherine E. Roscoe show that in 1877, inspired by a visit to an Art Needlework exhibition in London, her work included toilet cushions, bed cushions and an antimacassar.[112] The look and feel of the mid-Victorian interior, with its many ornaments, textiles and heavy draperies, was at least partly created by objects that were made by women. Rather than seeing the increasing density of ornament and drapery in the Victorian drawing room as a result of bourgeois bad taste, it might be equally appropriate to see them as the product of a creeping feminisation of space.

The final decades of the nineteenth century saw a renewed emphasis on female control of the domestic interior, as Cohen and Judith Neiswander have demonstrated, as feminist writers used the home as a means to secure a public voice.[113] Female consumers had figured frequently in the first design reform texts, published from the 1860s. As Emma Ferry shows, decorative advice manuals by male professionals such as Christopher Dresser and Charles Eastlake were misogynistic in approach and often blamed uneducated female taste for the poor state of middle-class homes.[114] According to Eastlake, the uninformed woman, ignorant of the 'simplest and most elementary principles of decorative art' was incapable of making good decorative choices, and needed to be educated to do so.[115] However, the arrival of the 'lady decorators', writers such the Garrett sisters, Eliza Haweis and Jane Ellen Panton, firmly restated that the home was a female territory. Although these women were often heavily critical of the hand-worked objects produced by their mothers, they often drew authority from arguments that homemaking was, and always had been, an almost exclusively female concern.

Jane Ellen Panton, the author of the best-selling *From Kitchen to Garret*, published in 1888, emphasised her female heritage, and played heavily on her mother's domestic skills in her advice writing but neglected to mention that her father had been one of the foremost artists of his day.[116] Mrs Arthur Stallard began *The House as Home* (1913) with: 'Man never was, and never will be, a home-maker; that greatest of all powers, to my mind, is vested solely in woman.'[117] While the arrival of these women on the public stage was clearly new and a result of growing professional and public opportunities, their rhetoric often drew on the assumption that the roles and responsibilities they were articulating had a much longer heritage. As an aspect of the creation and management of home, domestic decoration was ultimately a female responsibility.

While women were expected to competently arrange and maintain a home, men were under considerable pressure to provide for it

materially. Novelists presented a man's investment in his home before marriage as a sign of future marital success. In Trollope's *Can You Forgive Her?* (1864), Mr Grey's commitment to Alice is demonstrated by his purchase of 'feminine belongings' for their home together.[118] On the other hand, male failure to engage with the furnishing of the home could be used to signal domestic failings. Elizabeth Gaskell's *Wives and Daughters* (1866) similarly features the wifeless Dr Gibson struggling to make a suitable home for his daughter Mary. Gibson's solution to the problem is to remarry and the house is made over for the new bride. However, rather than making the improvements himself, Gibson calls on Miss Browning, a friend of the family, to decide how the new home should be furnished.[119] Gibson's disengagement here is subtly disturbing. His choice to remarry arises from his domestic problems: in taking a wife he seeks a moral guide for his daughter. Yet his willingness to relinquish decisions over the interior signifies his failure to understand or control his home life.

The husband oppressed by the weight of maintaining genteel domesticity was a powerful theme in novels produced at the end of the century. In Gissing's new realist novel *New Grub Street* (1891), the novelist Edwin Reardon, unable to repeat the success of his first novel, experiences a crisis of manhood as he can no longer produce the work necessary to sustain the respectable lifestyle his wife requires.[120] The image is repeated in H.G. Wells' *The History of Mr Polly* (1910), which deals with a man who blunders into wedlock and then struggles to keep up a lower middle-class lifestyle for himself and his wife.[121] The recurrence in the nineteenth-century novel of the faithless woman who deserts her man (spiritually or physically) when he cannot maintain the lifestyle she demands shows that novelists, both male and female, were aware that for every woman imprisoned in the gilded cage of the Victorian home, there was a man desperately struggling and quite possibly failing to keep her there.

While male responsibility for the home was emphasised in nineteenth-century culture, just how significant this role could be is borne out by the diaries of the surveyor Edward Ryde. Born in 1822, Ryde married 22-year-old Sarah Harrow from Alton when he was 26. The couple initially lived on the premises Ryde had occupied as a bachelor in London, before moving to 60 Warwick Square, which Ryde built in 1864. In 1865, Ryde purchased Poundfield House in Woking, where the family spent their summers before moving there permanently in 1878. The diary shows that the transformation of bachelor quarters into marital home was a matter of interest and personal pride for Ryde. Shortly before the marriage, he removed his books, papers and table from the room that had served as an office, so that it could be transformed into a

sitting room.[122] A carpet was fitted to the room, a side table given a new fitted cover, and a 'large slope top drawing table' that Ryde had probably used for draughtsmanship was converted into a dining table by a carpenter.[123] Discussion of the look of the domestic interior is rare in the diary, so it is significant that shortly after the marriage Ryde notes: 'much pleased with the appearance of our newly furnished sitting room, which thanks to Patty is in apple pie order'.[124] The comment suggests male pride in home-making, underpinned by assistance from female servants. The diary presents an ongoing story of a man who saw the provision of the home as a matter of pride: in both the case of the house of Warwick Square and Poundfield House at Woking Edward bought and arranged goods in the houses before Sarah arrived, presenting her with a fait accompli.[125]

As Sarah Ryde left no written record of her contribution to the home, our understanding of her role is circumscribed by Edward Ryde's narrative. When the home was set up, Sarah made the traditional feminine contributions. In 1847, when Ryde returned home after Christmas he brought with him a carpet bag full of linen that 'dear Sarah has purchased for our new home'.[126] The distinct areas of male and female consumption that Amanda Vickery has identified for the eighteenth century also seem in evidence here.[127] On joint shopping trips for the new home, Ryde paid for the furniture (although they clearly shopped for it together), whereas Sarah bought a tea caddy and coffee and teapots with her own money.[128] When the home was established, Ryde maintained overall control of the household budget: the diary records that he gave Sarah a fixed sum for housekeeping, making smaller grants for specific purposes such as fitting up her workbox.[129] Throughout the marriage, Ryde continued to purchase goods for the home. He was particularly proud of acquiring goods for 'dear Sarah' at a house sale: in the summer of 1848 he noted the purchase, delivery and bill payment of a set of bedroom furniture for her. Ryde's professional role may have increased his interest in household goods, but important decisions were tempered by the marital dynamic. The smart set of furniture from Gillows and Heal's for the new house on Warwick Square was acquired on a joint shopping trip.

Legal privilege, financial power and personal inclination could all lead to a significant male input into domestic decoration. As the couple were married before the Married Women's Property Acts, under common law, Edward Ryde would have gained control of any property or wealth Sarah brought to the marriage.[130] Ryde's purchase of furniture for his home is a testament to the financial control that men could wield in the home in this period. Other diaries also show men issuing a monthly allowance for housekeeping, which would have made the purchase of

large items of furniture difficult without their consent.[131] Ryde, and other middle-class men, would have had the resources to purchase high status goods such as furniture. However, as Finn has shown, even before the Married Women's Property Act, wives were able to purchase a range of luxury goods on credit in their husbands' names.[132] Rather than demonstrating patriarchal dominance, Ryde's diary has more resonance with the representations of home-making men in the novel, whose furniture symbolised their ability to love and to cherish. Ryde was far from being a power-hungry patriarch anxious to stamp domestic space with the mark of his control. He paid for the furniture, but the presence of his wife on shopping trips suggests joint decisions. Other diaries also suggest that pre-marital shopping for the home in particular was often carried out by both partners.[133] For Ryde, and for other middle-class men, the purchase of furniture was both a material responsibility and an emotional investment in the home, as much as an opportunity to exercise patriarchal dominance.

Marital spaces: drawing rooms and dressing rooms

Two rooms played a central role in middle-class marriages: the drawing room and the bedroom, with dressing room attached. Nineteenth-century domestic advice reveals that the drawing room was viewed as a key part of every home because of the behaviour it was thought to inspire in husbands and wives when they were alone together. The drawing room – and the restrained behaviour that entry into this room required – set the stage for 'polite' marriage. Such sociability supported the idea of a male breadwinner, in that it encouraged women to serve men who had returned to the home after working outside it, but it also demanded that men conform to feminine standards of behaviour. For example, Jane Ellen Panton, in *From Kitchen to Garret* (1888), wrote:

> It is on little things that our lives depend for comfort, and small habits, such as a changed dress for evening wear with a long skirt, to give the proper drawing-room air, the enforcement of the rule that slippers and cigars must never enter there, and a certain politeness maintained to each other in the best room, almost insensibly enforced by the very atmosphere of the chamber, will go a long way towards keeping up the mutual respect husband and wife should have for each other.[134]

Here Panton directly equates correct behaviour in the drawing room with long-term marital success. H.J. Jennings, whose advice manual *Our Homes* was published in 1902, also discusses the atmosphere of the drawing room at length. Again, the room is represented as a polite space

in which dress codes and certain rules of etiquette apply. Behaviour is thus conditioned by this atmosphere:

> It is thither that you adjourn from the dinner-table to listen to music, or indulge in the lighter intellectual *causeries* to which all can contribute their share. The inferior sex have cast off, for the time, the habiliments of their daily calling, and donned the dress jackets and polished boots of the masculine *demi-toilette*. The grace and elegancy of the surroundings, no less than the fact that it is the ladies' audience chamber, would exact this confession even if it were not convenient and comfortable in itself. You are in a room which expresses a quality *sui generis* – a quality of rest, sociability, and comfort in an artistic framework.[135]

These writers were expressing a view of the social role of the drawing room, and their sentimental descriptions of atmosphere and intimacy echo those which had already been established in the mid-century novel. In *Dr Thorne* (1858), Trollope plays on the image of the drawing room as polite space for marital conversation when he describes Dr Thorne's creation of a drawing room for his niece. Trollope's description of the Thorne home as prepared, 'as though a Mrs. Thorne with a good fortune was coming home tomorrow', underlines the doctor's devotion.[136] Using a very similar language to that which Panton would later employ to describe the 'small habits' of the drawing room, Trollope's description of this polite, intimate space illustrates the foundation of a warm relationship between Thorne and his niece:

> He took her first into the shop, and then to the kitchen, thence to the dining-rooms, after that to his and to her bed-rooms, and so on till he came to the full glory of the new drawing-room, enhancing the pleasure by little jokes, and telling her that he should never dare to come into the last paradise without her permission, and not then till he had taken off his boots.[137]

The drawing room was, therefore, seen as an essential part of the marital home, and might be absent from the homes of single men such as curates, who preferred to use the additional space for a study.[138] When Edward Ryde converted his modest London bachelor quarters for his bride in the 1840s, the transformation was effected principally through the conversion of his work space into a drawing room.[139] In the 1880s, when London artist and his wife Andrew and Aggie Donaldson decorated their home, they too concentrated their efforts on the drawing room.[140] It was during the evening when the husband had finished work or in the late afternoon for the five o'clock tea that the drawing room came into its own. Frederica Orlebar portrayed such drawing-room exchanges as vital to the success of her marriage. Her diaries show her frustration with the

formal family practice of eating in the dining room.[141] Later, when the dining room was being cleaned and her husband's uncle was away for the day, she relished the opportunity to eat in the drawing room. Unlike the formal, distant set-up of the dining room, the smaller drawing room table allowed a closer physical exchange between the couple. Of this arrangement, Orlebar wrote: 'I felt more brilliantly happy than I had done since the beginning of our wedding tour when I saw our own tea table pitched in the drawing room, with new bread and buns and coffee and eggs on the clean white cloth, instead of the stiff goodboy look of our regular everyday dinner.'[142]

Drawing room intimacy was also idealised by men. Richard Orlebar, in his courtship letters to Frederica, yearned for the day when the couple would sit beside their own drawing-room fireside.[143] While the design reformer Charles Eastlake relished the quiet intimacy the room offered in the evenings: 'it will be pleasant after dinner to sit around the drawing-room fireplace for a quiet chat'.[144] These men imagined the drawing room fireside, and the intimacy of husband and wife beside it, as the heart of the nineteenth-century middle-class home.

Surviving photographs also celebrate the drawing room as a symbol of married life, and show how this could be depicted in a variety of ways. The formality of many couples posed in drawing rooms echoes the polite marriage of advice manuals, but other, more informal images set up the room in different ways, as a more relaxed space for 'cosiness' or even as the scene of playful and daring physical intimacy. The majority of nineteenth-century portrait photography took place in the studio, but photographers and subjects often tried to create the impression that these pictures were taken in the drawing room. Audrey Linkman has found that a drawing room stage set was one of the two most used backdrops in *carte de visite* portraits.[145] Figure 2.4 shows a double portrait in the domestic interior, featuring Hugh and Esme Horrocks, a newly married lower middle-class couple from the Manchester area.[146] Probably taken in the studio, a range of objects have been chosen to create an environment of cultured middle-class domesticity. Family portraits on the wall behind suggest continuity, while a romantic landscape print and books suggest that this is a cultured home. The couple are formally posed, perhaps suggesting an adherence to 'polite' behaviour, although they may simply have been responding to the directions of the photographer.

Towards the end of the century, photography became cheaper, and it became technically easier to capture an interior. The drawing room became the most photographed room in the house, and often featured its master and mistress. Figure 2.5 is from an album prepared by Thomas Pumphrey, a Newcastle Quaker, in honour of his golden wedding in 1908. It shows the couple seated side by side in their drawing room at

2.4 Hugh Horrocks and his wife Esme

Summerhill Grove, the home they had shared since 1863. The portrait is titled 'In our cosy chairs.' Although they are apparently engaged in separate pursuits, their posture suggests intimacy. Their bodies mirror each other and they share a footstool. Surrounded by the tokens of many years of married life, the quietly occupied couple present a warm if staid version of the marital intimacy in the drawing room. Figure 2.6 shows

2.5 Mr and Mrs Pumphrey

Herbert and Mildred Twamley, in their drawing room at 'Bantadarwa', 7 Shakespeare Road, Bedford, was taken in 1900, a year after they were first married. Again, the drawing room has been chosen as the setting for a marital photograph, but this couple dare to share the same arm-chair, seated in such a manner as to grant her full view of his impressive moustache. The kind of marital intimacy that the drawing room offered depended on the couple involved, but the space was clearly associated with conjugal togetherness.

The niceties of polite marriage were, however, not realised in every drawing room. The weight of expectations placed on this room, both as the home's most public space and one in which female values should hold sway, could make it a site of marital turbulence. Mark Rutherford's memoirs recount the tale of a friend's failed marriage: in the first week of

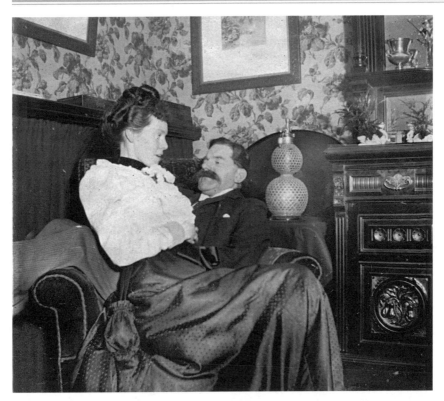

2.6 Mildred and Herbert Twamley shortly after their wedding, *c.*1900

the marriage, the wife arranged some of her treasured objects on some empty shelves in the drawing room, the husband responded by ordering her to place her shabby books upstairs, replacing them with a stuffed dog. Later, his lack of sympathy and her loneliness forced her to leave the marriage.[147] Couples were more likely to clash over drawing room decoration if the husband had a stake in artistic matters. Charles Eastlake struggled to control the appearance of his London drawing room, railing against his wife's insistence on piling occasional tables high with objects: 'For my own part I generally lose not only the game, but my temper.'[148]

The pressures of polite behaviour in this often female dominated space could become too much for some men. Eastlake strenuously avoided his wife's 'At Home'.[149] John Tosh has argued that towards the end of the century young men, in particular, were increasingly tired of the tyranny of the five o'clock tea.[150] More disturbingly, A. James Hammerton's study of conflict in nineteenth-century married life reveals that clashes between a wife's expectations of polite niceties and a husband's desire to dominate could result in tension and violence. In his study of marital violence in divorce records, Hammerton gives the example of Anne Smith, the wife of an army lieutenant, who in court

emphasised her husband's failure to respect her values, describing his practice of smoking throughout the house and particularly in the dining room.[151] As Hammerton has shown, marital violence was more widespread in nineteenth-century middle-class homes than contemporaries credited, with wives frequently resorting to the use of the poker as a weapon in self-defence.[152]

In cases of unhappy marriage, the spatial arrangement of the home could play a crucial role in providing consolation and making day-to-day life bearable. Divorce remained difficult to obtain in this period, but some couples did pursue informal separation.[153] However, for the unhappily married who remained in the same house, spatial negotiation and compromise was essential. Upper middle-class couples with larger living spaces had the advantage here. Beryl Lee Booker's parents were, she implies, not unhappy but temperamentally unsuited to each other, her father's illness in India making him unfit for any strain or exertion. Her parents, therefore, maintained separate bedrooms and dressing rooms in their large London house, meeting infrequently: 'mother and father went their own gay way'.[154]

The family of the advice writer Mary Eliza Haweis managed their differences rather less genially. In their house at Cheyne Walk, occupied by Haweis and her husband and their three children, constant arguments were heard and tension led to an almost complete family breakdown by the time the children were in their teens. At this time, mother and daughter, and father and son barely spoke to each other.[155] In this case, the formal organisation of the Victorian home at least facilitated a degree of functionality: the family met in the dining room for meals, and on other social occasions. Otherwise, the segregation of space in the home allowed them to avoid each other almost completely and Mary Eliza Haweis remained closeted in her drawing room.[156] For some, complete temporary physical separation was the only answer. In the summer of 1871, the unhappily married William Morris, for example, set up a separate home at Kelmscott in Lechlade for his wife Jane and her lover Dante Gabriel Rossetti, while he went on a long trip to Iceland.[157] Morris was unusual both in his tolerant attitude towards his wife's extra-marital activities, and in having the lifestyle that enabled him to do this.[158] However, many middle-class men in this period did go abroad for work or travel if they could afford it – so temporary separation may sometimes have offered a way out.

There was a strong cultural association between sleeping apart and marital (sexual) failure. This was made clear in more sexually open novels towards the end of the century. In George Gissing's *New Grub Street* (1891), on the night Amy and Edwin Reardon have the final argument that leads to their parting, they sleep separately: 'When Reardon

returned to the bedchamber an hour later, he unfolded a chair bedstead that stood there, threw some rugs upon it, and so lay down to pass the night.'[159] In a painful scene in Thomas Hardy's *Jude the Obscure*, published as a book in 1896, Sue Phillotson (formerly Bridehead), the heroine of the book, marries unwisely and, feeling no sexual attraction to her husband spends the night in a clothes closet rather than sharing a bed with him.[160] Letters and diaries demonstrate that nineteenth-century married couples were expected to share a bedroom. Barbara Caine has shown how Georgie Potter's sisters linked the failure of her marriage to her husband's disinclination to share a room with her, which was seen as: 'both symptom and source of strain'.[161] Couples would be expected to share rooms throughout their lives, although the onset of old age and illness could change this. In 1891, Edward Ryde, now 69 years old, in a rare emotional outburst, recorded in his diary his distaste for the idea of taking a separate room from his wife: 'My wife and I have lived together for 43 years: to propose to separate us is to my mind unnatural.'[162]

The bedroom was the heart of marital intimacy in the home – and the location for sexual relations between husband and wife. For many more affluent middle-class couples in this period, however, the marital bedroom came with at least one dressing room attached. A room called the 'dressing room' had long been a part of aristocratic homes, but it is less clear how common this room was in middle-class homes before the mid-nineteenth century.[163] In large country houses it was normal for both the master and mistress of the house to have their own dressing room.[164] In middle-class houses, however, it was more usual to have a single dressing room that was attached to the marital bedroom by a private door. The architect Robert Kerr's advice manual *The Gentleman's House* (1864), described this as 'a comparatively small private room attached to the Bedroom for the purposes of the toilet . . . the size of this room may vary from 9 or 10 feet square'.[165] Kerr drew a precise equation between the social position of the family and the number of dressing rooms in the house. At least one bedroom with a dressing room attached was to be found in 'every instance of what we might call a Gentleman's house, however small',[166] while a house with a suite that included two dressing rooms could be taken to 'mark a point of a very considerable advance in dignity'.[167]

Inventories and sale catalogues indicate that single dressing rooms were quite widely used: approximately 30 per cent of the lists from the north east, the north west and the south east included a bedroom with a single dressing room attached. The room was mainly used by the wealthier middle classes, and was most frequently found in the homes of well-off businessmen, well-to-do clergymen, doctors and the gentry. However, the 'brass founder' Alfred Savage Dixon also had a dressing

room in his opulent Leeds home: a caution against interpreting the use
of the dressing room as occupationally specific.

The single dressing room belonged to the man of the house. It was
widely assumed by advice writers that this would be the case.[168] It was
recommended that it should be furnished plainly. The advice writer
Mrs Dorothy Constance Peel, writing in 1898, remarked: 'The average
man does not appreciate a be-frilled and be-furbelowed room. As a rule,
he infinitely prefers plain strong furniture and little of it.'[169] Equally,
Panton believed that dressing-room ornaments would be damaged by
rough male use.[170] Diaries suggest that the dressing room had been used
in this way from the 1850s. Annie Dickinson, writing of the domes-
tic arrangements on her honeymoon in 1858, considered it essential:
'one large bedroom for me – a snug little one for Robinson [Annie
Dickinson's maid] and a funny little dressing room for Horace'.[171]
Jonathan Backhouse Hodgkin, the son of a Quaker preacher and bank-
er's daughter from Darlington, recalls a dressing room in his childhood
home, which was used by his father.[172]

Court records also show that in London, dressing rooms tended to
be used by middle-class men. As a place in which valuable jewellery and
clothing were stored, the dressing room was often a target for thieves and
thus frequently figures in court trials for theft. Between 1850 and 1910,
forty-three cases of theft from or via London dressing rooms were tried
in the Old Bailey courts.[173] The vast majority of these rooms were used
by married or single men, or single women. Only four of the dressing
rooms mentioned were used by married women, and the majority of
these were aristocratic.[174] The dressing room was necessary partly because
the bedroom was taken over by female dressing equipment.[175] In upper
middle-class homes that followed the practice of dressing for dinner, men
and women would be required to change their clothes more than once a
day.[176] Households wealthy enough to employ a lady's maid had a greater
need for a dressing room as this meant that the maid could attend on the
lady without witnessing the impropriety of the master of the house in a
state of undress.[177] So the dressing room could be important as part of the
division of space between masters and servants as explored in Chapter 1.

The spatial structure of the dressing room played an important role
in shaping behaviour within marriage. Here the deployment of space
may have been significant for sexual relations in marriage. This is out-
lined most clearly in the architect Robert Kerr's manual *The Gentleman's
House*, first published in 1864, which argues that even within intimate
marital space, there must also be a kind of privacy:

> For a single person the *Bed-room alone* is sufficient, as a rule. For a married
> couple with the least possible degree of fastidiousness the Bedroom alone, if

of sufficient size, may still suffice. Then comes the case of *one Dressing-room* (the universal standard plan,) by which it may be said the gentleman's toilet is taken out of the lady's way, she retaining the Bedroom; this admits also of the attendance of servants.[178]

Kerr notes that 'in a gentleman's room of a superior class there will be a small bedstead in one corner'.[179] Other advice manuals also comment on the usefulness of spare bed.[180] It is unclear what the spare bed was for. Kerr's use of the word 'fastidious' is interesting. It may simply refer to the spatial separation of man and wife via the dressing room, which ensured that each could dress away from the other's gaze. Yet the discussion of the bed raises the possibility of sleeping apart. While the Victorians were notoriously silent (or coded) in their discussions of sexual matters, the term 'fastidious' was used elsewhere to refer to sexual restraint.[181] It is also worth noting that middle-class observers of working-class life made a specific link between sexual promiscuity and access to space.[182] Kerr's discussion of this room coincided with a shift in middle-class sexual practices. The drop in the birth rate of children in middle-class families from 1870 onwards suggests that Victorian sexual behaviour may have been shifting, which historians have associated with a growing culture of abstinence.[183] It seems likely that the dressing room with bedroom attached would have allowed a degree of restraint within marriage, contributing to the culture of abstinence.

The spare bed had many practical values. Advice writers emphasised the fact that the bedroom may need to be taken over for some time as a lying-in room during the final stages of pregnancy and birth.[184] Yet the presence of a spare bed in the dressing room may have allowed some room for manoeuvre in marital sexual relations. Its position in the room adjoining the bedroom offered the potential for some separation even within the small shared space that demonstrated marriage to the outside world. There is no direct evidence that Kerr's instructions were followed, but the material potential clearly existed for this. A separate bed was present in approximately one fifth of the dressing rooms in my survey of inventories and sale catalogues, but it is worth noting that these tended to be made at the end of the life cycle and are, therefore, not necessarily a good indicator of the material culture of sexually active married couples.

Although there was very little discussion of this in Victorian advice literature, increasingly frank later commentators identified the dressing room and its spare bed with the possibility of sexual restraint. As Hilary Hinds has recently demonstrated, sexual advice writer Marie Stopes described the bedroom with dressing room attached as the ideal arrangement for married couples, co-opting the arrangement into her egalitarian vision of early twentieth-century marriage: 'Marriage to-day would

do well to go back to the Victorian era, and throne itself on a marriage bed, large, square and comfortable, attended by a single bed either in the same room or in a near-by dressing-room for one or other of the partners when either desires solitude.'[185] Reflecting on her childhood home, Stopes remembered that her parents slept in a giant Victorian four-poster while 'in the next room was a large comfortable single bed with an open door between the rooms'.[186]

Whatever the precise meaning of this term and its relationship with shifting middle-class sexual mores, it is clear that the dressing room fundamentally altered the experience of marital intimacy, as it meant that husband and wife would dress beyond each other's gaze, preserving a sense of privacy even within this most intimate marital space. In her critique of the modern practice of married couples sharing a bedroom, Stopes argued that one of the key disadvantages of this arrangement was the exposure of the husband to 'the most unlovely and even ridiculous proceedings of the toilet'.[187] Dressing beyond each other's gaze was, for Stopes, essential to preserving mutual attraction in marriage. Thus, even within the married couple's most private room, space was used to fashion but also to restrain intimacy, creating an emotional experience that was distinctive to marriage among the nineteenth-century upper middle classes.

Conclusion

The domestic interior has important implications for our understanding of nineteenth-century marriage. Middle-class women often gave gifts to their fiancés. These gifts could be used tactically, to provoke a response from the male testing their suitability as a partner. In the context of the, presumed, lifelong commitment of marriage and the long engagements especially common among the lower middle classes, such gifts could be powerful and poignant. While such tactical manoeuvring indicates that real men and women did not stumble blindly to the altar, the employment of the domestic interior as a means of evoking the intimate in the love letter shows that men and women did strive towards the ideal of romantic love. The symbols of romance decorated the home on the wedding day, but the elaborate white bunting also helped conceal the anxiety many women felt. Gift-giving was an important part of the middle-class wedding. Wedding gifts made an important material contribution to the domestic interior, but were also an expression of the relationship between the new couple and their social group. While the objects in wedding lists became increasingly modern, there were continuities in the way in which they were exchanged. The giving of a wedding present was a social statement that was displayed to the rest of

the community. Gifts exchanged at this time were particularly important in cementing the new family bonds, but the gifts between parents and children, often geared towards the creation of a new home, cemented old ties. In particular, the trousseau expressed the lasting bond between mother and daughter.

Engagement with domestic decoration was gendered. Men could play an important role: they might well be very interested in furniture selection and they often retained ultimate control of the purse strings. They might purchase furniture, and take a pride in their home-making ability. The selection of goods for the home was not necessarily a male strategy for domestic control; equally furniture could symbolise their emotional investment in home and their capacity to love and cherish. Despite the fact that married women could not own separate property until 1882, they had a much more intense relationship with the domestic interior on an everyday basis through its arrangement and maintenance. The evidence shows that mid-nineteenth century women also played a key role in acquiring goods for the home through a range of methods. Women professed to a stronger sentimental attachment to things than men. This could be advantageous. Women who were transplanted into alien domestic space by a patriarchal property structure used domestic decoration to regain and recreate their identity. Thus, rather than allocating responsibility for the domestic interior to either husband or wife, we need to view home decoration as a joint effort. While husbands and wives clearly could cooperate, 'companionate' does not seem to be the best definition, as decisions over the interior could also express some of the inevitable tensions in a marriage. Good marriages could be founded on shared taste and joint contributions to the décor of the home. But even if a couple shared an attitude to lifestyle, if this was pushed too far by one partner this could have adverse consequences for the relationship.

The organisation of space in the home played a crucial factor in shaping marital intimacies. Advice writers advocated the use of the drawing room for 'polite' marriage, an intimate space created for manly repose, yet also one in which the man of the house would be required to abide by feminine standards of behaviour. Of course, polite marriage was not realised in every home and the drawing room was also a site for marital tension and in some cases, violence. Nevertheless, the vision of this room as a space for intimate, personal exchange between men and women was embraced by them both. The practice of having a marital bedroom with dressing room attached, associated by Kerr with 'fastidious' marriage, was widely adopted by the upper middle classes and by some lower down the social scale. The use of the bedroom in this way may have allowed husband and wife to sometimes sleep apart, and may be connected to the 'culture of abstinence' that has been identified

in this period. Certainly, the dressing room defined marital intimacy. Diaries and letters confirm that it allowed husband and wife to dress apart, preserving modesty and the body from the marital gaze. While historians have variously characterised nineteenth-century marriage as 'companionate' or 'patriarchal', the study of the use and meaning of domestic space suggests that 'polite' and 'fastidious' may be equally apt descriptions.

Notes

1 Diary of Frederica Orlebar, 17 Oct. 1863, B&L, OR2244/6 vol. 2.

2 17 Oct. 1861, B&L, OR2244/6.

3 During the second half of the nineteenth century, those who remained unmarried were in a minority. Wrigley and Schofield note that according the census data, the proportion of those who never married at age 45–54 in the censuses of 1851, 1861 and 1871 was 11.9, 11.2 and 10.9 per cent, respectively. E.A. Wrigley and R.S. Schofield, *The Population History of England 1541–1871: A Reconstruction* (London: Edward Arnold, 1981), p. 259.

4 J.W. Kirton, *Cheerful Homes: How to Get and Keep Them Or, Counsels to Those About to Marry and Those Who Are Married* (London: Ward, Lock & Co., 1882), p. 32.

5 Michael Anderson, *Approaches to the History of the Western Family 1500–1914* (Cambridge: Cambridge University Press, 1995), p. 5.

6 Recollections from the childhood of Jonathan Backhouse Hodgkin with accompanying letter to his son Henry Hodgkin, June 1916, D/Ho/F 146.

7 Samuel and Isabella Beeton, for example, selected and decorated their suburban home in Pinner before their marriage. Sarah Freeman, *Isabella and Sam: The Story of Mrs Beeton* (London: Victor Gollancz, 1977), pp. 114–115.

8 Allen Horstman, *Victorian Divorce* (London: Croom Helm, 1985), p. 141.

9 In her recent study of co-habitation in nineteenth-century England, Ginger Frost identified 1,000 cohabiting couples (a large number of whom were cohabiting because they had been previously married). However, she notes that this was the exception rather than the rule. Ginger S. Frost, *Living in Sin: Cohabiting as Husband and Wife in Nineteenth-Century England* (Manchester: Manchester University Press, 2008), pp. 3 and 225.

10 J. Schneid Lewis, *In the Family Way: Childbearing in the British Aristocracy 1760–1860* (New Brunswick: Rutgers University Press, 1986), p. 19. Lewis, however, argues that the shift was linguistic rather than emotional; the terms in which love was expressed shifted but the feelings the words embodied did not; Ibid., p. 31. Barbara Caine argues that the reception of the romantic ideal varied from marriage to marriage. B. Caine, *Destined to be Wives: The Sisters of Beatrice Webb* (Oxford: Clarendon, 1986), p. 92.

11 Peterson argues that less well-off women were not as likely to experience companionate marriage, M. Jeanne Peterson, *Family, Love and Work in the Lives of Victorian Gentlewomen* (Bloomington: Indiana University Press, 1989), p. 84; while Frost suggests that companionship in marriage was not new among the lower classes. Ginger Frost, *Promises Broken: Courtship, Class and Gender in Victorian England* (London: University Press of Virginia, 1995), p. 63; Jane Lewis, however, suggests that it was only in the late nineteenth century that the 'angel in the house' ideal was superseded by companionate marriage. J. Lewis, *Women in England 1870–1950: Sexual Divisions and Social Change* (Sussex: Wheatsheaf, 1984), p. 77.

12 A. James Hammerton, *Cruelty and Companionship: Conflict in Nineteenth-Century Married Life* (London: Routledge, 1992), p. 169.

13 Michael Anderson, 'The Social Implications of Demographic Change', in F.M.L. Thompson (ed.), *The Cambridge Social History of Britain 1750–1950, Vol. 2, People and their Environment* (Cambridge: Cambridge University Press, 1990), p. 39.

14 Anderson, 'The Social Implications of Demographic Change', p. 44.

15 Simon Szreter, *Fertility, Class and Gender in Britain, 1860–1940* (Cambridge: Cambridge University Press, 1996), p. 394.

16 Peterson, *Family, Love and Work*, p. 66. For a discussion of why this should be the case, see Michael Mason, *The Making of Victorian Sexuality* (Oxford: Oxford University Press, 1995), pp. 1–8.

17 K. Lystra, *Searching the Heart: Women, Men and Romantic Love in Nineteenth Century America* (Oxford: Oxford University Press, 1989), p. 20.

18 Richard Orlebar to Frederica Rouse Boughton, 21 Jul. 1861, B&L, OR2246/44.

19 Frederica Rouse Boughton to Richard Orlebar, 23 Jul. 1861, B&L, OR2246/48.

20 B&L, OR2246/48.

21 Anthony Wallis to Amy B. Mounsey, Jan. 1909, DRO, D/Wa 5/1/162.

22 Anthony Wallis to Amy B. Mounsey, 15 Feb. 1909, DRO, D/Wa 5/1/169.

23 Anthropologists have argued that gift giving is often an expression of unequal gender relations. A.E. Komter, 'Women, Gifts and Power', in A.E. Komter (ed.), *The Gift: An Interdisciplinary Perspective* (Amsterdam: Amsterdam University Press, 1996), p. 124. Also see M. Strathern, *The Gender of the Gift: Problems with Women and Problems with Society in Melanesia* (London: University of California Press, 1988), p. xii.

24 Michael Anderson, 'The Emergence of the Modern Life Cycle in Britain', *Social History* 10:1 (1985), p. 82.

25 Lystra, *Promises Broken*, p. 63.

26 Ellen Ross, *Love and Toil: Motherhood in Outcast London 1870–1918* (Oxford: Oxford University Press, 1993), p. 65.

27 Diary of Annie Dickinson, 4 Mar. 1858, CKS, U1451 F4.

28 13 Mar. 1858, CKS, U1451 F4.

29 10 May 1858, CKS, U1451 F4.

30 11 May 1858, CKS, U1451 F4.

31 Jonathan Backhouse Hodgkin to his mother, 12 Mar. 1873, DRO, D/Ho/C 91.

32 2 Jul. 1861, B&L, OR2244/5.

33 E. Farjeon, *A Nursery in the Nineties* (London: Victor Gollancz, 1935), p. 147.

34 List of wedding gifts, Twamley Papers, 1898–1899, B&L, Z 826/5/6.

35 Beryl Lee Booker, *Yesterday's Child: 1890–1909* (London: Long, 1937), p. 251.

36 D. O'Hara, *Courtship and Constraint: Rethinking the Making of Marriage in Tudor England* (Manchester: Manchester University Press, 2000), pp. 197–200.

37 Diary of the Rev. John Coker Egerton, 28 Dec. 1874, ESRO, AMS 5637/6; List of Ella Druitt's wedding presents, 1880, WSRO, Druitt 286; List of the wedding presents of Charles Druitt, 1875, WSRO, Druitt 291; B&L, Z 826/5/6; List of wedding presents by Amy Mounsey, 1910, DRO, D/Wa 5/4/26; List of wedding presents received by Ida Elizabeth Dawson and Henry Darlow, 1915, B&L, Z1063/6/1/2; List of wedding

presents, Fanny Cleave Warne, 1889, CKS, F29 U1390; HERO, D/Eso F38; Anne Byng to Edward Frewen, May 1873, ESRO, FRE/4182/24–43; List of Talle's wedding presents, 1869, Diary of Henrietta Thornhill, SLS, IV/81/6; List of Augusta's wedding presents, 1865, Diary of Henrietta Thornhill, SLS, IV/81/2; List of wedding presents, 1861, Diary of Frederica Orlebar, 2 Jul. 1861, B&L, OR2244/5; List of wedding presents made on marriage of John Cullimore and Mary Dale, 1885, GRO, uncatalogued; List of wedding presents for the Senhouse family, c.1875, Carlisle Record Office, uncatalogued; List of wedding gifts of Barnard Orniston Dickinson and Agnes Elizabeth Kirkwood, 1898, Ironbridge Gorge Museum Library and Archives, lab/ASSOC/6/2; List of wedding gifts for Strode Lowe family, 1891–1905, Plymouth and West Devon Archives, MEA 11; List of wedding gifts for Stephens family, Cornwall County Record Office, ST/563; List of wedding presents for Marianne Caroline Bridgeman, 1862, SHRO, 4629/7/3/3; List of wedding presents for CWC Bridgeman, 1895, SHRO, 4629/1/71; Unidentified wedding list, 1878, Cumbria Record Office, Barrow Branch, BD/HJ/221/3/20.

38 B&L, Z 826/5/6; Amy B. Mounsey's list of wedding presents, 1910, DRO, D/Wa 5/4/26; List of wedding presents, Fanny Cleave Warne, 1889, CKS, F29 U1390; Wedding list of Mary Ann Exton, 1856, HAL, DE/So F38.

39 Mary Hughes describes her wedding presents as 'few' but gives quite a substantial list. M.V. Hughes, *A London Family 1870–1900* (Oxford: Oxford University Press, 1991), p. 531.

40 Mrs Haweis, *The Art of Housekeeping: A Bridal Garland* (London: Sampson Low & Co., 1889), p. 56.

41 Elizabeth Laverack, *With This Ring: 100 Years of Marriage* (London: Elm Tree Books, 1979), p. 123.

42 From correspondence with Sebastian Wormell, Harrods' Archivist and Judy Faraday, Partnership Archivist for John Lewis.

43 L. Purbrick, *The Wedding Present: Domestic Life Beyond Consumption* (Aldershot: Ashgate, 2007), p. 20.

44 M. Finn, *The Character of Credit: Personal Debt in English Culture 1740–1914* (Cambridge: Cambridge University Press, 2003), p. 87.

45 See J. Styles, 'Victorian Britain, 1837–1901: What Was New', in Michael Snodin and John Styles, *Design and the Decorative Arts: Britain 1500–1900* (London: V&A Publications, 2001), pp. 431–459.

46 F. Collard, 'Furniture', in Snodin and Styles, *Design and the Decorative Arts*, p. 442.

47 Jalland has noted how nineteenth-century women's wills placed great emphasis on returning gifts, a practice that showed 'the value these families placed on the exchange of keepsakes'. P. Jalland, *Death in the Victorian Family* (Oxford: Oxford University Press, 1996). p. 297.

48 The following diaries suggest that the display of wedding presents was a common practice in Victorian society: 28 Jul. 1858, CKS, U1451 F4; 14 Sep. 1894, CKS, U1930 F8; 21 Jun. 1869, LLS, IV/81/1; 13 Jul.1881, BRL, DX 1480/21.

49 A. Fine, 'A Consideration of the Trousseau: A Feminine Culture?', in M. Perrot (ed.), *Writing Women's History* (Oxford: Blackwell, 1992), p. 127.

50 Barbara Penner, '"A Vision of Love and Luxury": The Commercialisation of Nineteenth-century American Weddings', *Winterthur Portfolio*, 29:1 (2004), 1–20.

51 Ibid., p. 15.

52 [Anon.], 'Marriage and Giving in Marriage', *Hearth and Home*, 4 Jan. 1900, p. 348; [Anon.], 'Weddings', *The Gentlewoman*, 12 July 1890, p. 12.

53 [Anon.], 'Wedding at Homes for People of Small Incomes', *The Girl's Own Paper* (22 Nov. 1890), p. 124. Louise Purbrick notes that this practice was also common in mid-twentieth-century Britain, yet these objects did not always tell of the new owner's social position. 'The "element of competition" referred to above was not between the bride's family who host the display and the neighbours who look on, but between the givers to the bride and groom.' L. Purbrick, 'Wedding Presents: Marriage Gifts and the Limits of Consumption, Britain 1945–2000', *Journal of Design History*, 16:3 (2003), 222.

54 Hughes, *A London Family*, p. 531.

55 Ibid., p. 531.

56 See photographs of twentieth-century gift displays reproduced in Purbrick, *The Wedding Present*, pp. 39–48.

57 WSRO, Druitt 286; Mrs Mounsey gave Amy a selection of household linens, DRO, D/Wa 5/4/26.

58 Diary of Edward Ryde, 26 Nov. 1878, SHS, 1262/35.

59 Henrietta Leyser, *Medieval Women: A Social History of Women in England 450–1500* (London: Phoenix Giant, 1996), p. 106.

60 Advertisement for Old Bleach, *The Gentlewoman*, July 12 1890, p. viii; Advertisement for Linens at Maples, *Hearth and Home*, 4 May 1905, p. 38.

61 Pauline Stevenson, *Bridal Fashions* (London: Ian Allen, 1978), p. 15.

62 [Anon.], 'A Girl's Trousseau: Warnings and Suggestions By a Six Month's Bride', *Home Chat* (3 February 1900), p. 358.

63 Mrs G. Linnaeus Banks, 'The Dowry Chest', *The Girl's Own Paper*, vol. xvi (30 March 1895), 796.

64 George Eliot, *The Mill on the Floss* (William Blackwood and Sons, London and Edinburgh, 1860), vol. 1, p. 308.

65 Celia Davies, *Clean Clothes on Sunday* (Suffolk: Terrence Dalton, 1974), p. 142.

66 Mary Carberry, *Happy World: The Story of A Victorian Childhood* (London: Longmans Green, 1941), p. 11.

67 P. Jalland, *Women, Marriage and Politics 1860–1914* (Oxford: Oxford University Press, 1988), p. 33.

68 Fine, 'A Consideration of the Trousseau', p. 128.

69 Ibid., p. 137.

70 A.M. Davies (Douton), *A Book with Seven Seals: A Victorian Childhood* (London: Chatto & Windus, 1974), p. 263.

71 Hughes, *A London Family*, p. 533.

72 [Anon.], 'The Table Tasteful', *The House: An Artistic Monthly for Those Who Manage and Beautify the Home*, 5, 7 (May 1899), p. 101.

73 Frost, *Promises Broken*, p. 72.

74 2 Jul. 1861, B&L, OR2244/5.

75 Recollections of Jonathan Backhouse Hodgkin, DRO, D/Ho/F 146.

76 Photograph of wedding of Rev. Cleave Warne and Fanny Brice, 1889, CKS, U1390 Z6 ii.

77 Diary of Rev. John Coker Egerton, 6 Feb. 1875, ESRO, AMS 5637 6.

78 Lewis, *In The Family Way*, pp. 32–33.

79 E. Allen, 'Culinary Exhibition: Victorian Wedding Cakes and Royal Spectacle', *Victorian Studies*, 45:3 (2003), 457.

80 J. Gillis, *For Better, For Worse: British Marriages 1600 to the Present* (Oxford: Oxford University Press, 1985), p. 6.

81 2 Jul. 1861, B&L, OR2244/5; 20 Jul. 1858, CKS, U1451 F4.

82 Frost, *Promises Broken*, p. 72.

83 20 Jul. 1858, CKS, U1451 F4.

84 2 Jul. 1861, B&L, OR2244/5.

85 Deborah Cohen, *Household Gods: The British and their Possessions* (London: Yale University Press, 2006), p. 90.

86 Ibid., pp. 92–93. Also argued by Judith Neiswander, *The Cosmopolitan Interior*, p. 86.

87 Cohen, *Household Gods*, p. 89.

88 Dena Attar, *A Bibliography of Household Books Published in Britain 1800–1914* (London: Prospect Books, 1987), p. 17.

89 [Anon.], *The Book of the Household; or Family Dictionary of Everything Connected with Housekeeping and Domestic Medicine* (London: Ward Lock, 1862) vol. 1, preface.

90 [Anon.], *The Book of the Household*, vol. 2, p. 296.

91 Thomas Metcalf, advertisement in *English Woman's Review and Drawing Room Journal* (3 October 1857).

92 For example see [Anon.], 'Gossip Amongst the Ladies About Shopping', *The Lady's Own Paper* (1 December 1866), p. 6.

93 The expectation that the drawing room would be the responsibility of the wife was repeatedly stated in publications across the period. J.C. Loudon, *The Suburban Gardener and Villa Companion* (London: Longman, Orme, Brown, Green & Longmans, 1838), p. 101; Robert Kerr, *The Gentleman's House: Or, How to Plan English Residences, from the Parsonage to the Palace* (London: John Murray, 1864), p. 107; Robert Edis, *Decoration and Furniture of Town Houses* (London: Kegan Paul & Co., 1881), p. 193.

94 10 Oct. 1861, B&L, OR2244/6.

95 28 May 1861, B&L, OR2244/5.

96 1 Oct. 1861, B&L, OR 2244/6.

97 28 May 1861, B&L, OR2244/5.

98 1 Oct. 1861, B&L, OR2244/6.

99 17 Oct. 1861, B&L, OR2244/6.

100 28 May 1861, B&L, OR2244/5.

101 Mar. 1889, CKS, U1930 F24; 1869, LA, PT 83/76 35; Feb., Apr. and May 1880, BRL, D/X 1480/20; Jan. 1885, LMA, ACC/385/1.

102 The decision as to when to clean or not had important implications for the use of the home. In 1847 vicar's daughter Ann Pidcock expressed disappointment that the cleaning of the drawing room carpet prevented social interaction with a visitor in the home on that day. 4 Oct. 1847, ERO, PC 675.

103 12 May 1893, CKS, U1930 F7.

104 Ponsonby, *Stories from Home*, p. 89.

105 Sale book of household furniture of Mrs C. Fox, St Bees, Whitehaven, April 1864, CROW, DBH 18/2.

106 23 Apr. 1869, LA, PT 83/76 35; 10 Jun. 1869, LA, Pt 83/7635.

107 C. Edwards, '"Home is Where the Art is": Women, Handicraft and Home Improvements 1750–1900', *Journal of Design History*, 19:1 (2006), 12.

108 For example, *Young Ladies' Home Journal*, see index for 1864; Mrs I.M. Beeton, *Beeton's Housewife's Treasury of Domestic Information: Comprising Complete and Practical Instructions on the House and its Furniture, Artistic Decoration and other Household Matters* (London: Ward, Lock & Co., 1865); [Anon.], *Cassell's Household Guide: Being a Complete Encyclopaedia of Domestic and Social Economy* (London: Cassell & Co., 1869), vol. 3, p. 10.

109 Rozsika Parker, *The Subversive Stitch: Embroidery and the Making of the Feminine* (London: The Women's Press, 1984), p. 11.

110 8 Jun. 1877, BRL, DX/1480/19.

111 11 Mar. 1889, BRL, DX 1480/23.

112 Work list for 1877, BRL, D.115/56/5.

113 Cohen, *Household Gods*, pp. 106–110. Also see Neiswander, *The Cosmopolitan Interior*, chapter 4.

114 E. Ferry, '"Decorators may be Compared to Doctors": An Analysis of Rhoda and Agnes Garrett's Suggestions for House Decoration in Painting, Woodwork and Furniture (1876)', *Journal of Design History* 16:1 (2003), 25.

115 Eastlake, *Hints on Household Taste*, p. 9.

116 Charlotte Mitchell, 'Panton, Jane Ellen', *Oxford Dictionary of National Biography*. Online version: www.oxforddnb.com/view/article/55642?docPos=1 (accessed 07/08/2008).

117 Mrs Arthur Stallard, *The House as Home: Written for Those who Really Matter in All Classes* (London: Andrew Melrose, 1913), p. 7.

118 A. Trollope, *Can You Forgive Her?* (Leipzig: Bernhard Tauchnitz, 1865), vol. 1, p. 131. Earliest book edition available in the British Library.

119 Elizabeth Gaskell, *Wives and Daughters: An Everyday Story* (London: Smith, Elder and Co., 1866), vol. 1, p. 145.

120 G. Gissing, *New Grub Street* (London: Smith, Elder & Co., 1892), vol. 2, p. 168.

121 H.G. Wells, *The History of Mr Polly* (London: Thomas Nelson & Sons, 1910), pp. 206–207.

122 11 Jan. 1848, SHC, 1262/5.

123 18 Nov. 3 Dec. 6 Dec., 1847, SHC, 1262/4.

124 20 Jan. 1848, SHC, 1265/5.

125 23 Jun. 1866, SHC, 1262/23.

126 29 Dec. 1847, SHC, 1262/4.

127 Amanda Vickery, 'His and Hers: Gender, Accounting and Household Consumption in Eighteenth Century England', *Past and Present*, 1 (supplement 1) (2006), 29, 34.

128 9 Nov. 1847, SHC, 1262/4.

129 22 and 29 Jan. 1848, SHC, 1265/5.

130 I have not found any evidence of a marriage settlement, but it may not have survived.

131 Men's diaries suggest that it was a common practice to give wives an allowance for housekeeping: Account Book of Rev. Cleave Warne 1893–5, CKS, U1930 A3; Feb. 7 1857, CKS, U3213 F16; the diaries of James Raven show that he allocated a certain sum each month to his wife, and other than that kept a tight rein on accounts, noting many purchases including china (although his wife did make her own purchases of decorative objects for the home), SRO, 52/4/1.10.

132 M. Finn, 'Women, Consumption and Coverture in England *c*.1780–1860', *The Historical Journal*, 39:3 (1996), 716. Even after the Married Women's Property Act, some county court judges persisted in holding husbands liable for their wives' debts for 'necessary' goods. M. Finn, *The Character of Credit: Personal Debt in English Culture 1740–1914* (Cambridge: Cambridge University Press, 2003), p. 267.

133 Diary of Rev. John Coker Egerton, 13 Jan. 1875, ESRO, AMS 5637 6.

134 J.E. Panton, *From Kitchen to Garret: Hints to Young Householders* (London: Ward & Downey, 1887), p. 86.

135 H.J. Jennings, *Our Homes, and How to Beautify Them* (London: Harrison and Sons, 1902), p. 173.

136 A. Trollope, *Doctor Thorne* (London: W Clowes and Sons, 1858), vol. 1, p. 61.

137 Ibid., vol. 1, p. 69.

138 Memorandum of Furniture at Curate's House, Pember, 1891, BRO, D/Eby Q 39.

139 11 Jan. 1848, SHC, 1262/5.

140 Diaries of Andrew and Aggie Donaldson, 4 Sep. 1872, LMA, F/DON/1.; 27 Aug. 1877, LMA, F/DON/4.

141 17 October 1861, B&L, OR2244/6.

142 14 April 1862, B&L, OR2244/6.

143 Letter from Richard Orlebar to Frederica Orlebar, July 21 1861, B&L. OR 2246/44.

144 Jack Easel (pseud. Charles Eastlake), *Our Square and Circle: or, The Annals of a Little London House* (London: Smith, Elder & Co., 1895), p. 66.

145 Audrey Linkman, *The Victorians: Photographic Portraits* (London: Tauris Park, 1993), p. 52.

146 GMCRO, DPA, 489/5.

147 M. Rutherford, *Autobiography and Deliverance* (Leicester: Leicester University Press, 1969), p. 63.

148 Eastlake, *Our Square and Circle*, p. 55.

149 Ibid., p. 59.

150 J. Tosh, *A Man's Place: Masculinity and the Middle-Class Home in Victorian England* (London: Yale University Press, 1999), p. 179.

151 Hammerton, *Cruelty and Companionship*, p. 107.

152 Ibid., p. 112. Elizabeth Foyster also suggests that although marital violence was viewed as less acceptable than previously in the early nineteenth century, it remained pervasive. Elizabeth Foyster, *Marital Violence: An English Family History 1650–1857* (Cambridge: Cambridge University Press, 2005).

153 Frost, *Living in Sin*, pp. 84–86.

154 Lee Booker, *Yesterday's Child*, p. 64.

155 Bea Howe, *Arbiter of Elegance* (London: The Harvill Press, 1967), p. 215.

156 Ibid., p. 254.

157 Fiona MacCarthy, *William Morris: A Life for Our Time* (London: Faber & Faber, 1994), p. 279.

158 Ibid., p. 275.

159 Gissing, *New Grub Street*, vol. 2, p. 127.

160 T. Hardy, *Jude the Obscure* (London: Osgood McIlvain, 1896), pp. 276–277.

161 B. Caine, *Destined to be Wives*, p. 95.

162 7 Dec. 1891, SHC, 1262/48.

163 For the evolution of the dressing room in the country house, see Mark Girouard, *Life in the English Country House: A Social and Architectural History* (London: Yale University Press, 1978), pp. 150, 206 and 231. For its use in the nineteenth-century country house, see Jill Franklin, *The Gentleman's Country House and Its Plan 1835–1914* (London: Routledge & Kegan Paul, 1981), p. 77. Surveys of eighteenth-century middle-class inventories and sale catalogues did not reveal dressing rooms. J. Hamlett, Geffrye Museum Report 5, Sep. 2004.

164 Girouard, *Life in the English Country House*, p. 231.

165 Kerr, *The Gentleman's House*, p. 149.

166 Ibid., p. 152.

167 Ibid., p. 152.

168 Panton, *From Kitchen to Garret*, p. 135; Kerr, *The Gentleman's House*, p. 131; J.E. Panton, *Leaves from a Housekeeper's Book* (London: Eveleigh Nash, 1914), p. 23.

169 Dorothy Constance Peel, *The New Home: Treating of the Arrangement, Decoration, Furnishing of a House of Medium Size* (London: Constable & Co., 1898), p. 178.

170 Panton, *From Kitchen to Garret*, p. 138.

171 5 Aug. 1858, CKS, U1451 F4.

172 DRO, D/Ho/F 146.

173 Old Bailey Database, www.oldbaileyonline.org/ (accessed 12/06/09).

174 Ibid. Cases of theft that reveal married women occupying dressing rooms include: wife of James Archer; Lady Selina Martin; Eleanor Festion; wife of the Hon. William Lowther; Duchess of Westminster; Mrs Prinsep, the wife of Mr Val Prinsep.

175 The crinoline, which could be up to 5½–6 yards in circumference, and reached its apogee in 1859–64, was particularly cumbersome. Alison Gernsheim, *Victorian and Edwardian Fashion: A Photographic Survey* (London: Dover, 1981), pp. 47–48.

176 Alison Gernsheim gives a full description of Victorian evening dress. Gernsheim, *Victorian and Edwardian Fashion*, p. 28.

177 Kerr, *The Gentleman's House*, p. 150.

178 Ibid., p. 136.

179 Ibid., p. 135.

180 Mrs Peel treats the dressing room as a male bedroom. Peel, *The New Home*, pp. 178–186.

181 The word 'fastidiousness' is used to describe Sue Bridehead's sexual aversion to her husband, in Thomas Hardy, *Jude the Obscure* (London: Osgood McIlvain, 1896), p. 263. Here Hardy's radical text openly describes aversion as 'fastidiousness', clearly voicing a meaning at which Kerr's manual discreetly hinted.

182 F. Barret-Ducrocq, *Love in the Time of Victoria: Sexuality, Class and Gender in Nineteenth-Century London* (London: Verso, 1991), p. 19.

183 Jeanne Peterson believes that family size declined partly because of the use of contraception, Jeanne Peterson, *Family, Love and Work*, p. 64. Michael Anderson argues that there is no substantial evidence to suggest this before the mid-nineteenth century, M. Anderson, 'The Social Implications of Demographic Change', p. 42. Carole Dyhouse shows that

1890s feminists promoted the restriction of the family through abstinence in marriage. C. Dyhouse, *Feminism and the Family in England 1880–1939* (Oxford: Basil Blackwell, 1989), p. 170. Most recently, based on a new reading of population data, Simon Szreter has argued for a culture of abstinence from 1870 onwards. *Fertility, Class and Gender in Britain*, passim.

184 Peel, *The New Home*, p. 170.

185 H. Hinds, 'Together and Apart: Twin Beds, Domestic Hygiene and Modern Marriage', *Journal of Design History* (forthcoming, 2010); Marie C. Stopes, *Marriage in My Time* (London: Rich and Cowan Ltd, 1935), p. 58.

186 Stopes, *Marriage in My Time*, pp. 56–57.

187 Marie Carmichael Stopes, *Married Love: A New Contribution to the Solution of Sex Difficulties* (London: A.C. Fifield, 1918), p. 68.

3 ✧ The nursery and the schoolroom: children and the domestic interior

ERYL LEE Booker, a gentleman's daughter who grew up in
London and Leicestershire in the second half of the nineteenth
century, described her childhood as punctuated by 'tiresome trips
downstairs' – visits to the drawing room from the nursery that upset her
'after tea plans'.[1] Like many middle-class homes, the Lee Booker house-
hold was organised according to the nursery system. The children (in
this case Beryl and her brother Charles) were sequestered in a nursery,
at the top of the house, under the care of a nanny. The arrangement of
the home shaped Booker's childhood experiences and the development
of her relationships with her parents. Crucially, her contact with them
was determined by access to their private territories. The fact that her
mother only rarely and grudgingly allowed her into the drawing room,
contributed to hostility between them, while Beryl's constant presence
in her father's dressing room enabled them to built a warm and loving
relationship, although one from which her siblings were excluded.

This chapter explores the nursery system that was in common
use among middle-class families in the second half of the nineteenth
century. The impact of the divide between the nursery and the rest of
the house on relationships between parents and children is considered,
alongside children's interaction with servants. The material culture of
the nursery, explored in the second part, could be designed to inculcate
discipline. However, children often had their own ideas about this and
did not always use nursery goods as adults intended. Finally, the chapter
considers children's changing relationship with the home as they grew
older and how this was increasingly marked by gendered differences.

From the middle of the nineteenth century, nurseries were common
in middle-class homes.[2] Assistance with childcare, enabling women to
accomplish tasks beyond ministering to the immediate physical needs of
newborn or very young children, had long been a privilege of the rich.[3]
But during the early part of the century there was an increasing moral

emphasis on the correct management of children in terms of their spatial position in the home. Hannah More's *Coeleb in Search of a Wife* (1809) contrasts two families, one in which overindulged children run amok during family meals, and another in which more disciplined children only appear at set times, ensuring that adult sociability is undisturbed.[4] During the nineteenth century, designers of country houses began to include accommodation for children.[5] Nurseries had been designed and represented before 1850,[6] but it was at this point that specialist goods such as nursery wallpapers began to be manufactured.[7] From the middle of the century the country house commonly had a suite of rooms for children, including a night and day nursery and a room for the nurse.[8] In the second half of the century, advice writers emphasised the need to distance children's rooms from those of their parents.[9] As the architect John J. Stevenson, in his *House Architecture* published in 1880, put it: 'The nursery department should be shut off from the rest of the house; for however interesting children may be, there are times when our appreciation of them is increased by their absence.'[10]

The autobiographies explored in this chapter suggest that the nursery was widely used from the 1850s.[11] Only those in the least well-off middle-class families do not mention a nanny or nursemaid.[12] Theresa McBride's study of the nineteenth-century census also suggests that the nanny-cum-housemaid was the typical single servant employed by middle-class households.[13] Although the employment of servants declined in the twentieth century, the continued use of residential female servants in some upper-middle-class families suggests that this system persisted into the early decades of the twentieth century.[14]

The nursery system was not necessarily synonymous with neglectful parents. Indeed, the second half of the nineteenth century has been associated with increasing warmth in parent–child relations, and a growth in the care lavished on offspring. Contentiously, Laurence Stone argues that during the Victorian period the total emotional life of all family members became focused within the boundaries of the nuclear family. The repression of the years 1800 to 1860 was followed by a second, more intense period of permissiveness.[15] More recently, historical studies founded in detailed explorations of the writings of Victorian parents have emphasised the variation within family relationships, moving away from the image of the stern paterfamilias and offering a more playful vision of fatherhood.[16] Most recently, Eileen Gillooly has argued that by the mid-century advice for parents placed much emphasis on loving care, with the parent taking on the role of 'constant gardener'.[17] The nursery, then, had the potential to be lovingly arranged and frequently visited. Nevertheless, as this chapter shows, the nursery's spatial position in relation to the rest of the house had a powerful effect on the formation

of parent–child relations, and created a distinctive experience of middle-class family life.

Space and family relationships: the impact of distance

The nursery system had an important impact on the formation of nineteenth-century family relations. By placing children within the nursery, the emphasis was shifted on to parents to decide when and how they visited. The first effect was that distance could make parents appear more glamorous. This may have been most pronounced in aristocratic and upper-middle-class homes. Winston Churchill wrote of his mother: 'She shone for me like the Evening Star. I loved her dearly – but at a distance.'[18] The suffragist Dora Montefiore describes her mother on her visits to the nursery at Kenley Manor in the 1850s, as glamorous guest rather than familiar comforter: 'we little ones pressed round her, showing our toys and picture books, with subconscious longings for the touch of her beautiful soft hand on hair or shoulder'.[19] These feelings were also reported lower down the social scale. Winifred Peck, a vicar's daughter from Leicestershire, remarks that the organisation of the nineteenth-century home 'invested a parent with the mystery and enchantment of a certain distance'.[20] Peck also comments, 'one great advantage that modern children have over us must already have emerged clearly. They see far more of their parents, and are far less in the care of uneducated nurses and nursery maids.'[21] However, the inverse of these idealised visions was lonely children who had little contact with their parents. Neglected children often expressed a great deal of anger in their later accounts.[22]

Many autobiographers wrote in the early to mid-twentieth century, and assessed their own childhoods against the experiences of contemporary children. H.J. Bruce writes that his upbringing was 'an average Victorian one . . . Our place was the nursery most of the time, the background always. We only made brief appearances "downstairs".'[23] Architect's son Charles Reilly also wrote of 'Victorian home life' as 'rather like that of life in the hotel at Brighton in which I am now spending my days. We knew one another, but not intimately. . . As in the hotel the management and servants were more important to us than the fellow-guests.'[24] Of course, the degree of separation created by typical Victorian family structures varied from family to family. A.C. Deane, the son of a barrister at Lincoln's Inn, recalled frequently playing in the drawing room, rather than being kept in the nursery.[25] Many mothers, and indeed fathers, were frequent nursery visitors. Celia Davies, who grew up in a small middle-class home on Woodford Green at the turn of the century, recalled that her mother and father both spent a lot of time in

the nursery, although she does contrast her experience to that of other Edwardian children.[26]

Mothers were under moral pressure to put the right amount of space between themselves and their children. Despite the distancing of the nursery, architects also emphasised the need to closely link it to the mother's bedroom.[27] The moral implications of mothers' management of domestic space were articulated in William Makepeace Thackeray's *Vanity Fair* (1847). The characters of the book's two heroines, Amelia Sedley and Becky Sharpe, are thrown into relief through their contrasting styles of child rearing. The virtuous, if boring and ineffectual, Amelia invests all her affection in her child after her husband's death, keeping him too close at home and spending much time with him in the same room.[28] This over-close contact results in the boy becoming spoilt and headstrong.[29] In contrast, Becky is an absent mother, concerned only with her position in society. Her son is consigned to a wet nurse in the French fashion.[30] On the family's return to England, the boy remains 'hidden upstairs in a garret somewhere'.[31] Becky visits the nursery only once or twice a week.[32] Thackeray suggests that such spatial distancing had the power to transform relationships: 'She was an unearthly being in his eyes, superior to his father – to all the world; to be worshipped and admired at a distance.'[33] The relationship ends badly, and after Becky's subsequent disgrace in later life, her child cuts contact with her.[34] Thus Thackeray presents a complex moral message: too great a distance between parent and child results in disaster, but a little distance is necessary to achieve the appropriate discipline.

For mothers, the drawing room played a crucial role in fashioning their relationships with their children. The previous two chapters have shown that the drawing room could be the home's most public room, and also at different times the location of marital intimacy between husband and wife. But from the child's perspective access to the drawing room was a mark of favour. Mothers controlled their relationships with their children by determining how and when they entered it. As Gordon and Nair point out, this did not preclude mothers from having loving, close involvements with their children.[35] Nevertheless, these spatial practices could have an important effect on family relationships. Dora Montefiore, who grew up at Kenley Manor in Surrey in the 1850s and 1860s, recalls spending the 'children's hour' from six to seven each evening in the drawing room.[36] This practice was not repeated everywhere, and children might visit the drawing room for as little as five minutes a week.[37] The organisation of domestic space in this way could allow parents to develop favouritism, singling out some children for greater intimacy by granting them more time in the drawing room. Beryl Lee Booker, for example, remembered of her sister: 'we were jealous

3.1 Photograph of Betsy Lee's Study

of her. She was pretty and petite, and Mummy had her down to the drawing-room far more often than she had us.'[38]

The library and study were often presented by advice writers as sacred adult male territories, the domain of fathers, not to be entered by children. Jennings presents the library as a silent and hallowed space.[39] Panton writes that: 'No child or very young person, and no servant, no matter whom, should ever be allowed to read the library books, which should never under any pretext whatever be removed from the library.'[40] Yet children were often present here. Male autobiographies more frequently discuss the formative influence of their father's library on their education.[41] Fathers' studies were often an important place of learning for informally educated daughters.[42] In the case of Virginia Woolf, Hermione Lee argues that the study was simultaneously a forbidden terrain and a place where she acquired her passion for reading.[43] Figure 3.1 shows a photograph from the end of our period depicting a young girl at work in an unusual female study belonging to her aunt, Betsy Lee, at Weston-Super-Mare. The library was frequently invaded by the wider family. Carola Oman, the daughter of an Oxford don, recalls being lectured to and taught accounts in the study.[44]

But it should be noted that the study as a place of refuge, and of succour is represented equally strongly in female autobiography. One writer recalls how her fractious sister was pacified by being taken into her father's den.[45] Another remembers how she would take refuge with her father in his study from her mother's antagonism.[46] Libraries in

country houses could function as social, family spaces, rather than male retreats.[47] Autobiographies suggest that this was also the case in libraries and studies in smaller, middle-class homes. Clare Leighton, growing up in the 1900s, describes the study in 'Vallombrosa', the family home in St John's Wood, as the territory of both her father and mother who were writers.[48] Horace Collins, the son of a Maida Vale-based architect, also writes of how during the 1890s, the family library, supposedly his father's sanctum, was frequently invaded by the entire family in the evenings, forcing the father to retreat with his book to his bedroom.[49]

Access to the father's most private rooms, in particular, the dressing room, could also signify a special relationship between the father and child. Children, both male and female, were often allowed into the father's dressing room early in the morning.[50] Again, access to this private, personal space was offered only to some children, building special relationships with favourite children. Beryl Lee Booker recalls how as her father's favourite she was allowed privileged access to his dressing room in the mornings: she describes its messiness with affection.[51] Brian Lunn, the child of the famous businessman and nonconformist Sir Henry Lunn, was brought up at Harrow Hill in the 1890s, and recalls how, just before he was sent to school at the age of nine, his parents primed him for this important experience in their personal spaces: 'mother told me in the drawing-room how I had come into the world, an interview which left me with a slight sense of having been reprimanded. Father told me in his dressing-room, where I often used to talk to him while he shaved, not to allow any master to play with my person.'[52]

Children's experiences of their parents' personal spaces could play a crucial role in the formation of early gendered identity. In nineteenth-century popular culture, the smoking room figured as a restful utopia for male relaxation.[53] Male memoirs frequently recall a fascination with smoking paraphernalia. Lindsay W. Brown recalled playing with the ends of cigars in the family billiard room.[54] Smoking in the home in this period was accompanied by a distinctive and often exotic material culture that was simultaneously distancing and fascinating. Hubert Nicholson was entranced by the smoking room in his godfather's house: 'The smoking-room was like an excavated Egyptian tomb, with odds and ends of science and art from far countries.'[55] Thomas Beecham remembered his father smoking in a 'remote den' on the top floor of his home:

> There he would put on a cap of Turkish design crowned with a long flowing tassel, and a richly coloured jacket decorated with gold-braided stripes and silver buttons. On the rare occasions when I was admitted to this holy of holies I would gaze upon this gorgeous spectacle with rapture while my sire puffed away in placid and silent content, absorbed in reflections which I felt were of world-shaking import.[56]

The distinctive material culture that was associated with smoking in the home enabled men to escape domestic cares, but it also brought in the exotic, colonial world from outside and used it to mark out a distinctive territory which men could devote to their own ends.

Girls were also fascinated by masculine and feminine spaces in the home, and the interaction with their mothers' personal spaces often fed into early ideas of the relationship between beauty and self-construction. Sonia Keppel found the spaces belonging to her father and mother equally alluring: 'Sensually, I loved the smell of Mamma's room, with its flower smells, and a certain elusive smell, like fresh green sap, that came from herself. And the smell of Papa's room (hair oil and tobacco), next door. And I loved their thrilling intimacy, generously extended to me.'[57] For girls, the glamour of the female space held the additional promise of gendered knowledge. Beauty paraphernalia could be a particular draw for young girls. Keppel notes that 'each morning I visited Mama's room, where, enchantedly, I played with all the lovely things she had worn the night before'.[58] Keppel's family, who, if not extremely wealthy, were of aristocratic origin, may represent upper-class social practice. But similar accounts emerge from lower down the social scale. Clare Leighton was fascinated by her mother's dressing table, and made regular trips to her mother's bedroom to steal her face cream. 'My fingers strayed upon my mother's hair-curlers, and suddenly I wondered whether part of her power over her admirers lay in the beauty of her yellow curls.'[59]

But parents' rooms did not always inspire veneration: children's reactions to these rooms were complex, and bound up in the nuances of individual relationships. Beryl Lee Booker's mother's bedroom was the epitome of feminine décor. 'Mummy's bedroom had walls panelled with a paper covered with bunches of violets or lilac . . . It had an off-white pile carpet, and chair covers, and an old dark walnut Norman armoire. The dressing-tables then were of course kidney shaped and draped, with three-fold gilt mirrors.'[60] While the room had a certain allure for Booker, her description of it is ultimately ambivalent. Rejected by a distant mother, Booker's representation of the exquisite femininity of the space is also cold, and suggests an interest in the worldly and material that precludes maternal feeling:

> Mother rustled and glittered round her beautiful bedroom. Often she would be ill, and then perhaps we could be allowed to creep down at teatime to see her lying in beautiful embroidered sheets, threaded with broad white satin ribbons, at the back of her head several down pillows with fine transparent lawn covers, monograms and initials everywhere . . . But we mustn't touch her, or jog the bed, or fidget.[61]

Booker's response to such feminine material culture clearly shaped her own identity. Much of her description of herself suggests a rebellion against the feminine excesses of her mother. Throughout the text she describes herself as a tomboy, and when she was allowed a bedroom of her own she clearly used it to express a more ambiguous gendered identity. 'I laid out my treasures, the collection of rubbish from Egypt; and on a table by themselves my dumbbells, embrocation and a book from Mr Sandow telling how to get muscles like his!'[62]

The layout of the home also played a crucial role in structuring the relationship between children and servants. The arrangement of the middle-class house often meant that children had different points of spatial contact with the servants from that of their parents, and forged separate and distinctive relationships with them. A house with an unusual layout might push children and servants together. Reilly, born in 1874, commented on the social consequences of the unusual layout of his home: 'It meant, too, that we were cut off from our parents and from the only lavatory by a couple of servants' rooms . . . it meant in our early days were at the mercy of the servants.'[63] Leighton recalled how the children knew far more about the servants' clandestine assignations than their parents, because the back gate was clearly visible from the nursery window.[64] Hugolin Olive Haweis, the daughter of the advice writer Mary Eliza Haweis, describes how the servants took pity on the children, who were fed a spartan diet by their parents, and gave them jam on the sly,[65] and when the parents were away for the evening the children went down to the kitchen where they joined in the servants' laughter as one of the footmen dressed in drag.[66]

Similarly, Agnes Maud Douton in *A Book of Seven Seals* (1928) describes the life of two sisters who grew up in a Chelsea vicarage, in which the children dressed in the clothes of the grandmother and aunt, and paraded before the servants in the kitchen, imitating their relatives for the servants' amusement.[67] Such illicit interactions were not always benign. H.J. Bruce recalled how, unknown to his parents, the servants dressed up as ghosts and invade the nursery, terrifying the six-year-olds.[68]

From a child's perspective, the nurse or nanny was the most important servant, an ever-present force in the lives of her charges.[69] Usually sleeping in the nursery with the children, nannies and children shared the same space constantly. Jonathan Gathorne Hardy's popular account of the British nanny presents the nanny as an upper-class ideal, a matronly figure who has been with the family her entire life and is retained in old age.[70] Theresa McBride's census survey sets up a different picture that is more accurate for the middle classes in this period. She suggests that in the middle-class home it was common for the nursemaid to be the only servant of the house, that they were often young and untrained, and that

there was a high turnover.[71] Children would have spent some time with parents, and nannies would have had occasional time off, but the bulk of their existence was spent in the same physical space. Nannies were generally responsible for the physical care of their children. Although mothers occasionally performed some tasks, nannies performed the lion's share of the work. The practice of having a specialised nanny was distinctively British.[72] Such constant contact often meant that a strong bond of love was formed between nanny and child. Autobiographical descriptions of these carers are frequently glowing.[73] Mary Cholmondeley, the daughter of a vicar from Hodnet in Shropshire, describes her nanny as 'the source of all comfort'.[74] Hugolin Haweis openly stated that she loved her nanny, Ann, more than her mother and was devastated when her mother dismissed Ann.[75] The extent of the attachment of children to their nannies is sometimes shown by the introduction of the nanny into the autobiographical narrative before either of the parents.[76]

While nannies are accused of being too strict, their constant power over children beyond parental eyes could be a licence for abuse. Booker writes, 'We lived upstairs in a different world, and were at the mercy of our nurses.'[77] She goes on to describe the nanny's physical abuse of the children. Eventually, the nanny was dismissed, but the parents only discovered her behaviour because she made the mistake of hitting one of the children with an umbrella in the street, thus revealing herself to the local vicar who contacted the children's father.[78] Doubtless, the abuse would have continued in private, had the abuser not revealed herself in public space. Mary Carberry, the daughter of an ex-army officer who was brought up in a Hertfordshire country home in the late 1860s and 1870s, felt unable to report her governesses' violence to her parents.[79]

The closeness of nanny and charge could transcend the class division that the spatial segregation of the middle-class home set up. Cholmondeley, rather than identifying with her nanny's working-class origins, promotes her nanny to middle-class status by imbuing her with key moral qualities that were seen to betoken ladylike behaviour: 'Ninny was in the best sense a lady, well-bred, incapable of a coarse word or a mean and self-seeking action, respectful in manner and self-respecting, refined and dignified.'[80] The nanny's presence and importance in the nursery is emphasised in autobiographical narratives by the description of nanny's possessions. Agnes Maud Douton describes how her nanny's clothing was placed in a special area of the nursery, as was a food store that only the nanny had access to.[81] Cholmondeley's description of her nanny's possessions reinforces her definition of her nanny as 'refined', as she had books and 'possessed interesting china, and knew its value'.[82] This representation contrasts with Booker's depiction of her nanny's china collection. This comprised fifty pieces, but the author did not

consider it fine, and commented on the constant war that the nanny was forced to engage in to defend it from the family cat's forays onto the mantelpiece.[83] Here the size of the collection and the ridiculous battle with the family pet, an animal introduced into the nursery space presumably by authorities above the nurse, suggest a lack of taste and underline the nanny's secondary status within the family hierarchy.

The material world of the nursery: discipline and resistance

Nursery design became a subject of increasing concern in the late nineteenth and early twentieth centuries. Home-made improvements on items for the newborn may have a longer heritage. *Cassell's Household Guide*, for example, which was published in 1869, included elaborate instructions for the creation of a baby's 'burceaunette' – a decoratively draped cradle.[84] From the 1870s onwards, decorative advice manuals were concerned with the location and furnishing of the nursery. Advice literature criticised the material culture of existing nurseries, especially in town houses.[85]

The architect Robert Edis was particularly sensitive to the power of material objects to inculcate an appreciation for beauty at an early age:

> To surround our little ones with decoration and every-day objects, in which there shall be grace and beauty of design and colour, instead of the common-place and vulgar tawdriness which in so many houses is thought good enough for the nurseries, will imbue them with a love and appreciative feeling for things of beauty and harmony of form and colour.[86]

The catalogues of the furniture company Heal's show a steady increase in the range of nursery goods throughout the second half of the nineteenth century.[87] The later nineteenth century saw the development of some quite elaborate furniture for children by fashionable companies of the era including Morris and Co. Figure 3.2 shows a design for a decorative frieze for a nursery from Jennings' *Our Homes and How to Beautify Them* (1902). Even before this range of goods appeared on the market, parents invested in the nursery both materially and emotionally. The nurseries of the 1850s and 1860s were by no means neglected. Edward Parry, for example, who grew up near Baker Street in the 1860s, remembers his nursery as 'spacious and carpeted'.[88] Mary Carberry also described her 1850s nurseries as carefully fitted out.[89] In the later part of the period, children benefited from the growth of material goods specifically designed for them. Carola Oman, who spent her childhood in Oxford in the 1890s, recalls having Kate Greenaway wallpaper,[90] the designs for which were sold in 1893.[91]

AND HOW TO BEAUTIFY THEM.

to unlearn the prejudice in favour of vulgarity which this early tutelage has fostered. I contend that the nursery should be, if not a training in art, at least an object lesson in simplicity, refinement, and harmony of colour. It is possible to buy wall-papers which, while directly appealing to the interest of children by the pictorial narration of some nursery tale, shall at the same time surround them with an artistic influence from the benefits of which they cannot possibly escape. I saw, not long since, a nursery, very simply but very appropriately decorated. The dado was of match-boarding, painted an exceedingly pale terra cotta. Above this, the walls were distempered in a rich ivory white up to the frieze moulding. As for the frieze it was very deep, and consisted of scenes from "Alice in Wonderland,"

FIG. 98. DESIGN FOR A NURSERY FRIEZE.

beautifully copied from Sir John Tenniel's illustrations. The material was a plain pale buff canvas filling, the design being painted in colours. The bareness of the wall was relieved with quaint cupboards supported on corbels, and brackets holding amusing figures in wood of Swiss workmanship. On the floor was a warm-toned cork carpet. All the furniture was of plain, simple, polished wood, without carving but finely shaped after old models, and upholstered in terra cotta leather. Here was a room severe enough in all conscience; yet it was beloved by the children; they were familiar with every character on the frieze; they knew every figure on the brackets; and they had a joyous sense of the beauty and the quiet graciousness of their surroundings. It would be almost impossible for such children to grow up without an intuitive appreciation of tasteful effects.

241 Q

3.2 Nursery Frieze

Even before this, the material culture of the nursery was often richly figurative, as parents drew on the increasing range of printed images available to decorate them. Angela Schofield argues that children could contribute to the creation of scrap screens by selecting and sticking on pictures.[92] The practice of decorating the nursery with many cheaply

produced but stimulating pictures in this fashion was common,[93] and actually recommended by domestic advice manuals.[94] Autobiographical accounts suggest that children engaged with and actively enjoyed their brightly coloured walls. Frank Kendon describes the decoration of his nursery:

> From wainscot to ceiling the walls of our nursery were papered with pictures. Most of these were those large lithographs in many colours that used to be given away with Pears' Annual. They were stuck to the wall itself and varnished there, so that they were as much a part of the room as the walls and floor and the window, and more permanent than the chairs and the table, the toys and other movables. All our pictures were peaceful and genial, domestic or quietly humorous scenes.[95]

Material goods and arrangement of the nursery were employed in the inculcation of discipline. Linda Pollock argues that during the first half of the nineteenth century, British and American parents came to demand greater obedience from their children, but that this declined in the later period.[96] Davidoff and Hall also posit that the rise of evangelicalism in the 1830s and 1840s brought with it an increased emphasis on discipline.[97] While the disciplinary impulses of the first half of the century abated from the 1850s, the material culture of the nursery continued to be used to teach children lessons about neatness and order. Moral order was connected to a visible neat arrangement of objects. Up to the age of about five, boys and girls were similarly dressed, and furniture does not seem to have been used in a way that made overt distinctions either. But girls were expected to behave in a different way from boys.

Figure 3.3 shows a rare photograph of a nursery from the home of the Garsten family in London. The room is tidy and the children have been carefully posed by the photographer to represent good, industrious behaviour. This is clearly gendered: the eldest girl is shown sewing, her brother reading a book. Girls, as potential homemakers, were under particular pressure to keep their goods in order. The virtues of tidiness were constantly emphasised in didactic literature for girls, such as *The Girl's Own Paper*, which represented tidiness as a practical skill, which would help girls make homes and tend the sick.[98] 'Are you the little housekeeper? Then study early rising for your dear one's sake . . . Have the room tidy and cheerful, a cloth laid, and a bright fire in the grate.'[99]

However, the majority of autobiographies were more critical of the austere food regimes practised in some nurseries, than of enforced tidiness.[100] The troubled Hugolin Haweis records how, as punishment for leaving in a sandwich in her drawer, she returned home from school to

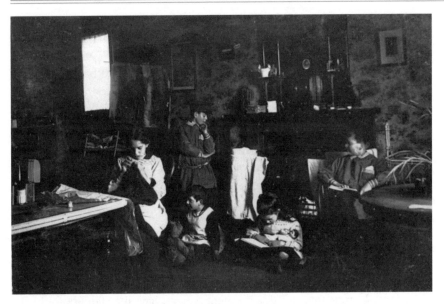

3.3 The nursery of the home of the Garsten family in London

find every drawer in her room turned upside down and in the middle of the floor, she was also made to stay in her room for three days with only bread and water to eat.[101] However, the author of this text had a particularly bad relationship with her mother, and the extremity of the punishment seems unusual.

The decoration of the nursery could be literally didactic. Into the late nineteenth century, the evangelical moral message also continued to be transmitted through physically inscribed domestic objects. While not always explicitly religious, these messages clearly dictated correct behaviour. John Harvey has noted the predominance of goods inscribed with the 'Word of God' in Welsh nonconformist homes,[102] but such objects seem to have been equally common in Anglican nurseries. By the 1850s, cups, bowls and plates decorated with themes for children had appeared on the market: such goods would often bear moral mottoes such as 'never speak to deceive nor listen to betray'.[103] Agnes Maud Douton describes how, as a small girl in the 1850s, she was filled with terror on the receipt of a sampler featuring a didactic motto 'Thou God Seest Me.'[104]

Messages that were slightly less unsettling, but still stern, continued to appear later in the century. A nursery design shown in *The House* magazine from the 1890s features the legend 'First deserve, then desire.'[105] Visible didacticism was not always a source of terror. Robert Graves and his sister rather priggishly entered into the spirit of things by voluntarily decorating their nursery with instructive notices. Graves wrote:

We learned to be strong moralists and spent a great deal of our time on self-examination and good resolutions. My sister Rosaleen put up a printed notice in her corner of the nursery – it might just as well have been put up by me: 'I must not say bang bust or pig bucket, for it is rude.'[106]

It was also hoped that the appropriate images would exert an improving influence on children. Panton wrote that: 'a good picture is full of teaching to a thoughtful child . . . But all should be carefully selected, either for the lesson they teach or the pleasant story they tell.'[107] Yet such images may not have been received in the way they were intended. Kendon remarks that he completely missed the moral purpose of one picture that was displayed in the nursery:

> There was, for example, a picture of a butcher's boy . . . who had sat himself down on the stone steps of a great house to read a paper called Tit Bits. He had left his basket of chops and steaks meanwhile on the bottom step, and here was a dog stealing them while he read. We saw the fun of this, though I must confess that, till this moment, I never saw the significance of the name of the paper; but we did not see the boy as a boy, nor follow out the consequences of his neglect.[108]

Whatever the intent behind nursery design, it is certain that children engaged deeply with the earliest physical environments they were exposed too. Martin notes that religious imagery had an important impact on children who could not yet read.[109] Kenneth Hare, a lawyer's son born in 1888, recalls his nursery in the family home in Twickenham: 'The bars of my cot present themselves to me as semi-animate objects. The brass knobs which surmount them have gnome-like personalities.'[110]

Nurseries were spaces in which children were forced to operate within previously set physical limits. They would often have been crowded, particularly before family sizes began to fall in the last decades of the century. This sense of physical restriction emerges in the military metaphors that many autobiographers employed to describe their nursery existence. William Aubrey Darlington, son of an academic and later a journalist, writes of the 'permanent strength' of his East Dulwich nursery and refers to the giving of 'rations'.[111] Keppel describes her nursery thus: 'My day-nursery was a white-painted fortress, my nurse the garrison-commander; my sister's French governess a spirited captain of the guard . . . At first, the fortress floor controlled all my movements, and any expedition outside it was tacitly on parole.'[112] The physical restriction to the nursery prompted both Keppel and Carberry to try and escape.[113] Both girls, when very young, attempted to leave the home (although both were eventually retrieved from their journeys and returned) evincing a desire to move beyond it. But the restriction of the

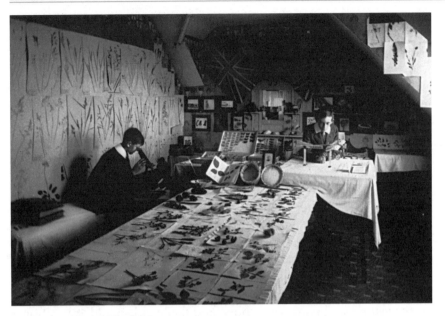

3.4 The 'Museum' at Frondeg

nursery could also be interpreted as security. One writer described her nursery as filled with 'nest-like warmth'.[114]

But if children were initially restricted in their movements about the home, as they grew older they became adept at colonising outlying spaces through play, escaping adult censure and the imposition of discipline. The interior as experienced in childhood looked and felt very different from the interior experienced by an adult.[115] An ordinary interior could be transformed into a new world by play. Such play frequently took the form of travel into the wider world, colonising unused spaces in the home and showing that Victorian children of both sexes were well aware of the possibilities offered by empire. Carberry travelled to sea in her mother's bed,[116] and Brian Lunn recalls riding the train from the back of the nursery horsehair sofa.[117]

Far flung spaces beyond adult eyes, such as attics and outhouses, were particularly popular. Ernst Rhys, the son of a wine merchant who lived in Newcastle in the late 1860s, and Darlington, recalled playing at deserts in the attic.[118] The image in figure 3.4 shows two boys at work in an attic that has been converted into a museum at 'Frondeg', Weston-super-Mare, in 1909. This photograph was almost certainly produced with adult connivance, but other children seen to have made greater use of the possibilities that the attic offered for transgression. Perhaps the most impressive transformation was effected by Booker and her brother Chas who, taking over an attic, attempted to set up a 'gambling hell', which they had learned

about from penny dreadfuls: 'Here, swearing horribly as we thought, we played nap, old maid and other games of skill or chance while we consumed home-made elderberry wine of disgusting inkiness . . . We tried also, but failed, to acquire the tobacco chewing habit.'[119]

Did boys and girls transform their interiors differently? Certainly boys noted playing in a rough and boisterous fashion. The poet C. Wrey Gardiner recalls how he played quietly at his aunt's until another boy was brought round for his entertainment. Together, they engaged in destructive play, terrorising servants and shooting birds.[120] Of course, girls could also appropriate rough play; in fact, this seems to have been common. Montefiore, Carberry, Booker, Amy Barlow and Caroline Louisa Timmings, the daughter of Birmingham jeweller, all defined themselves as tomboys in their narratives, citing their engagement in the rough outdoor play adopted by boys as evidence of this identity.[121] But girls' imaginings might be shaped by the areas they had access to. As children grew older, access to the wider world could be gendered. Mary Hughes, the daughter of a London stockbroker, recalls that her father believed that 'boys should go everywhere and know everything, and that a girl should stay at home and know nothing'.[122] This forced Hughes to engage with her domestic interior in a different, more intense fashion than her brothers. When the family were holiday, the boys were allowed to go off but Mary had to stay at home with her mother. This quotation shows how she compensated for her loss: 'I was completely happy with a wooden stool on four legs, padded with red velvet . . . I had such glory with it that it compensated for my being left at home . . . oftenest of all it was Bucephalus, on which I careered about the room, conquering country after country.' [123]

Toys were also used to encourage gendered ideals, but were open to appropriation through play. Davidoff and Hall argue that in the early part of the nineteenth century, 'while boys were given hoops, balls and other toys associated with physical activities, girls played with dolls, dolls' houses, needle books and miniature workbaskets'.[124] Calvert's study of nineteenth-century America draws a similar conclusion.[125] Nineteenth-century English prescriptive literature confirms that dolls were thought to awaken the desire for motherhood in young girls.[126] Figure 3.5 shows a photograph of two girls posed with dolls, which clearly represent contemporary hierarchies of class and race: one doll is opulently dressed while the other two are dressed as servants, and one of the 'servant' dolls is black. Not every girl longed for a doll: Booker, predictably, 'loathed' them.[127] But many girls built emotional worlds around them. *A Book of Seven Seals* recalls Mary Ann's joy on being given a doll.[128] Women's education pioneer Louisa Lumsden recalls believing that her doll was actually alive, and wailing when it was broken.[129] Parents could also intervene. Mary Paley Marshall relates how her

"Clare" & "Cara"

3.5 Photograph from Shaw Storey family of Bursledon, family album

religious father burned their dolls, believing that the children had begun to treat them as idols.[130] Dolls could also be confiscated as punishment.[131] Doll play allowed the creation of a secret world ordered by the girls in which they could play out their fantasies. To a certain extent such play did imitate life, but girls did not necessarily choose the conventional female roles that dolls were thought to encourage. A fascinating example of this is Carberry's detailed account of her doll play with her sister. The girls played at being mothers, but they chose to adopt the role of widows, giving them the power to punish and discipline their children in an accepted role, yet avoiding subjection to male authority.[132]

The allocation of different toys to girls and boys reinforced gendered distinctions between siblings, but these distinctions were not always accepted by the children themselves. Brothers could intervene in doll play and manipulate their sisters' belief in their dolls. Mary Carberry remembers how two boys who were staying with the family buried her doll and her 'frantic' response when she heard that it was buried.[133] But while male autobiographies did not admit to playing with dolls, there were few male toys or practices of play that girls did not engage in. The toy trade shared in the vast expansion of the nineteenth-century retail trade,[134] and the years after 1850 saw the arrival of a range of new mechanical toys, such as toy engines.[135] Such mechanical items might

have been expected to appeal more to boys, but the autobiographical evidence does not bear this out. Clearly, such toys were much desired.

Herbert E. Palmer, who was born in 1880 and the son of a Wesleyan Methodist minister, recalls being driven into a 'furious passion of want' by the sight of a mechanical tin engine, but in this case the toy belonged to a little girl.[136] Booker writes that 'locomotives fascinated me, and I would dream of a complete railway system.'[137] Toy soldiers had a similar cross-gender appeal. The author of *Four to Fourteen* recalls playing soldiers against her brother; he had more soldiers than she did, but she was able to win by marshalling troops into formation.[138] Booker also remembers especially coveting the Gordon Highlanders.[139] Even the nineteenth-century practice of collecting, usually associated with masculinity, was ambiguous in early childhood.[140] Often, collections were a keen source of competition between siblings. Oman remembers how she was encouraged to collect crests in competition with her sister who collected stamps.[141]

Growing up: the school room, promotion and spaces for young women

The nursery was a transient space, and once the youngest child in the family was over the age of about five, it was no longer needed.[142] For mothers, the dissolution of the nursery could be a poignant moment. In *Nooks and Corners* (1889) Jane Ellen Panton wrote: 'I know nothing sadder than an empty nursery.'[143] She suggested that the nursery should be preserved and used for visiting children or as a sanatorium, and that some toys and decoration should be kept (see figure 3.6). However, few families had the space to create a shrine to their children. More often, the nursery was renamed the schoolroom, and again pressed into the service of the family. As such, it would be used for educational activities and some play, especially for girls and those boys who were not sent away to school. The title 'schoolroom' gave a purposeful air, and was favoured by nursery governesses. Lunn recalls: 'On the first floor was the nursery, soon promoted by Frau Vischer to "schoolroom", although father teased her by continuing to call it the nursery.'[144]

Schoolrooms are mentioned less frequently in autobiographies than nurseries, perhaps because, as nurseries were the first spaces children inhabited, they left a stronger imprint on the memory. Isolated under the care of the governess in the schoolroom, children were sometimes vulnerable to abuse. Mary Carberry remembered that her governess was both violent and abusive in the schoolroom.[145] On the other hand, the schoolroom's separation from the rest of the house could also be welcome. Lunn recalls: 'The schoolroom was a separate entity in the

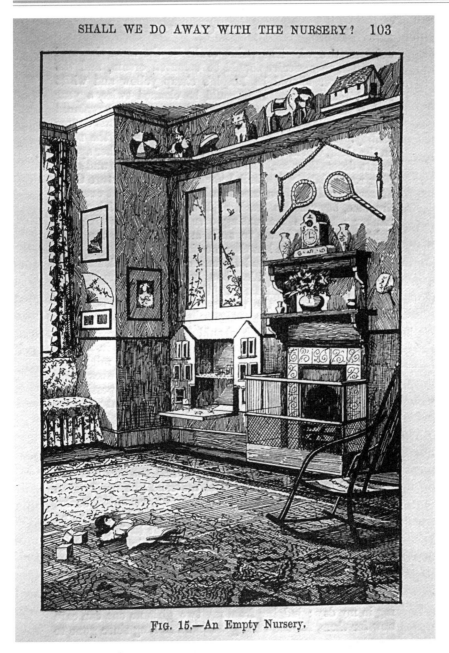

SHALL WE DO AWAY WITH THE NURSERY? 103

Fɪɢ. 15.—An Empty Nursery.

3.6 'An Empty Nursery'

house, and on Monday mornings when the washing was sorted and listed before being sent off to the laundry, I felt a sense of security from domestic turmoil incidental to this task.'[146] The schoolroom was not only perceived as a space for learning. This additional space, separated

from the rest of the house, was often highly valued by children. Mary Hughes and her brothers had possession of a schoolroom, optimistically known as 'the study' by their parents.[147] Little schoolwork took place here, however, with Hughes remembering that 'the word study is always associated in my mind with sheer fun'.[148] The children took a pride in not allowing anything that took place within its walls to come to adult ears.[149] For the Streatfeild children, the family's move to a new house in Eastbourne without a schoolroom was a considerable blow as it left the children with only their bedrooms, and no shared space for play: 'There was nowhere to lay out a game and leave it for another day. No room in which to be noisy, and on occasion, to fight.'[150]

As middle-class children grew up, their passage to maturity was marked by the practice of 'promotion', the granting of greater spatial and material autonomies. During the nineteenth century, the declining fertility rate led to a decrease in the size of middle-class families, and a reduction in the typical number of siblings.[151] This may have contributed to a greater flexibility in the use of space, although many homes continued to be crowded.[152] It was usual for boys and girls to be given their own room (which might be shared with a sibling of the same sex) between the ages of five and seven.[153] Streatfeild recalls that her parents attempted (unsuccessfully) to use this as a disciplinary strategy: 'Telling Victoria she must start to grow up, and giving her the little honour of a room shared with Isobel had been on of the many little schemes tried to make her a better behaved child.'[154]

Promotion to a room shared with a single sibling had an important impact on sibling relationships. Brian Lunn recalled, in his autobiography, his delight at being given his own room, away from the nursery, for the first time: 'When I was about seven I was put to sleep with my brother Hugh, while next to us Arnold [the eldest brother] slept in a smaller room alone. I felt this was promotion.'[155] Rather than remarking on the individual privacy these new arrangements afforded him, Lunn described the transition primarily in terms of its impact on his relationship with his brothers.[156] Frank Kendon recalls how being put together in a room with his brother caused the boys to bond through shared activities: 'When my younger brother and I, aged about five and seven, were promoted to a room of our own, one of our amusements was to work together in a tale.'[157]

As boys and girls grew older, gendered differences in their relationship with home became more pronounced. Girls were expected to engage in the work of the home to a far greater extent than their brothers. For example, Mrs Loftie recommended that 'every young lady should take charge of a corner of the dining room and keep it as bright as a bit of Dutch picture'.[158] Panton argued that lamp-tending and the

other finer points of housekeeping such as flower arranging should be done by the daughters of the house.[159] Boys were not necessarily remote from domestic work, and indeed could choose to participate in it. Oliver Lodge remembers that, aside from keeping the accounts for the family business, his mother was also an excellent cook: 'What I chiefly remember is being allowed to help her at cooking.'[160] Lodge found pleasure in domestic work. For daughters, it was more often a duty. Clare Leighton, the daughter of writers who grew up in St John's Wood in the 1890s, remembered with annoyance that from an early age she was allocated the daily task of watering the aspidistra.[161] Amy Barlow celebrated her mother's domesticity, and remembered that 'my mother used to do all the cooking and seemed to know all the recipes by heart as she never measured or weighed anything or used a cookery book'.[162] But Barlow herself had an ambivalent relationship with household work, on one occasion throwing her sewing from a window.[163] On some occasions this work could be physically overwhelming, as William J. Dawson's poignant account of the death of his half-sister Georgiana from consumption demonstrates. As a member of a hard-pressed nonconformist family, Georgiana was literally worked to death: 'From morn to night she was incessantly employed in the tedious duties of the household: cooking, baking, sweeping rooms, mending clothes.'[164]

Boys, who might be sent away from home to boarding school as young as seven or eight, often had a very different relationship with home after this point. Habits acquired by boys at school could rub off on their sisters. Booker describes how, when her brother arrived home from school with butterfly collecting paraphernalia, she took up photography in response.[165] Being sent away to school altered play, and many boys, revelling in a new sense of masculinity, rejected the toys and games that they had previously played with their sisters.[166] In some cases, however, boarding school boys set increasing store by familiar nursery objects, as they came to be the touchstones of home life. Noel Streatfeild poignantly evokes her brother Dick's changed relationship with their nursery toys, when he returned home for the holidays, having been sent away to preparatory school aged eight. Dick was appalled to find that the family dolls' house had been given away: 'Louise knew that Dick, when he was homesick at school, pictured his home, seeing everything in the exact place it had always lived. The dolls' house had been allowed to go with scarcely a sigh from the three girls, but Dick cared that it was gone.'[167]

The slightly awkward position of boarding school boys, and their displacement from home, was addressed by advice writers who often recommended that special efforts should be made to accommodate them, allowing for masculine behaviours forbidden elsewhere in the house.[168] Kerr comments that 'the young gentlemen of the house may find

themselves very much at a loss sometimes for an informal place in which to "do as they like"'.[169] He suggests that young men should be provided with space for the use of carpentry tools, or botanical collections, and even that 'the fireside may be dedicated to the cigar, very properly forbidden elsewhere'.[170] These recommendations acknowledge that, by being sent away to school, boys are in some way transformed and cannot be expected to continue to completely conform to the feminised rules and regulations of the home. Not all boys went to school, however:[171] boys with health problems might be considered too delicate; and some families would have not had the financial resources. Richard Church remarks that the close atmosphere of family intimacy in his lower-middle-class childhood home was very different to that of homes staffed with servants where the boys were sent away to school.[172]

As middle-class girls were sent away to school less frequently than boys, and did not tend to move away to enter paid employment, they remained at home for longer. Panton felt that these older girls at home should be adequately provided for and, most importantly, that they should not feel pushed into unsatisfactory marriages by material privations at home. She argued that:

> If the girls have their own sitting-room, they feel their residence under the paternal roof is meant to last as long as the roof itself, and they have not that hurried, disagreeable feeling some unfortunate girls must be given by the parents who make no provision for their permanent comfort, and openly speak of what we shall do when So-and-so gets married.[173]

To this end, she recommended that parents should create 'bedroom boudoirs' for young girls.[174] In *Nooks and Corners* (1889), Panton suggests that when the elder daughter is 'out' and requires a room for herself, 'a capital arrangement could be made for her by copying the French boudoir bedroom'.[175] Figure 3.7 shows Panton's recommended boudoir-bedroom: an optimistically large apartment that includes both a writing desk and a number of chairs for social occasions in addition to a bed. In 1910, Mrs Talbot Cooke also recommended the boudoir bedroom in *Hearth and Home* magazine.[176] Talbot Cooke describes how the room may be carefully arranged and draped, to conceal its washing and sleeping functions during the day: 'making only three-fourths of the room visible by day, i.e. the sitting room end, and yet by drawing back the curtain at 6 p.m., the bedroom end, where should abide the wash stand, the bed, etc., etc., would be thrown into the room again'.[177]

Bed-sitting rooms were used for the girls in the Woolf household: 'When Stella married, Vanesssa and I were promoted to separate bed

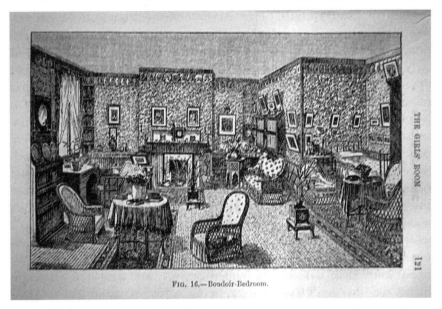

FIG. 16.—Boudoir-Bedroom.

3.7 A 'Boudoir-Bedroom'

sitting rooms; that marked the fact that we had become, she at eighteen, I at fifteen, young ladies.'[178] For Virginia Woolf, her bed-sitting room was a conflicted space, the living half of the room and the sleeping half 'fought each other'.[179] It was here that she spent most of her time in her family home at 22 Hyde Park Gate, London, during her troubled teenage years after her mother's death. Looking back, she associated the room with an intense range of emotions: 'How often I was in a rage in that room; and in despair; and in ecstasy.'[180]

The boudoir-like atmosphere of the bedroom could be enhanced by a dressing table. Muslin-draped deal dressing tables, like that belonging to the new Mrs Gibson in *Wives and Daughters* (1866), were heavily criticised by advice writers on grounds of taste, authenticity and safety.[181] For Eastlake, they represented 'a milliner's notion of the pretty and nothing more'.[182] Jennings has an almost religious hatred for the things, writing that 'the cheap deal dressing-table, decked out in the garb of white muslin with bows of coloured ribbon, is a fraud. There is no other term for it, unless you prefer "whited sepulchre"'.[183] Even Panton, who usually took the female side, did not have a good word to say for them: 'truly abominable dressing-tables, the deal frame covered with muslin and lace and glazed calico, like the frock of a ballet-dancer, or else with some serge material that resembles nothing so much as a church altar'.[184]

Nevertheless, it seems likely that the cheap, home-draped dressing table remained popular with young women until the end of the

century. In 1880, *The Girl's Own Paper* continued to cheerfully encourage their construction, allowing young women to add a touch of homespun glamour to their bedchambers.[185] A feature explaining how girls could decorate their bedrooms cheaply included a section on the dressing table. The dressing table to be created, with its draperies and fake gold pincushion, is essentially fake, yet is presented in the story as an object of fun and fantasy rather than deceit: 'I am going to propose an old strawberry basket as an ornament and pincushion combined, you see, expense being an object. But it shall look like gold, if that will be of any comfort to you.'[186] The dressing table allowed girls to play at being grown up. As Nora, the heroine of the story declares: 'It has been my ambition for years to possess such a thing, but I never thought I should until I was married and had a house of my own; I'm sure if I were engaged it would be the first thing I would settle.'[187] The dressing room may have been particularly attractive (and controversial), because it was so definitely a female space. It was here that a woman might keep her jewellery, or paraphernalia (some of the few valuable items that women legally owned before the Married Women's Property Acts).[188] As we have seen, young girls were fascinated by their mothers' dressing tables, identifying them as the site for the creation of female beauty and sexual power.

Young women continuing to live at home often had a strong investment in personal domestic space, and this could be a means of developing their own identity against that of their family. In these circumstances, the individual and the exotic had a strong appeal, as girls sought to mark out their own territory. Lee Booker recalls how, in her teens in the 1900s, she greatly admired the gothic distinctiveness of the bedroom of her friend, Evelyn Court: 'She had a bluey greeny bedroom, photogravures of the purer of Mr Watts' pictures, a skull procured from an Irish graveyard which was falling into the sea, and a cast of a smiling girl's face who was found in the Seine, reposing on a black velvet cushion.'[189]

The longer a young woman remained at home, the stronger the potential conflict between her taste and that of her parents. The diaries of Maud Berkeley, who lived with her parents on the Isle of Wight until her marriage at 29, demonstrate this.[190] In January 1888, she railed against 'the dull hours closeted with the Great G and Nannie [her father and mother]'.[191] Her frustrations with home life were expressed through attempts to impose her own taste on her parents' house: 'Very disturbed by Nannie's [her mother] refusal to allow me to make the arrangement of Japanese fans I wanted on the overmantel in the library. She insisted the Great G [her father] would not be amused so I gave up the idea.'[192] 'Artistic' decor was tolerated on sufferance in her own bedroom, although it was also subject to criticism from her mother. Undaunted,

Maud attacked the library when her parents left for a week's holiday, in July 1888 she noted: 'celebrated my independence by re-hanging the corner bracket in the library'.[193]

Conclusion

From the 1850s, most English middle-class children were segregated in the nursery under the care of a nanny or nursemaid. This arrangement can explain some of the most distinctive features of nineteenth-century middle-class family life. Although a number of parents were frequent visitors to the nursery, generally it distanced parent and child and allowed mothers and fathers to control when and how they saw their children. The system also allowed parents to exercise favouritism, a practice that many autobiographers, recalling their childhoods in the mid-twentieth century, found unacceptable. But the structuring of the home in this way was also crucial to building intimacies between parents and children: special relationships were forged in parents' personal spaces, and first ideas about gender were formed here. The position of children in the home often allowed them to forge hidden relationships with servants, and they were often privy to knowledge that was secret from their parents. The isolation of nanny and charge in the home could lead to abuse beyond parental eyes, but also often led to intense warmth that subverted the class divide that the middle-class home was designed to set up.

Great care was lavished in the decoration of the nursery in some homes, even before the growth in production of commercial nursery goods and furnishings. While many mid-Victorian nurseries had a richly figurative decoration, children's engagement with the material culture was expected to create disciplined behaviour: tidiness was seen as a particularly important quality in girls. Material objects in the nursery could be literally inscribed with evangelical moral messages, but children often remained blissfully ignorant of their meaning, preferring to co-opt them into their own imaginative worlds. The adult world of the domestic interior could be transformed through play, with outlying spaces such as attics and outhouses offering particular scope for the fulfilment of childhood fantasies. The toys offered to children were often premised on nineteenth-century ideas of gender identity, and expected to instil gendered difference within sibling hierarchies. However, many toys such as rocking horses, toy theatres and toy soldiers were enjoyed by boys and girls alike. Dolls, strongly associated with the inculcation of maternal values, might not be used that way in play, as the little girls who played at 'widows' demonstrate.

As children grew up, the nursery fell into disuse. It was often

renamed the schoolroom, although its purpose was not solely educational as it was also a cherished space for shared play. In homes with room to spare, children's growing independence and autonomy was recognised through 'promotion', the allowance of room to themselves, or one shared with siblings. This may have become easier to achieve in the final decades of the century as middle-class family sizes became smaller. As boys and girls grew older, increasing emphasis was placed on the difference between them. Boys, often banished to school for much of their time, experienced a very different relationship with domestic material culture. School life was expected to alter their behaviour, and there was a perceived need to accommodate this in the home. Girls, on the other hand, were expected to conform increasingly to the domestic ideal, and were thus obliged to perform household tasks, undertake needlework, and to water the omnipresent aspidistra.

Advice writers recognised the need to accommodate young girls, and the bedroom boudoir was put forward as a means to grant girls a space for independent sociability. For some girls, remaining at home was frustrating: a tension that could be played out in arguments with their parents over decoration. For some children, it was only when they left home that they could fully develop their own tastes. Chapter 4 explores the decorative decisions young men and women made when they left home for the first time, examining the interiors of schools, university rooms and middle-class lodgings.

Notes

1 Beryl Lee Booker, *Yesterday's Child: 1890–1909* (London: Long, 1937), p. 72.

2 Annemarie Adams has argued that the nursery system was a late Victorian innovation, which stemmed from a lapse of mid-century evangelical power. Annemarie Adams, *Architecture in the Family Way: Doctors, Houses and Women 1870–1900* (London: McGill-Queen's University Press, 1996), p. 138. However, my survey questions this. See note 11.

3 According to Amanda Vickery, eighteenth-century gentry mothers do seem to have spent more time with their offspring, although they still had assistance. A. Vickery, *The Gentleman's Daughter: Women's Lives in Georgian England* (London: Yale University Press, 1998), pp. 110–115.

4 Hannah More, *Coelebs In Search of A Wife. Comprehending Observations On Domestic Habits and Manners, Religion and Morals* (London: T. Cadell and W. Davies, 1809), vol. 1. See discussion of the Belfield family pp. 41–44 and the Stanley family, pp. 172–177.

5 Mark Girouard, *Life in the English Country House: A Social and Architectural History* (London: Yale University Press, 1978), p. 286.

6 For images of the nursery before 1850, see P. Thornton, *Authentic Décor: The Domestic Interior 1620–1920* (London: Weidenfeld & Nicolson, 1984), p. 205; C. Saumarez Smith, *Eighteenth-Century Decoration: Design and the Domestic Interior in England* (New York, H.M. Abrams, 1993), p. 325; Charlotte Gere, *Nineteenth-Century Decoration: The Art of the Interior* (London: Weidenfeld & Nicolson), p. 168.

7 C. White, *The World of the Nursery* (London: Herbert, 1984), p. 60.

8 Jill Franklin, *The Gentleman's Country House and Its Plan 1835–1914* (London: Routledge & Kegan Paul, 1981), p. 80.

9 H.J. Jennings, *Our Homes, and How to Beautify Them* (London: Harrison and Sons, 1902), p. 240.

10 John J. Stevenson, *House Architecture* (London: Macmillan & Co., 1880), p. 70.

11 Some 62 per cent of the accounts from the period 1850–1859 mentioned a nursery, 45 per cent from the following decade and roughly 50 per cent of the accounts from the following periods, with the exception of the period 1880–1889, which mentioned slightly fewer.

12 E. Thomas, *The Childhood of Edward Thomas: A Fragment of Autobiography* (London: Faber & Faber, 1938); M.V. Hughes, *A London Family 1870–1900* (Oxford: Oxford University Press, 1991); L. Knight, *The Magic of a Line: The Autobiography of Laura Knight* (London: William Kimber, 1965).

13 T. McBride, '"As The Twig is Bent": The Victorian Nanny', in A.S. Wohl (ed.), *The Victorian Family: Structure and Stresses* (London: Croom Helm, 1978), p. 45.

14 P. Horn, *The Rise and Fall of the Victorian servant* (Stroud: Sutton, 1995), p. 190.

15 L. Stone, *The Family, Sex and Marriage in England 1500–1800* (London: Penguin, 1979), p. 423. Stone's view of family relationships as constantly fluctuating has been successfully disputed by Linda Pollock's study of parental writings: 'There are some basic features of human experience which are not subject to change . . . Instead of searching for the existence or absence of emotions such as love, grief, or anger, we should concede that these emotions will be present in all cultures and communities.' L. Pollock, *A Lasting Relationship: Parents and Children over Three Centuries* (London: Fourth Estate, 1987), p. 13. However, she does concede that as the nineteenth century waned, parental control over areas like career and marriage lessened, and the state began to play a greater role in the regulation of family life. L. Pollock, *Forgotten Children: Parent-Child Relations from 1500 to 1900* (Cambridge: Cambridge University Press, 1983), pp. 269–270.

16 John Tosh, *A Man's Place: Masculinity and the Middle-Class Home in Victorian England* (London: Yale University Press, 2007), p. 88; Eleanor Gordon and Gwyneth Nair, *Public Lives: Women, Family and Society in Victorian Britain* (London: Yale University Press, 2003), p. 61.

17 Although she also stresses the difference between real parenting and idealised representation. Eileen Gillooly, 'The Constant Gardener, or Nursery Government', paper given at 'Past and Present' British Association of Victorian Studies/North American Victorian Studies Association Conference, Churchill College, Cambridge, 15 July 2009.

18 W.S. Churchill, *My Early Life: A Roving Commission* (London: Thornton Butterworth Ltd, 1930), p. 19. Discussed in detail in J. Gathorne-Hardy, *The Rise and Fall of the British Nanny* (London: Weidenfeld, 1993) p. 22.

19 Dora Montefiore, *From a Victorian to a Modern* (London: E. Archer, 1927), p. 11.

20 Winifred Peck, *A Little Learning or A Victorian Childhood* (Faber & Faber, London, 1952), p. 31.

21 Ibid., p. 30.

22 Booker, *Yesterday's Child*, passim; *A Victorian Child* [pseudo. Olive Haweis] *Four to Fourteen* (London: Robert Hale, 1939), passim.

23 H.J. Bruce, *Silken Dalliance* (London: Constable, 1946), p. 5.

24 C.H. Reilly, *Scaffolding in the Sky: A Semi-Architectural Autobiography* (London: Routledge & Sons, 1938), p. 7.

25 A.C. Deane, *Time Remembered* (London: Faber & Faber, 1945), p. 8.

26 Celia Davies, *Clean Clothes on Sunday* (Suffolk: Terrence Dalton, 1974), p. 17.

27 Robert Kerr, *The Gentleman's House: Or, How to Plan English Residences, from the Parsonage to the Palace* (London: John Murray, 1864), p. 144; Stevenson, *House Architecture*, p. 71.

28 William Makepeace Thackeray, *Vanity Fair: A Novel Without a Hero* (London: Bradbury and Evans, 1848), p. 345.

29 Ibid., p. 446.

30 Ibid., p. 326.

31 Ibid., p. 336.

32 Ibid., p. 337.

33 Ibid., p. 338.

34 Ibid., p. 624.

35 Gordon and Nair, *Public Lives*, p. 141.

36 Montefiore, *From a Victorian to a Modern*, p. 12.

37 Booker, *Yesterday's Child*, p. 72.

38 Ibid., p. 46.

39 Jennings, *Our Homes*, p. 207.

40 J.E. Panton, *Nooks and Corners* (London: Ward & Downey, 1889), p. 97.

41 J. Marriott, *Memories of Four Score Years: The Autobiography of the late Sir John Marriott* (Blackie & Son, 1946), p. 16; E. Parry, *My Own Way: An Autobiography* (London: Cassell & Co., 1932), p. 31.

42 K. Flint, *The Woman Reader 1837–1914* (Oxford: Oxford University Press, 1993), p. 223.

43 H. Lee, *Reading in Bed: An Inaugural Lecture Delivered before the University of Oxford* (Oxford: Oxford University Press, 2002), pp. 19–20.

44 C. Oman, *An Oxford Childhood* (London: Hodder & Stoughton, 1976), p. 113.

45 A.M. Davies, *A Book with Seven Seals: A Victorian Childhood* (London: Chatto & Windus, 1974), p. 196.

46 Haweis, *Four to Fourteen*, pp. 26–27.

47 The National Trust, *Tyntesfield* (Swindon: The National Trust, 2003), p. 17.

48 Clare Leighton, *Tempestuous Petticoat: The Story of an Invincible Edwardian* (London: Victor Gollancz, 1948), p. 13.

49 H. Collins, *My Best Riches: Story of a Stone Rolling Round the World and the Stage* (London: Eyre and Spottiswoode, 1941), p. 33.

50 Owen Berkeley-Hill, *All Too Human: An Unconventional Autobiography* (London: Peter Davies, 1939), p. 3; W. Leaf, *Walter Leaf 1852–1927 Some Chapters of Autobiography, with a Memoir by C. M. Leaf* (London: John Murray, 1932), p. 20.

51 Booker, *Yesterday's Child*, p. 63.

52 Brian Lunn, *Switchback: An Autobiography* (London: Eyre & Spottiswoode, 1948), p. 21.

53 Matthew Hilton, *Smoking in British Popular Culture 1800–2000: Perfect Pleasures* (Manchester: Manchester University Press, 2000), p. 34.

54 L.W. Brown, *Suivez Raison and I.T:. Or, A Chap's Chequered Career An Autobiography* (London: Watts & Co., 1933), p. 10. Also see George Gray, *Vagaries of a Vagabond by 'The Fighting Parson'* (London: Heath Cranton, 1930), p. 18.

55 H. Nicholson, *Half My Days and Nights: Autobiography of a Reporter* (London: William Heinemann, 1941), p. 12.

56 T. Beecham, *A Mingled Chime: Leaves from an Autobiography* (London: Hutchinson, 1944), p. 9.

57 Sonia Keppel, *Edwardian Daughter* (London: Hamish Hamilton, 1938), p. 13.

58 Ibid., p. 13.

59 Leighton, *Tempestuous Petticoat*, p. 182.

60 Booker, *Yesterday's Child*, p. 29.

61 Ibid., pp. 71–72.

62 Ibid., p. 99.

63 Reilly, *Scaffolding in the Sky*, p. 6.

64 Leighton, *Tempestuous Petticoat*, p. 59.

65 Haweis, *Four to Fourteen*, p. 99.

66 Ibid., p. 100.

67 Davies, *Seven Seals*, pp. 82–83.

68 Bruce, *Silken Dalliance*, pp. 11–12.

69 In later childhood the nanny might be replaced by a governess. For a full account, see K. Hughes, *The Victorian Governess* (London: Hambledon Press, 1993), passim.

70 Gathorne Hardy, *The Rise and Fall of the British Nanny*, p. 20.

71 McBride, '"As The Twig is Bent"', pp. 49–50.

72 P. Robertson, 'Home as Nest: Middle Class Childhood in Nineteenth-Century Europe', in L. de Mause (ed.), *The History of Childhood: The Untold Story of Child Abuse* (London: Bellew, 1991), p. 424.

73 Davies, *Seven Seals*, p. 20; Mary Carberry, *Happy World: The Story of A Victorian Childhood* (London: Longmans, Green, 1941), p. 39.

74 M. Cholmondeley, *Under One Roof: A Family Record* (London: John Murray, 1918), p. 58.

75 Haweis, *Four to Fourteen*, p. 79.

76 H. Redwood, *Bristol Fashion* (London: Latimer House, 1948), p. 21.

77 Booker, *Yesterday's Child*, p. 23.

78 Ibid., p. 27.

79 Carberry, *Happy World*, pp. 192–193.

80 Cholmondeley, *Under One Roof*, p. 61.

81 Davies, *Seven Seals*, pp. 25, 48.

82 Cholmondeley, *Under One Roof*, p. 61.

83 Booker, *Yesterday's Child*, p. 80.

84 [Anon.], *Cassell's Household Guide: Being a Complete Encyclopaedia of Domestic and Social Economy* (London: Cassell & Co., 1869), vol. 2, p. 12.

85 C. Orlando Law, *House Decoration and Repairs: A Practical Treatise for Householders, Craftsmen, Amateurs, and Others Interested in House Property* (London: John Murray, 1907), p. 99.

86 Robert Edis, *Decoration and Furniture for Town Houses* (London: Kegan Paul & Co., 1881), p. 231.

87 Archive of Art and Design, Heal's Archive, catalogues for 1884, 1889 and 1894.

88 Edward Parry, *My Own Way* (London: Cassell & Co., 1932), p. 24.

89 Carberry, *Happy World*, pp. 47, 185.

90 Oman, *An Oxford Childhood*, p. 68.

91 M.H. Spielmann and G.S. Layard, *Kate Greenaway* (London: Adam and Charles Black, 1905), p. 182.

92 A. Schofield, *Toys in History* (Hove: Wayland, 1978), p. 52.

93 G. Hurst, *Closed Chapters* (Manchester: Manchester University Press, 1942), p. 11.

94 Edis, *Decoration and Furniture*, p. 228.

95 F. Kendon, *The Small Years* (Cambridge: Cambridge University Press, 1930), p. 56.

96 Pollock, *Forgotten Children*, p. 184.

97 Leonore Davidoff and Catherine Hall, *Family Fortunes: Men and Women of the English Middle Class 1780–1850* (London: Hutchinson, 1987), p. 343.

98 For examples see [Anon.], 'High Ideals: Early Married Life', *The Girl's Own Paper*, 16 (1895), p. 275; [Anon.], 'On Nursing the Sick', *The Girl's Own Paper*, 18 (1880), p. 599.

99 [Anon.], 'How to Nurse and Tend the Aged', *The Girl's Own Paper*, 4 (1882), pp. 122–123.

100 Mary Clare Martin's study of childhood and religion in Walthamstow and Leytonstone found that a 'puritan' approach to children's clothes and eating habits was adopted in some local elite families. M.C.H. Martin, 'Children and Religion in Walthamstow and Leyton *c.*1740–*c.*1870' (PhD thesis, University of London, 2000), p. 473. Also see Booker, *Yesterday's Child*, pp. 13, 23 and 72; Haweis, *Four to Fourteen*, p. 113.

101 Haweis, *Four to Fourteen*, pp. 110–111.

102 John Harvey, *The Art of Piety: The Visual Culture of Nonconformity* (Cardiff: University of Wales Press, 1995), p. 28.

103 White, *The World of the Nursery*, p. 48.

104 Davies, *Seven Seals*, p. 52.

105 Nursery design from [Anon.], 'Art Furniture in Kensington', in *The House* (May 1901), p. 112.

106 R. Graves, *Good-bye to All That: An Autobiography* (London: Jonathan Cape, 1929), p. 28.

107 Panton, *From Kitchen to Garret*, p. 177.

108 Kendon, *Small Years*, p. 60.

109 Martin, 'Children and Religion', p. 237.

110 K. Hare, *No Quarrel with Fate* (London: Sampson Low & Co., 1946), p. 4.

111 W.A. Darlington, *I Do what I Like* (London: MacDonald & Co., 1947), p. 27.

112 Keppel, *Edwardian Daughter*, p. 8.

113 Carberry, *Happy World*, p. 30.

114 Montefiore, *From a Victorian to a Modern*, p. 12.

115 Bodies in childhood have a different dialogue with the interior to adult bodies. See A.C. Colley, 'Bodies and Mirrors: The Childhood Interiors of Ruskin, Pater and Stevenson', in I. Bryden and J. Floyd (eds), *Domestic Space: Reading the Nineteenth-Century Interior* (Manchester: Manchester University Press, 1999), p. 40.

116 Carberry, *Happy World*, pp. 91–92.

117 Lunn, *Switchback*, p. 21.

118 E. Rhys, *Wales England Wed* (London: J.M. Dent and Sons, 1940), p. 19; Darlington, *I Do What I Like*, p. 32.

119 Booker, *Yesterday's Child*, p. 44.

120 C. Wrey Gardiner, *The Colonies of Heaven: The Autobiography of a Poet* (Essex: Grey Walls Press, 1941), p. 13.

121 Montefiore, *From a Victorian to a Modern*, p. 14; Carberry, *Happy World*, p. 209; A. Barlow, *The Seventh Child: The Autobiography of a Schoolmistress* (London: Gerald Duckworth & Co., 1969), p. 16.

122 Hughes, *A London Family*, p. 33.

123 Ibid., p. 26.

124 Davidoff and Hall, *Family Fortunes*, p. 344.

125 K. Calvert, *Children in the House: The Material Culture of Early Childhood 1600–1900* (Boston: North-Eastern University Press, 1992), p. 118. Recent scholarship, however, has demonstrated the capacity of play to subvert the gendered stereotypes that dolls are assumed to carry. M. Formanek-Brunell, *Made to Play House: Dolls and the Commercialisation of American Girlhood 1830–1930* (London: Yale University Press, 1993), p. 1; J. Attfield, 'Barbie and Action Man: Adult Toys for Girls and Boys 1959–93', in P. Kirkham (ed.), *The Gendered Object* (Manchester: Manchester University Press, 1996), p. 88; H. Hendershot, 'Dolls: Odour, Disgust, Femininity and Toy Design', in Kirkham, *The Gendered Object*, p. 97.

126 W.H. Cremer Junior, *The Toys of Little Folks of all Ages and Countries or the Toy Kingdom* (London: W.H. Cremer Jnr, 1873), p. 50.

127 Booker, *Yesterday's Child*, p. 20.

128 Davies, *Seven Seals*, p. 52.

129 L.I. Lumsden, *Yellow Leaves: Memories of a Long Life* (London: Blackwood & Sons, 1933), p. 2.

130 M. Paley Marshall, *What I Remember* (Cambridge: Cambridge University Press, 1947), p. 5.

131 Carberry, *Happy World*, p. 192.

132 Ibid., p. 129.

133 Ibid., p. 23.

134 K. Fawdry and M. Fawdry, *Pollock's History of English Dolls and Toys* (London: Benn, 1979), p. 102.

135 Schofield, *Toys in History*, p. 49.

136 H.E. Palmer, *The Mistletoe Child: An of Autobiography of Childhood* (London: J.M. Dent & Sons, 1935), p. 33.

137 Booker, *Yesterday's Child*, p. 33.

138 Haweis, *Four to Fourteen*, p. 53.

139 Booker, *Yesterday's Child*, p. 33.

140 For a detailed analysis of the association of gender and collecting, see R.W. Belk, 'Of Mice and Men: Gender Identity and Collecting', in K. Martinez and K.L. Ames (eds), *The Material Culture of Gender: The Gender of Material Culture* (New York: Henry Francis du Pont Winterthur Museum, 1997), pp. 7–26.

141 Oman, *An Oxford Childhood*, p. 113.

142 This varied from family to family, but may have coincided with the point at which boys were 'breeched' i.e. taken out of petticoats. Davidoff and Hall, *Family Fortunes*, p. 344.

143 Panton, *Nooks and Corners*, p. 99.

144 Lunn, *Switchback*, p. 13.

145 Carberrry, *A Victorian Childhood*, p. 192.

146 Lunn, *Switchback*, p. 16.

147 Mary Hughes, *A London Child of the 1870s* (London: Persephone Books, 2005), p. 3.

148 Ibid., p. 3.

149 Ibid., p. 169.

150 N. Streatfeild, *A Vicarage Family* (London: Collins, 1963), p. 105.

151 Gordon and Nair, *Public Lives*, p. 40.

152 Anderson argues that across the population as a whole, family sizes continued to be very diverse due to the high mortality rate. M. Anderson, 'The Emergence of the Modern Life Cycle in Britain', *Social History* 10:1 (1985), 80.

153 Lunn, *Switchback*, p. 13; Kendon, *Small Years*, p. 45.

154 Streatfeild, *A Vicarage Family*, p. 11.

155 Lunn, *Switchback*, p. 13.

156 Ibid., p. 13.

157 Kendon, *The Small Years*, p. 45.

158 Mrs Loftie, *The Dining-Room* (London: Macmillan & Co., 1878), p. 128.

159 Panton, *Nooks and Corners*, p. 70.

160 O. Lodge, *Past Years: An Autobiography* (London: Hodder & Stoughton, 1931), p. 32.

161 Leighton, *Tempestuous Petticoat*, pp. 20–21.

162 Barlow, *Seventh Child*, p. 21.

163 Ibid., p. 27.

164 W.J. Dawson, *The Autobiography of a Mind* (London: Century Co., 1925), p. 31.

165 Booker, *Yesterday's Child*, p. 44.

166 Lunn, *Switchback*, p. 21.

167 Streatfeild, *A Vicarage Family*, p. 54.

168 See Panton, *From Kitchen to Garret*, p. 131; Lady Barker, *The Bedroom and Boudoir* (London: Macmillan, 1878), pp. 13–14.

169 Kerr, *The Gentleman's House*, p. 130.

170 Ibid., p. 130.

171 Parry, *My Own Way*, p. 29. For accounts of home life while at day school see Bernard M. Allen, *Down the Stream of Life* (London: Lindsey Press, 1948); W. Heath Robinson, *My Line of Life* (London: Blackie & Son, 1938), p. 25.

172 Richard Church, *Over the Bridge: An Essay in Autobiography* (London: Heinemann, 1955), p. 22.

173 Panton, *Nooks and Corners*, p. 119.

174 Ibid., pp. 120–126.

175 Ibid., p. 120.

176 [Anon.], 'On Boudoir Bedrooms', *Hearth and Home* (5 May 1910), p. 62.

177 Ibid., p. 62.

178 Virginia Woolf, 'Sketch of the Past', in Jeanne Schulkind (ed.), *Moments of Being* (London: Pimlico, 2005), p. 128.

179 Ibid., p. 129.

180 Ibid., p. 129.

181 Jennings, *Our Homes*, pp. 224–225; Panton, *From Kitchen to Garret*, pp. 118–119.

182 Eastlake, *Hints on Household*, p. 212.

183 Jennings, *Our Homes*, pp. 224–225.

184 Panton, *From Kitchen to Garret*, pp. 118–119.

185 [Anon.], 'The Girl's Bedroom', *The Girl's Own Paper*, 17 July 1880, p. 458.

186 Ibid. p. 458.

187 Ibid., p. 458.

188 Morris argues that before the Married Women's Property Acts the older practice of allowing the wife rights to 'paraphernalia', i.e. clothes and jewellery if the husband died survived in the early nineteenth century. R.J. Morris, 'Men, Women and Property: The Reform of the Married Women's Property Act 1870', in F.M.L. Thompson (ed.), *Landowners, Capitalists and Entrepreneurs: Essays for Sir John Habakkuk* (Oxford: Clarendon, 1994), pp. 175.

189 Booker, *Yesterday's Child*, p. 181.

190 Flora Fraser (ed.), *The Diaries of Maud Berkeley* (London: Secker & Warburg, 1985).

191 Ibid., p. 19.

192 Ibid., p. 19.

193 Ibid., p. 30.

4 ✧ Leaving home:
schools, colleges and lodgings

MARION PICK, who arrived at Holloway College for Women in 1887, wrote: 'To a first year on arrival, two private rooms were unspeakable bliss; I simply sat and looked and loved it all.'[1] For Pick and many other female students, the college room was the first place that they had complete personal control over. Holloway College for Women, at Egham in Surrey, was founded by the manufacturer and philanthropist Thomas Holloway, and opened in 1886. The college was one of a number of new educational institutions founded during this time, which changed the experiences of young men and women when they left home. Unusually for a women's college, Holloway was generously funded, allowing the student rooms to be relatively lavishly furnished. However, Pick did not relish the heavy mid-Victorian style chosen by the founder, noting that the rooms were 'devoid of any frivolity and a powerful effect was needed to achieve charm'.[2] Rejecting the juvenile decorative choices of some of her fellow students (several rooms displayed the same picture of a 'little faun', which she particularly disliked),[3] Pick was quick to stamp her own taste on the space, choosing her own goods and decorating it with presents from friends: 'a friend gave me a Holland table cloth with the art nouveau design of the moment in blue'.[4]

This chapter explores the decorative choices made by young men and women when they left home for the first time. The limited personal spaces and autonomy that were granted to boys and girls who were sent away to school in this period are examined, and the extent to which the use of space in these institutions remained linked to home life. The second part of the chapter looks at young men and women at university who, although living under gendered restrictions, had more freedom to accept or flout the decorative conventions of their parents. Finally, the chapter turns to the more common experiences of young people in lodgings who often had less control over their material surroundings.

For young middle-class men and women, the experience of leaving home was altered in the second half of the nineteenth century by the reform of institutions for secondary and higher education. It was common for middle-class boys to be sent away to school, sometimes as young as seven or eight years old.[5] The most important secondary schools for boys were the nine great or public schools, for the middle class there was also a multitude of short-lived private schools, many 'proprietary' schools owned by shareholders and about 700 ancient endowed grammar schools that had been founded in the sixteenth and seventeenth centuries.[6] Following the report of the Taunton Commission in 1868, the Endowed Schools Commissioners remoulded endowments and schools.[7] In response to the growing middle-class appetite for sending their sons to live away at school, by the end of the nineteenth century some 60 high status 'public' schools had emerged.[8]

Girls had a very different educational experience. Before the 1860s, parents who could afford to do so sent their girls to private schools or employed governesses.[9] As private boarding schools for girls were often short-lived, it is difficult to assess their numbers: one estimate suggests that at mid-century at least half of all middle-class girls were attending a private school of some sort.[10] From mid-century, a campaign for the reform of secondary education for girls led to the foundation of new girls' schools that modelled themselves on public schools for boys. The North London Collegiate School was established in 1850 and Cheltenham Ladies' College in 1853.[11] In 1872 the Girls' Public Day School Company was established.[12] By the end of the century there were about a hundred proprietary high schools. The Endowed Schools Act of 1869 also triggered the foundation of 80 schools for girls by 1894.[13] Many girls boarded at the new high schools.[14] But boarding was not as common as with schools for boys. The founders of girls' schools believed that girls were physically weaker and that it was not desirable for them to spend long periods away from home, so many girls' schools taught in the morning to allow girls to return home each day.[15] As this chapter shows, these institutions played a crucial role in shaping the experiences of young men and women when they left home for the first time, although the relationship between home and school was often complex.

Some middle-class school boys and girls continued their education at university. University education was dominated by Oxford and Cambridge throughout the nineteenth century, although there was some reform in this era. In 1836, London University had been established to allow those who were debarred from Oxford and Cambridge for religious reasons to take degrees.[16] The University Extension Movement campaigned for the expansion of university education from the 1860s.[17] Victoria University, made up of a federation of provincial colleges at

Manchester, Liverpool and Leeds, was granted a charter in 1880.[18] However, student numbers at both London and Victoria remained relatively small in comparison to Oxford and Cambridge.[19] The ancient universities were reformed in this era, with the 1871 abolition of religious tests which allowed non-Anglicans to enter Oxford. Higher education for women was established in the second half of the nineteenth century, with the foundation of colleges for women at Girton and Newnham in Cambridge in the 1870s.[20]

The University of London in 1878 was the first university to award degrees to women.[21] Victoria University also granted degrees to women graduates, from the 1880s.[22] For the most part, however, university education remained in the hands of the privileged.[23] Oxford and Cambridge were probably less aristocratic from the mid-century as a result of the growing importance of honours examinations.[24] At Oxford, there was a small increase in the number of male undergraduates from lower-middle-class or working-class backgrounds after 1890, but the male student body remained predominantly aristocratic and middle class.[25] In the women's colleges, the student body tended to be middle class: aristocratic women had little need of education, and working-class students were rare.[26] Student incomes varied – but for most of these young people the acquisition of a student room (or rooms), and almost complete control over their individual consumption and expenditure, marked a significant assumption of autonomy and independence.[27] Here, in a situation of relative power and privilege, students could make the choice to recreate or jettison the material cultures that they had experienced at home.

A larger group of young men and women – usually lower down the social scale – also moved away from the home for work in the second half of the nineteenth century. The growth of the white collar service sector created more jobs for lower-middle-class young men and women in England's urban centres.[28] Women were recruited into office work at a proportionately faster rate than men, and between 1881 and 1911 women increased their share of the commercial and civil service workforces by up to 25 per cent or more.[29] The arrival of the typewriter in the 1880s transformed office work, and the 'typewriter girl' became an established cultural stereotype.[30] The expansion in secondary education for women created more jobs as teachers, but also more women who were qualified to teach.[31] As Colin Pooley and Jean Turnbull have shown, the distance that young people moved from the family home was increasing during this period.[32] Most young people who moved away would have lived in lodgings.[33] Lodging houses in London advertised in the Post Office Directories (and therefore likely to be middle class) grew from 762 in 1851 to 1,401 in 1871.[34] Lodging was for young men, like

residential service for young women, part of the nineteenth-century pattern of delayed marriage.[35] While a move to lodgings provided a break from the family home, this too had its checks and privations. Here young people were able to distance themselves from the material practices of their parents, but the discomforts of lodgings could prompt a desire to return to the domesticity of the family home.

Schools: separation from home?

For children who boarded at school, material ties with home were often maintained through a constant flow of letters and objects sent through the postal system. Foodstuffs were the most commonly sent items. Tales of boxes of goodies, carefully packed by mothers, seized by other children or pilfered by school staff, are among the most poignant in children's unhappy memories of school.[36] Some schools found it necessary to restrict the flow of goods from home: at Thame School in the mid-nineteenth century, boys were only allowed to receive a single hamper per term.[37] Many children, however, were more than amply provided for. Material demands show that some children were fully aware of, and able to manipulate, the parental guilt that could accompany sending them away to school.

The letters of Hilda Sebastian, a boarder at Queenwood Private School for Girls in Eastbourne from 1910, show how her mother was besieged by a series of requests for minor objects, including pens, newspapers and clothes brushes, on an almost daily basis.[38] A particularly lengthy missive requested a large set of provisions for a midnight feast, including: 'chocolate biscuits, sherbert . . . pears, cake and could you make some sausage rolls do they would be lovely.'[39] An insistent postscript added: 'There are five of us so don't be mingy.'[40] These demands finally proved too much for Hilda's parents: the provision of a midnight feast would have directly contravened the rules of the school. The next letter had a distinctly disappointed tone, and emphasised that many other parents had come up with the goods, noting that 'heaps of bedrooms had had them [midnight feasts] already'.[41]

While the nineteenth century saw the increasing institutionalisation of girls' schools, some aspects of school life, particularly boarding arrangements, remained modelled on family life. Christina de Bellaigue has shown that the familial character of the early nineteenth-century private schools for girls was reinforced by the use of space: girls shared small bedrooms, ate in the dining room, and might spend evenings in the family drawing room.[42] School numbers were often deliberately kept low.[43] Small-scale private girls' schools, particularly for younger children, continued to exist into the twentieth century alongside the new

high schools.[44] Within these smaller establishments family-like intimacies could grow up. Noel Streatfeild, who was a day girl at a private school for girls in Eastbourne, envied the intimacy between teachers and boarders who kissed each other goodnight.[45]

Joyce Senders Pedersen argues that, in contrast, the new high schools for girls had the opposite effect: rather than mimicking the family, headmistresses lectured parents on their duties, and the world of school invaded the world of home.[46] The new schools for girls followed the boys' public school model of large, hierarchically structured establishments.[47] As these schools expanded, they were often able to build impressive institutional edifices.[48] Yet the domestic arrangements for boarders often remained of an ad hoc and familial character. At Winchester High School for Girls, the first girls who occupied the school 'houses' in the late nineteenth and early twentieth centuries felt that living conditions were close to those of the home. One old girl remembered: 'At the High House we were a happy family of about sixteen . . . the home life was a very real thing.'[49] And another commented: 'There can be few Hillcroft Old Girls who did not feel the House to be their dear family circle.'[50]

Perhaps more surprisingly, the domestic arrangements in boys' public schools also often took on a familial aspect. While historians have largely viewed the public school as a means of separating boys from domesticity, the set-up of these schools had a complex relationship with the family. The reform of the public schools was led by Thomas Arnold at Rugby School in the 1840s. Central to the reforms at Rugby were the elimination of 'Dames Houses' and the appointment of regular assistant masters as heads of the school boarding houses.[51] Bellaigue notes that Arnold's system treated the boarding houses as a kind of extended family, with schoolmasters' wives often playing an important role in the life of the house.[52]

As the century progressed, other boys' schools followed Arnold's lead, placing masters in charge of boarding houses.[53] The extent to which the boarding house reproduced the familial environment varied between schools and individual housemasters. At Radley College it was planned that 'boys [were] to live in the bosom of one large Christian family'.[54] Some housemasters were far harsher. White, a housemaster at Rossall School in the late nineteenth century, was particularly noted for the harsh conditions of his house, where boys would be obliged to sleep all year with the windows open, and would wake up on winter mornings with their beds swathed in snow.[55] However, other housemasters clearly viewed themselves as in loco parentis. A pupil at Winchester College in the late nineteenth century remembered the cosy informality fostered by his housemaster 'Trant': 'He would never allow himself to be called "Sir" inside his House; and his study . . . on the boys' side of the House,

he turned into a club for his seniors, who reclined on the sofa and easy chairs while he himself sat in the midst on the floor.'[56]

Tosh argues that 'women were effectively banned as points of emotional reference' from the public schools.[57] Yet it is clear from many accounts of the period that housemasters' wives often provided a welcome note of femininity. At Wellington College, the headmaster's wife was known as Mother Benjy.[58] G.R. Smith remembered that on the marriage of Furneaux, his housemaster at Rossall in 1914, boys were 'frequently invited into her [his housemaster's wife's] bright drawing room for tea or coffee or music. Four homeless years of billet and barrack life in this war remind me of how indescribably much that meant to me then.'[59] Sending boys away to school did not necessarily turn them away from domesticity: indeed, it encouraged some to view the home as a lost Eden.

There was, however, in the reformed schools for boys and the new girls' high schools, an increasingly pronounced sense of difference between institutional and domestic space. When boys and girls went to school they entered a different spatial and material world, which was governed by a new set of rules and disciplines. As they moved between dormitory and classroom, the days of public school boys were carefully regulated. At Radley, boys kept to a strict timetable and silence was enforced in the dorms.[60] At Marlborough, boys also followed elaborate dormitory rules, rising at the sound of a bell.[61] The larger new girls' schools also had elaborate behavioural codes. A set of photographs from Manchester High School for Girls in the early twentieth century shows girls clad in uniforms, undertaking new routines in large, specially designed spaces. For example, figure 4.1 shows the girls in the gym. Mary Hughes remembers being dazed by the complexity of the rules when she first arrived at the North London Collegiate School.[62] However, girls were less likely to experience such extensive institutional control, as they boarded less often and those who did often lived under laxer regulations.[63]

In boys' public schools, rules about spaces and objects were used to reinforce hierarchy. Quintin Colville's study of Dartmouth Naval College in the early twentieth century demonstrates how new cadets would be stripped of possessions and privacy, which would gradually be restored to them as they acquired seniority.[64] Within the reformed public schools, sixth form boys were granted greater autonomy and expected to play an active role enforcing spatial and material regulations.[65] In many boys' schools, however, the enforcement of discipline could turn into violent physical bullying that was reinforced by the spatial arrangements of the institution. Boys were most vulnerable when sleeping in unprotected dormitory beds, and when washing. E.L. Grant Watson, who

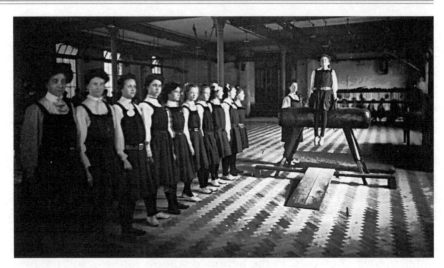

4.1 The gym at Manchester High School for Girls, 1902

attended a 'progressive' boarding school for boys in the early twentieth century, recalls that at bed time vulnerable boys were rolled out of bed and forced to eat soap, and that boys were violently slapped with wet towels when bathing.[66]

Looking closely at material culture reveals how experiences varied between institutions. Historians have written of the Victorian public school system as if it were a monolithic institution, churning out boys of a uniform, unemotional character, suitable for British public service.[67] But partly by accident and partly by design, the way in which these institutions were built and used was very different, leading to a breadth of personal experiences of autonomy and independence. Malcolm Seaborne notes that, during the second half of the nineteenth century, dormitories were purpose built and increasingly uniform.[68] However, the use of space in older, converted buildings often remained chaotic. At mid-century Rossall, first year boys who occupied the dark and dingy studies in Sir Hesketh Fleetwood's converted stables, regularly battled with large black rats.[69] At Radley, pupils who occupied the converted attics at the top of the former country house, known as the 'far studies,' were situated side by side with servant rooms, far beyond the sight of their schoolmasters.[70] The situation was further complicated by the fact that accommodation for pupils was often provided in the private houses of individuals outside the central school organisation.[71]

School authorities also differed over the allocation of personal space to the individual boy. At Eton and Harrow, each pupil was given an individual study in which he slept.[72] At Winchester, boys slept in dormitories in the houses, and there were no private studies. Study was carried out

at 'toys' – individual desks with large bookshelves above them – that were placed in common halls.[73] J. D'e Firth, the historian of Winchester in the 1950s, who like his father before him had also been a pupil at the school, believed that the absence of private studies produced a distinctive school ethos, and represented an 'emphasis on the fullness of community life' which was not present at Eton.[74] The most ardent advocate of the use of cubicles in nineteenth-century boys' schools was William Sewell, who installed them at Radley because he believed that individual isolation was essential to prayer, and the boy's development of a communion with God.[75] Thus public schools varied in the way they used material culture to enforce discipline, and there was no dominant view of the best way that this might be achieved.

Boys' and girls' schools were geared towards the reinforcement of gendered identity: public schools for boys sought to instil a sturdy masculinity and a sense of fair play,[76] while the authorities of girls' schools never forgot that woman's destiny was marriage and motherhood.[77] To a certain extent, these ideas were played out through personal material goods. At Wellington, femininity was quite literally stamped out: the school historian recalls that when he attended the school, a friend, later to become a leading horticulturist, attempted to cultivate a window box of rare bulbs. But the flowers were quickly vanquished on discovery by the dorm captain: '"There is no room for this rotten effeminate stuff here," he said sweeping them on to the floor and trampling them underfoot.'[78]

Tokens of home were clearly harder to maintain in the more abrasive environment of the boys' public schools. The exposure of personal objects, particularly those with a connection with home, risked ridicule.[79] At Wellington, boys had a robust disregard for ornamentation, which carried associations of femininity: 'not that the boys made much of their rooms, which were hung with pictures that had long been in the dormitory and were handed down from one generation to another'.[80] Graham Seton Hutchison recalled that he took a wooden bear given to him by his father to his preparatory school. When homesick he clutched the bear in bed at night, although one day he forgot to remove it, and it was held up 'to the dormitory's derision by a matron whom ever afterwards I hated with a smouldering passion'.[81] In contrast, girls were encouraged to cherish personal objects. At one late nineteenth-century boarding school, girls of eighteen adorned their beds with cuddly toys.[82] These divisions continued into the twentieth century. This can be seen in contrasting publicity images of school dormitories: the Observatory Prep School for Boys dormitory, in figure 4.2, shows bare, uniform beds for boys, whereas in a dormitory from Twizzletwig, an early twentieth-century school for girls of a similar age near Hindhead in Surrey, shown in figure 4.3, the beds each display a cuddly toy.

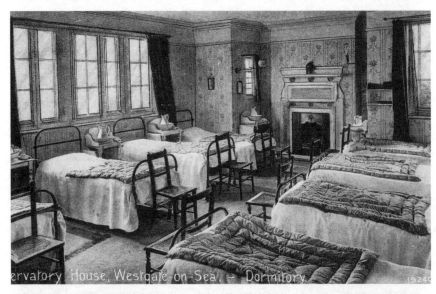

4.2 Boys' dormitory at the Observatory House School

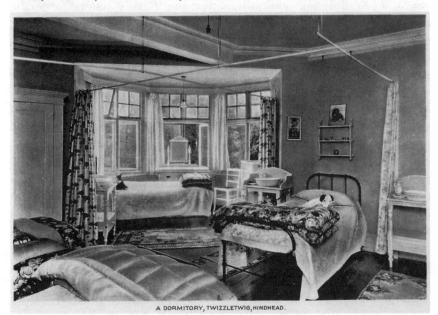

A DORMITORY, TWIZZLETWIG, HINDHEAD.

4.3 Dormitory from Twizzletwig School for Girls near Hindhead

Yet a broad equation of masculinity with a rejection of decorative choice did not hold sway in every school. Some founders of boys' schools, such as Sewell at Radley, were actively concerned that boys should develop a sense of beauty through taste.[83] Boys who had their own studies, at Eton, Harrow and Rossall, often invested a great deal in

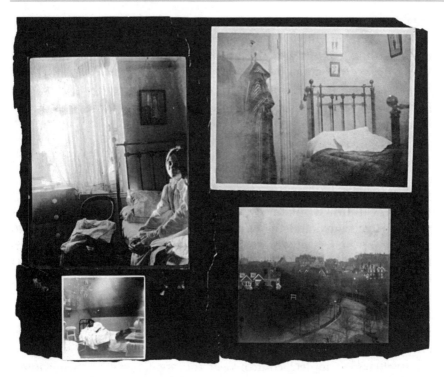

4.4 Photographs from the album of Elsie Marie Hughes when at Queenwood School, 1914

the decoration of these spaces. Bertie Owen, a senior boy at Rossall in the late 1860s, described his study in a series of letters home to his parents. Obsessed with drapery, he hung red curtains and red calico on his walls, covered his trunks with red baize, and even decked his bookcase with a red curtain and valance.[84] The acquisition of brown patterned carpet for the room in 1868 caused great excitement. He repeatedly tried to convince his parents to visit his garish room, but was unable to do so.[85] Crawshay Williams, the son of an MP, recalls the comfort of installing favourite objects in his Eton room on his arrival there as a first-year boy in the 1890s.[86] Later in his school career, the semi-private space of the study offered him the opportunity to indulge in forbidden sexual behaviour:

> once these manifestations actually got so far as to result in the object of my misapplied passion sitting on my knee, in his room. Almost immediately the door was flung open and in marched my tutor. The ensuing scene very nearly resulted (such was the Etonian standard of rectitude) in our both being expelled.[87]

Schoolgirls were less likely to have their own studies, but they too were enthusiastic decorators. The photograph album of Elsie Marie Hughes, a schoolgirl at Queenwood in 1914, shown in figure 4.4, demonstrates

how she decorated her corner of her shared bedroom with pride.[88] Home is clearly present in the photograph of her parents' wedding, which hangs on the wall. Both boys and girls at school were able to manipulate such rooms to create an alternative personal space within the world of school, often recreating the arrangements of domestic objects they had learned from home, and sometimes resisting the gendered norms and behavioural codes imposed on them by these new institutions.

The student room: new freedoms?

If school children were sometimes able to exert a degree of control on the spaces around them, this was realised more fully by students at university. Here many students were given their own room, or rooms, to decorate for the first time. As with schools, however, men had very different experience from women. An important difference at Oxford and Cambridge was that men could, and did, live outside college. In 1868, the ban on students at Oxford living outside college walls was lifted,[89] and several male students note in their memoirs that they found lodgings in the town.[90] Female students, on the other hand, were almost always housed within the protective walls of their colleges. Neither sex, however, had complete control over the appearance of their rooms. Student taste was subject to budget, availability and, most importantly, the power of the institution. At the men's colleges it was customary for the occupant of a room to buy the furniture in a room from its previous occupant and to then sell it on to their successor.[91] Occasionally, university rooms would be refurbished. A notebook written by the then bursar, Charles Faulkner, an associate of William Morris, records how rooms at University College were lovingly decorated in Morris papers, only to be covered up by their student occupants who objected to the designs.[92]

The early women's colleges did not have the same funds at their command. Letters between St Hilda's first principal Miss Beale and Mrs Burrows show the difficulties of furnishing a women's college on a budget: the first rooms at St Hilda's were furnished with second-hand furniture from sales and with goods that had been given to the college as gifts.[93] At Girton, students were supplied with basic items of furniture for their student rooms.[94] At Holloway, which was exceptionally well-endowed by the standards for women's colleges in this period, the student rooms were rather heavily but lavishly furnished with identical items from Maples. It may have been selected by the founder, who died four years before the college was opened,[95] but Marion Pick, a student and teacher in the college's early years, suggests it was the work of the first Principal. Such lavish provisions may have made it harder for students to stamp their individual tastes on these spaces.

The spaces inhabited by early college women were more tightly bound by rules and regulations than those of male students. The problems faced by the pioneers of women's education have been seen to create what Sara Delamont has termed 'double conformity': while women strove to prove they could follow the curricula of the Oxford and Cambridge universities to the letter, to appease their critics they maintained lady-like behaviour at all times.[96] Female colleges imposed particularly strict rules on how students used their space according to time. These ideals encouraged the creation of spaces and structures that aligned the women's college with the rituals of the middle-class family home.[97] At Holloway, the founder's statement required that the college life was to be that of 'an orderly Christian household'.[98] Students were expected to form 'families': friendship groups of four or five who would spend time together and support each other during their college life. The student study played an important role in the quasi-domestic life of the college. The daily tea ritual, similar to the 5 o'clock tea that took place in the middle-class home, was important enough to be photographed by Miss Frost, a maths lecturer who created a substantial photographic record of the life of the college. As the slightly tense posture of the students in this photograph (figure 4.5) may indicate, tea was not always a social event welcomed by students. This ritual was still firmly in place at Holloway when Winifred Seville wrote her diaries in the late 1900s, in which she records that she managed to avoid a tedious grouping with her college 'family' at teatime, leaving herself free for a more exciting tête-à-tête in her room alone with her special friend.[99] The lives of early women students may seem disciplined and restricted in comparison to men, but in contrast to some women's home lives, female student life was a heady whirlwind of social interaction. Helena Swanwick remembered: 'The social life of the college [Girton] was to me so intoxicating that it was more than enough for me. I was too excited to sleep or eat properly.'[100]

Male student life was not as heavily structured as women's and offered more freedom. Men came and went, almost as they pleased within certain limits. Student rooms were often used to host homo social dining parties. Dinner parties could be elaborately organised formal events. Memento albums often display little printed menus from these occasions, detailing rich fare. In popular literature of the period, the male student room was represented as a site for the achievement of masculinity through the conspicuous consumption of masculine goods. In *The Adventures of Mr. Verdant Green* (1853), the hero is treated on his arrival at Oxford to a party involving 'spirituous liquors and mixtures of all descriptions' and 'a great consumption of tobacco'.[101] After a term of such conviviality, Verdant Green returns home a smoker.[102]

For some men, this description was not far removed from their

own experiences. The memoirs of Francis Henry Hill Guillemard, who was at Gonville and Caius College, Cambridge, in 1870, note that it was common to have wine in a friend's room after hall two days out of three.[103] These 'quite informal little séances' were distinct from 'wines', which were 'dreadful functions to which you asked as many men as you could' and ordered a lot of wine.[104] Figures 4.5 and 4.6, showing a tea party at Royal Holloway College for Women in the 1890s, and an all-male lunch party of students from Magdalene College, Cambridge in 1910, demonstrate the different kinds of sociability male and female student interiors fostered. Photographs also suggest that male under-graduates were anxious to record their intake of alcohol. I have found several other photographs that echo the prominently placed bottles in the party from Magdalene. A University College, Oxford picnic shows a total of 19 bottles to 26 picnickers, and a large box of cigars spills open in the foreground. Clearly these men were keen to display their consump-tion of masculine goods for the photographic record.[105] Of course, there was no single model of masculine sociability. Male student experience varied markedly according to wealth and family background, college and social set. Thus, sociability was less tightly controlled for the men than for their female counterparts and the material make-up of male student rooms reflects this.

Both male and female colleges sought to control the way in which student spaces were used, and were very anxious about contact between the sexes. A student from St Hilda's recalls that another student was sent down (i.e. expelled) for visiting her male cousin in his college rooms.[106] Edith Mumford was critical of the heavy stress on chaperonage at Girton in 1888, and resented the way student space was policed by the staff. She recalls being reproved for looking out of a window by Girton's founder Emily Davies who, patrolling the college corridors, had crept up silently behind her in carpet slippers.[107] Florence Ada Keynes who was at Newnham in 1878, remembered Miss Clough, the Principal, behav-ing similarly: 'She would wander about the corridors in the evening in her rather vague way and pay unannounced visits to students' rooms to make sure her charges were profitably occupied.'[108] There are no compa-rable comments surviving from Holloway: it may be that the elongated plan of the college, with its lengthy corridors and difficult access, made such supervision difficult.

Both male and female spaces were vigorously protected from con-tamination by the opposite sex. Linda Dowling notes that the lodging house debate became a matter of national attention when in 1876 a former vicar from St Mary's, Oxford argued that allowing undergradu-ates to live out led to sexual profligacy with housemaids.[109] Brian Lunn, at Christ Church, Oxford in 1912, recalled that when he had diphtheria

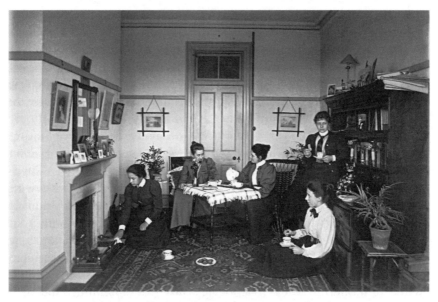

4.5 Students posed for the 5 o'clock tea in a student room at Royal Holloway

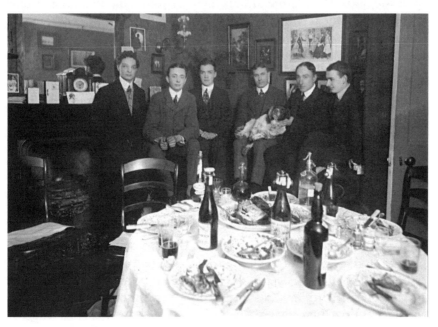

4.6 Male students from Magdalene College, Cambridge at lunch

he was provided with 'a nurse of an age "suitable for an undergraduate" who slept on the sofa in my sitting-room'.[110] Helena Swanwick remembered that at Girton in the 1880s, male visitors were allowed, provided the female occupant of the room did not sit down and kept the door

open. This could lead to awkward episodes: on one occasion Swanwick was kept standing for two hours.[111]

Despite these arrangements, for both men and women, the student room also offered an unprecedented opportunity to express their own taste, free from the intervention of parents or schoolteachers. There was a contrast between such restrictions on social behaviour and the degree of autonomy and freedom often felt by students who had control over their own space for the first time. Pleasure was the dominant emotion felt by students when confronted with these new spaces. While Helena Swanwick's mother was appalled by the drab little space her daughter was to occupy, Helena herself remembered being 'speechless with delight'.[112] These spaces offered women in particular a new kind of freedom, an escape from the demands of domesticity and family that Virginia Woolf was to call for three decades later in her seminal essay 'A room of one's own'. E.E. Constance Jones praised the 'disciplined freedom' she found in the allocation of student spaces at Girton in 1875: 'as free from interruption as in a private house – or rather much more so. You had only to "sport your oak" by sticking a card labelled "Engaged" upon the door. Having the arrangement of your time to a great extent in your own hands, you could try and make the most of it.'[113] Helena Swanwick also prized freedom from cares of the home:

> To have a study of my own and to be told that, if I chose to put 'Engaged' on my door, no one would so much as knock was so great a privilege as to hinder me from sleep. I did not know till then how much I had suffered from the incessant interruptions of my home life. I could have worked quite easily in mere noise. I never found it at all difficult to do prep. in a crowded school room. What disturbed my mind were the claims my mother made on my attention, her appeals to my emotions and her resentment at my interest in matters outside the family circle.[114]

Some women were initially unsettled by the move from school to college. A student at St Hilda's recalled: 'at times one was very much alone in one's room which was a great change after living in a crowd in a large school . . . In time we learned to appreciate that privacy which at first rather appalled one.'[115] It was more usual for men to be sent away to school before they attended university,[116] so although men also took pleasure in their new spaces, they often reacted against school rather than home. The goods-filled student rooms bear testament to personal consumption that far outstripped what would have been allowed in the schools of the period.[117] R.G. Hollingwood, who had an unhappy school life, remembered going up to Oxford was 'like being let out of prison'.[118] Sir Gervase Rentoul recalled that 'released from the restraints of parental supervision and school routine' the student rooms 'gave me

more personal satisfaction at the time than any place of residence has done ever since'.[119]

University women, although under pressure to appear feminine to the outside world, did not always choose to recreate the femininity of the drawing room in their personal space. Although student rooms were usually partly institutionally furnished, male and female students could select smaller pieces of furniture and ornaments. Student rooms (frequently photographed and lovingly documented), can show us how far young people followed the decorative conventions of the middle-class home. An unusually large collection of photographs of 56 student rooms, taken at Holloway in the late 1890s, shows that some students draped and ornamented their rooms in 'feminine' fashion, while others did not. The photographs in figures 4.7 and 4.8 show just how different these rooms could look. Rooms at Girton were similarly varied.[120] Indeed, some women were also comfortable displaying objects that contemporary domestic advisers and some historians have strongly associated with masculinity.

Several of the women's rooms at Holloway show rugs that are clearly made of animal skin.[121] Miss Owen's room, shown in figure 4.9, prominently displays the skin of a dead crocodile. Weaponry also features in a photograph of an artistic tea party from 1897–98, shown in figure 4.10, which clearly shows a pair of fencing irons hanging from a wall.[122] We will never know why Miss Owen chose to hang a crocodile skin on her wall: it may have been a trophy from a colonial relative, and more than likely it was a means of making her own room (as one in a corridor of identical rooms) different and individual from those of her college fellows. Nevertheless, her willingness to display an object conventionally associated with masculinity is important. While the founders of the early women's colleges may have felt it necessary to use domestic space to impose feminine behaviour, the college's first female students did not feel bound to decorate in 'feminine' styles. At the very least, these rooms show that female students were unmindful of the gendered decorative conventions proffered by advice manuals of the period. They may even have been deliberately flouted instruction with these choices.

Male students also shied away from decorative convention. The late Victorian male student was fond of the motif of the hunt. Stag horns were displayed in rooms at Lincoln *c.*1865.[123] Landseer's stag, 'The Monarch of the Glen' was given pride of place in H.W. King's room at Selwyn.[124] But the most elaborate display of this kind of masculinity is in the Richard J. Reece rooms at Downing. There are two pairs of crossed swords and a pair of rifles hung from the walls, and on another wall a pair of pistols is arranged either side of a large shield and a pair of horns immediately above the pistols. However, not every room was stuffed

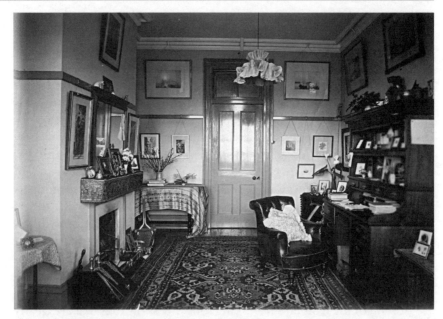

4.7 Photograph of Miss Russell's room

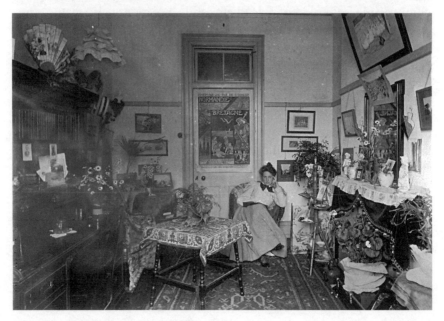

4.8 Photograph of Miss Tremlett's room

with hunting trophies and owners of more aesthetic rooms eschewed them. Moreover, male students were often quite happy to replicate the conventional femininity of the drawing room in their personal spaces.

Figure 4.11 shows a room at St John's, Cambridge. It illustrates that

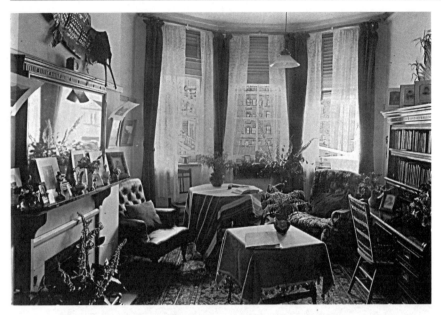

4.9 Photograph of Miss Owen's student room

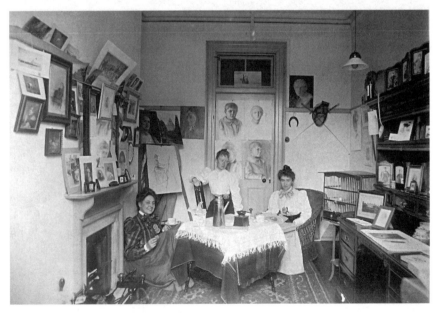

4.10 Tea party in Royal Holloway student room

men also chose to decorate their rooms with flowers, floral hangings and a large number of ornaments. Other photographs of male student rooms also include 'feminine' goods, including cut flowers, knick-knacks and clusters of decorative goods.[125] While these men may have yearned

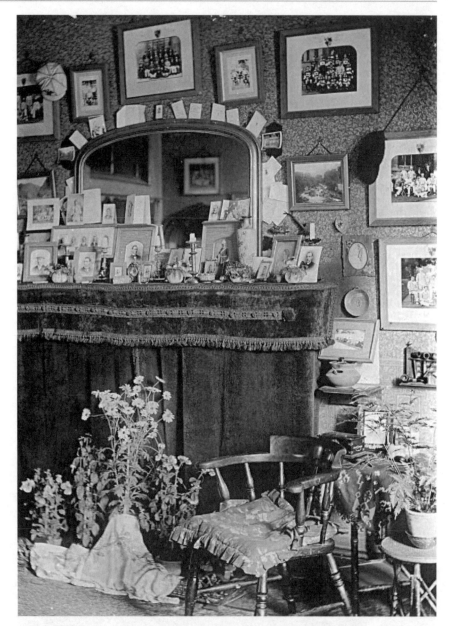

4.11 A student room, E6 New Court, at St John's College, Cambridge

for their mothers' drawing rooms, these photographs clearly compli-
cate the representation of gendered decorative choice offered in the
advice manual. Male space could include as many frills, knick-knacks
and ornaments as rooms belonging to women. The willingness of male
students to decorate in a style that art historians have termed 'feminine'
and, equally, the female students' choices to display 'masculine' objects,

suggests that the relationship between decoration and gender may be more fluid than contemporary advice manuals and some historians suggest. The careful investment of many male students in their heavily decorated rooms also implies that rather than being in flight from the femininity of the home, these men actively desired it, or were at least experimenting with it, choosing to invest time and resources in the creation of interiors for themselves and their friends.

Lodging: recapturing domesticity?

A far larger group of young people lived in lodgings in the nineteenth century. Middle-class lodging was a world apart from the densely packed and often insanitary common lodging houses inhabited by the working classes.[126] Nevertheless, there was considerable variation in middle-class lodgings. Young people might live on institutional premises, as was often the case with male and female school teachers. As Christopher Hosgood has shown, a growing number of young lower-middle-class shop workers lived in accommodation provided by shops, often in uncomfortable conditions and under severe restrictions that, he argues, compromised the status of shop workers as adults.[127] Even independent lodgings differed according to how much the lodger could afford. The more expensive sets of rooms maintained by a landlady, occupied either singly or with a chosen companion, were quite different from rooms in a lodging house where social space would be shared with the other lodgers and, potentially, the landlady's family.

Staying long term with relatives was also a solution for some young men and was considered particularly suitable for young women. As Styles has shown, for the eighteenth century, lodgers could be 'involuntary consumers': basic household goods were purchased by landladies and young men and women might have very little control over the material world around them.[128] Moreover, the enforced sociability of the lodging house in particular, and the need to placate landladies, could make lodgings uncomfortable and encouraged some young men to try to recreate the domesticity of the family home that they had intended to leave behind.

In the final decades of the nineteenth-century 'new woman' fiction introduced the single woman's quarters, reflecting a growing awareness of the position of independent women.[129] In George Gissing's *The Odd Women* (1893), Mary Barfoot and Rhoda Nunn – unmarried women who fight for single women's rights – live together in a house in which they create a professional, yet feminine, interior.[130] However, despite the growth of opportunities for women in the last decades of the nineteenth century, a single woman without friends might have struggled to find suitable lodgings. Anxieties ran high over young women living away

from home. A short article, 'Living in Lodgings', which appeared in the April 1900 edition of *The Girl's Own Paper*, stressed the importance of ritual dining, including the need to sit down to regular meals and to use the correct cutlery, including a separate knife for the butter.[131]

A series by Florence Sophie Davison, 'Three Girl Chums and their Life in London Rooms', appeared in nine issues of the paper between 1888 and 1889.[132] This offered girls advice on how to manage their households, through a fictional account of the experiences of three girls who had moved to London to work as a typist, cookery teacher and music teacher, and to live in a set of rooms in West Hampstead. The article emphasised how the women cooperated to achieve the same standard of housekeeping as they might get at home.[133] H.G. Wells's *Ann Veronica* (1909) demonstrates that even at the end of our period, the idea of a girl leaving home to fend for herself could still be represented as controversial. After an argument with her father, Ann Veronica leaves her suburban home and seeks work and lodgings in London. Here her new, unprotected and ambiguous status in society is underlined by her naive movements around the streets of London as she searches for lodgings, and there is a strong suggestion here that single women lodging alone were associated with prostitution. Wells's novel highlights the stigma and difficulties that could still be attached to a lone young woman seeking lodging: 'One or two landladies refused her with an air of conscious virtue she found hard to explain. "We don't let to ladies," they said.'[134] Other evidence also suggests that the search for lodgings for women was difficult. Mothers prized the names of reliable landladies and handed them down to their daughters, alongside special recipes.[135]

As Lynne Walker has shown, the absence of safe lodging for women was recognised as a problem by late nineteenth-century feminists. The Ladies Dwelling Company was set up by Agnes Garrett and her sister, Dr Elizabeth Garrett Anderson, and oversaw the building of chambers for women – Chenies Street Chambers (1889) and York Street Chambers in Marylebone (1891) – where professional women were able to have private rooms but where cleaning, cooking and laundry were shared.[136] It is likely that middle-class working women continued to find the search for lodging difficult into the twentieth century. In 1913, the Ada Lewis Lodging House for Women on the Old Kent Road was set up by a charitable committee. It was intended to supply poor women with lodging, and the building was set up with small cubicle-style rooms with meagre furnishings. Yet the authorities were swiftly inundated with requests from lower-middle-class women, often teachers and clerks, seeking safe habitation in the capital.[137]

A growing number of young women worked as teachers in this period: this often forced them to live away from home, either in lodgings

or accommodation provided by the school. Mary Hughes, who worked as a teacher before her marriage, had a mixed experience. Her first years were spent at Darlington, where her mother was able to follow her into nearby lodgings. The lodgings were extremely comfortable and her mother got on well with the landlady and her family: in fact, the kindness of the landlady in providing her with extra food proved vital when the school Hughes was working for fell into financial difficulty, reducing the quality of meals provided for the resident school staff.[138] When Hughes moved to a second school in West Kensington, she and her mother were initially allowed to reside near the school, in a flat above a grocer's shop, which they enjoyed extremely.[139] However, as the school expanded, they were requested to help support new boarding houses by living on site: this they did, but felt that their freedom and intimacy were severely curtailed.[140]

Single male school teachers also often had to live on site. Arguably, the situation was worse for female teachers at girls' schools, whose work was less prestigious and who had far fewer options if they chose to leave. Amy Barlow's account of life as a late nineteenth-century school teacher resounds with anger at the conditions in which female teachers were expected to live and work: her catalogue of woes included a miserly school that failed to provide the staff with sufficient bed coverings, forcing them to use sheets of newspaper.[141] She also resented the lack of privacy in sleeping accommodation: staff were not given separate rooms but made to share a room divided by curtains.[142] A particular indignity occurred when illness broke out at the school, staff quarters were used to isolate patients and the teachers were forced to occupy the tiny cubicles that had been used by the children: 'We were so close together that every sound made by one of us disturbed the others and those who went to early service on Sundays were cursed audibly by those who didn't.'[143] Barlow notes that her experience was shared by other female friends who taught in this period: a fellow girls' school teacher habitually headed her letters 'From Hell.'[144]

The greater economic resources and independence of young men meant that they were more likely to live away from home in lodgings. Young middle-class men chose to move out of the family home for a variety of reasons: convenience, new financial power or, in some cases, irritation with the family. The reminiscences of theatre critic Edward Whyte describe his decision to move out of home for the first time in 1895 – a choice motivated by the acquisition of a larger income and a desire for greater independence.[145] Novelist and biographer Colwyn Edward Vulliamy, the son of a minor Welsh squire, describes how he was shunted into a series of lodgings by his parents, simply because he was a nuisance at home in rural Wales.[146] The diaries of George Rose, a clerk at a gasworks in Dalston, recorded the process of transition from the family home in Ongar to lodgings in Kilburn in the early 1900s.

Rose was pushed from the family home by the inconvenience of the long daily commute from Ongar to Dalston, in combination with a growing irritation with his family. In early 1904, his diary expressed his dislike of his parents' visitors, noting 'undesirables in the dining room',[147] and in February of that year he was so irritated by a family conversation about music that he felt obliged to quit the room.[148] And yet when he finally made arrangements to move out in November of that year, he surveyed the Essex countryside with nostalgia and 'felt regretful' that he was leaving.[149]

Men who left the home before marriage tended to do so through necessity: and it was frequently the case that men moved for work (if independence was a draw, then so were the comforts of home). If work could be accommodated in the family home, then where possible this was achieved. After university, Charles Reilly lived at home in London in the 1890s while training to be an architect. He recalls how the spatial structure of his parents' unusual house was adapted to meet his needs: 'I was given the old breakfast-room at the end of the one of the wings as a bedroom . . . but it meant I could get to it at night in our queerly planned house without going through anyone else's bedroom.'[150]

Lodgings offered the possibility of great pleasure. The freedom of bachelor rooms was celebrated in Arthur Conan Doyle's depiction of the detective, Sherlock Holmes. Famously, Conan Doyle depicted rooms at 221B Baker Street, shared by Holmes and his companion Dr Watson: 'They consisted of a couple of comfortable bedrooms and a single large airy sitting-room, cheerfully furnished, and illuminated by two broad windows.'[151] Roomy and spacious, yet somehow available at a reasonable price, the rooms represent ideal bachelor living in London. Here Holmes is able to pursue antisocial activities such as tuneless violin playing and drug taking, and to receive unsavoury visitors that would not be tolerated in a family home or a lodging house.[152] Feminine comforts are secure, as the men are ministered to by the landlady, the faithful Mrs Hudson. Rather than having to socialise awkwardly with other lodging house clientèle, the men are served their meals in private, at times of their own choosing.[153] While this representation is somewhat idealised, it is clear that lodgings could offer men the opportunity to indulge in activities that might have been frowned upon or restricted at home. An unidentified photograph of two young men smoking in lodgings, shown in figure 4.12, demonstrates the pleasures of homo social conviviality, and hints at the new freedoms that independent space might offer.

Independence was far greater for those who could afford private rooms, rather than sharing social space in a lodging house. Vulliamy, when dispatched by his parents to study at the Newlyn School of Art, took rooms in the town, and recalls that, 'one of our chief joys in

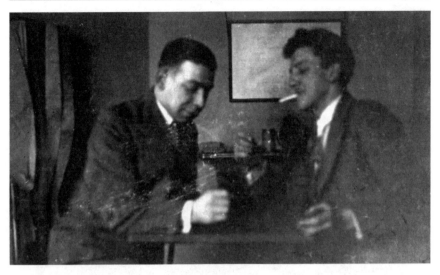

4.12 Simon Bacola with a friend (bachelor's quarters)

Newlyn was the freedom with which we could run in and out of each others rooms'.[154] Similarly, Whyte looked back on his early lodgings as a source of pleasure and excitement. Whyte moved to a second set of lodgings on Adam Street after Villiers Street, which he particularly praised, and shared with a colleague from Cassells, W.F. Shore.[155] Yet both of these writers occupied privileged positions: Vulliamy was funded by his parents, and Whyte had a successful literary career. Their experiences were a far cry from the experiences of lower middle-class clerks living in cheaper lodging houses and commuting across London to earn a wage.

Young men who lodged away from home could savour independence, but the world of lodging (and the lodging house in particular) also offered new checks and impositions. Far fewer photographs of lodging house rooms survive than of student rooms. Images of the student room abound partly because they have been preserved by college archivists, whereas the records for lodging are fragmentary, but it may also be that lodging rooms were seen as convenient resting places and were not cherished in the same way. A longing for domestic comforts was a common experience. In his account of living in lodgings before his marriage, in Lancashire and Newcastle in the 1840s, the Congregationalist minister James Guinness Rogers recalled: 'smarting under the annoyances of lodgings, and longing for a home of my own'.[156]

The Rose diaries reveal the more mundane everyday trials and tribulations of a London lodger. Rose's troubles began in October 1904, shortly after he had left the family home to lodge in Kilburn. Here he missed the seclusion of the family home, and, in particular, access to the piano: although there was a piano in the lodging house he felt uncomfortable

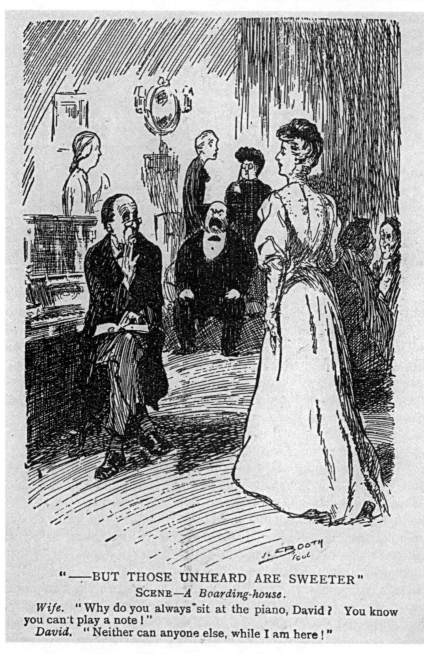

"——BUT THOSE UNHEARD ARE SWEETER"
SCENE—*A Boarding-house.*

Wife. "Why do you always sit at the piano, David? You know you can't play a note!"
David. "Neither can anyone else, while I am here!"

4.13 J.E. Booth, 'But Those Unheard are Sweeter', 1906

playing it in front of the other lodgers.[157] He also found it difficult to fit in with the set meal times provided by his landlady, and felt frustrated when these did not conform to a regular pattern: 'What a wretched poor existence this is when there is a landlady to combat, when meals are irregular

and time is wasted.'[158] Comfort and routine were absent from his new life: 'There's no such thing as settling down in this boarding house. Duncan tells me that one never does.'[159] As the month wore on, the situation worsened and on 28 October he wrote: 'My condition is little short of madness now!' In November, the situation improved a little, and Rose was able to arrange his boarding house bedroom as a studio: 'Tonight I have invested in a lamp for my little bedroom in order that I may work there and find it gives me great satisfaction.'[160] However problems resurfaced in December: 'The depressing glimmer of street lamps and the muddy aspect of everything all tend that way and added to that the discomforts allied to boarding house life . . . now make a sufficient total of wretchedness.'[161] December saw further rows with the landlady:

> considered myself a martyred hero this morning I went off without my breakfast. It has been late every morning so tonight I expect Mrs Mac to be humbly apologetic. But what is my astonishment to find that it was entirely my fault. She talked to me for ten minutes asserting such things and in so voluble and ear piercing a tone that I was soon persuaded that she and all her servants were the martyrs not I.[162]

During the following year, Rose changed his lodgings, 'to be quit of the tie of the 7 o'clock dinner.'[163] But it was not long before he was in conflict with his new landlord, this time over piano playing: 'Strange, that this same Sunday a year ago I should have been troubled with precisely the same annoyance: an impertinent landlord.'[164]

The trials of living in lodgings may have contributed to the continual reliance on goods and assistance from home. When they set up their first homes, many young men were heavily assisted by their mothers and sisters. Young doctors, moving away from home to set up practices for the first time, were often helped out in this way. Anthony Weymouth recalls how, when he decided to take a house, 'My mother and Miss Yardley [a family friend] set out to find one for me.'[165] When Dr Hartley moved from the North to Bedford to set up his first practice, his diaries reveal the painstaking efforts of his sister who stayed for a number of weeks at his house, arranging furniture and hanging curtains.[166] Anxious mothers who had plied their sons with food parcels at school continued to send foodstuffs to sons in lodgings. The letters of George Vivian Poore, when at his first practice in Shepperton in the 1860s, show a son actually having to urge his mother to cease sending him food parcels as these were creating a conflict with the landlady:

> My landlady is a perfect creature, neat, clean as a pink in everything she does, obliging and last but not least she is a professed cook of the first style of excellence & as I have compounded with her to board and lodge me for a

stated sum I am loath to interfere with what Miss Jane Perkins would have called her little domesticities.'[167]

Some forty years later, Maurice Bonham-Carter, a recent graduate who had taken a job in a metal works near Edgbaston, was also reliant on his mother's advice via letter when he took lodgings. His difficulties arose on being obliged to select his own dinner: 'I think I shall be comfortable here, it is clean and the food good enough, though I am supposed to order my own dinner, which is a nuisance, as I have already said "mutton and beef" and I cannot think what to say next.'[168]

If home was far away, men in lodgings might resort to other strategies to maintain domestic comforts. The period 1870–1914 saw a peak in middle-class club culture in London.[169] Amy Milne Smith argues that clubland in this period functioned as a rival domestic space for upper-class men, and had a particular appeal for bachelors who lived under the parental roof and wielded no patriarchal authority.[170] Single men who could afford it may well have chosen to dine at their clubs, like Harvey Rolfe in George Gissing's *The Whirlpool* (1897), who, 'had known of the pasture of poverty, and the table as it is set by London landladies; to look back on these things was to congratulate himself that nowadays he dined [in the club]'.[171] Yet the social connections and cash required for club membership were beyond the means of most middle-class young men,[172] so further efforts were required to avoid the cold and dreary lodging house.

One option was to attach oneself as a satellite to a nearby family home, and to visit regularly. Richard Church recalls that his brother spent a great deal of time away from their joint lodgings at the home of his fiancée.[173] Maurice Bonham-Carter, when in Edgbaston, also arranged to spend Sundays with the Steer family, who were friends of his parents.[174] When George Rose came to London he spent much time with his relatives, the Kennedys. A succession of young women also caught his interest, which would result in frequent visits to their homes. Even when a potential love interest was out of favour, Rose was not above considering a visit to the house on material grounds alone. In February 1906, tired of the lack of warmth in his lodgings bedroom, he wrote: 'no comfort for me all day. I would even (secretly) perhaps have been glad to have gone to the Grants for the sake of creature comforts. But I refrained and made up my mind to advertise for a homely lodging.'[175]

Conclusion

The new material worlds of school children, students and young men and women living in lodgings reveal how the experience of leaving

home changed in late nineteenth-century England. Domesticity was altered: but this shift was not as sharp as some historians have argued. The reformed boys' public schools and secondary education for girls produced increasingly institutionalised spaces that emphasised the distance between home and school for their occupants. However, these institutions retained some links with the family, through the flow of letters and goods that were sent to the schools by parents, and through the socio-spatial structure of the schools themselves, which were often designed to mimic family structure. Boys were particularly subject to spatial discipline, and isolation within a peer group was a crucial part of the institutionalised bullying that took place in some schools. There were limits, however, to the control that could be exerted through space: the physical environments of schools varied, leading to different experiences of autonomy. Schools for boys and girls built gendered identities through material culture: girls, in particular, seem to have been encouraged to cherish home possessions. However, while some schools systematically stripped children of their goods, some boys' schools allowed the re-creation of the home in the study, where boys often embraced the seemingly feminine domesticity of the parlour and drawing room.

Male and female students were given far more freedom, although they too were subject to control. College girls were often delighted with their rooms, and their new-found ability to shut their doors to family cares. Nevertheless, the domestic arrangements of the early colleges for women, particularly Holloway, demanded a certain degree of domesticity from its occupants. College girls did not find this unduly arduous, mixing customs from home, such as the 5 o'clock tea, with the new sociability of college life. Men at college were under far less pressure to imitate the life of the home: nevertheless, their carefully decorated studies and well-organised parties often suggest competent and pleasurable engagement with domesticity. The material culture of the student room, displayed in the many photographs that were produced, demonstrates that young men were quite comfortable to fill their rooms with the trappings of the conventional middle-class parlour, often displaying goods that advice manuals labelled feminine. If anyone here was in flight from domesticity, it was perhaps the rebellious girl students who decked their rooms with tokens of the hunt. Gendered prescriptions seem to have been, if not flouted, then virtually ignored. These rooms are a testament to the limits of the influence of domestic advice literature in this period, and perhaps, the search for new kinds of identity that moved away from that of their parents.

Finally, young men and young women who lived in lodgings also experienced some freedoms, yet the conditions they found could increase their desire for the comforts of a family home. The growth of the

white-collar service sector and the increase in women's secondary and higher education pushed more women into the workplace in this period. While the 'new woman' who threatened the stability of the family by moving into lodgings and relinquishing marriage was a popular cultural stereotype, young women who sought lodgings beyond the protection of parental and family networks could be perceived as morally ambiguous, and respectable accommodation could be difficult to acquire. The majority of girls who worked after college went on to teach in schools. Here, living conditions could be very restricted indeed, and young women chafed against them. Young men living away from home had more job options and were freer in their choice of accommodation.

However, the experiences of young men in lodgings in the late nineteenth century do not suggest that they were in flight from domesticity. While the freedoms offered by bachelor rooms were an agreeable fantasy, those without the means for independent rooms could find the privations of the lodging house far worse than the irritations of the family circle. Lodging house living meant turning up at set times for meals, sharing parlour and dining spaces with unsavoury fellow lodgers, and the potential tyranny of the landlord or landlady. Indeed, the discomforts of lodging were such that many young men adopted strategies to regain the domesticity of the family home. Female relatives were imported to help establish domestic interiors, food parcels were despatched by anxious mothers. Wealthier men could dine at the club, others were able to attach themselves as satellites to the homes of friends and family. Almost as soon as many men had thrown off the shackles of the family home it seems that they sought to regain it, and the next logical step was marriage and the establishment of a family for themselves.

Notes

1 M. Pick, 'Social life at R.H.C 1887–1939', RHCA, RHC RF/131/7, p. 47.

2 Ibid., p. 45.

3 Ibid., p. 400.

4 Ibid., p. 100.

5 Tosh notes that many middle-class boys were not sent away to school. J. Tosh, *A Man's Place: Masculinity and the Middle-Class Home in Victorian England* (London: Yale University Press, 1999), p. 119.

6 C. Shrosbree, *Public Schools and Private Education: The Clarendon Commission 1861–64 and the Public School Acts* (Manchester: Manchester University Press, 1988), p. 2.

7 Anne Digby and Peter Searby, *Children, School and Society in Nineteenth-Century England* (London: Macmillan, 1981), p. 12.

8 Ibid., p. 11.

9 Joan N. Burstyn, *Victorian Education and the Ideal of Womanhood* (London: Croom Helm, 1980), p. 22.

10 Christina de Bellaigue, *Educating Women: Schooling and Identity in England and France 1800–1867* (Oxford: Oxford University Press, 2007).

11 Burstyn, *Victorian Education*, p. 24.

12 Ibid., p. 26.

13 Digby, *Children, School and Society*, p. 52.

14 E. Finlay, *St Swithun's School, Winchester 1884–1934* (Winchester: Warren and Son Ltd, 1932), p. 9.

15 Digby, *Children, School and Society*, p. 51.

16 F.M.G. Willson, *The University of London 1858–1900: The Politics of Senate and Convocation* (Suffolk: The Boydell Press, 2004), pp. 1 and 7.

17 Stuart Marriott, *Backstairs to a Degree: Demands for an Open University in Late Victorian England* (Leeds: Leeds Studies in Adult and Continuing Education, 1981), p. 3.

18 Thomas Kelly, *For Advancement of Learning: The University of Liverpool 1881–1981* (Liverpool: Liverpool University Press, 1981), p. 61.

19 In 1902, Victoria University had a student body of approximately 500. Kelly, *For the Advancement of Learning*, p. 65. In 1900, 1917 men and women matriculated at the University of London, but only a quarter of these students went on to take degrees. Willson, *The University of London*, p. 5.

20 Mary Hilton and Pam Hirsch (eds), *Practical Visionaries: Women, Education and Social Progress 1790–1930* (London: Longman, 2000), p. 8.

21 Carol Dyhouse, *No Distinction of Sex? Women in the British Universities, 1870–1939* (London: University College London Press, 1995), p. 12.

22 Kelly, *For the Advancement of Learning*, p. 93.

23 Dyhouse, *No Distinction of Sex*, p. 25.

24 William C. Lubenow, 'University History and the Histories of Universities in the Nineteenth Century', *Journal of British Studies*, 13:2 (2000), p. 53.

25 M.C. Curthoys and J. Howarth, 'Origins and Destinations: The Social Mobility of Oxford Men and Women', in M.G. Brock and M.C. Curthoys (eds), *The History of the University of Oxford, vol. VII nineteenth-century Oxford, part 2* (Oxford: Oxford University Press, 2000), pp. 581–582.

26 Brock and Curthoys, 'Origins and Destinations', p. 58; C. Bingham, *The History of Royal Holloway College 1886–1986* (London: Constable, 1987), p. 78.

27 Paul R. Deslandes, *Oxbridge Men: British Masculinity and the Undergraduate Experience* (Bloomington: Indiana University Press, 2005), pp. 64–70.

28 G. Anderson, *Victorian Clerks* (Manchester: Manchester University Press, 1976), p. 2.

29 Gregory Anderson, 'The White Blouse Revolution', in Gregory Anderson (ed.), *The White-Blouse Revolution: Female Office Workers since 1870* (Manchester: Manchester University Press, 1988), p. 4.

30 Anderson, 'The White Blouse Revolution', p. 7; Christopher Keep, 'The cultural work of the typewriter girl', *Victorian Studies* 40:3 (1997), 401–426.

31 Between half and three quarters of early women graduates were destined for teaching. Dyhouse, *No Distinction of Sex*, p. 18.

32 Colin G. Pooley and Jean Turnbull, 'Leaving Home: The Experience of Migration from the Parental Home in Britain since *c.*1770', *Journal of Family History* 22:4 (1997), 416,

406. However, they also note that increasing geographical distance did not necessarily mean more distant family relationships as increasing leisure time and better transport facilities made it easier for young people later in the century to maintain contact with the family home. Pooley and Turnbull, 'Leaving Home', 421–422.

33 Leonore Davidoff, Megan Doolittle, Janet Fink and Katherine Holden, *The Family Story: Blood, Contract and Intimacy 1830–1960* (London: Longman, 1999), p. 178.

34 A.C. Kay, 'A little Enterprise of her Own: Lodging-house Keeping and the Accommodation Business in Nineteenth-century London', *The London Journal* 28: 2 (2003), 43.

35 Davidoff et al., *The Family Story*, p. 180.

36 A.G. Bradley, A.C. Champneys and J.W. Baines, *A History of Marlborough College: During Fifty Years from its Foundation to the Present Time* (London: Murray, 1893), p. 122; A Victorian Child [pseudo. Olive Haweis] *Four to Fourteen* (London: Robert Hale, 1939), p. 38.

37 J. Howard Brown, *A Short History of Thame School of the Foundation of Sir John Williams Knight, Lord Williams of Thame* (London: Hazell, Watson & Viney, 1927), p. 125.

38 See for example: Hilda Sebastian to her mother, 23 Feb. 1912, 11 May 1912 and 17 May 1912, ESRO, ACC 5456.

39 Hilda Sebastian to her mother, 28 June 1912, ESRO, ACC 5456.

40 Ibid.

41 Hilda Sebastian to her mother, 30 June 1912, ESRO, ACC 5456.

42 Bellaigue, *Educating Women*, p. 19.

43 Ibid., p. 21.

44 For example, Beryl Lee Booker, Noel Streatfeild and the author of *Four to Fourteen* both attended small-scale private schools for girls in the late nineteenth century. Haweis, *Four to Fourteen*, p. 30; N. Streatfeild, *A Vicarage Family* (London: Collins, 1963), p. 110; Beryl Lee Booker, *Yesterday's Child: 1890–1909* (London: Long, 1937), p. 54.

45 Streatfeild, *A Vicarage Family*, p. 116.

46 Joyce Senders Pedersen, *The Reform of Girls' Secondary and Higher Education* (London: Garland, 1987), p. 310.

47 Bellaigue, *Educating Women*, p. 23.

48 Amy K. Clarke, *A History of the Cheltenham Ladies College 1851–1953* (London: Faber & Faber, 1953), p. 63; Dorothy E. de Zouche, *Roedean School 1885–1955* (Brighton: Printed for private circulation, 1955), p. 39.

49 Finlay, *St Swithun's School*, p. 21.

50 Ibid., p. 47.

51 J.B. Hope Simpson, *Rugby since Arnold: A History of Rugby School from 1842* (London: Macmillan, 1967), p. 7.

52 Bellaigue, *Educating Women*, pp. 16–17.

53 Lionel Cust, *A History of Eton College* (London: Duckworth & Co., 1899), p. 211; Bradley et al., *History of Marlborough*, p. 57.

54 A.K. Boyd, *The History of Radley College 1847–1947* (Oxford: Basil Blackwell, 1948), p. 5.

55 W. Furness, *The Centenary History of Rossall School* (Aldershot: Gale & Polden, 1945), p. 243.

56 J. D'e Firth, *Winchester College* (London: Winchester Publications, 1949), p. 175.

57 Tosh, *A Man's Place*, p. 118.

58 R. St C. Talboys, *A Victorian School: Being the Story of Wellington College* (Oxford: Basil Blackwell, 1943), p. 17.

59 Furness, *The Centenary History of Rossall School*, pp. 250–251.

60 Boyd, *History of Radley College*, p. 41.

61 Bradley et al., *A History of Marlborough*, p. 74.

62 M.V. Hughes, *A London Family 1870–1900* (Oxford: Oxford University Press, 1991), p. 165.

63 Although unwritten codes were often followed. E. Finlay, *St Swithun's School*, p. 43.

64 Q. Colville, 'The Role of the Interior in Constructing Notions of Class and Status: Case Study of Britannia Royal Naval College Dartmouth, 1905–39', in P. Sparke and S. McKellar (eds), *Interior Design and Identity* (Manchester: Manchester University Press, 2004), p. 124.

65 Hope Simpson, *Rugby since Arnold*, p. 6; Rupert Hugh Wilkinson, *The Prefects: British Leadership and the Public School Tradition* (Oxford: Oxford University Press, 1964), p. 31.

66 E.L. Grant Watson, *But to What Purpose: The Autobiography of a Contemporary* (London: Cresset Press, 1946), pp. 30–31.

67 Wilkinson, *The Prefects*, pp. 116–118; J.R. De S. Honey, *Tom Brown's Universe: The Development of the Victorian Public School* (London: Millington, 1997), pp. 229–237.

68 Malcolm Seaborne, *The English School: Its Architecture and Organisation* (London: Routledge & Kegan Paul, 1971), p. 182.

69 Peter Bennett, *A Very Desolate Position: The Story of the Birth and Establishment of a Mid-Victorian Public School* (Blackpool: Rossall Archives, 1992), p. 124.

70 Boyd, *History of Radley*, p. 241.

71 According to the historian of Marlborough, the first large boarding house run not for profit was instituted at Marlborough in 1843. A.G. Bradley et al., *A History of Marlborough College*, p. 56. Boarding houses at Sherborne were also initially run by masters for their won private speculation. A.B. Gourlay, *A History of Sherborne School* (Winchester: Warren and Son, 1951), p. 269. Cust, *A History of Eton*, p. 209. At Winchester, boarding houses reformed in the late 1850s and 1860s. D'e Firth, *Winchester College*, p. 135.

72 P.H.M. Bryant, *Harrow* (London: Blackie & Sons, 1936), p. 107; *Yesterday's Child*, p. 112. Also Rossall. *A Very Desolate Position*, p. 124.

73 D'e Firth, *Winchester College*, p. 210.

74 Ibid., p. 210.

75 Boyd, *History of Radley*, pp. 41–42.

76 Tosh, *A Man's Place*, p. 105; Honey, *Tom Brown's Universe*, pp. 110–112.

77 Bellaigue, *Educating Women*, p. 232.

78 Talboys, *A Victorian School*, p. 51.

79 Ian Hay, *The Lighter Side of School Life* (London: T.N. Foulis, 1914), p. 196.

80 Talboys, *A Victorian School*, p. 47.

81 Graham Seton Hutchison (Lieutenant-Colonel G.S. Hutchison), *Footslogger: An Autobiography* (London: Hutchinson & Co., 1931), p. 25.

82 Barlow, *Seventh Child*, p. 59.

83 Boyd, *History of Radley College*, p. 5.

84 Bennett, *A Very Desolate Position*, p. 132.

85 Ibid., p. 132.

86 Eliot Crawshay Williams, *Simple Story: An Accidental Autobiography* (London: John Long, 1935), p. 35.

87 Williams, *Simple Story*, p. 42.

88 Photograph album of Margaret Elsie Hughes, ESRO, AMS 6570 1/1.

89 M.G. Brock, 'A Plastic Structure', in Brock and Curthoys, *The History of the University of Oxford*, vol. VII, p. 21.

90 See A.C. Deane, *Time Remembered* (London: Faber & Faber, 1945), p. 48; A. Birrell, *Things Past Redress* (London: Faber & Faber, 1937), p. 63; R.R. Marett, *A Jerseyman at Oxford* (Oxford: Oxford University Press, 1941), p. 60.

91 G. Rentoul, *This Is My Case: An Autobiography* (London: Hutchinson & Co, 1944), pp. 32–33.

92 Notebook of C.J. Faulkner, 1879, UCA, UC.FA6/1/MS1/3.

93 Miss Beale to Mrs Burrows, 4 Jan. 1894, in M. Clewlow (ed.), 'Ammonites and Moabites: The Letters of Dorothea Beale and Esther Burrows 1892–1905' (Unpublished edition for MA in Archiving, University College London, 1995), p. 43.

94 Girton College household regulations, 1912, GCA, C1 29 7.

95 M. Birney Vickery, *Buildings for Bluestockings: The Architecture and Social History of the Women's Colleges in Late Victorian England* (London: Associated University Presses, 1999), p. 143.

96 S. Delamont, 'The Domestic Ideology and Women's Education', in S. Delamont (ed.), *The Nineteenth-Century Woman: Her Cultural and Physical World* (London: Croom Helm, 1978), p. 146.

97 At Somerville in 1879 it was expected that daily intercourse would be similar to that of a country house party. Pauline Adams, *Somerville for Women: An Oxford College 1879–1993* (Oxford: Oxford University Press, 1996), p. 105.

98 Caroline Bingham, *The History of Royal Holloway College 1886–1986* (London: Constable, 1987), pp. 79–80.

99 Diaries of Winifred Seville, 1906–1910, RHCA, RF/136/9.

100 H.M. Swanwick, *I Have Been Young* (London: Victor Gollancz, 1935), p. 117.

101 C. Bede, *The Adventures of Mr Verdant Green, An Oxford Freshman* (London: Nathaniel Cooke, 1853), part 1, pp. 66–67.

102 Ibid., p. 117.

103 F.H.H. Guillemard, 'The Years the Locusts Have Eaten, 1852–1923', GCCA, PPC/GUI102.

104 Ibid., p. 109.

105 Photograph album, probably of Charles Crisp, 1897–1900, UCA, UC:P53/P/1.

106 HCA, Reminiscences: Hamilton, E.B., p. 3.

107 E.E.R. Mumford, *Through Rose-Coloured Spectacles: The Story of a Life* (Leicester: Edgar Backus, 1952), p. 41.

108 F.A. Keynes, *Gathering up the Threads: A Study in Family Biography* (Cambridge: Heffer & Sons, 1950), p. 38.

109 L. Dowling, *Hellenism and Homosexuality in Victorian Oxford* (London: Cornell University Press, 1994), p. 117.

110 Brian Lunn, *Switchback: An Autobiography* (London: Eyre & Spottiswoode, 1948), p. 70.

111 Swanwick, *I Have Been Young*, p. 122.

112 Ibid., p. 117.

113 E.E. Constance Jones, *As I Remember: An Autobiographical Ramble* (London: A & C Black, 1922), p. 69.

114 Swanwick, *I Have Been Young*, p. 118.

115 Reminiscences of E.B. Hamilton, HCA, Reminiscences: Hamilton, E.B., 1898–1901.

116 The nineteenth century saw an expansion in the public school system. J.A. Mangan, *Athleticism in the Victorian and Edwardian Public School: The Emergence and Consolidation of an Educational Ideology* (Cambridge: Cambridge University Press, 1981), p. 2.

117 At the Britannia Royal Naval College at Dartford, for example, possessions were stripped away when cadets entered college, only five shillings spending money was allowed and the adornment of dormitory walls was not permitted. Colville, 'The Role of the Interior', p. 122.

118 R.G. Collingwood, *An Autobiography* (Oxford: Oxford University Press, 1939), p. 12.

119 Rentoul, *This is My Case*, p. 33.

120 For example, at Girton there is a contrast between the knick-knack filled space in an album from 1902–3, GCA, small album Ph 10 Folio Box 1, and the plainer space shown in Miss Mary Lynch's album, 1894–1897, GCA, Ph 10 3.

121 Photograph of Miss Vivian's room, RHCA, RHC, PH/116/53; Photographs of Miss Shipley's room, RHCA, RHC PH/116/42; RHC PH/116/43.

122 Photograph of tea party, RHCA, RHC PH/271/5.

123 Photograph of an unidentified student room, *c*.1865, LCA, uncatalogued.

124 Photograph album belonging to G.W. Saunders, 1900–1, SECA, C TRM 37.

125 Album containing photographs of A.R. Ingram's rooms, 1898, JCL, Album 25; SECA, C TRM 37.

126 Raphael Samuel, 'Comers and Goers', in H.J. Dyos and Michael Wolff (eds), *The Victorian City: Images and Realities* (London: Routledge, 1973), vol. 1, pp. 127–128.

127 Christopher P. Hosgood, 'Mercantile Monasteries: Shops, Shop Assistants and Shop Life in Late Victorian and Edwardian Britain', *Journal of British Studies* 38:3 (1999), 331–335.

128 John Styles, 'Lodging at the Old Bailey', in John Styles and Amanda Vickery (eds), *Gender, Taste and Material Culture in Britain and North America* (London: Yale, 2006), p. 77.

129 For discussions of the rise of new woman fiction see: Gail Cunningham, *The New Woman and the Victorian Novel* (London: Macmillan, 1978); Ann Heilmann, *New Woman Strategies: Sarah Grand, Olive Schreiner, Mona Caird* (Manchester: Manchester University Press, 2004); Ann Heilmann and Margaret Beetham (eds), *New Woman Hybridities: Femininity, Feminism and International Consumer Culture 1880–1930* (London: Routledge, 2004); Angelique Richardson and Chris Willis (eds), *The New Woman in Fiction and in Fact: Fin-de-Siecle Feminisms* (London: Palgrave, 2001).

130 G. Gissing, *The Odd Women* (London: Lawrence & Bullen, 1893), vol. 1, p. 54.

131 [Anon.], 'Living in Lodgings', *The Girl's Own Paper*, 16 April 1900, p. 563.

132 *Girl's Own Annual*, 15 Oct. 1898, pp. 58–59; 18 Nov. 1898, pp. 126–127; 17 Dec. 1898, pp. 186–187; 14 Jan. 1899, pp. 252–3; 11 Feb. 1899, pp. 312–314; 1 April 1899, pp. 428–429; 15 July 1899, pp. 628–629; 26 Aug. 1899, pp. 762–763; 16 Sept. 1899, pp. 806–807.

133 *Girl's Own Annual*, 15 Oct. 1898, p. 58.

134 H.G. Wells, *Ann Veronica* (London: Fisher Unwin, 1909), p. 78.

135 Diary of Ann Eliza Branfill, 1859, ERO, D/DRu/F12/31.

136 Lynne Walker, 'Home and Away: The Feminist Remapping of Public and Private Space in Victorian London', in Iain Borden, Joe Kerr, Jane Rendell, with Alicia Pivaro (eds), *The Unknown City: Contesting Architecture and Social Space* (London: Massachusetts Institute of Technology, 2001), p. 303.

137 Ada Lewis Lodging House for Women, Committee Report December 1914, LMA, LMA/4318/B/03/013.

138 Hughes, *A London Family*, p. 286.

139 Ibid., p. 299.

140 Ibid., p. 310.

141 Barlow, *Seventh Child*, p. 53.

142 Ibid., p. 54.

143 Ibid., p. 55.

144 Ibid., p. 56.

145 Frederic Whyte, *A Bachelor's London: Memories of the Day Before Yesterday 1889–1914* (London: Grant Richards, 1941), pp. 270–271.

146 C.E. Vulliamy, *Calico Pie* (London: Michael Joseph, 1940), p. 52.

147 Diaries of George H. Rose, January 1904, ERO D/DU 418.

148 2 February 1904, ERO D/DU 418.

149 5 September 1904, ERO D/DU 418.

150 C.H. Reilly, *Scaffolding in the Sky: A Semi-Architectural Autobiography* (London: Routledge & Sons, 1938), p. 59.

151 Arthur Conan Doyle, *The Study in Scarlet* (London: Ward, Lock, Bowden & Co., 1891), pp. 16–17.

152 Ibid., pp. 23–25.

153 Ibid., p. 26.

154 Vulliamy, *Calico Pie*, p. 107.

155 Whyte, *A Bachelor's London*, p. 273.

156 J. Guinness Rogers, *An Autobiography* (London: James Clarke & Co., 1903), p. 104.

157 6 October 1904, ERO D/DU 418.

158 26 October 1904, ERO D/DU 418.

159 21 October 1904, ERO D/DU 418.

160 13 November 1904, ERO D/DU 418.

161 3 December 1904, ERO D/DU 418.

162 5 December 1904, ERO D/DU 418.

163 7 October 1905, ERO D/DU 418.

164 31 December 1905, ERO D/DU 418.

165 A. Weymouth, *Who'd be a Doctor? An Autobiography* (London: Rich & Cowan, 1937), p. 112.

166 Diary of Dr A Conning Hartley, January and February 1892, B&L, FAC 6811.

167 George Vivian Poore to his mother, 8 June 1866, HRO 39M85/PC/F27/5.

168 Maurice Bonham-Carter to his mother, 28 September 1903, HRO 94M72/F970.

169 A. Milne-Smith, 'A Flight to Domesticity? Making a Home in the Gentleman's Clubs of London, 1880–1914', *Journal of British Studies* 45:4 (2006), 799.

170 Ibid., 804.

171 George Gissing, *The Whirlpool* (London: Lawrence and Bullen, 1897), p. 1.

172 Anthony Le Jeune, *The Gentlemen's Clubs of London* (London: Malcolm and Jane's, 1979), p. 14. Tosh suggests that young men could afford it. Tosh, *A Man's Place*, p. 128. But as yet little detailed research has been done on the social composition of these clubs.

173 R. Church, *Golden Sovereign: A Conclusion to Over the Bridge* (London: Heinemann, 1951), p. 24.

174 Maurice Bonham-Carter to his mother, 28 September 1903, HRO, 94M72/F970.

175 4 February 1906, ERO D/DU 418.

5 ✧ Death, memory and the reconstruction of home

STANLEY LUPINO, the son of a struggling theatrical family, remembered how his mother's death in 1899 was accompanied by the loss of the family furniture: 'She died the same morning as the brokers came to take away the poor little home that she had struggled to keep together for so long.'[1] For the five-year-old Lupino, the emotional loss of his mother was accompanied by material loss, and the two reinforced each other: 'The full tragedy of her loss only dawned on me the day after her funeral, when the brokers came in. I was left behind to see stick after stick of our furniture being taken out, leaving an empty room, while I was unable to stop it all, and, of course, could not understand it.'[2]

This example demonstrates not only the damaging material impact of the death of a parent, but also the way in which domestic objects could be freighted with new emotional significance in the wake of death. This chapter examines what happened to space and material culture in the home on the death of a family member. The first part shows how the advent of death transformed home life, focusing on the sick room, the display of the body and the sorting of the deceased's mundane goods. The second part examines the way in which goods were willed to relatives, continuing family relationships and carrying ideas of class and gender beyond the grave. Finally, the chapter looks at how homes were re-established after the deaths of mothers and fathers. For widows, the biggest challenge was often keeping the home together materially, after the loss of their husband's income. Widowers, although often better off, might struggle with the difficulties of managing a home alone and, in particular, with the notion that men alone could not provide the necessary emotional support to bring up children.

Between 1850 and 1910 the experience of death altered. There was a noticeable decline in the death rate in England and Wales from 21.8 per 1,000 in 1868 to 18.1 in 1888, reducing to 14.8 in 1908 and 11.7 in 1928.[3] Pat Jalland argues that this demographic shift, combined with

the wane of evangelicalism in the last quarter of the nineteenth century, brought about a significant change in attitudes to death among the upper and middle classes, and a decline in traditional assurances about death and immorality.[4] David Cannadine suggests that the second half of the nineteenth century saw a decline in the celebration of death, but a rise in its glorification, until this was muted by the horrors of the First World War.[5] For Phillipe Ariès the main transition in Western attitudes to death occurred later, between 1930 and 1950, as the 'hushing up of death' accelerated owing to the displacement of the site of death, and its movement from the home to the hospital.[6] However, Julie-Marie Strange has recently pointed out that there was also continuity in working-class cultures of death: burial customs remained unchanged until the Second World War, with corpses continuing to be held in the home for the period preceding interment.[7] It is clear that although the death rate declined in the decades before the First World War (and therefore attitudes towards it began to shift), death remained firmly located in the home until the end of our period and continued to have a profound influence on material culture and family life, which is explored in this chapter.

The Victorian middle classes are famous for their ostentatious material culture of death, but less attention has been paid to the role of everyday goods in memory making. James Curl has demonstrated the extent of elaborate Victorian funerals and burial practices.[8] The nineteenth-century middle classes were very open about death and grief, and this was expressed through the display of the body in the home and the cherishing of physical tokens of the dead, such as photographs of the body.[9] But more mundane domestic goods were also used to create memories, and the process of sorting through, and disposing of, the goods of the dead could play an important part in the grieving process. Sociologists Elizabeth Hallam and Jenny Hockey emphasise the active role of objects combined with social practices in producing memory.[10] They argue that female domestic expressions of memories of the dead have been overlooked: 'Memories of the deceased sustained by women through actions within inhabited domestic spaces and with habitually familiar objects would appear to be pronounced, yet marginalized in relation to more publicly visible ritualised practices.'[11]

This chapter considers the relationship between everyday domestic objects and memory making by considering death in the home as a material process. How was the body displayed and how were objects dispersed? Decisions over what to throw away and what to keep were partly decided by the dead themselves through wills and informal bequest lists. These documents show us how these goods were used to control family life from beyond the grave, and to pass on identities of class and gender to the next generation. But the narratives of bereaved parents also

emphasise the significance of small, invaluable items, particularly in commemorating the lives of children.

Death in the home and sorting the objects of the dead

Immediately prior to death, the serious illness of a member of the family could change the configuration of the home. The patient's bedroom, or another room, would often be set aside or designated as a 'sick room'. It was a common for childbirth, serious illness and death to take place in the home throughout our period.[12] Emily Marion Blathwayt, whose husband had retired from service in India, describes how the billiard room in their home at Batheaston in Somerset was converted into a sick room in her husband's final days in 1919.[13] The sick room was widely represented in nineteenth-century culture and frequently appeared in novels.[14] Domestic advice writers commented a great deal on the sick room, and specific manuals were published with recommendations about its arrangement and management.[15] Hygiene was a concern: and the need for cleanliness, tidiness and fresh air was emphasised.[16] Plain, simple decoration, of a kind unlikely to aggravate the patient, was recommended.[17]

In *The Bedroom and the Boudoir* (1878), Lady Barker called for this chamber to be 'a place of calm, discipline and organisation'.[18] As Judith Neiswander has shown, during the final decades of the nineteenth century writers on the sick room became increasingly aware of scientific ideas about hygiene, and stressed the need to pare back furnishings, and to banish dusty four-poster beds with their draped curtains.[19] Special efforts might be made in urban areas. Horace Collins remembered that in Maida Vale in the 1890s 'when anyone was seriously ill it was the custom to spread large quantities of straw over the roadway surrounding the house and for some distance beyond, in order to deaden the sound of the traffic and to decrease the disturbance to the patient'.[20] As death drew near, houses might fill up with relatives coming to say their fare-wells, and assisting with the nursing.[21]

The sick room could frequently be physically awkward, particularly for those in smaller homes. Wheelwright's daughters Emma and Rebecca Groom struggled to nurse their invalid sister Elizabeth in their small London home from December 1882 until her death in early January 1883.[22] The situation here was far from the disciplined ideal that Lady Barker imagined, as the sisters shared a room and the patient was fre-quently noisy. Katharine Furse remembered the frustrations of nursing her tall but immobile artist husband, Charles, in a small bedroom, when he fell ill in 1904 – it was particularly difficult to ensure the circulation of air that was considered so vital by the writers of advice manuals.[23]

Richard Church recollects how when his mother lay dying of bronchial asthma in 1908, she refused to have any other women in the home, leaving Church, as the youngest son with the most time free from work, responsible for her care.[24] Church's intimate care of his dying mother increased the bond between them: 'it made my love for Mother increase almost to a fanaticism', but it also drove a wedge between his mother, father and elder brother: 'Everything they tried to do for her, in the sick-room, was mistimed or wrong, causing her such irritation that her asthmatic spasms were aggravated by their efforts.'[25]

Illness could also result in a new dependence on members of the wider family, a necessary invasion of the home circle. As Sile O'Connor has shown, power relationships in the eighteenth-century family could be dislocated by illness.[26] In a cruel twist of fate, Katherine Furse's husband Charles lay dying as she was herself severely incapacitated by childbirth. Unable to nurse her dying husband, she was dependent on the assistance of the doctor and family members to help both herself and Charles. She was no longer able to control her home, and even the decision as to where her own body should be, in relation to the death-bed, was taken away from her. She remembered afterwards how she had been laid side by side with her dying husband by the wider family who hoped to grant the couple some last moments together: 'In the kindness of people's hearts it was decided that I should be taken to him, and they laid me on the bed beside him.'[27] At the time, Katharine Furse resented this intervention, feeling that she had already said goodbye and that her husband would understand her absence. Yet retrospectively she cherished her memories of these last moments: 'Though almost unconscious he seemed to know I was there but we did not speak. There seemed to be incense in the room; perhaps it was something to help him breathe. There were candles burning and the Furse brothers and sisters as well as the doctors standing around.'[28]

In the days that followed a death, it was usual for the body to remain in the home, on display, before the funeral. Jalland's study of the upper middle classes has demonstrated that after death, the body of the deceased would usually be laid out in the home by a nurse or servant before being put on display there for viewing by family members and visitors, for several days before the funeral.[29]

Strange has shown that this practice was also common among the working classes although, without the services of nurses or servants, working-class families often took responsibility for laying out the body for themselves.[30] A key difference between working-class and middle-class family homes would have been proximity to the cadaver. As Strange points out, many working-class families would have had no option other than to share a room with the corpse for a number of days.[31] She

argues that keeping the corpse at home could in fact be a beneficial part of the grieving process and that 'the act of gazing on the corpse could encourage the bereaved to reassess their relationships with the dead'.[32]

The middle-class dead were not left in such close proximity to the living, yet their presence in the home in the run-up to the funeral could allow family members to view the body over a period of time, which might provide a similar source of comfort to bereaved relatives. Ann Linley Blathwayt, the wife of Charles Linley Blathwayt, a clergyman who had been incapacitated by illness for twelve years before his death, noted the changing appearance of his body in her diary when his death finally came soon after midnight on Thursday 15 January 1874. The following day, Ann Blathwayt noted in her diary 'No change in the face very calm.'[33] On the Saturday the body was moved into its coffin, and again Ann Blathwayt noted that the face remained calm.[34] The next day she felt moved to write: 'He looks beautiful the features perfect and young looking, he does not look more than 50, there is not a wrinkle or spot on the face.'[35] Finally, the next week, just before the funeral she noticed some deterioration: 'There is a change in the face which is just enough to reconcile us better to its being removed from our sight.'[36]

The affection for the dead body extended into a culture of domestic artefacts that alluded to the physical body of the deceased. Audrey Linkman has explored the practice of photographing the dead in late Victorian Britain, which may have helped some relatives come to terms with their loss.[37] Marcia Pointon has written on the Victorian enthusiasm for goods such as jewellery that included the hair of the dead.[38] Jalland argues that the desire to preserve 'likeness' was an all important part of Victorian memory-making, and explains the fascination with objects such as the death mask.[39] In the interior of the middle-class home, the display of portraits and miniatures of the dead helped to preserve their memory. Stabile notes that the flexible way in which the miniature could be displayed – 'as jewellery . . . set in the top of snuff boxes and memorandum cases or secreted in a woman's dressing table' – made the miniature a peculiarly personal form of remembrance.[40]

After the funeral, the relatives of the deceased faced the task of sorting and organising the deceased's possessions. Valuable possessions and property were often covered by will, and senior male family figures might be called in to negotiate the legal distribution of goods. The diary of James Simmons, a Surrey paper maker, shows how on the death of one of his sisters he ensured a 'just and conscientious' division of property.[41] Women could play a legal role too. Maxine Berg has found that women were often named as executors in the early nineteenth century.[42] Outside of the will there was often scope for negotiation: Winchester grocer's daughter Bessie King, for example, noted in her diary after her

father's death that her brothers (who were in charge of executing her father's will) allowed her to keep the furniture from the house.[43] But in addition to the division of valuable goods and property, there was often a wealth of small, personal domestic items to deal with. Sorting through these possessions may have been seen as particularly a woman's task, as an extension of the woman's special role in the sick room and at the deathbed.[44]

Recent essays on the meaning of objects belonging to the deceased, in particular clothes, suggest that the cherishing of certain objects by the relatives of the deceased can assist the grieving process and assist 'a more positive comprehension of absence'.[45] Stabile argues that the result of the bequest itself, the receipt of the goods of the dead, could help stem grief.[46] Widowers could also use objects in this way. Robert Needham Cust, a twice-widowed retired Indian civil servant, sorted through the possessions of Emma, his deceased second wife, on his return to England in 1868. Experience made Cust well aware of the emotive power of this act: 'I made the final arrangement of the last of dear Emma's boxes, and looked over the other that remained, the remnant of a former happiness, now dimmed away.'[47] Thus, disposing of the deceased's personal effects could play an important role in the grieving process. Robert Cust carefully arranged his wife's things with family recipients in mind: 'Some things I wished to keep for my own children – some things I wished to make over to her sisters.'[48] Later, he got out his wife's wedding shawl for the christening of his new baby, the child she had given birth to before she died.[49] The shawl became a material bridge between the dead and the living, demonstrating symbolic continuity between mother and child.

Katherine Fry, the daughter of Elizabeth Fry, agonised over how she should dispose of her mother's goods, after her death in 1845, anxious to that she should fulfil her last duty to her mother. In her narrative, the disposal of the mother's clothes is used to represent Katherine Fry's difficulty in letting go of her mother. The distribution of her mother's clothes represented Fry's relinquishment of the physical body of her mother, but in doing so she fulfilled what she felt were her mother's last wishes, and satisfied the requirements of the family's Quaker faith: 'The next day we made the great effort of looking over and distributing our dear Mother's clothes, the last thing that I could do for her. My state was little understood by anyone.'[50] Religious identity could thus influence the way in which objects were used to remember the dead.

One way of dealing with death was to distance oneself from traces of the deceased completely. The advice writer Jane Ellen Panton used this strategy when her husband died unexpectedly in the early twentieth century. Panton chose to move away from the places she had shared with her husband: 'I want somewhere Randolph has never been, where

he would never live could he come back to us from out of the silence into which he went so suddenly last year.'[51] Throughout her professional career Panton robustly advocated the destruction of letters and tokens kept purely for sentiment.[52] When it came to her own goods she was equally thorough:

> I have been married more than forty years, but still have remnants of breakable wedding presents, which, chipping and splitting as they go, have accompanied us faithfully from house to house: they shall go no farther, they shall be softly broken to atoms and decently buried in the Square garden. They must be as tired of their lives as I am . . .[53]

In a text that curiously mingles criticism of past fashion with a need to escape personal memory, Panton writes 'I want a clean wide space, untortured walls, one or two good pictures, no dust-collecting furniture, only new dainty chairs and tables, none of which he ever saw.'[54] Panton's desire to erase her husband's memory from her surroundings, although unsurprising given her professional interest in material meaning, bordered on the obsessive. Not content with obliterating her own material past, she acquired someone else's. During the nineteenth century it was common to acquire goods from house sales.[55] Goods were cheaper in house sales, but also offered interest without painful memories.

In addition to practical goods she acquired 'wardrobes full of old silks and pieces and packets of old letters and diaries', which she meant to look through on long winter evenings.[56] To distract herself from her own painful memories, Panton deliberately acquired objects that carried a different set of meanings.

The way in which the Victorians often treasured the goods of the dead also underlines the importance of such objects in their emotional lives. At the top end of the social scale, the veneration of such objects was taken to an extreme by Queen Victoria. Victoria went to considerable effort to ensure the elaborate maintenance of the Blue Room at Windsor Castle, where Prince Albert had met his death in 1861. An official memorandum had communicated that the room was to be kept in the state it was when he died.[57] In fact, the room was not kept the same and was redecorated with wreaths for the beds: a bust of Alfred was placed between them. More strangely, the daily requirements of the dead prince were repeated every day for the next forty years.

> Albert's dressing case, opened and at the ready, sat on a table near the window for good light. Fresh towels and hot water were replenished everyday; clothes were laid out, ready to wear. Mundane necessities of daily civilised activities, such as changing sheets and pyjamas, washing up and shaving, became sanctified for ritual consumption.[58]

Adrienne Munich argues that although the mourning was a deliberate act that visually stabilised a potentially unsteady monarchy, Victoria's emotional investment in goods was part of a wider Victorian trend. 'Victoria's memorial rooms testify to a Victorian trait of concretising feelings as if a material object were equivalent to an emotion.'[59]

The Victorian middle classes would rarely have had the resources to follow their queen, but the well-off upper classes might. When the aristocratic Mary Elizabeth Lucy lost her son Herbert in 1840, she carefully preserved his possessions and toys 'often looked at through blinding tears! For what trifle is not dear to a mother's heart when it reminds her of her child'.[60] Smaller middle-class homes would not have been able to afford the luxury of the allocation of entire rooms to the dead, but niches and cupboards might be designated for goods devoted to the preservation of memory. In a mid-Victorian family chronicle assembled from letters and diaries, Lilias Rider Haggard describes the deaths of Emma and Rose, the young daughters of the family. While the family did not preserve their rooms, which were redecorated, clothes and toys were kept in a schoolroom cupboard and a chest on the landing.[61] Instead of disposing of the goods, or keeping them near to inspire memory, these objects were secreted within the house, not on display, but still present. Rather than suffering a social death, objects stored in this way lived a strange kind of half life. Hidden from everyday use and social display, the objects were prevented from acting as a regular reminder of the dead.

During the second half of the nineteenth century, the death rate for young children remained high. According to Jalland, the death rate in England and Wales for infants under one year remained almost constant between 1840 and 1900, at approximately 15 per cent, only dropping to less than 10 per cent after 1916.[62] Therefore, many parents experienced the loss of a child. Grieving parents often found comfort through cherishing goods that had belonged to their small children. These were often small, everyday items that seldom made it into wills and bequest lists. Described in texts, the domestic goods of the dead might come to represent the virtue of their owners in life. Jalland has noted that the death of a child had an especial sadness.[63] Hannah S. Allen, in a letter to her aunt written in 1856, describes the pain associated with going through the objects of a small daughter:

> As I put aside all her little belongings, and see what order all the dear child's things are in, I find everything in its place. There is her little work-box and scissors, sundry little bits of ribbon and pieces, and a small piece of work just begun; her neat little desk (thy gift), and all my letters to her neatly tied up, her two dolls and much prized little trunk! Oh what heartaches comes as I assign to one and another as she desired.[64]

Allen's description of the objects conveys her particular pain at the death of a child. The smallness of the belongings is pathetic, and the tidy state in which they have been left suggests the model behaviour of a good child, the grown-up woman's objects in miniature hint at the loss of the woman the dead child might have become. There is also some consolation here. The prized objects such as the desk also stand for the way in which the child was cherished by her family, and the child's model behaviour suggests her home in heaven. The mother chooses to note the care with which her letters to the child were preserved, a final comforting reminder that her love was returned. Mary Clare Martin has assessed accounts of child death, finding that it was more usual to deal with dying children's piety and sweet nature, rather than deathbed testimony and repentance.[65] Allen's description of her daughter's goods seems to fit with Martin's findings: domestic goods were an essential part of nineteenth-century narratives of death.

Power from beyond the grave: domestic objects as bequests

In addition to the many mundane domestic things that needed to be disposed of after death, a smaller number of special goods were often selected by the deceased to bequeath to the next generation. References to objects in formal, legal wills probably under-represent the extent of the interest in using domestic objects to shape memories. R.J. Morris argues that middle-class wills suggest relatively little interest in specifying the fate of domestic objects after the death of their owner.[66] Alastair Owens also notes: 'In spite of popular images that suggest otherwise, Victorian wills did not specify long lists of cherished material possessions.'[67] However, it may not have been thought necessary to put bequests of domestic goods of little value into wills. Benjamin Harris's bequest list included twenty-four separate objects, only three of which appeared in his will.[68]

Informal bequests, which often survive in family papers, tell a different story. In 1871, Mary Craticum made an extensive list that divided 264 household goods among family members.[69] In 1892, Isabella Druitt, a wealthy surgeon's widow, made an even longer list dividing 301 items between her surviving children.[70] Sale catalogues show that it was common practice to dismantle and sell the domestic interior after the death of its owner. But the same catalogues are often riddled with annotations and crossings out, suggesting objects hastily drawn back into the family before the sale.[71] A rare survival of a sale catalogue and bequest list in the Purchase papers shows that at least 39 objects were bequeathed to the next generation rather than sold.[72] The transmissions of objects recorded in wills probably represent only a small fraction of the bequests that actually took place. The evidence of informal bequest

lists suggests that in fact many Victorians were keen to carefully specify a number of bequests of domestic goods.

Under the law, the power to determine bequests was gendered. The Married Women's Property Act in 1882 gave married women the right to dispose of their property 'by will or otherwise'.[73] But before this, married women did not have the right to make wills under common law, although they could do so under equity.[74] In practice, few married women made wills.[75] In certain circumstances wives may have been 'allowed' to make wills if husbands chose not to interfere with their property, for example, to protect the family from bankruptcy.[76] The impact of the Married Women's Property Act on everyday practice has been debated. Finn has shown that even before the act, married women denied the right to hold property under the law of coverture were entitled to 'necessaries' from their husbands suitable to their social station.[77] Jalland argues that the Act had little effect on the top 10 per cent of upper- and middle-class women, as their assets could be protected under equity law arrangements.[78] The majority of wills explored here were made by widows or single women, who could make wills before the Act, so it is unclear from the sample how this important legal change affected the way married women willed domestic goods. But the survival of informal bequest lists also makes clear that in many cases the arrangements for passing goods on were simply made outside the legal system: women, and some men, relied on their relatives in the transference of small bequests, made through informal lists or by word of mouth. Small bequests such as family portraits or pieces of furniture were valuable in sentimental rather than monetary terms, and their transference did not necessarily require protection under the law. Thus, it seems that in the case of bequests of domestic goods, at least, the substantial changes in the law in this period had relatively little impact on everyday practices.

The way in which domestic goods were transmitted over several generations distinguished the middle classes from the aristocracy. F.M.L. Thompson argues that one way in which successful nineteenth-century businessmen distinguished themselves from the aristocracy was to divide their estate or land between their children rather than leaving it to a single heir.[79] The middle-class system of partible inheritance also applied to homes and possessions. The aristocratic practice of leaving the ancestral home to a single heir meant that there was usually a list of objects made heirlooms which were to stay with the estate.[80] The middle classes, however, tended to dismantle domestic interiors on the death of their owners, parcelling out prized goods to surviving relatives and selling the remainder. Morris argues that middle-class wills, in contrast to aristocratic practice, were not concerned with establishing a 'continuity of possession' for the family house, which was 'simply an asset'.[81]

The middle classes did, however, use objects to ensure continuity of family heritage. Some families had their own version of the heirloom: both men and women set up legacies, which were intended to operate beyond the next generation. The Reverend Daniel Jonas Olivier of Clifton, who made his will in 1848, left a large diamond-set brooch to his wife, specifying that after her death it should pass to their son.[82] Mrs Alice Jane Titfield's bequest of plate to her son Robert was made for his life only, after which she specified that certain items should pass to other family members who had a particular association with them. The Titfield list, as an informal will, did not carry the legal clout of aristocratic heirloom specifications. Nevertheless, it may well have been carried out by the family. It is certainly as detailed as the aristocratic instructions, and it allowed its female writer to voice her own ideas about objects and family meaning.

Women were more likely to specify the fate of domestic objects after their deaths. The female tradition of leaving particular objects as personal bequests, identified by historians of earlier periods,[83] continued during the nineteenth and early twentieth centuries. For early modern Italy, Sandra Cavallo argues that women emphasised personal possessions in their bequests because they had less to leave.[84] Owens argues that this was also the case for women in the early nineteenth century.[85] It may be that these women were more specific in their bequests because, as they usually made wills as widows or single women, they would not be handing over the household intact to their surviving spouse, but dividing up its contents among a number of family members.

Although fewer women made wills than men, they were more likely to discuss household goods. Morris's study of Leeds and Owens' study of Stockport have both identified this tendency for the first half of the nineteenth century.[86] This survey, which is confined to the minority of wills that mention furniture, found that approximately half of the wills that qualified to be included were made by women. As fewer women than men made wills in this period, this suggests that in the second half of the nineteenth century women were also more inclined to specify the fate of their furniture. Moreover, of the nineteen wills from the sample that singled out individual articles for particular bequests, fourteen were made by women and only five by men.

Although men were less likely to discuss domestic goods, their significance in male will-making should not be overlooked. Detailed studies of the meaning of will-making and domestic goods have argued that male and female bequests tended to differ. Again, we can see an apparent continuity here between the early modern period and the nineteenth century. Erickson, writing on early modern England, states that 'rather than providing for children or distributing largesse, women made

wills out of the need to thank and acknowledge small favours . . .'[87] Owens also argues that early nineteenth-century bequests show that women had a more immediate and emotional understanding of posses- sion than men,[88] so there clearly was a difference in the way that men and women bequeathed domestic goods. However, the wills examined here also show that some men were very aware of the emotional reso- nance of bequeathed domestic goods. Benjamin Harris, of Odiham in Hampshire, who died in 1897, left an official will in which two specific bequests are mentioned,[89] but also a much longer informal list entitled 'directions to my executors as to the disposal of my household furni- ture and effects'.[90] So even if men had full legal powers, they also made informal bequests. Moreover, the Harris document (as other masculine bequests discussed later), show that late nineteenth-century men could and did have an emotional investment in such bequests. This awareness often developed in relation to goods belonging to women, as men might also use their wills to try and preserve the memory of dead wives.

George Burley, a well-to-do farmer from Puloxhill, made his will in 1854, and divided his furniture between his girls, allocating a par- ticular piece to each daughter.[91] Hannah was to get his tent bedstead and bedding, Louisa the buffet cupboard, Georgenna (*sic*) an oak chest of drawers that was specified as her mother's, and Elizabeth was left a white corner cupboard that was also 'her mother's'. Henry Irish's specific bequests also included a watch 'given to me by Helen my dear departed wife'.[92] Benjamin Harris also left some jewellery belonging to 'my late wife', to a niece, again illustrating male desire to revive the memory of deceased wives.[93] So while this survey of late nineteenth- and early twentieth-century wills suggests that the close relationship between women and domestic bequests continued in this period, we need to be aware that men could also closely associate themselves with household goods.

The disposition of domestic objects in a will could cause turmoil within the surviving family. Relationships in the family of the advice writer Mrs Haweis were as unhappy after her death in 1898 as they had been during her life (perhaps intentionally), largely thanks to her will, which, made after the Married Women's Property Act, left all her goods, including the very valuable furniture and furnishings in her house, solely to her third son Stephen, bypassing her husband and two elder children.[94]

Men might continue to control the lives of their spouses from beyond the grave, by specifying the fate of their goods. The majority of men left their furniture to their wives, but were not obliged to do so. Since the Dower Act of 1833, a husband could will away the contents of the family home as he chose.[95] Certain goods, known as 'paraphernalia',

such as clothing, jewellery and personal ornaments could not be willed away by the husband and legally reverted back to the wife on widowhood, but these did not necessarily include furniture. Husbands left domestic goods to wives under a variety of provisos. Of the thirty-one male wills sampled here, twenty-three men bequeathed their furniture to their spouse. Six such bequests were made 'absolutely', that is, the widow would have the furniture for her absolute use and be able to will it away as she chose.[96] Four of the bequests left the furniture to the widow 'for life', which meant she would have the use of it during her lifetime but could not decide where it went after her death (usually the children were specified as the recipients in her husband's will). Only two men specified that their wife should have the use of the furniture only while she remained his widow. The control of women through provisions in wills was not new. Erickson has discussed the practice of limiting a wife's bequest to her widowhood in the seventeenth century. She finds that less than 10 per cent of the men in her sample restricted their wives' bequests to widowhood, which she argues suggests a desire to prevent widows from remarrying.[97] Morris and Owens have also argued that nineteenth-century husbands sought to control wives from beyond the grave in this way, but they conclude such decisions were motivated by the desire to protect family goods against new husbands.[98]

Victorian middle-class bequests were clearly designed to transmit ideas of identity, encompassing class, gender and family, to the next generation. As shown earlier in this chapter, women were more likely to bequeath domestic goods or have them bequeathed to them. However, the nature of the goods themselves also reflected the distinct masculine and feminine material cultures that appeared in the domestic advice texts discussed in Chapter 1. The papers of Benjamin Harris, a Nonconformist from Odiham in Hampshire, show us in detail how one man chose to divide up his goods.[99] The main beneficiary of the will is Mr James Lane Brooks, Harris's son in law. Brooks's goods included those that could be associated with masculine social practices: office chairs, a walnut smoker and oil paintings of hunting scenes. The goods specifically allocated to his daughter (considerably less than to his son-in-law – presumably it was assumed that she would have the use of those goods also), 'the small work box in the table in my parlour and the small mahogany chest of drawers in my bedroom', were those that could be associated with feminine social practice. Other female relatives were also given items of furniture, including a piano, a Davenport writing table and a dressing glass. Morris's study of Leeds also notes 'an awareness of female things and male things when allocating property'.[100]

Yet it was women who were most likely to receive bequests of domestic goods. Of the men who did not leave the furniture to their

wives, two left their furniture to their nieces, one to his sister, one to his nephew, and the rest were included among specific bequests.[101] Women also tended to favour other women when specifying who should have their furniture in their wills. Six women left the furniture to their daughters, four to their nieces, three to friends, one to her sister, one to her servant, and the remainder divided their goods between their families. One widow, Mrs Isabel Unwin, whose will was proved in 1881, specifically allocated her furniture only to her son, but it came with the request that it should be sold off immediately and converted into a cash legacy. Morris's study of Leeds also suggests that household objects, such as beds and bedding, tended to be left to women.[102]

Certain kinds of goods tended to figure in female legacies, particularly jewellery, china and linen. Cavallo suggests that in early modern Italy a woman's right to her jewellery may have been seen as inalienable.[103] The association between women and jewellery was also strong in nineteenth-century England, where before 1870 jewellery fell into the category of 'paraphernalia' and could not be willed away by husbands. Women usually left jewellery to daughters or granddaughters.[104] Mrs Alice Jane Titfield, who made her informal will in 1886, left goods that could be associated with feminine responsibilities in the home to her female relative Alice Evelyn Isabel Carey. The bequest included 'all jewellery, ornamental china, buff coalport dinner service, blue coalport dessert service'.[105] This trend continued throughout our period and beyond. Mrs M.A. Purchase, who died in 1918, also made an informal will specifying that certain goods were to be left to her daughter Florence, which included a needle-worked chair, a blue ornament and linen marked with her initials (which may originally have been her trousseau).[106] Such bequests may have expressed the special relationship between mother and daughter, as discussed in Chapter 2. Laurel Thatcher Ulrich has argued that in early modern North America goods were often passed from mother to daughter at the time of the daughter's marriage: as Ulrich usefully comments, such transmissions are not represented in wills or inventories.[107] It is likely that many similar transferences of goods between nineteenth-century English mothers and daughters have also escaped the written record.

Perhaps the most important transference that took place was that of the identity of the family. Certain key goods were associated with the family by both men and women. Owen's study of Stockport wills notes that certain goods that belonged to the middling sort, such as Bibles, watches and portraits, were seen as family, rather than individual property.[108] Marked silver was often an important object in specific bequests. Alice Jane Titfield left all her plate, which she specified in her informal will as marked with the Jarrett crest and marked with the Titfield crest.[109]

This shows an interest in preserving the identity of both sides of the family, rather than just the patrilineal line. Domestic goods might also express family identity through a sense of place. Isabella Druitt's bequest divided the family pictures among her five children.[110] Each child was allocated at least one image of Wimborne in Dorset, where the Druitt family had lived eighty years before, and where they had practised medicine for more than a century.

Family portraits clearly had an important role in the iconography of family identity. Alice Jane Titfield specified that George Charles Kelly (presumably a nephew on the Jarrett side of the family) was to receive the family miniatures.[111] Mrs M.A. Purchase noted that she wished her daughter Florence to receive 'her father's framed portrait in the drawing room'.[112] Important family paintings remained with prominent members of the family. Mary Ann Sadd ensured the heritage of her family by bequeathing 'the family picture over my drawing room mantelpiece to the eldest child living' and 'my late mother's portrait to my eldest living son'.[113]

The middle-class heirloom was often included, then, in lists made by women. Such bequests were of a particularly personal nature. Cavallo has argued that the wills of women in early modern Italy tended to describe goods using possessive adjectives – 'her silver bowl', for example, which may suggest that women had a stronger relationship with the goods with which they came into contact.[114] Middle-class women's informal wills did not tend to use personal pronouns to refer to their own relation to things, rather pronouns were employed to associate objects with particular, often female, members of the family. Mary Craticum's bequests, made in 1871, included 'Grandma's bookcase in the smoke room' and 'Mama's dessert service'.[115] Isabella Druitt's bequest list included a 'silver mufffiner marked "J" that belonged to my mother' and a set of tea things that 'belonged to my grandfather and grandmother Christopher and Mary Ibbertson'.[116] Jalland has noted in her study of women's informal wills that they tend to specify who goods originally came from.[117] The women in this case study used informal wills to remember family members to the next generation. Rather than passing a patrimony to a male heir, these wills created a sense of female lineage, calling to mind a female community of users and owners of objects. Through these legacies women preserved the memories of themselves and their predecessors.

Surviving homes: widows and widowers

Jack Smithers, the son of an art-dealer, solicitor and publisher, fallen on hard times, was startled to find when his father died, destitute, in 1907, that his house was completely empty: 'My father's body lay on a bed in

the lower room and that bed was the only piece of furniture in the house, beyond two empty hampers . . .'[118] As middle-class homes were often dependent on the income of husbands and fathers, the loss of a male provider was likely to be a financial blow for the surviving household. Male control of property in this period meant that while men who lost their wives tended to retain their homes,[119] the death of a husband often meant immediate material loss. Jalland notes that the legal position of Victorian wives meant that although the sexes experienced the first shock of death in a similar fashion, the experience of the Victorian widow differed markedly to that of the widower. Widows experienced dislocation and reduced financial circumstances,[120] whereas men could return to their occupations much earlier, and were in need of less consolation.[121]

Widowers were also far more likely to remarry than widows.[122] Clergymen's wives and families were particularly vulnerable to loss, as the family home – usually the vicarage or rectory – would pass away to the next incumbent with the salary. Vicar's daughter Mary Sibylla Holland reflected in her letters with a painful awareness that her family no longer had any rights to the former home to which they had been so strongly attached: 'It is almost impossible to realise that Harbledown is standing empty, and that we have no longer any right or possession of our old home.'[123] For Katherine Furse, the death of her husband in 1904 meant the painful relinquishment of Chockley House, the couple's recently furnished marital home near Chobham in Surrey, and a temporary move into a home shared with relatives, before beginning the hard struggle to bring up two small boys alone.[124]

Widowed mothers usually found a way of keeping home and family together, even under straightened conditions. In *Cranford* (1853) Elizabeth Gaskell made light of the 'elegant economy' practised by single women and widows, and their endeavours to appear genteel on limited means.[125] Such struggles were a reality for many widows in the second half of the nineteenth century. Ramsay Muir's mother, the wife of a Scottish Presbyterian minister resident in Birkenhead near Liverpool in the 1880s, was widowed after her husband's premature death from pneumonia. On a much reduced income, Jane Muir managed to maintain the house, pay off part of a mortgage and feed, clothe and train her four children. To cope with the situation, Muir's mother adopted parsimonious habits: 'she denied herself every indulgence',[126] and 'habits of extreme economy and social isolation'.[127] Muir was fiercely proud of his mother's sacrifices, and for him, her household furnishings demonstrated economy, yet also a virtuous nature: 'She had impeccable taste, and however poor she might be, her rooms always had quiet charm.'[128]

E.L. Grant Watson, a barrister's son who was born in London in 1885, in a chapter in his autobiography titled 'Genteel Poverty,' recalls

that when his father died in 1890 the family's income dropped from £1,000 to one £180 per year.[129] As a result, his mother faced a number of 'minor humiliations' including the sale of the lease of the house and the furniture: 'these were hard, necessary tasks'.[130] But she was able to hold the family together, renting a house near Grant Watson's school, and insisting on dressing for dinner every evening, 'although dinner only consisted of Teny's [the family servant] excellent milk and potato soup'.[131] Not every widowed mother coped: Jack Smithers recalls that he was deserted by his mother, as she was completely destitute on his father's death, unable even to pay his funeral expenses: Smithers was sent back to lodgings which were not paid for, his mother later struggling to earn her way as a maid.[132]

However, it is important not to overemphasise the losses sustained by widows. Recent work has shown that widows were often not ruined by their husbands' deaths.[133] Margaret Ponsonby's assessment of the inventories of eighteenth- and early nineteenth-century widows on and after their husbands death has shown that in some cases widows actually appeared to have more goods than when their husbands were alive.[134] Some widows were relatively well provided for. John Marriott recalls that when his father, a Manchester solicitor, died prematurely in the early 1870s, his widowed mother, although weak in health, managed to keep the family together: 'Mother made it a very pleasant home for her children and for their friends.'[135]

The diaries of Ann Linley Blathwayt suggest that her husband's death (long expected, as he had been ill for over twelve years) was a relatively smooth material transition. In late January 1874, nine days after the funeral, an appraiser, William Hunt of Church Street, arrived at the house and valued the furniture at £155 3s.[136] Although this was before the Married Women's Property Acts, Ann Linley Blathwayt's property was protected by trust, and after the will was proved in early February the trusteeship of her property was set up in the name of another family member.[137] Following the death of her husband, Ann Linley Blathwayt continued to live in her London home, apparently retaining the furniture as before. In 1919, the transition to widowhood was also smooth for her daughter-in-law Emily Rose Blathwayt. It was agreed that the family home would be used to take lodgers, and even the valuation of the household furniture was not unpleasant: 'Mr Powell's two representatives came early and spent the day valuing the property in the most pleasant and sympathetic way.'[138] For both women, the transition may have been relatively straightforward, as both of their husbands were old and had been expected to die for some time, and careful preparations had been made for their widowhood.

The material lives of widowers were more likely to remain relatively

unchanged by the death of their spouse. As Jalland has shown, the experience of grief was gendered: 'Widowers had access to two important sources of consolation which were largely closed to upper-class and middle-class widows – work and remarriage.'[139] Continuity in working life, combined with ownership of property made for continuity in home and material life.[140] However, while widowers were more likely to maintain continuity in their material lives, for some, particularly those at an earlier stage of the life cycle, the loss of a wife or mother could change the emotional atmosphere of the home: objects and spaces remained the same, while their associations were completely altered. For twice-widowed Robert Cust, the domestic objects in the cottage that his children had inhabited while he was away in India powerfully evoked his grief for his lost wife. On his return home to England early in 1868 he wrote: 'the sight of all the comforts of an English home, the double posted bed, the fires, the voices of the children, recalled my happy London home, and my dark future quite appalled me'.[141] For Cust, the domestic scene with its roaring fire and four-poster bed embodied domesticity and marriage, and were therefore profound indicators of his loss.

The changed meaning of the material culture of home is also evident in Richard Church's account of his mother's death, in the 1900s, in his tight-knit lower middle-class south London suburban home. While Church, his father and his elder brother continued to reside in the same house, they found a very different atmosphere there. Two days after their mother's funeral, Richard's elder brother Jack had the piano tuned: 'The music was delicious again. It perfumed our death-tainted home. But it also emphasised its emptiness.'[142] In the absence of the mother, the father and sons treated the home differently, spending more time outside it.[143] Generally, the family avoided each other, and any exchange between them was short-lived: 'The wrongness of the house settled over us again, and we went to bed in silence, each to his separate cell.'[144]

Widowers may have had an easier time materially than widows, and would have had less need to retrench financially. Yet as men attempted to set up an independent household – to create a domestic interior without the aid of a wife – they faced complex and more subtle challenges. For men widowed at an earlier stage in the life cycle, particularly those widowed with young, dependent children, the impact of a wife's death on home and the material life of the family was far more significant.

The difficulties of re-establishing a home as a widower and a father of young children are exemplified by the diaries of Robert Cust, which provide an unusually detailed account of the experience of widowhood. When Cust, a former Indian civil servant, returned home to England after the death of his second wife Emma in childbirth, he was determined that

he, his five children from his first marriage, and his new baby girl should live together under the same roof. Maintaining family unity was not straightforward. Cust was urged by many friends and relatives to return to India leaving his children in the care of nursemaids and relatives.[145] The biggest challenge came from Emma's family, who had taken in the baby on its return to England. Cust found it difficult to get on with them on his return, writing: 'I felt badly the want of Emma to be my champion.'[146] The family (a father living with his grown-up daughters) made it very clear that they felt they should keep the baby. On 6 March 1868 Cust wrote: 'and the objection urged that I had no lady at the head of my family: but surely this was the Lord's doing, and it is hard because my wife's dead to take my child from me: widowers are fair prey to every argument'.[147] Cust expressed the difficulties of his position as a man, and as a widower: 'This is an old story. I am in the way of everybody – even my own children, and this is told me pretty clearly.'[148]

Once he had wrested his baby girl from her relatives, Cust established his widower's home with all his children at Eskbank Lodge, Bolton Road, Eastbourne in April 1868. On signing the lease, Cust felt great relief: 'I then and there signed the agreement and found that a great weight was off my shoulders to think that something was settled.'[149] Cust's diaries include a small sketch plan of the house, showing the first, second and third floors.[150] The house was clearly organised around the needs of the children: the dining room doubled as a schoolroom, the second floor (which would have usually housed the best or marital bedroom) was given over to the day and night nurseries, and the third floor to separate bedrooms for the boys and Cust's eldest daughter Alba (Albinia Lucy) who was eleven years old in 1868. (Where the servants slept is not discussed – presumably the nursemaids would have stayed in the nursery and the cook in the basement). Cust himself occupied a small room with a bed on the ground floor of the house, opening out of the dining room. This private space had been one of Cust's requirements when he sought the house: 'I did not require a smart house, but I required a room to myself free from the maids.'[151]

The twice widowed Cust felt a powerful emotional need to live closely with his children: 'Nothing shall separate me from the children. By living within them I shall learn how to manage them and how to continue myself.'[152] But the little room off the dining room allowed him to do this while maintaining his own space, a separate domain beyond the nursery and the daily activities of childcare that took place on the floor above.[153] Once established in this house, Cust began to feel secure for the first time since the loss of Emma: 'I felt so glad to have a roof of my own again, and my children under it, and I rejoiced to think of their being safely tucked in.'[154] The drawing room, however, remained

unused, except when female guests were present.[155] Cust was discouraged from using this room on account of its powerful association with his late wife: 'the pretty drawing room suggested the thought of the dear mistress, as she might have been'.[156]

Household management was a difficult task, for which female assistance was absolutely necessary. In February 1868, when contemplating what to do next, he had written: 'I reckoned so much on dear Emma's practical knowledge. The burden is wide and heavier than I can bear.'[157] As David Hussey has recently shown, widowers would, by necessity, need to engage to a greater extent with the day-to-day consumption of the household than other men.[158] It was usual for widowers in this period to enlist the help of a female relative or servant as housekeeper.[159] While Cust undertook the housekeeping himself,[160] he enlisted the support of 'Meech', the family nurse, who had been with the children for some years: 'as neither of my sisters can assist me, she is the only woman whose influence in my domestic affairs I can tolerate: I can fully trust to her and to the health and moral management of the children'.[161] Yet even with the assistance of the faithful Meech, household management was an uphill struggle. The grieving Cust also found the practical arrangements necessary to establish a home a considerable challenge. In November 1868, a year and three months after Emma Cust's death, Cust remarried. He was very happy with his third wife, Elizabeth Matthews,[162] but it is quite clear that the need for assistance in household management was a strong motivator. On the eve of his third marriage, Cust reflected on his position:

> When I thought of the long solitary evenings, the long solitary nights – the . . . management of young children – the troubles of female servants – the unkind remarks of false friends – the kind hints of real friends – the hopeless prospect – the restless desire for companionship and a complete and settled home (if only for a short season, if only for a few weeks).[163]

Ultimately, widowhood proved too much of a challenge for Cust, driving him into a third marriage which although ultimately very happy was also a practical necessity.

Conclusion

In conclusion, the advent of death transformed middle-class homes. Immediately before death, the sick room and the attendance it required might be the source of considerable rearrangement and disruption in the household, altering family dynamics. The home – usually the bedroom of the deceased (although sometimes the parlour) – was also the location

of the corpse for a few days before the funeral. The presence of the body in the home was seen as part of the grieving process. Sorting through the deceased's possessions could also be an important part of this. One strategy was to distance oneself from the goods of the dead. Other men and women preferred to enshrine objects in the home. Whole rooms might be preserved intact as shrines, or objects might be stowed in store cupboards, in temporary obscurity, ready to be examined in private moments of reflection and remembrance. However, female narratives also showed the importance of everyday paraphernalia. Of little material value, certain everyday goods such as children's toys were cherished for their associations. While the Victorians are famous for their ostentatious mourning culture, the expression of memory through domestic goods was equally important, particularly for women for whom the home was the prime location for the construction of personal memory.

Men and women transmitted meaning to the next generation through bequests outlined in wills and informal lists. As in the early modern period, women were more likely to bequeath domestic goods or to have household objects left to them. While the survey of wills broadly concurs with the conclusions of early modern studies, it is clear that some nineteenth-century men did ascribe an emotional meaning to certain goods in a way that has been downplayed by the historiography. Masculine legacies could be practical, consisting of the tools of a man's trade. But they were also complex. Women also left legacies from mother to daughter, often of goods associated with hospitality or beauty.

Gender was not the only factor that influenced such bequests: there was a clear divide between the inheritance practices of the gentry and other members of the middle class. But those lower down the social scale also had their own heirlooms. Both male and female wills designated key goods, such as portraits and family silver as carriers of family memory. Female informal bequests show that women were as, if not more, involved in such designations as men. While it is hard to draw conclusions about the impact of the Married Women's Property Act from a small sample of wills that concentrates on widows, the sample does reveal broad continuities in informal female will-making practice throughout the period that seem relatively unmoved by legal change. The goods women marked out in their wills could hand matrilineal heritage on from one generation to the next. It seems likely that only a small fraction of transmissions of goods between family members were recorded in legal documents. Of course, many bequests would have escaped the historical record: one can only speculate on the transmissions that were instructed and received orally, perhaps on the deathbed or at other moments.

It was difficult to recover from the loss of any family member, but the

demise of a husband or wife, or father or mother, was particularly damaging to the household. Widows often had a harder material struggle: the death of a husband often involved the loss of income, the downsizing of the home, and hard economies were often required to keep family and home together. Many widows seem to have adopted 'genteel economy' as a strategy to maintain middle-class values for their children. This should not be overstated however, as some widows were left quite well off, and others had their own separate property protected under trust. Widowers did not usually face the same material challenges initially, but it was harder for them to re-establish homes without a female partner. The loss of a mother had a particularly strong impact on the atmosphere of the home, rendering the sight of formerly mundane domestic objects painful. Widowed fathers with young children could find it particularly difficult to re-establish their homes; and female relatives sometimes felt able to claim their children. Those, like Robert Cust, who succeeded in setting up single-parent households would face considerable practical challenges – negotiating housekeeping and managing the servants for themselves, alongside superintending childcare. Fulfilling the role of both provider and nurturer was no easy task. It is therefore not surprising that many widowers chose to remarry as the struggle to create a home alone proved too much.

Notes

1 Stanley Lupino, *From the Stocks to the Stars: An Unconventional Autobiography* (London: Hutchinson & Co., 1954), p. 18.

2 Ibid., p. 30.

3 Pat Jalland, *Death in the Victorian Family* (Oxford: Oxford University Press, 1996), p. 5.

4 Ibid., p. 3.

5 D. Cannadine, 'War and Death: Grief and Mourning in Modern Britain', in J. Whaley (ed.), *Mirrors of Mortality: Studies in the Social History of Death* (London: Europa, 1981), p. 195.

6 Philippe Aries, *Western Attitudes Toward Death from the Middle Ages to the Present* (trans. Patricia M. Ranum) (London: Marion Boyars, 1976), p. 87.

7 Julie-Marie Strange, *Death, Grief and Poverty in Britain 1870–1914* (Cambridge: Cambridge University Press, 2005), p. 263.

8 J. Curl, *The Victorian Celebration of Death* (Stroud: Sutton, 2000).

9 Audrey Linkman, 'Taken from Life: Post-mortem Portraiture in Britain 1860–1910', *History of Photography*, 30: 4 (2006), 309–347.

10 E. Hallam and J. Hockey, *Death, Memory and Material Culture* (Oxford: Berg, 2000), p. 2.

11 Ibid., p. 194. The relationship between women, objects and remembering has been the subject of a growing literature, which focuses on private and personal memory. Certain goods associated with the physical body such as clothes are seen as crucial in evoking the dead. C. Mavor, 'Collecting Loss', *Cultural Studies*, 11:1 (1997), 129; C. Mara,

'Divestments', in K. Dunseath (ed.), *A Second Skin: Women Write About Clothes* (London: Women's Press, 1988), p. 57; J. Ash, 'Memory and Objects', in Pat Kirkham (ed.), *The Gendered Object* (Manchester: Manchester University Press, 1996), p. 220.

12 Roy Porter, *The Greatest Benefit to Mankind: A Medical History of Humanity from Antiquity to the Present* (London: HarperCollins, 1997), pp. 644–645.

13 Gloucestershire Record Office, D2659 24/16, Diary of Marion Emily Blathwayt, 24 Sept. 1919.

14 Miriam Bailin, *The Sickroom in Victorian Fiction: The Art of Being Ill* (Cambridge: Cambridge University Press, 1994), p. 1.

15 Esther Le Hardy, *The Home Nurse and Manual for the Sick Room* (London: John Churchill and Sons, 1863), pp. 146–163; R. Hall Bakewell MD, *Practical Hints on the Management of the Sick-Room* (London: John Snow, 1857); W. Anderson, MD, LRCS, Edinburgh, Spencer Thomson, 'On the Management of the Sickroom', in *Dr Spencer Thomson's Handy-Book of Domestic Medicine: Containing the Latest Information on the Treatment of Sickness and Disease* (London: Charles Griffin and Company, 1866), pp.1–60.

16 [Anon.], 'Rules to be Observed in the Sick Chamber',*The Girl's Own Paper*, No. 3, 17 Jan. 1880, p. 35.

17 R.W. Edis, *Decoration and Furniture of Town Houses* (London: Kegan, Paul & Co., 1881), p. 234; Lady Barker, *The Bedroom and the Boudoir* (London: Macmillan, 1878), pp. 98–99.

18 Barker, *The Bedroom and Boudoir*, p. 106.

19 Judith Neiswander, *The Cosmopolitan Interior: Liberalism and the British Home, 1870–1914* (London: Yale University Press, 2007), pp. 58–71.

20 Horace Collins, *My Best Riches: The Story of a Stone Rolling around the World and the Stage* (London: Eyre & Spottiswoode, 1941), p. 37.

21 Diaries of Ann Linley Blathwayt, 12, 13, 14 Jan. 1874, GRO, D2659 20/2.

22 Emma Groom Diary, Dec. 1882–Jan. 1883, Museum of London, Ephemera Collections, 93.160/32.

23 Katharine Furse, *Hearts and Pomegranates: The Story of Forty-Five Years 1875–1920* (London: Peter Davies, 1940), p. 226.

24 Richard Church, *Over the Bridge* (London: Heinemann, 1937) p. 232.

25 Ibid., p. 233.

26 S. O'Connor, 'Family and Illness in Eighteenth-century England' (M.Phil. Thesis, University of London, 2007).

27 Furse, *Hearts and Pomegranates*, p. 228.

28 Ibid., p. 228.

29 Jalland, *Death in the Victorian Family*, pp. 211–213.

30 Strange, *Death, Grief and Poverty*, pp. 69–76.

31 Ibid., p. 68.

32 Ibid., p. 77.

33 Diary of Ann Linley Blathwayt, 16 Jan. 1874, Gloucestershire Record Office (GRO), D2659 20/2.

34 Diary of Ann Linley Blathwayt, 17 Jan. 1874, GRO, D2659 20/2.

35 Diary of Ann Linley Blathwayt, 18 Jan. 1874, GRO, D2659 20/2.

36 Diary of Ann Linley Blathwayt, 21 Jan. 1874, GRO, D2659 20/2.

37 Linkman, 'Taken from Life', 309–347.

38 M. Pointon, 'Materialising Mourning: Hair, Jewellery and the Body', in M. Kwint, C. Breward and J. Aynsley (eds), *Material Memories: Design and Evocation* (Oxford: Berg, 1999), pp. 39–57. Also see S.M. Stabile, *Memory's Daughters: The Material Culture of Remembrance in Eighteenth-Century America* (London: Cornell University Press, 2004), p. 224.

39 Jalland, *Death in the Victorian Family*, p. 290. Also see Stabile, *Memory's Daughters*, p. 193.

40 Stabile, *Memory's Daughters*, p. 164.

41 Diary of James Simmons, 3 Dec. 1852, SHC, 1657/1/25.

42 M. Berg, 'Women's Property and the Industrial Revolution', *Journal of Interdisciplinary History* 24:2 (1993), 238. Also see D.R. Green, 'Independent Women, Wealth and Wills in Nineteenth-Century London', in J. Stobart and A. Owens (eds), *Urban Fortunes: Property and Inheritance in the Town 1700–1900* (Aldershot: Ashgate, 2000), pp. 214–215.

43 Diaries of Bessie King, 24 Feb. 1891, HRO, 110M88W/5.

44 Jalland, *Death in the Victorian Family*, pp. 12 and 98.

45 Ash, 'Memory and Objects', p. 222.

46 Stabile, *Memory's Daughters*, p. 223.

47 Diary of Robert Needham Cust, 11 Mar. 1868, British Library (BL), Add MSS 45398. vol. IX .

48 14 Mar. 1868, BL, Add MSS 45398. vol. IX .

49 11 Apr. 1868, BL, Add MSS 45398. vol. IX .

50 J. Vansittart (ed.), *Katharine Fry's Book* (London: Hodder & Stoughton, 1966), p. 148.

51 J.E. Panton, *Leaves from a Garden* (London: Eveleigh Nash, 1910), p. 15.

52 See J.E. Panton, *Nooks and Corners* (London: Ward & Downey, 1889), p. 3; J.E. Panton, *Leaves from a Housekeeper's Book* (London: Eveleigh Nash, 1914), p. 332.

53 Panton, *Leaves from a Garden*, p. 32.

54 Ibid., pp. 33–34.

55 See Diary of the Rev. James Raven, 2 Oct. 1860, SRO S2/4/1.10.

56 Panton, *Leaves from a Garden*, pp. 39–40.

57 M. De-la-Noy, *Queen Victoria at Home* (London: Constable, 2003), pp. 271–272.

58 A. Munich, *Queen Victoria's Secrets* (Chichester: Columbia University Press, 1996), p. 87.

59 Ibid., p. 85.

60 M.E. Lucy, *Biography of the Lucy Family* (London: E. Faithfull & Co., 1862), p. 143.

61 L.R. Haggard, *Too Late for Tears* (Suffolk: Waveney Publications, 1969), p. 94.

62 Jalland, *Death in the Victorian Family*, p. 120.

63 Ibid., p. 119.

64 J.B. [?Jane Budge], *A Beloved Mother: Life of Hannah S. Allen by her Daughter* (London: Harris & Co., 1884), p. 127.

65 M.C.H. Martin, 'Children and Religion in Walthamstow and Leyton *c.*1740–*c.*1870' (PhD thesis, University of London, 2000), p. 198.

66 Morris, *Men, Women and Property*, p. 253.

67 A.J. Owens, 'Small Fortunes: Property, Inheritance and the Middling Sort in Stockport 1800–1857' (PhD thesis, University of London, 2000), p. 217.

68 Instructions to the executors of Benjamin Harris, 1897–1906, HRO, 50M63/B38/1.

69 List of furniture bequeathed by Mary Craticum, 1871, T&WAS, DT/SC/159/1–2.

70 Book containing lists of Mrs Druitt's property, 1892, WSRO, DRUITT MSS/254.

71 Inventory of furniture at Southfield Lodge, Christchurch Road, Winchester, 1892, HRO, 100M99/E21; Furniture sale catalogue for Abbotsford House, Market Place, Romsey, 1918, HRO, 4M92/G16/5.

72 HRO, 4M92/G16/5.

73 L. Holcombe, 'Victorian Wives and Property: Reform of the Married Women's Property Law 1857–1882', in M. Vicinus (ed.), *A Widening Sphere: Changing Roles of Victorian Women* (Bloomington: Indiana University Press, 1977), p. 203.

74 Under common law, a wife's property belonged to her husband and she could therefore make no will. W. Holdsworth, *A History of English Law* (London: Methuen, 1972), vol. 3, p. 544. However, a married woman could make a will if given the power do so under a deed, settlement, will or other instrument. Trusts were in common use among the nineteenth-century middle class. C. Stebbings, *The Private Trustee in Victorian England* (Cambridge: Cambridge University Press, 2002), p. 6.

75 Owens, 'Small Fortunes', pp. 156–157. Morris, *Men, Women and Property*, p. 235.

76 Morris, *Men, Women and Property*, p. 237.

77 M. Finn, 'Women, Consumption and Coverture in England *c.*1780–1860', *The Historical Journal*, 39:3 (1996), 71.

78 P. Jalland, *Women, Marriage and Politics 1860–1914* (Oxford: Clarendon, 1988), p. 59. Mary Beth Combs argues that lower down the social scale the act did make a difference. Analysing wealth holding data and census information for shopkeepers, she argues that women married after the act tended to transfer their wealth holding into forms of property that they could own and control. M.B. Combs, 'Wives and Household Wealth: The Impact of the 1870 British Married Women's Property Act on Wealth-holding and Share of Household Resources', *Continuity and Change*, 19:1 (2004), 159.

79 F.M.L. Thompson, 'Life after Death: How Successful Nineteenth-Century Business Men Disposed of their Fortunes', *Economic History Review*, 43:1 (1990), 41. Also see Morris, *Men, Women and Property*, p. 117.

80 Examples include: Valuation of certain heirlooms to be taken at valuation by the purchaser of the Battle Abbey Estate, 1901, ESRO, BAT 2332; Valuation of furniture . . . created heirlooms under the will of Sir John Duncan Bligh, 1912, ESRO, CHR/29/7.

81 Morris, *Men, Women and Property*, p. 124.

82 Will of Rev. Daniel Jonias Olivier, 1848, B&L, Z 754/3.

83 S. Cavallo, 'What did Women Transmit? Ownership and Control of Household Goods and Personal Effects in Early Modern Italy', in M. Donald and L. Hurcombe (eds), *Gender and Material Culture in Historical Perspective* (Basingstoke: Macmillan, 2000), p. 40, also see A. Vickery, *The Gentleman's Daughter: Women's Lives in Georgian England* (London: Yale University Press, 1998), p. 194.

84 Cavallo, 'What Did Women Transmit?', pp. 42–44.

85 Owens, 'Small Fortunes', p. 218. This is a matter for debate. In a study of women and property in Sheffield and Birmingham in the late eighteenth century, Maxine Berg argues that while women's goods had a greater emotional significance for women, this cannot be explained by their lack of real property. Berg, 'Women's Property and the Industrial Revolution', pp. 248–249.

86 Owens, 'Small Fortunes', p. 216. *Men, Women and Property*, pp. 129 and. 247.

87 A.L. Erickson, *Women and Property in Early Modern England* (London: Routledge, 1993), p. 209.

88 Owens, 'Small Fortunes', p. 217.

89 HRO, 50M63/B38/1.

90 Ibid.

91 Will of George Burley, 1853, B&L, X 291/496.

92 Letters of administration with will annexed, of the goods of Henry Irish of Montserrat, 1853, HRO, 10M57/L268.

93 HRO, 50M63/B38/1.

94 Bea Howe, *Arbiter of Elegance* (London: The Harvill Press, 1967), p. 282.

95 The widow still had a right to dower, the traditional third of the husband's property, and this could now be drawn from both legal and equitable estates. However, this Act enabled the husband to take away this right by deed or will. Holdsworth, *A History of English Law*, vol. 3, p. 197. Despite the change in the law the custom of dower may have continued to inform will-making practice in some areas. Morris finds that his Leeds wills tended to follow the dower formula. Morris, *Men, Women and Property*, p. 87.

96 This seems to have been the most usual practice. Leaving goods to wives 'absolutely' was also the most common wording in the examples given in legal advice manuals. See J.T. Christie, *Concise Precedents of Wills with an Introduction and Practical Notes* (London: A. Maxwell & Son, 1849).

97 Erickson, *Women and Property*, p. 166.

98 Morris, *Men, Women and Property*, p. 103. Owens, 'Small Fortunes', p. 202.

99 50M63/B38/1, HRO.

100 Morris, *Men, Women and Property*, p. 239.

101 The only exception was Thomas Winterflood Legerton of Shalford, whose will was made in 1851. He chose to leave his nephew his furniture while his niece got a cash legacy. ERO, D/DU 293/329.

102 Morris, *Men, Women and Property*, p. 129.

103 Cavallo, 'What Did Women Transmit?', p. 46.

104 Will of Mary Ann Sadd, 1857, ERO, D/DDw/B5/6; Will of Mary Ann Granger, 1852, ERO, D/DDw/B5/6l; Will of Ann Hay Pattison, 1885, ERO, D/DCf/B911.

105 Informal will of Mrs Alice Jane Titfield, 1886, HRO, 67M92W/28/13.

106 HRO, 4M92/G16/5.

107 L. Thatcher Ulrich, 'Hannah Barnard's Cupboard: Female Property and Identity in Eighteenth-Century New England', in R. Hoffman, M. Sobel and F.J. Teute (eds), *Through a Glass Darkly: Reflections on Personal Identity in Early America* (Chapel Hill: University of North Carolina Press, 1997), p. 258.

108 Owens, 'Small Fortunes', p. 211.

109 HRO, 67M92W/28/13.

110 WSRO, DRUITT MSS/254.

111 HRO, 67M92W/28/13.

112 HRO, 4M92/G16/5.

113 ERO, D/DDw/B5/6.

114 Cavallo, 'What Did Women Transmit?', p. 42.

115 TWAS, DT/SC/159/1–2.

116 WSRO, DRUITT MSS/254.

117 Jalland, *Death in the Victorian Family*, pp. 296–297.

118 Jack Smithers, *The Early Life and Vicissitudes of Jack Smithers: An Autobiography* (London: Martin Secker, 1939), p. 44.

119 Although, sometimes, the capacity of the mother to manage the home could be equally important in keeping the family together. Sir John Martin-Harvey recalls that on the death of his mother his family was split and the children sent to separate schools. J. Martin-Harvey, *The Autobiography of Sir John Martin-Harvey* (London: Sampson Low & Co., 1933), p. 11.

120 Jalland, *Death in the Victorian Family*, p. 230.

121 Ibid., p. 252.

122 Ibid., pp. 230 and 251.

123 Bernard Holland (ed.), *Letters of Mary Sibylla Holland Selected* (London: E. Arnold, 1898) London 1 Dec. 1865, p. 10

124 Furse, *Hearts and Pomegranates*, pp. 255–256.

125 Elizabeth Gaskell, *Cranford* (London: Chapman and Hall, 1853), pp. 4–7.

126 Stuart Hodgson (ed.), *Ramsay Muir: An Autobiography and some Essays* (London: Lund Humphries & Co., 1943), p. 13.

127 Ibid., p. 13.

128 Ibid., p. 14.

129 E.L. Grant Watson, *But To What Purpose: The Autobiography of a Contemporary* (London: Cresset Press, 1946), pp. 3 and 8.

130 Ibid., p. 7.

131 Ibid., pp. 8–9.

132 Jack Smithers, *The Early Life and Vicissitudes of Jack Smithers: An Autobiography* (London: Martin Secker, 1939), p. 44.

133 For examples of flourishing widows, see P. Thane, *Old Age in English History: Past Experience, Present Issues* (Oxford: Oxford University Press, 2000), pp. 68–69. Sylvia Hahn has contrasted the passive image of the widow with the actual choice of many nineteenth-century widows to adopt independent lifestyles, rather than remarrying. S. Hahn, 'Women in Older Ages – 'Old' Women?', *The History of the Family*, 7:1 (2002), 33–58.

134 Margaret Ponsonby, *Stories from Home: English Domestic Interiors, 1750–1850* (Aldershot: Ashgate, 2007), p. 134.

135 John Marriott, *Memories of Four Score Years: The Autobiography of the late Sir John Marriott* (London: Blackie & Son Ltd., 1946), p. 19.

136 Diary of Ann Linley Blathwayt, 30 Jan. 1874, GRO, D2659 20/2.

137 20 Feb. 1874, GRO, D2659 20/2.

138 Diary of Emily Rose Blathwayt, 23 Sept. 1919, GRO, D2659 24/16.

139 Jalland, *Death in the Victorian Family*, p. 264.

140 For example, see the Diary of John Boustead of 8 Upper Gloucester Place, 1859, 16, 17, 23, 25 Nov., City of Westminster Archives; The diary of Bertram Dobell, a bookseller and writer, made no mention of the possessions of his dead wife, or any other household disruptions, until his daughters arrived to collect the goods a month later. Diary of Bertram Dobell, 23 Sept. 1910, Bodleian Library, 38534 (e.31).

141 28 Jan. 1868, BL, Add MSS 45398. Vol. IX.

142 Richard Church, *The Golden Sovereign: A Conclusion to Over the Bridge* (London: Heinemann, 1957), p. 28.

143 Ibid., p. 42.

144 Ibid., p. 38.

145 7 Apr. 1868, BL, Add MSS 45398. Vol. IX.

146 19 Jan. 1868, BL, Add MSS 45398. Vol. IX.

147 6 Mar. 1868, BL, Add MSS 45398. Vol. IX.

148 24 Feb. 1868, BL, Add MSS 45398. Vol. IX.

149 21 Mar. 1868, BL, Add MSS 45398. Vol. IX.

150 21 Mar. 1868, BL, Add MSS 45398. Vol. IX.

151 20 Mar. 1868, BL, Add MSS 45398. Vol. IX.

152 7 Apr. 1868, BL, Add MSS 45398. Vol. IX.

153 8 Apr. 1868, BL, Add MSS 45398. Vol. IX.

154 8 Apr. 1868, BL, Add MSS 45398. Vol. IX.

155 17 Apr. 1868, BL, Add MSS 45398. Vol. IX.

156 9 Apr. 1868, BL, Add MSS 45398. Vol. IX.

157 24 Feb. 1868, BL, Add MSS 45398. Vol. IX.

158 David Hussey, 'Guns, Horses and Stylish Waistcoats? Male Consumer Activity and Domestic Shopping in Late-Eighteenth- and Early-Nineteenth-Century England', in David Hussey and Margaret Ponsonby (eds), *Buying for the Home: Shopping for the Domestic from the Seventeenth Century to the Present* (Aldershot: Ashgate, 2008), p. 67.

159 Leonore Davidoff and Catherine Hall, *Family Fortunes: Men and Women of the English Middle Class 1780–1850* (London: Hutchinson, 1987), p. 347.

160 25 Feb. 1868, BL, Add MSS 45398. Vol. IX.

161 Ibid.

162 Robert Needham Cust, *Memoirs of Past Years of a Septuagenarian* (Hertford: Stephen Austin and Sons, 1899), p. 120.

163 10 Nov. 1868, BL, Add MSS 45398. Vol. IX.

Epilogue: from Victorian to modern?

WHAT HAPPENED to the middle-class home in the first half of the twentieth century? This concluding chapter outlines the relationship between the material culture of nineteenth-century middle-class homes and the families who occupied them, and considers, in the light of the existing studies, continuity and change in the period beyond. For a particularly vocal part of that generation that followed the Victorians, the nineteenth and early twentieth-century middle-class interior came to stand for a lost and alien world, which carried with it a host of emotional failings and repressions. Virginia Woolf expressed an acute distaste for her Victorian childhood home, 22 Hyde Park Gate, London, describing it as 'the cage'.[1] The dark and heavy furniture and drapery of the Victorian home symbolised for her an out-dated and inhibited mode of living. In *Orlando* (1928), she wrote that the Victorian 'men and women lived through curtains of brown and purple plush'.[2] Woolf's repudiation of her family home drove her desire for the modern. Famously, Virginia and her sister Vanessa instituted new domestic practices when they set up a home of their own in Bloomsbury: 'We were going to do without table napkins, we would have [large supplies of] Bromo instead; we were going to paint; to write; to have coffee after dinner instead of tea at nine o'clock. Everything was going to be new.'[3]

Of course, not every post-Victorian agreed with this view. Autobiographies of nineteenth and early twentieth-century childhoods reveal many happy Victorian homes.[4] Winifred Peck was just one of many Victorian children who remembered the home's 'mystery and enchantment' fondly. What these writers agreed on, however, was that the Victorian middle-class home, with its carefully segregated spaces, the drawing room and dining room, the den and the smoking room and, above all, the distant nursery, was a thing of the past. The material living practices and the emotional world they described were in decline from the early twentieth century. Less emphasis was placed on formal spatial

segregation between members of the family, and the configuration of intimacy changed in this era. Yet the gulf between Victorian and modern can be overstated. As we will see, some of the material practices of the nineteenth and early twentieth-century home continued to influence modern family life well into the twentieth century.

In the period 1850 to 1910, there was no single middle-class material culture, but middle-class homes shared some key characteristics. The elaborate and sometimes bizarre house names of the period, such as 'Cornikeraium', 'Bantadarwa' and 'Villette', are a testament to the intensely personal nature of the Victorian middle-class investment in domestic space. Above all, most middle-class homes were quite small in comparison to those inhabited by the upper end of the middle classes, and the aristocracy. The two main reception rooms were usually the dining room and the drawing room. The middle classes were also bound together by shared ritual practices that were realised through the distribution of material things. The exchange of wedding gifts, listing and displaying wedding presents, were widespread, revealing marriage as a symbolic investment of kith and kin as well as a union between man and woman.

There was a clear divide between the gentry and the aristocracy who bequeathed intact interiors with heirlooms attached, and the middle-class practice of dismantling the domestic interior on the death of its owner. Informal wills show that the middle classes had their own heirlooms, and specified the passage of objects over several generations. The breadth of economic difference within the middle classes was visible on the walls of the home. For example, the slightly threadbare furnishings and religious iconography of Stoke Vicarage contrasted sharply with the new-bought Maples furniture of rising London surveyor Edward Ryde. Money bought the upper middle-class lifestyle: the spacious Backhouse Hodgkin family home in Darlington with its bedrooms with dressing rooms attached and full staff was the product of well-placed investment in the Victorian railways. But decorative choice was a complex cultural decision: the Backhouse Hodgkin family silver was emblazoned not with a coat of arms, which was considered too ostentatious for a Quaker family, but instead with a specially designed monogram.[5] Domestic advice manuals were clearly class-conscious, and contemptuous of the blandishments of shop men and haberdashers. While some middle-class taste may have been emulative, the middle classes did not automatically use material culture to create social status. Certainly, the middle classes used material culture to distinguish themselves from other social groups. Yet in seeking to distinguish her interior from the 'aristocratic' style, Frederica Orlebar's decorative choice was the opposite of emulative.

This book has demonstrated the limits of privacy and the separation

of men and women as the key characteristics of nineteenth-century middle-class domestic space. Home and work were often not separate: professionals, shopkeepers and businessmen all worked at home and, rather than operating within restricted areas, exercised a profound influence on the material world around them. While different rooms, such as drawing rooms and dining rooms, bedrooms and nurseries, became more clearly defined during the nineteenth century, main rooms in small middle-class houses were often used for joint purposes rather than having a single function. Individual privacy could be important but was hard to find in smaller houses, particularly for children or servants. Yet, in many cases the quest for individual privacy was not paramount. In larger homes the family might cluster in the breakfast room, or the library. And while advice literature urged that spatial boundaries be set up between master and servant, in smaller homes it was almost impossible to follow these recommendations.

That said, a great deal of effort went into the creation of spatial boundaries inside the nineteenth and early twentieth-century home, both within the pages of advice manuals and in actual homes. Yet the desire for privacy was not the only, or indeed the most important driver. Rather, the arrangement of rooms and things was determined by the perceived needs of the family – the need to construct appropriate relations between family members, rather than the need to secure individual privacy. Material culture, space and family relationships were mutually constitutive: the home was designed with social relations in mind, yet, once in place, domestic material boundaries acted to create the distinctive set of intimacies and distances that characterised nineteenth-century middle-class family relationships.

Victorian class relationships were forged on a day-to-day, face-to-face basis between masters and servants in middle-class homes. Middle-class houses were designed to separate masters and servants, and to reinforce class boundaries. Servants were expected to sleep in attics, work in basements, and carefully avoid rooms where the family were present during the day. Yet, perhaps surprisingly, drawing boundaries could also protect the servant. Although masters could snoop through their servants' possessions, there was a wider, culturally sanctioned, recognition that the servant's box represented a line that masters and mistresses could not cross without forfeiting the servant's trust. However, again there was an enormous difference between middle-class households: from the genteel poverty of the homes that made do with the assistance of one servant (or none at all), to the opulent homes of the wealthy middle classes, which might retain a large staff. In small homes, maid and mistress would have spent long hours working side by side as a matter of necessity, often allowing intimacy between the two. In some homes, servants' acceptance

into the family was marked by two spatial orders: one for public view and one in which the servants were allowed to eat with the family. For children placed under the care of nannies in the nursery, extremely close bonds of love and affection sprang up that in some cases could, and sometimes, did supersede their relationships with their parents. It is also clear that in addition to creating a sense of difference between the middle and working classes, the way in which the home was used could also in some cases overcome this difference, creating a close bond between maids and mistresses.

The material world of the home offers us a new insight into the power relationships between nineteenth and early twentieth-century husbands and wives. There was no simple correlation between women's social power and their control over the home. There was a tacit cultural assumption that home decoration was predominantly a woman's role, as an extension of domestic management. This emerges strongly in the increasing number of domestic advice manuals and magazine articles published in the second half of the nineteenth century. Novelists, however, could imagine the interior as a male emotional investment, that men were obliged to keep up materially, and on which the happiness of their home life often rested. In practice, male investment in the interior has clearly been underestimated. Nineteenth-century popular advice cast men as 'household mechanics' long before the rise of the DIY movement. Men often retained overall control of household finances, and had more power to choose expensive goods such as furniture.

Edward Ryde's furniture purchases were emotional as well as material investments: like Trollope's Dr Thorne, Ryde used domestic goods to create the atmosphere of a family home. Women had a significant but different role to play in the creation of the domestic interior. Diaries show that women were intimately involved with the upkeep of the home: arranging, maintaining and dressing furniture were all part of domestic management. The Orlebar diary demonstrates that a woman could use the domestic interior as a means of reasserting her own identity, when separated from home and family by patriarchal power structure. Ultimately the assignation of responsibility for decoration to one sex or the other is too reductive: the wedding list demonstrates that gifts could make a substantial material contribution to the domestic interior, showing how the home could be product of the investment of family and wider community as much as the specific taste of either husband or wife. Domestic interiors were often mediated through the joint decision-making process of nineteenth-century marriage: a shared passion for the 'artistic' built the Donaldson home, but for others, wrangles over furnishing could express deeper fissures in married life. Decisions about

domestic goods were the result of cooperation or conflict, as much as dominance or indifference.

The spaces in which nineteenth-century marriage were lived greatly influenced the nature of marital relationships. The creation of the home and domestic material culture was intimately linked to the construction of marriage, the dominant social form of the period. Advice manuals and novels created fictions of the ideal marriage, and in some cases illustrated how the interior could both contribute to and demonstrate marital failure. While historians have imagined nineteenth-century marriage as 'patriarchal' 'romantic' or 'companionate', the analysis of the use of space in the home suggests that 'fastidious' and 'polite' are equally apt descriptions. Couples spent most time together in the drawing room and the marital bedroom. A carefully arranged drawing room could foster mutual respect between husband and wife. The drawing room was frequently constructed as a site of marital intimacy: a haven created for the man of the house, but simultaneously one in which he would have to obey the feminine rules of behaviour.

In upper middle-class homes, marital bedrooms often came with a dressing room attached. The dressing room allowed the wife's dressing process – particularly cumbersome in the age of the crinoline – to proceed unhampered in the bedroom. But it also meant that husband and wife could dress modestly hidden from the other's gaze, maintaining a sense of mystique between marital partners. If space permitted, a spare or moveable chair bed could be placed here to accommodate the husband in the lying-in period, or perhaps after the family had been completed. The rise of the middle-class dressing room was apparently paralleled by a culture of abstinence that suggests that the ethos of a fastidious marriage included sexual restraint. Divorce or separation was difficult for the middle classes in the nineteenth century, so the arrangement of space could also be a vital consolation in learning to live within an unhappy marriage. Upper middle-class couples had the advantage here, as they often had the space to create completely separate terrains. The formal system of arranging space in the home, and gendered segregation, would have made it easier for unhappy couples to avoid each other. But in homes with little space to spare, this may have been difficult for some couples to achieve.

During the nineteenth century the relationship between men and home remained complex, but this research does not indicate a comprehensive flight from domesticity. Male professionals remained firmly ensconced in the home. Schoolhouses and vicarages were ordered around male professional spaces, and the homes of businessmen often also contained a counting house or study where a father must not be disturbed. Yet the mystique of male spaces such as the doctor's surgery

fascinated young men, and initiated them into the profession from an early age. Inventories show that the size of many middle-class homes prohibited the proliferation of male niches such as the study, smoking room and billiard room. When men were able to create their own spaces, these rooms were often an expression of pleasure and enjoyment, rather than an attempt to stave off female dominance. For many men the exotic smoking room may have been a playful hangover from their student rooms. It was also an overt symbol of empire: men seem to have brought the empire into the home, as much as fled the home for the colonies.

Although the practice of sending boys away to school was often intended to separate them from the home, such exile could have the opposite effect, increasing schoolboys' yearning for domesticity. If they had their own rooms, students and schoolboys reproduced the decorative conventions of the drawing room with enthusiasm. While throwing off the shackles of the family home could be exciting, young male lodgers often ended up satellites of nearby friends and family in a bid to recapture the comforts of home. Perhaps the most poignant struggle was that faced by widowers when they attempted to keep family and home together. The diaries of Robert Needham Cust demonstrate the material and emotional challenges widowers might face when they chose to make a home alone with a young family.

During the nineteenth and early twentieth centuries, when children arrived, it was usual to house them in the nursery, under the care of a nursemaid when financial resources permitted. A number of autobiographies suggest that the nursery was in widespread use in English middle-class homes from at least 1850. This placing of children at a distance from their parents had a crucial impact on childhood experience. Parents used space to control their relationships. For some children contact with their parents consisted solely of fleeting visits to the drawing room, perhaps as infrequently as once a week. But by providing access to their personal spaces, in particular the bedroom, the dressing room and the study, parents could also create special intimacies allowing favouritism to be exercised. The spatial organisation of the home often threw children into greater contact with servants, in particular the nanny whose presence in the nursery had a huge impact on the experience of home from the child's point of view. Those who looked back to their Victorian childhoods, like Winifred Peck, were aware that the results of this system were not entirely negative. Distance could add excitement to family relationships, and did not necessarily preclude warmth. It is also worth remembering just how these relationships would have varied from home to home. The upper middle classes are over-represented in autobiography, but families on the fringe of the lower middle classes could have very different experiences. The autobiography of Mary Hughes, for

example, whose family could not afford even one servant, recounts a particularly close and intense relationship with her mother.

After the First World War, the character of the middle classes shifted, and nineteenth-century styles of living were no longer economically feasible. The 1920s and 1930s saw a growth in the clerical sector, and in particular an increase in the technical and scientific professions.[6] This led to an expansion in the size of the middle classes in relation to the rest of the population, and an increase in the percentage of salaried employees.[7] In the immediate aftermath of the war, middle-class spending power was much reduced. The falling value of rental properties, the impact of inflation on formerly 'safe' investments such as railways, gas, trains and public utilities, combined with rises in the cost of living whilst middle-class salaries stayed at the same level, all reduced the amount of money that the middle classes had available to spend on their homes.[8] Ross McKibbin argues that although the middle classes voiced their plight loudly, the fall and stabilisation of prices, continuous employment and relatively limited taxes meant that they enjoyed an economic 'golden age' before 1938.[9] Nevertheless, as John Burnett points out, the pressures of increasing taxes, local rates and the wages of domestic servants could only be met by running smaller houses with just one or two servants, or none at all.[10]

In the commuter area of London the number of servants per 100 families fell from 24.1 in 1911 to 12.4 in 1921.[11] Some well-off middle-class families were able to continue to employ servants, but these were fewer in number.[12] Tellingly, speculatively built middle-class housing in the interwar period tended not to include servants quarters.[13] With servant help diminishing, the highly polished and heavily ornamented Victorian interior became unsustainable. Randal Phillips' *The Servantless House* (1920), first published at the height of the post-war middle-class spending crisis, offered ways to reduce labour in the home, including dispensing with brass door knockers, which required daily polishing.[14] The Second World War, and the subsequent labour shortage, brought a new range of opportunities for female workers, and the number of servants reduced still further. By 1951 about 350,000 women were employed in private domestic service in England and Wales compared with 1.3 million recorded in 1931.[15] Under these conditions it finally became impossible for the majority of middle-class families to maintain the staffed establishments that had been common in the nineteenth century.

Despite economic challenges, the period after the First World War saw a new enthusiasm for domesticity among the middle classes. Alison Light has argued that the predominant middle-class ideology of the interwar period was an introverted conservatism, focused on quiet home

life, a reaction to the strident nationalism that had gripped the nation in the run up to war.[16] The interwar English were thus 'a private and retiring people, pipe smoking little men and their quietly competent partners, a nation of housewives and gardeners'.[17] A growth in home ownership, particularly among the lower middle classes, also encouraged emotional and material investment in home.[18]

There was a massive growth in speculative building: between 1919 and 1939 2,886,000 new homes were built by private builders.[19] New homes appeared on the outskirts of every city, but suburban development was concentrated in London, the south and the Midlands.[20] By the 1930s a salary as low as £200 a year could be used to secure a mortgage.[21] By 1961, 41 per cent of houses were owner occupied.[22] The design of new housing was heavily influenced by the Garden City movement, which promoted low density housing in green open spaces.[23] These homes looked very different from their nineteenth-century counterparts: they tended to be smaller, with rooms spread horizontally over two storeys rather than vertically upwards. The semi-detached house, which combined low-density layout, green space and compatibility with lower middle-class budgets, was wildly popular.[24]

The twentieth century saw the decline of the formal spatial segregation of the home, and the emergence of the living room as a shared family space. While the notion of 'upstairs downstairs' remained firmly entrenched in twentieth-century popular consciousness, the basement and attics were no longer servant territories in most middle-class homes.[25] Adrian Forty argues that for many twentieth-century families, the kitchen replaced the drawing room as the heart of the household[26] – a change that took place gradually. The gloomy Victorian dining room was increasingly criticised by twentieth-century advice writers,[27] and the drawing room, which was associated with the ostentation of the Victorian age, increasingly branded 'vulgar'.[28] For Randal Phillips, the drawing room had 'the smack of a rather artificial place for special occasions only, where everyone is supposed to be on his best behaviour'.[29] Instead, advice writers advocated the more informal 'living room'.[30]

Yet it was also acknowledged that the living room was still far from common.[31] The persistence of the drawing room in sale catalogues and inventories around 1910 suggests that this change may have been slow, particularly in high-end homes belonging to the older generation.[32] Flora MacDonald Mayor depicts one such home in *The Rector's Daughter* (1924), in which Dedmayne Rectory, the home inhabited by Canon Jocelyn and his daughter Mary has remained unchanged since Mary's mother's death in early childhood: 'the drawing-room with its straight-backed arm-chairs and striped chintz, had been getting old-fashioned forty years before'.[33] But Mayor presents this room as a fragile survival of

6.1 Illustration showing a converted living room

the Victorian age, increasingly buffeted by modernity. In smaller, newer middle-class homes, the drawing room was on its way out.

This change in the spatial organisation of the family home was accompanied by a transformation in personal relationships. In D.H. Lawrence's *Women in Love* (1921) the establishment of a home and its furnishing represent the old ways of the previous century. The leading characters, Ursula and Birkin, struggle with the problem of constructing a new and meaningful relationship, while throwing off the old form of nineteenth-century marriage. Ostensibly, shopping for furniture for their new life together, Birkin is inspired by a chair, but the couple turn against the object when they consider the past way of living that it represents: 'The truth is, we don't want things at all,' he replied. 'The thought of a house and furniture of my own is hateful to me.'[34]

For most people, the domestic shift was far less radical than Lawrence imagined. Marriage, and the establishment of a home, remained at the heart of their lives. Nevertheless, from the turn of the century, writers began to place less emphasis on the division of the home between the sexes.[35] An increasingly conservative Jane Ellen Panton, writing in 1910, criticised the breakdown of the gendered divide in the home and urged a return to older uses of space to recreate the marital harmony that she

supposed existed in the pre-divorce era.[36] Historians, however, take a more positive view, suggesting that twentieth-century marriage became more mutual and companionate as the twentieth century wore on.[37] This has been linked to an increase in leisure time, particularly for the lower middle and working classes.[38] The spread of birth control and increased expectations of sexual pleasure were also an influence. In middle-class homes the rise of the living room and shared spaces for husbands and wives may also have contributed to an increased sense of companion-ship in marriage. The modern flat, although restricted to a small part of the population at this time, represented a new opportunity for the expression of intimacy between husband and wife, figuring as early as 1905 in the *The Girl's Own Paper*. The dressing-room spare bed, with its possibilities for sleeping apart, seems to have evolved into the twentieth-century practice of keeping twin beds in the marital bedroom. As Hilary Hinds has shown, twin beds could powerfully shape the experience of twentieth century marriage, offering companionable intimacy, yet dis-tance, and perhaps, for women, a greater possibility for sexual refusal.[39]

In the twentieth century, separate rooms for men gradually fell out of fashion, although new male terrains also emerged. In *The New Home* (1899), Mrs Peel led the way by advocating a combined morning room and smoking room.[40] In the years that followed, criticisms of the smoking room mounted. Mrs Stallard, whose manual was published in 1912, was firmly set against it.[41] In 1913, Edward W. Gregory argued that the practice was both ostentatious and offensive: 'At one time the smoking-cap and smoking jacket were fashionable. Nowadays they would make a man feel a fool and look it. The same may be said of the smokers' cabinet in its more elaborate forms.'[42] Stallard believed that the presence of the smoking room had a negative effect on husband and wife, and remarked that she had 'seen them [smoking rooms] account-able for a great deal of harm'.[43]

In practice, male rooms did not disappear altogether. Some profes-sionals continued to require studies in the home.[44] In smaller homes, male engagement with space may simply have taken a new form. As Sean O'Connell has shown, cars and their paraphernalia, constituted a new twentieth-century male domain.[45] Although car ownership was initially restricted to the elite, for those that could afford it, the garage offered a new male space.[46] The diaries of retired military man Walter Gunnell Wood, for example, who lived at Camberley in 1929 and 1930, show that he generally spent the best part of at least two days a week in his garage with his car, cleaning, polishing and generally fiddling with it.[47] The majority of houses built in the 1920s and 1930s had a small private garden.[48] Conservatories and outbuildings were of course present in the nineteenth-century homes,[49] but the increase in gardens coupled with

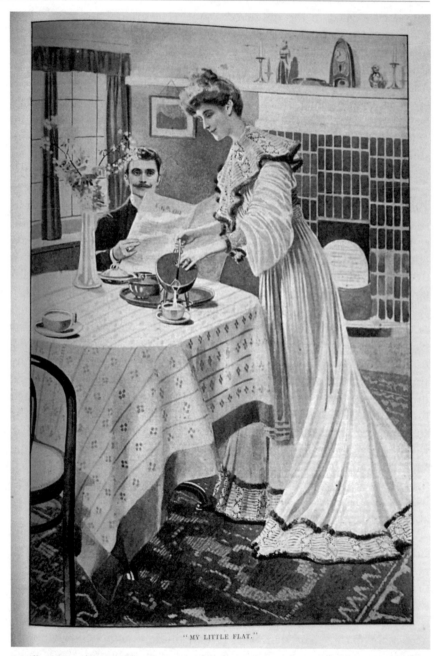

"MY LITTLE FLAT."

6.2 Illustration showing a flat

the reduction in home size may have encouraged more men to retreat to the shed – and it may be here that we see the beginnings of the later stereotype of the shed as a masculine lair.[50]

Perhaps the most notable difference between a Victorian and a

THE GARAGE

of the garage should correspond, and where they join, bricks must be cut out on the house wall to enable the bricklayer to " tooth and bond " the new work to the old. If, then, the garage walls are to have facing bricks, the thickness must not be less in any part than 9 ins. for weatherproofing reasons, and even 9 ins. solid is not sufficient to prevent penetration of damp under prolonged driving rain at gale force. However, it is an advantage, in a way, if the house walls are rendered in white cement or rough-cast, for then the building of the garage—again following suit—

FIG. 23.—Brick-built, with tiled roof and concrete wash-down in front.

can have a cheaper brick, and advantage can be taken of a by-law concession which permits the walls to be built only 4½ ins. thick if treated as panels, with 9 in. by 9 in. solid piers at the corners, and at least one pier intermediately.

But, of course, the weather-proofing will depend on a good cement

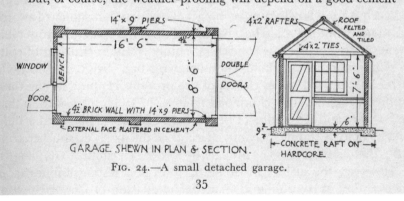

GARAGE SHEWN IN PLAN & SECTION.

FIG. 24.—A small detached garage.

35

6.3 Illustration showing a garage

modern home was the separation of the nursery from the rest of the house. The decline of the nursery was partly a result of the shrinking availability of domestic servants, but it was also influenced by changing views on childcare. Many autobiographers, writing in the mid-twentieth century, presented their nineteenth-century experiences using a new

language and set of concepts. Freudian theories were introduced and popularised in the 1920s.[51] Psychoanalysis, the study of the mind and the new system of ideas it brought – particularly those in relation to identity formation in childhood – had an important impact on the way writers described their lives. Dora Montefiore's reflections on her child-hood experiences, published in 1927 are typical, she writes: 'When I look back at those happy sheltered days of what I suppose was more of less typical Victorian home life, I note the vast difference that separates the psychology of parents, children and domestic staff from that of the twentieth century.'[52] Freud's ideas were based on a pervasive and power-ful critique of the Victorian bourgeois family, and came to be associated with their material culture and living practices. Eleanor Acland's autobi-ography, published in 1935, stated:

> Unconsciously we were all swathed and muffled in a plethora of upholstery; and so likewise was our furniture. The more important the room the more upholstery it had to have . . . the minds of our elders, no less than their bodies, were lumbered with a load of upholstery: dogmas, prejudices, for-mulas, customs and taboos of all sorts.[53]

This criticism, of Victorian material cultures and behaviours, became more pronounced as views changed on the problems created by the sepa-ration of mothers and children. During the Second World War, sociolo-gists and childcare experts placed a new emphasis on the socialisation of children and the importance of good mothering.[54] Work by psycholo-gists such as John Bowlby on the impact of evacuation heightened aware-ness of how children could be adversely affected by separation from their parents.[55] Bowlby and his colleagues mainly wrote in criticism of con-temporary working-class families, but his work had obvious implications for the middle and upper classes of the previous century. By the time Winifred Peck wrote her childhood memoir in 1952, her assertion that the 'mystery and enchantment of a certain distance' could lend a little excitement to the home, playfully questioned the newly established con-sensus that a child should be brought up in close proximity to its parents.

However, the history of domestic roles and responsibilities is as much a story of continuity as change. The division of labour between men and women in the nineteenth century bears a marked similarity to that of the eighteenth and first half of the twentieth centuries.[56] Judy Giles's analysis of the emergence of the 'professional housewife' in the first half of the twentieth century, demonstrates how modern technolo-gies and the growth of consumption combined to create a new role for middle and lower-middle-class housewives.[57] Heating, lighting and cooking were substantially improved by the installation of electricity in

the home: by 1939 some 75 per cent of houses were wired.[58] Yet the professional housewife was also a reinscription of an older idea of the duties of womanhood through new technologies and cultural forms. As Avner Offer and Sue Bowden have shown, the take-up of household technologies was far slower than consumer items for leisure, as assistance for women continued to be given a low priority in household budgets.[59]

During the First World War, life in many homes was disrupted by the absence of men, and women took on their roles as far as possible.[60] Joanna Bourke, however, argues convincingly that for the majority of returning soldiers the horrors of war greatly increased the attractions of home, many men at the front yearned for domesticity, and gratefully welcomed it on their return.[61] This even led to a short-lived willingness among some men to engage in mundane domestic tasks, such as washing up.[62] The diaries of Alan Withington, a well-to-do clerk who moved into a new home near Manchester with his wife Morag in 1933, show the division of labour in one middle-class couple.[63] Husband and wife made domestic purchases for the home together, on joint shopping trips to Manchester. Withington took charge of the task of moving furniture into the home, a process he describes himself as 'directing'.[64] Like many of the nineteenth-century men described in this book, Withington was heavily involved in setting up the home, and maintained financial control of it, while leaving its arrangement and maintenance to his wife – tasks that were seen to fall within her remit as domestic manager.

Perhaps the most striking survivals into the twentieth-century are the material practices that surrounded the Victorian middle-class wedding. Throughout the nineteenth-century, technological innovation brought a new range of objects into the home that were absorbed into older domestic practices. The middle-class wedding list, for example, stayed remarkably constant throughout the period. Cutlery became electroplated rather than silver, china changed to blue and white, and Japanese-style goods appeared from the 1870s: but the way these small ornamental things were gifted between family, friends and local acquaintances remained unchanged. As Louise Purbrick has shown, the wedding list became more entrenched in British culture in the first half of the twentieth century. It was taken on by the working classes and, with department stores offering ready-to-buy wedding lists, it became a firmly established part of consumer culture.[65] This gifting practice remains unchanged in many marriages today.

There was considerable continuity in the gendered meaning of things, from the nineteenth century and into the twentieth. Throughout the period, a consistent female world of objects emerges that seems relatively undisturbed by social and legal change. Tastemakers such as Jane Ellen Panton happily swept away clutter after 1900, but the dense

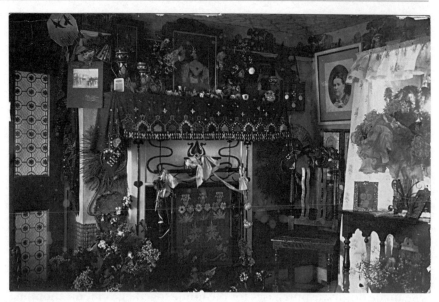

6.4 The interior of 'Bantadarwa', 1910

decoration of the earlier era lingered in small middle-class homes like 'Bantadarwa'. The Twamley family home in 1910 is shown in figure 6.4. The female portraits clustered on that Bedford mantelpiece suggest a pride in matrilineal heritage that continued to dominate the interior. The 1882 Married Women's Property Act was an important victory for the feminist movement, and allowed married women to hold separate property and to will away their own goods. The Act transformed property holding for lower middle-class women who had not previously had access to protection under equity law, but outside the legal framework middle-class women continued to make elaborate informal wills that assigned domestic goods to other women.

The transmission of goods from mother to daughter was particularly important. The trousseau represented the powerful and enduring bond between them. If goods were not passed at the moment of marriage, informal wills suggest that this took place on the mother's death. The use of domestic goods to carry matrilineal legacy is very old: studies of will-making in previous periods suggest that the association of women and domestic goods in the bequest stretched back to the medieval period. At the end of our period women's informal wills still carefully assigned domestic goods such as linen and china to their daughters or immediate female relatives. Yet these goods continue to play an important role in some families today – china and silver are handed down from generation to generation, christening robes are passed from mother to daughter.

While the British middle classes no longer divide up their homes as

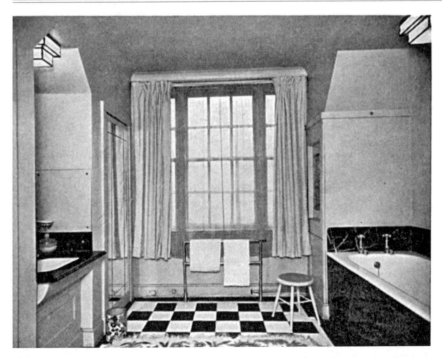

6.5 Illustration showing a bathroom

the Victorians did, arguably, the desire for some degree of segregation remains prominent across social groups. Extra reception rooms remained popular in the twentieth century. Mark Swenarton has shown that when the government built new housing for the working classes after the First World War, the York Labour movement put pressure on York County Council to build houses with parlours.[66] As Judy Attfield has demonstrated, in the 1950s, the residents of Harlow new town, frequently used DIY to alter their modernist open-plan interiors, building walls between dining and sitting areas, and kitchen and dining spaces.[67] The desire for personal space has, if anything, become more pervasive. The dressing room persisted in high-end homes into the twentieth century. Indeed, the modernist architect Le Corbusier famously insisted that undressing should never take place in the bedroom, as it was not 'clean'.[68] The emphasis here – on dressing and hygiene – is clearly rather different to the semi-sexualised 'fastidious' space that Robert Kerr mapped out some sixty years earlier. Yet the notion of a private personal space for dressing and self-cultivation became increasingly popular, as the use of bathrooms spread. Working-class homes built after the First World War usually included a separate internal bathroom.[69] As Forty shows, the 1920s insistence of health, efficiency and hygiene led to the appearance of new hard white enamel bathrooms that were clearly distinct from

the rest of the home[70] (see figure 6.5). It seems likely that the Victorian middle-class practice of dressing apart continued and developed in the twentieth century through the use of the bathroom. In the Victorian spatial segregation of the home, then, we may see the beginnings of the modern relationship between individuals and space – and we may be closer to the Victorians than we think.

Notes

1 Virginia Woolf, 'A Sketch of the Past', in Jeanne Schulkind (ed.), *Moments of Being* (London: Pimlico Press, 2002), p. 128.

2 V. Woolf, *Orlando* (London: L & V Woolf, 1928), p. 229.

3 Virginia Woolf, 'Old Bloomsbury', in Schulkind, *Moments of Being*, pp. 46–47.

4 Edmund Gosse famously wrote of his overly religious and restricted Victorian childhood in Edmund Gosse, *Father and Son: A Study of Two Temperaments* (London: Heinemann, 1907), but this was contested by subsequent autobiographers. See Sir Henry S. Lunn, *Chapters from My Life: With Special Reference to Reunion* (London: Cassell & Co., 1918), p. 4; J.C. Carlile, *My Life's Little Day* (London: Blackie & Sons, 1935), p. 23.

5 Letter from Jonathan Backhouse Hodgkin to his mother, 12 March 1873, DRO, D/ Ho/C 90/1.

6 Richard Trainor, 'The Middle Class', in Martin Daunton (ed.), *The Cambridge Urban History of Britain vol III 1840–1950* (Cambridge: Cambridge University Press, 2000), p. 686; Ross McKibbin, *Classes and Cultures: England 1918–1951* (Oxford: Oxford University Press, 1998), p. 46.

7 McKibbin, *Classes and Cultures*, pp. 46–47.

8 Martin Pugh, *We Danced All Night: A Social History of Britain Between the Wars* (London: Vintage Books, 2009), p. 87; McKibbin, *Classes and Cultures*, pp. 51–52.

9 McKibbin, *Classes and Cultures*, pp. 54, 59–61.

10 John Burnett, *A Social History of Housing 1815–1985* (London: Methuen, 1986), p. 251.

11 Pamela Horn, *The Rise and Fall of the Victorian Servant* (Stroud: Sutton, 2004), p. 185.

12 McKibbin, *Classes and Cultures*, p. 61.

13 Burnett, *A Social History of Housing*, p. 265.

14 Randal Phillips, *The Servantless House* (London: Country Life, 1921), p. 12.

15 Horn, *The Rise and Fall of the Victorian Servant*, p. 199.

16 Alison Light, *Forever England: Femininity, Literature and Conservatism between the Wars* (London: Routledge, 1991) pp. 11–12.

17 Ibid., p. 211.

18 Burnett, *Social History of Housing*, p. 253.

19 Ibid., 252.

20 Colin G. Pooley, 'Patterns on the Ground: Urban Form, Residential Structure and the Social Construction of Space', in Daunton, *The Cambridge Urban History of Britain*, p. 446.

21 Burnett, *Social History of Housing*, p. 252.

22 Pooley, 'Patterns on the Ground', p. 444.

23 Mark Girouard, *Cities and People: A Social and Architectural History* (London: Yale University Press, 1985), p. 351; Simon Pepper, 'The Garden City', in Boris Ford (ed.), *The Cambridge Cultural History of Britain: Early Twentieth-Century Britain* (Cambridge: Cambridge University Press, 1992), p. 115.

24 Trainor, 'The Middle Class', p. 693; Burnett, *Social History of Housing*, p. 271.

25 See Lucy Delap, *Domestic Service in Twentieth Century Britain: Memory, Culture, Emotions* (forthcoming, Oxford University Press, 2010). See especially, chapter 'Heritage Nostalgia: Domestic Service Remembered and Performed'.

26 Adrian Forty, *Objects of Desire: Design and Society 1750–1980* (London: Thames & Hudson, 1986), p. 149.

27 Constance Louisa Stallard, *The House as Home Written for Those Who Really Matter in All Classes* (London: Andrew Melrose, 1915), p. 28; Flora Klickmann, *The Mistress of the Little House* (London: *The Girl's Own Paper* and *Woman's Magazine*, 1912), p. 32.

28 Edward W. Gregory, *The Art and Craft of Home-Making* (London: Thomas Murby & Co., 1913), p. v.

29 Phillips, *The Servantless House*, p. 32.

30 Harriette M. Brown, *To Those about to Marry: Don't! Without A Practical Guide to the Choice, Building, & Furnishing of a House* (Paisley: Alexander Gardner, 1905), p. 22; Gregory, *The Art and Craft*, p. 25; Klickmann, *The Mistress of the Little House*, p. 33.

31 Gregory, *The Art and Craft*, p. 25.

32 In 1912, the large gentry home Lartington Hall in county Durham still boasted a drawing room. Sale catalogue of the contents of Lartington Hall, Barnard Castle, 8 and 9 July 1912 DRO D/Ed 18/11/13. The widowed Mrs M.A. Purchase also had a drawing room when her home was sold off after her death in 1918. Furniture sale catalogue for Abbotsford House, Market Place, Romsey, by order of the executors of Mrs M.A. Purchase deceased, 1918, 4M92/G16/5.

33 F.M. Mayor, *The Rector's Daughter* (London: The Hogarth Press, 1924), p. 9.

34 D.H. Lawrence, *Women in Love* (London: William Heinemann Ltd, 1935, first published 1921), p. 376.

35 J. Kinchin, 'Interiors: Nineteenth-Century Essays on the "Masculine" and the "Feminine" Room', in P. Kirkham (ed.) , *The Gendered Object* (Manchester: Manchester University Press, 1996), p. 25.

36 J.E. Panton, *Leaves from a Housekeeper's Book* (London: Eveleigh Nash, 1914), p. 49.

37 Davidoff et al. *The Family Story: Blood, Contract and Intimacy 1830–1960* (London: Longman, 1999), pp. 215–216.

38 Ibid., p. 215.

39 Hilary Hinds, 'Together and Apart: Twin Beds, Domestic Hygiene and Modern Marriage', *Journal of Design History* (forthcoming, 2010).

40 Dorothy Constance Peel, *The New Home: Treating of the Arrangement, Decoration, Furnishing of a House of Medium Size* (London: Constable & Co., 1898), p. 112.

41 Stallard, *The House as Home*, p. 148.

42 Gregory, *The Art and Craft*, p. 63.

43 Stallard, *The House as Home*, p. 148.

44 Diary of William Henry Hallam, 1 June 1918, BRO, D/EX 1415/25 vol. 25 Jan. 1917–July 1919.

45 Sean O'Connell, *The Car and British Society: Class, Gender and Motoring 1896–1939* (Manchester: Manchester University Press, 1998), p. 44.

46 Pugh, *We Danced All Night*, p. 243.

47 Walter Gunnell Wood diaries, 1929–1930, SHC, 4159/1–2.

48 Stephen Constantine, *Social Conditions in Britain 1918–1939* (London: Lancaster Pamphlets, 1939), p. 395.

49 R. Preston, 'Home Landscapes: Amateur Gardening and Popular Horticulture in the Making of Personal, National and Imperial Identities 1815–1914' (PhD thesis, University of London, 1999).

50 See Gordon Thorburn, *Men and Sheds* (London: New Holland Publishers Ltd, 2002).

51 Susan Kingsley Kent, *Gender and Power in Britain 1640–1990* (London: Routledge, 1999), p. 293.

52 D.B. Montefiore, *From a Victorian to a Modern* (London: E. Archer, 1927), p. 18.

53 E. Acland, *Goodbye for the Present: The Story of Two Childhoods Milly 1878–88 & Ellen 1913–24* (London: Hodder & Stoughton, 1935), pp. 133–134.

54 Jane Lewis, *Women in Britain since 1945: Women, Family, Work and the State in the Post-War Years* (Oxford: Basil Blackwell, 1992), p. 17. These ideas had been popularised during the war by the radio broadcasts of Donald Woods Winnicott and Denise Riley, *War in the Nursery: Theories of the Child and of the Mother* (London: Virago, 1983), pp. 88–90.

55 Lewis, *Women in Britain since 1945*, p. 18. Also see Riley, *War in the Nursery*, pp. 92–101.

56 A. Vickery, 'His and Hers: Gender, Consumption and Household Accounting in Eighteenth-century England', *Past and Present*, 1 (supplement 1) (2006), 15 and 19; J. Giles, *The Parlour and the Suburb: Domestic Identities, Class, Femininity and Modernity* (Oxford: Berg, 2004).

57 Giles, *The Parlour and the Suburb*, chapter 3.

58 Burnett, *Social History of Housing*, p. 262.

59 Sue Bowden and Avner Offner, 'The Technological Revolution That Never Was: Gender, Class and the Diffusion of Household Appliances in Interwar England', in Victoria de Grazia with Ellen Furlough (eds), *The Sex of Things: Gender and Consumption in Historical Perspective* (Berkeley: University of California Press, 1996), p. 245.

60 Gerard J. DeGroot, *Blighty: British Society in the Era of the Great War* (London: Longman, 1996), pp. 223–224.

61 Joanna Bourke, *Dismembering the Male: Men's Bodies, Britain and the Great War* (London: Reaktion Books, 1996), p. 167.

62 Ibid., p. 169.

63 Alan Withington Diaries, Highgate Scientific and Literary Institute.

64 Alan Withington Diaries, 16 June 1933.

65 L. Purbrick, *The Wedding Present: Domestic Life Beyond Consumption* (Aldershot: Ashgate, 2007), passim.

66 Mark Swenarton, *Homes fit for Heroes: The Politics and Architecture of Early State Housing in Britain* (London: Heinemann Educational Books, 1981), p. 179.

67 Judy Attfield, 'Bringing Modernity Home: Open Plan in the British Domestic Interior', in Irene Cieraad (ed.), *At Home: An Anthropology of Domestic Space* (New York: Syracuse University Press, 2006), p. 78.

68 Burnett, *Social History of Housing*, p. 249. Le Corbusier, *Towards a New Architecture* (trans. Frederick Etchells) (London: John Rodker, 1927), p. 122.

69 Swenarton, *Homes Fit for Heroes*, p. 179.

70 Forty, *Objects of Desire*, p. 116.

Bibliography

Primary sources

Manuscript collections

All Saints' Library, Manchester Metropolitan University

Correspondence between Richard Orlebar and Frederica Orlebar nee Rouse Boughton, 1862–1884, OR/2240–2246

Diaries of Frederica Orlebar, 1860–1875, OR2244/5–8

Diary of Dr A. Conning Hartley, 1892–1897, FAC 68/1

Draft will of Elizabeth Emery, 1840s, Z694/62

Draft will of Elizabeth Sarah Hooper, 1857, HF 89/3/1

List of wedding gifts, Twamley Papers, 1898–1899, Z 826/5/6

List of wedding presents received by Ida Elizabeth Dawson and Henry Darlow, 1915, Z1063/6/1/2

Papers of Henrietta Hooper, including draft will, letter revising provisions of will, and note as to whom her jewellery is to be left, 1857–1859, HF 89/2/1–7

Photograph of Mildred and Herbert Twamley shortly after their wedding, c.1900, Z 826/8/9

Photograph of the interior of 'Bantadarwa', 1910, Z826/8/37

Probate copy of the will of Hannah Grant, 1853, Z 694/12

Probate of the will of the Rev. Daniel Josias Olivier, 1848, Z 754/3

Reconveyance for Frederick Croft 1874 including will of Joseph Bailey 1874 X 815/15/3 1

Sale catalogue of contents of No. 7 Castle Street, Buckingham, 1906, BML 5/2/5

Will of George Burley, 1854, X 291/496

Will of Issac Green, 1843, Z1063/2/1

Will of John Harris, 1855, HF 17/5/1

Will of William Robins Matthews, 1887, HF 90/2/26

Berkshire Record Office

Diary of Richard Hooper, 1862–1885, D/P 20C/28/2–8

Diary of William Henry Hallam, 1917–1919, D/EX 1415/25

Memorandum of furniture at Curate's House, Pember, 1891, D/Eby Q 39

Bodleian Library

Diary of Bertram Dobell, 1910, 38534 (e.31)

The British Library

Diaries of Robert Needham Cust, 1842–1909, Add 45390 – 45406

Buckinghamshire Records and Local Studies Centre

Diaries of Katherine E. Roscoe, D.115/56/1–10

Diary of G.A. Cooke, D/X 1136

Diary of Margaret C. Burgess, D/X 1480

Diary of Margaret Owen, 1881, DX 1480/21

Carlisle Record Office

List of wedding presents for the Senhouse family, *c.*1875

Centre for Kentish Studies

Account Book of Rev. Cleave Warne, 1893–5, U1390 A3

Diaries of Rev. Cleave Warne, 1887–1909, U1390 F1–23

Diary of Annie Dickinson, 1858–1859, U1451 F4

Diary of Fanny Pyner Brice, 1889, U1390 F24

Diary of Rev. J. Woodruffe, 1851–1856, P 377/28/34

List of wedding presents, Fanny Cleave Warne, 1889, F29 U1390

Set of photographs of Stoke Vicarage in 1909, U1390, Z23

Wedding photographs of Rev. Cleave Warne and Fanny Brice, 1889, U1390 Z6

City of Westminster Archives

Diary of John Boustead of 8 Upper Gloucester Place, 1859

Cornwall County Record Office

List of wedding gifts for Stephens family, ST/563

Cumbria Record Office Barrow Branch

Bill of sale for 'Littlebank', Settle, Yorkshire, May 1883, BD/HJ 12/2/1

Inventory for 5 Mount Pleasant Barrow in Furness, BDB17/1/4

Inventory for 149 Abbey Rd, 1901, BDB 17/1/3

Inventory of Aldingham Hall, 1905, BDB 17/3/2

Inventory of Arndean, Barrow in Furness, 1905, BDB/17/3/3

Inventory of Clarence House, Dalton in Furness, July 1891, BDB/17/SP3/13

Inventory of Clonavon, Barrow in Furness, 1910, BDB 17/3/5

Inventory of Crake house, Sparke Bridge, Colton, November 1902, BD/HJ/256 2/13

Inventory of East Mount, Barrow in Furness, 1910, BDB 17/1/7

Inventory of furniture belonging to Dudley Wright, 1908, BDB 17/1/5

Inventory of Oaklands, Grange over Sands, May 1906, BDB/17/SP3/18

Inventory of Risedale, Newbarns, Barrow in Furness, 1892, BDB 17/3/1

Inventory of the dwellinghouse in Iron Works Road, Barrow in Furness, BDB 17/1/6 a b and c

Inventory of the Hermitage, No 6 Peter Street, Southport, BD/TB 8/5/1

Marriage settlement between William Simpson Ramsayand Mary Hannah Atkinson of Barrow in Furness, 1901, BDB/17/T2/9/18

Sale catalogue for Broughton Lodge, Grange over Sands, April 1902, BDB/17/SP3/16

Sale catalogue for Croslands, Furness Abbey, January 1910, BDB/17/SP3/5

Sale catalogue for Duddon Hall, near Broughton in Furness, 1902, BDB/17/SP3/8

Sale catalogue for Forrest Villa, 1908, BDB/17/SP3/23

Sale catalogue for Greenscoe House, Askam in Furness, March 1891, BDB/17/SP3/2

Sale catalogue for Hamilton House, Dalton in Furness, BDB/17/SP3/12

Sale catalogue for Rothay Bank, Ambleside, 1902, BDB/17/SP3/1

Sale catalogue for Salthouse villa, Salthouse Road, Barrow in Furness, 1903, BDB/17/SP3/3

Sale catalogue for Stock Park, Lakeside, Windermere, 1911, BDB/17/SP3/26

Sale catalogue for 'The Guards', Kirkby, Ireleth, November 1895, BDB/17/SP3/20

Sale catalogues for Hazel Bank, Gosforth, 1903, BDB/17/SP3/14

Sale catalogues for 'The Towers', Grange-over-Sands, 1901, BDB/17/SP3/15

Schedule and inventory of the furniture of Mr Thomas Westwood, 1898, BD HJ 339/1/9

Valuation of furniture belonging to the late Mr George Robinson, 1915, BDB 17/1/9

Valuation of furniture belonging to late Thomas Brooks, 1866, BD/HJ 39 4/18

Unidentified wedding list, 1878, BD/HJ/221/3/20

Cumbria Record Office Whitehaven Branch

Accounts, valuations of furniture, relating to the estate of William Cooke deceased, 1866–1871, DWM 13/83/3

Bill of sale of furniture and effects, Rev. Philip Ahier to James Davidson, 1878, DBH 24/19/12

Catalogues for the auction of furniture and effects from 'Arica Villa', Whitehaven, 1871, DBH 24/22/26

Inventories of furniture, ornaments, etc. at 28 Bramham Gardens, 1904, DBH 24/47/44

Sale book of furniture of Mrs C. Fox, 1864, DBH 18/2

Schedule of books, furniture of Gilfred William Hartley, 1876–1888, DBH 24/32/23

Valuation of furniture, belonging to William Carlyle, 1883 – 1903, DBH 24/13/9

Valuation of furniture at Greenbank, 1894, DBH 24/9/6

Valuation of furniture and effects at Hall Croft, 1892, DBH 24/15/4

Valuation of furniture and effects of James Davidson, 1881, DBH 24/19/10

Valuation of furniture and other effects of the late John Askew, 1882, DBH 24/1/7/1

Valuation of furniture and personal belongings of John Harris, 1863, DWM 5/116/2

Downing College Archives

Photograph album compiled by Richard J. Reece, DCPH/08/001

Durham Record Office

Correspondence from Anthony Wallis to Amy B. Mounsey, 1908–1910, D/Wa 5/1/157–239

Inventory of furniture and effects at 17 Oakfield Terrace, Gosforth, 1907, D/Gw 43

Inventory of furniture and effects of G.W. Howard, 1900, D/SJ ZZ19

Inventory of furniture at 3 Warwick Crescent, 1875, D/HH 9/2/19

Inventory of furniture at New Spittal, 1909, D/HH 6/15/32

Inventory of the household effects of the late Isabella Bowron, 1904, D/X 920/4/12

Inventory of Thomas Hogget, Gilesgate, 1871, D/SJ C103

Letters of Jonathan Backhouse Hodgkin, 1872–1873, D/Ho/C 90/1–6

List of furniture made by Amy Mounsey, 1909, D/Wa5/4/25

List of wedding presents by Amy Mounsey, 1910, D/Wa 5/4/26

Poster advertising the sale of the furniture of late Ann Laycock, 1874, D/X 571/3/27

Recollections from the childhood of Jonathan Backhouse Hodgkin, 1916, D/Ho/F 146

Sale catalogue of contents of East Carleton Rectory, 1907, D/Ed 18/11/11

Sale catalogue of contents of 8 Clare Hall Road, Halifax, D/Ed 18/11/3

Sale catalogue of contents of Lartington Hall, Barnard Castle, 1912, D/Ed 18/11/13

Sale catalogue of furniture at Bird Hill House, Whickham, 1866, D/St/E5/9/33

Sale catalogue of furniture at Coronation Hall, Gainford, 1914, D/Ed 18/11/16

Sale catalogue of Snow Hall, Gainford, 1910, D/Ed 18/11/12

Sale catalogue of the Deanery of Durham, Durham, 1912, D/Ed 18/11/15

Valuation of furniture at 7 Framlington Place, c.1870s, D/X 776/243

East Riding of Yorkshire Archives

Advertisement for sale of furniture upon the premises of Mr George Stephenson, 1842, DDX 24 83

Diary of Mary Ann Turner, DDX 857/2/5

Inventory of furniture at White Bank House, Brinnington, 1845, DDX 94/183

List of silver and furniture belonging to Edith Binnington, 1861, DDX 353 51

Photograph album of Griffiths Thomas William Purchase, DDX 498/1

Pocket Book of Ralph Boast, including inventory and valuation of furniture, undated, DDX 496 1

Sale book of furniture, for executors of Elizabeth Binnington, 1879, DDX 353/17

Sale catalogue for collections of Gilyatt Sumner, 1877, DDX 17/1

Valuation of the furniture of the late Joseph Beaumont of Brantingham Wold, 1860, DDBD 8 45

East Sussex Record Office

Copy will and drafts of John Wood, 1877, HIC/785–788

Copy will of Jane Lane, 1849–1854, SAY/2978

Copy will of Maria Jane Sayer, 1887, SAY/2980

Copy will of Mary Sayer, 1878, SAY/2979

Diaries and papers of the Rev. John Coker Egerton, 1842–1900, AMS 5637–6193

Inventory of furniture at Bexhill Lodge, Bexhill, 1853, AMS886–888

Inventory of furniture at the 'Friars', Battle, 1870, BAT/2329

Inventory of furniture at Newhouse Farm, 1861, BAT/2328

Inventory from Down House, Rottingdean, 1844, BRD 8/14/1

Letters of Anne Frewen nee Byng, FRE/4214–4222

Letters of Hilda Sebastian to her mother, 1912, ACC 5456

List of fixtures, fittings, furniture and plate belonging to Hickstead Place, Twineham, 1877, HIC/785–788

Original will, copies and draft of Charlotte Sarah Wood, 1880–1902, HIC/793b–f

Papers relating to the executors of Frances Constable, 1866, MOB 1633–1638

Photograph album of Margaret Elsie Hughes, AMS 6570 1/1

Printed catalogue of furniture, china and books at Farthings Cottage, 1872, FRE/913

Probate of will and 2 copy wills of Harriet Wood, 1904–1910, HIC/793g–k

Probate of will of Martha Wood, 1880, HIC/789

Probate of will of Olivia White, 1871, HIC/784d

Sale catalogue of the furniture of Middle House, Mayfield, 1842, AMS497

Sale catalogues for sale of Middleham, 1866, MOB 1639, 1640

Settlement on the marriage of Maria Harvey with Nathaniel Hamer, 1867, ADD MSS 3406

Valuation of certain heirlooms, Battle Abbey Estate, 1901, BAT 2332

Valuation of furniture . . . created heirlooms under the will of Sir John Duncan Bligh, 1912, CHR/29/7

Wills, depositions of servant re verbal bequests and declaration re gifts of Mrs Dealtry, 1844, BRD 11/17/2–4

Essex Record Office, Chelmsford Branch

Assignment of interest in furniture and affects of John Finch, carpenter, 1888, D/DS 500/43

Copy of will of George Green, 1851, D/DMq/M37/7

Copy of will of Stephen William Streeter, 1852, D/DMq/M37/26

Copy of will of Thomas Winterflood Legerton, D/DU 293/329

Diary of Ann Eliza Branfill, 1859, D/DRu/F12/31

Diaries of George H. Rose, 1882–1956, D/DU 418

Documents relating to the estate of Captain Joseph Pattisson, 1885–1888, D/DCf/F35

Inventories of articles on the premises of Myrtle Cottage, 1886, D/DCf/F103

Papers relating to estates of Maria Margaret Playle, 1905, D/F 35/8/194

Papers relating to the estate of Susan Porter, 1860–1863, D/DGs/F166

Papers relating to the executorship of Mary Ann Sadd, 1852–1857, D/DDw/B5/6

Probate of will of Frederick Arthur Bentall, 1893, D/DCf/F566

Probate of will of George Asser White Welch, 1867, D/DMq/T5/26

Probate of the will of Rev. Abraham William Bullen, 1887, D/DSu/F43

Will of Ann Hay Pattison, 1885, D/DCf/B911

Will of John Green, 1847, D/DU 854/40

Will of Joseph Grice, 1849, D/DWv/T85/27

Will of Louisa Middleton, 1881–1885, D/DCf/F103

Girton College Archives

Album from 1902–3, Ph 10 Folio Box 1

Girton College household regulations, 1912, C1 29 7

Mary Lynch's album, 1894–1897, Ph 10 3

Gloucestershire Record Office

Diaries of Ann Linley Blathwayt, 1872–1874, D2659 20

Diaries of Emily Rose Blathwayt, 1895–1940, D2659 24

List of wedding presents made on marriage of John Cullimore and Mary Dale, 1885

Gonville and Caius College Archives

F.H.H. Guillemard, 'The Years the Locusts Have Eaten, 1852–1923', PPC/GUI102

The Documentary Photography Collection, Greater Manchester Record Office

Photograph of a boys' dormitory at the Observatory House School, DPA, 1911/29, 2/D27/42

Photograph of a musical evening at the Wilkinsons, DPA 612/47

Photograph of Betsy Lee's Study, DPA, 1073/5, U28/23

Photograph of Dr and Mrs McBain at dinner, DPA, G1578/3, 1/R7/8

Photograph of Hugh Horrocks and his wife Esme, DPA, 489/5, ES/1

Photograph of Simon Bacola with a friend (bachelor's quarters), DPA, 1128/47

Photograph of the breakfast room at Brentwood, DPA, 1790/12, 1/211/10

Photograph of the drawing room at Durham Rise, DPA 1823/23, 1/Z26/2

Photograph of the drawing room at Frondeg, DPA, 1642/37, 1/U12/37

Photograph of the 'Museum' at Frondeg, DPA, 1642/30, 1/U12/25

Photograph of the nursery of the home of the Garsten family in London, DPA, 2357/143

Hampshire Record Office

Bundle of papers for Benjamin Harris, 1897–1906, 50M63/B38/1

Documents re administration of will of Thomas Roberts, 1878–1892, 67M92W/8/10

Documents re probate of will of Thomas Drover, 1883, 67M92W/28/5

Documents relating to the estate of Mary Ann Bowker, 1885, 11M70/D18

Furniture sale catalogue for Abbotsford House, Market Place, Romsey, 1918, 4M92/G16/5

Informal will of Mrs M.A. Purchase, 1887–1953, 4M92/G16/5

Informal will of Alice Jane Titfield, 1886, 67M92W/28/13

Inventory of 'Ayrfield', Bournemouth, *c.*1870s, 81M74/69

Inventory of furniture and effects of the late Thomas Roberts, 1887, 67M92W/8/10

Inventory of furniture and effects of Jacob Ray, 1866, 67M92W/16/2

Inventory of furniture and live and dead farming stock at 'Inwoods Farm', Hants, 1892, 27A03/12

Inventory of furniture at 'Cambrian Lodge', Shirley, 1886, 4M92/F5/6

Inventory of furniture at 'Cornikeranium', Oxford Avenue, Southampton, 1907–1908, 4M92/N225/4

Inventory of furniture at 'Montrose', Cargate Avenue, Aldershot, 1893, 27A03/3

Inventory of furniture at 99 High Street, Winchester, 1889, 67M92W/10/17

Inventory of furniture at Southfield Lodge, Christchurch Road, Winchester, 1892, 100M99/E21

Inventory of furniture at 27 Southgate Street, Winchester, 1890, 11M70/D31

Inventory of furniture belonging to John Corrie, 1862, 34M87/16

Inventory of furniture, linen, wearing apparel and other indoor effects of William White, 1890, 4M92/N232/12

Inventory of furniture, plate, linen and effects of Wintershill House near Bishops Waltham, 1888, 106M87/A11/21

Inventory of furniture taken at the residence of the late Dr J.P. Stephens, *c.*1897, 124M71/C18

Letters of administration with will annexed, of the goods of Henry Irish of Montserrat, 1853, 10M57/L268

Letters of administration with will annexed, of the goods of Ann Webb, 1855, 10M57/L270

Letters of George Vivian Poore to his mother, 1866, 39M85/PC/F27/5

Letters of Maurice Bonham Carter to his mother, 1903, 94M72/F970

Papers re probate of will of Charles Macklin, 1881, 67M92W/27/28

Papers re settlement of the will of Jacob Ray, 1866–1903, 67M92W/16/2

Papers re settlement of the will of John Castell, 1903–1905, 67M92W/9/18

Papers re settlement of the will of Maria Pritchard, 1884–1888, 67M92W/19/18

Photograph album belonging to Shaw Storey family of Bursledon, 58A01/1

Photograph of the Rev. Canon Vaughan in his study, Undated, 217M84/37/45

Poster advertising household furniture, property and effects of Mr Dumper, 1862, 1M90/12

Probate copy of will of Jane Hunt, 1882, 67M92W/25/6

Sale catalogue for Browning Hill House, Basingstoke, Hants, 1854, 10M57/SP85

Sale catalogue for 'Tufton Warren Farm', Whitchurch, 1882, 46M84/F91/1

Sale catalogue of furniture and other effects at Biddesden House, Ludgershall, 1908, 46M84/C9/14

Sale catalogue of furniture at Bentley Green, 1857, 27A03/7

Sale catalogue of furniture at 'Bramblys', Basingstoke, 1857, 10M57/SP96

Sale catalogue of furniture at Hurstbourne Tarrant, Andover, 1882, 46M84/F43/4

Sale catalogue of furniture at Southfield Lodge, Christchurch Road, 1892, 100/799/E21

Sale catalogue of furniture at 'The Shrubbery', Whitchurch, 1881, 46M84/F101/1

Sale catalogue of furniture at Thruxton, Weyhill, 1882, 46M84/F89/1

Sale catalogue of furniture belonging to the late Mrs Cottle, 1862, 10M57/SP101

Sale catalogue of furniture from 'The Rectory', Upper Clatford, Andover, 1881, 46M84/F94/1

Sale catalogue of furniture the property of Miss Tubb, 1856, 10M57/SP90

Sale catalogue of furniture to be sold at Winslade Rectory near Basingstoke, 1850, 10M57/SP747

Sale catalogue of goods of the late Mr Francis Baker, 1855, 10M57/SP545

Sale catalogue of wheelwright's and carpenters equipment at Mottisford, Romsey, 1904, 4M92/N/186/12

Sale poster for goods of Maria Pritchard, 1888, 67M92W/19/18

Valuation of furniture the property of the late Mrs Lempriere, 1887, 4M52/116

Will of Charles Richard Harrington of Southampton, 1907, 4M92/N225/4

Will of Margaret Ann Cocks, 1891, 67M92W/28/23

Will of Mary Anna Theresa Whitby, 1850, 99A00/A1/1

Will of William Fowey of Tunworth, proved 1855, 10M57/L278

Hertfordshire Record Office

Catalogue of furniture, West Hill Rectory, Buntingford,1898, D/Ele/B25/3

Diary of Ann Pidcock, 1847, PC 675

Sale catalogue for St Mary's Rectory, Little Hormead, 1890, D/EL5095

Wedding list of Mary Ann Exton, 1858, D/Eso F38

Highgate Scientific and Literary Institute

Alan Withington diaries

Ironbridge Gorge Museum Library and Archives

List of wedding gifts of Barnard Orniston Dickinson and Agnes Elizabeth Kirkwood, 1898, lab/ASSOC/6/2

Lambeth Local Studies Library

Diary of Henrietta Thornhill, IV/81/6

Lewisham Local Archives

Diaries of Mary Maria Paine, 1868–76, LA, PT 83/76 35

Lincoln College Archives

Photograph of an unidentified student room, *c.*1865

London Metropolitan Archives

Ada Lewis Lodging House for Women, Committee Report December 1914, LMA/4318/B/03/013

Diaries of Andrew and Aggie Donaldson, LMA, F/DON/1–27

Magdalene College Cambridge Archives

Photograph of male students from Magdalene College, Cambridge, 1910, E/P/9/8.

Magdalene College Oxford Archives

Photograph of a student room in album inscribed FBD, MCA, CR/1/17

Museum of London

Emma Groom Diary, 1882–1883, Ephemera Collections, 93.160/32

Newnham College Archives

Photograph of a student room *c.*1900, 3.4

Photograph of a student room, 3.26

Plymouth and West Devon Archives

List of wedding gifts for Strode Lowe family, 1891–1905, MEA 11

Royal Holloway College Archives

Diaries of Winifred Seville, 1906–1910, RF/136/9

Holloway College Register of Students 1887–1921, AR/200/1

M. Pick, 'Social life at R.H.C 1887–1939', RHC RF/131/7

Photograph album presented to the college by Miss Frost, RHC PH/328/6/10

Photograph showing students posed for the 5 o'clock tea, RHC PH/271/6

Photographs of student rooms, 1896–1898, PH/116/1–56

Photograph of study belonging to Miss Bishop, RHC PH/115/3

Photograph of tea party, PH/271/5

St Hilda's College Archives

Reminiscences of E.B. Hamilton, Reminiscences: Hamilton, E.B., 1898–1901

St John's College Library, Cambridge

Album containing photographs of A.R. Ingram's rooms, 1898, JCL, Album 25

Photograph of a student room, E6 New Court, at St John's College, Cambridge, Arch IX

Shropshire Record Office

List of wedding presents for CWC Bridgeman, 1895, 4629/1/71

List of wedding presents for Marianne Caroline Bridgeman, 1862, 4629/7/3/3

Selwyn College Archives

Photograph album belonging to G.W. Saunders, 1900–1, C TRM 37

Suffolk Record Office, Ipswich branch

Diaries of Rev. James Raven, 1850–1906, S2/4/1.1–1.54

Surrey History Centre

Diaries of Edward Ryde, 1844–1892, 1262/1–49

Diaries of James Simmons, 1813–1868, 1657/1

Diaries of Walter Gunnell Wood, 1929–30, 4159/1–2

Tyne and Wear Archives Service

Auction of furniture at Deckham Hall, Gateshead, 1874, DX951, DX951/1

Inventory of furniture, 16 Eldon Road, Newcastle, 1886, DT/MSM/44

Inventory and valuation of furniture at 31 Rye Hill, Newcastle, 1869, DT/SC/38

List of debts and appraisal of goods of Henry Chambers, 1846, DT/SC/52

Lists of furniture bequeathed by Mary Craticum, 1871, DT/SC/159/1–2

Sale catalogue 18 Windsor Terrace, Jesmond, Newcastle, 1878, DT/SC/137

Scrapbook titled 'Gleanings of the Pumphrey family, 1835–1908', 1441/8

University College Oxford Archives

Notebook of C.J. Faulkner, 1879, UC.FA6/1/MS1/3

Photograph album, probably of Charles Crisp, 1897–1900, UC:P53/P/1

West Sussex Record Office

Book containing lists of Mrs Druitt's property, 1892, Druitt MSS/254

Catalogue of furniture and effects at Manor House, Appledram, 1916, RAPER/53

Catalogue of sale of farming stock and furniture, property of Mr Brandon, 1868, Albery and Lucas/303

Catalogue of sale of furniture at Woodman's Green Farm, 1870, Albery and Lucas/285

Inventory and appraisement of the furniture belonging to Henry Hill, 1841, Add Mss40

Inventory of the heirlooms the property of the late Colonel Warden Sergison, 1849, SERGISON/1/529

Inventory of furniture late the property of Thomas Brooks, 1850, RAPER/332

List of Ella Druitt's wedding presents, 1880, Druitt 286

List of the wedding presents of Charles Druitt, 1875, Druitt 291

Probate copy of the will of James Brown, 1845–1849, Add Mss855

Probate of the will of Isabel Unwin, 1881, COBDEN/1114

Probate copy of will of William Chalwin, 1867, Add Mss 1814

Sale catalogue of furniture and effects of Isabel Unwin, 1881, COBDEN/1116

Schedule of furniture of John Smith, 1858, Add Mss1422

Valuation of the furniture of Bank Cottage, Lancing, 1843, Add Mss42

West Yorkshire Local Archive Service, Bradford

Catalogue of furniture at 2 Mount Royd, Manningham, 1903, 10D76/3/571/35

Inventory of furniture at no.18 Oak Lane, Manningham, 1902, 10D/76/3/40/5/3

Inventory of furniture upon the premises of Belle Vue House, Morecambe, 1886, 10D/76/3/22

Inventory of furniture of Mrs Mitchell, 1910, 10D76/3/77/15

Inventory of furniture belonging to Rev. William Mitchell, 1909, 10D76/3/77/15

List of furniture valuation for Mary More, late nineteenth century, 14 D00/2/2

Settlement made on the marriage of Josef Lustig and Rose Farbstein, 1893, 10D76/4/40/5/1

Settlement made on the marriage of William Harrison [Tetley] Mary Ann Lee, 1892, 10D76/3/40/4/1

West Yorkshire Local Archive Services, Calderdale

Inventories of furniture and effects at Shibden Hall, 1854–1868, SH1 SH 1854–1885

Inventory of furniture belonging to Esther Booth, 1888, SH 2 SHE SM 1888

Inventory of furniture belonging to Mrs Hebden, undated, FW31/56

Inventory of furniture etc at house in North Parade, Halifax, 1876, FW 30/30

List of furniture belonging to Charles Healey, 1890, WYC: 1069/68

West Yorkshire Local Archive Service, Leeds

Bill of sale of furniture in dwelling house at Tunbridge Street in Leeds, 1863, WYL 295 17 5

Bill of sale of furniture and effects in dwelling house, No. 16, Park Place, Leeds, 1854, WYL 295 17 5

Catalogue of household furniture at Cliff Villa, Headingley, 1875, ACC 2363

Family settlement of Edmund Smith and Frank Wilkinson, 1863, WYL 295 17 1 3

Inventory of 'Villette', The Drive, Roundhay, 1898. WAYS313

Treaty of marriage of Alfred Savage Dixon, 1867, WYL 295 17 1 4

Printed primary sources

Advice manuals

Anderson, W., 'On the Management of the Sickroom', in S. Thomson, *Dr Spencer Thomson's Handy-Book of Domestic Medicine: Containing the Latest Information on the Treatment of Sickness and Disease* (London: Charles Griffin and Company, 1866)

[Anon.], *Cassell's Household Guide: Being a Complete Encyclopaedia of Domestic and Social Economy* (London: Cassell & Co., 1869)

[Anon.], *Domestic Servants, As They Are & as They Ought To Be* (Brighton: W. Tweedie, 1859)

[Anon.], *Home Difficulties: Or, Whose Fault is it? A Few Words on the Servant Question* (London: Griffith and Farran, 1866)

[Anon.], *The Book of the Household; or Family Dictionary of Everything Connected with Housekeeping and Domestic Medicine* (London: Ward and Lock, 1862)

Bakewell, R. Hall, *Practical Hints on the Management of the Sick-Room* (London: John Snow, 1857)

Barker, Lady, *The Bedroom and Boudoir* (London: Macmillan, 1878)

Beeton, I.M., *Beeton's Housewife's Treasury of Domestic Information: Comprising Complete and Practical Instructions on the House and its Furniture, Artistic Decoration and other Household Matters* (London: Ward, Lock & Co., 1865)

Black, A., 'The Amateur Photographer', reprinted in B. Newhall (ed.), *Photography: Essays and Images, Illustrated Readings in the History of Photography* (London: Secker & Warburg, 1980, originally published 1887), pp. 148–153

Brown, H.M., *To Those about to Marry: Don't! Without A Practical Guide to the Choice, Building, & Furnishing of a House* (Paisley: Alexander Gardner, 1905)

Christie, J.T., *Concise Precedents of Wills with an Introduction and Practical Notes* (A. Maxwell & Son, 1849)

Cremer Jnr, W.H., *The Toys of Little Folks of all Ages and Countries or the Toy Kingdom* (London: W.H. Cremer Jnr., 1873)

Eastlake, C.L., *Hints on Household Taste in Furniture, Upholstery and Other Details* (London: Longmans Green, 1878 reprint)

Edis, R., *Decoration and Furniture of Town Houses* (London: Kegan Paul & Co., 1881)

Gregory, E.W., *The Art and Craft of Home-Making* (London: Thomas Murby & Co., 1913)

Le Hardy, E., *The Home Nurse and Manual for the Sick Room* (London: John Churchill and Sons, 1863)

Haweis, M.E., *The Art of Housekeeping: A Bridal Garland* (London: Sampson Low & Co., 1889)

Herrick, C. Terhune, *The Expert Maid-Servant* (New York and London: Harper Brothers, 1904)

Hibberd, S., *Rustic Adornments for Homes of Taste; And Recreations for Town Folk in the Study and Imitation of Nature* (London: Groombridge and Sons, 1857)

Jennings, H.J., *Our Homes, and How to Beautify Them* (London: Harrison and Sons, 1902)

Kerr, R., *The Gentleman's House: Or, How to Plan English Residences, from the Parsonage to the Palace* (London: John Murray, 1864)

Kirton, J.W., *Cheerful Homes: How to Get and Keep Them Or, Counsels to Those About to Marry and Those Who Are Married* (London: Ward, Lock & Co., 1882)

Klickmann, F., *The Mistress of the Little House* (London: The Girl's Own Paper and Woman's Magazine, 1912)

Law, C. Orlando., *House Decoration and Repairs: A Practical Treatise for Householders, Craftsmen, Amateurs, and Others Interested in House Property* (London: John Murray, 1907)

Loftie, M.J., *The Dining-Room* (London: Macmillan & Co., 1878)

Loudon, J.C., *The Suburban Gardener and Villa Companion* (London: Longman, Orme, Brown, Green & Longmans, 1838)

Panton, J.E., *From Kitchen to Garret: Hints to Young Householders* (London: Ward & Downey, 1887)

Panton, J.E., *Leaves from a Housekeeper's Book* (London: Eveleigh Nash, 1914)

Panton, J.E., *Nooks and Corners* (London: Ward & Downey, 1889)

Peel, D.C., *The New Home: Treating of the Arrangement, Decoration, Furnishing of a House of Medium Size* (London: Constable & Co., 1898)

Phillips, R., *The Servantless House* (London: Country Life, 1921)

Sargeant, A.M., *The Housemaid's Complete Guide and Adviser* (London, Thomas Dean and Son, 1854)

Stallard, Mrs A., *The House as Home: Written for Those who Really Matter in All Classes* (London: Andrew Melrose, 1913)

Stevenson, J.J., *House Architecture* (London: Macmillan & Co., 1880)

Stopes, M.C., *Marriage in My Time* (London: Rich and Cowan Ltd, 1935)

Stopes, M.C., *Married Love: A New Contribution to the Solution of Sex Difficulties* (London: A.C. Fifield, 1918)

Veritas, A., *The Servant Problem: An Attempt at its Solution by an Experienced Mistress* (London: Simpkin, Marshall & Co., 1899)

Warren, E., *My Lady Help and What She Taught Me* (London: Houlston and Sons, reprint 1889)

Autobiographies, published diaries and letters

Acland, E., *Goodbye for the Present: The Story of Two Childhoods Milly 1878–88 & Ellen 1913–24* (London: Hodder & Stoughton, 1935)

Allen, B.M., *Down the Stream of Life* (London: Lindsey Press, 1948)

Barlow, A., *The Seventh Child: The Autobiography of a Schoolmistress* (London: Gerald Duckworth & Co., 1969)

Beecham, T., *A Mingled Chime: Leaves from an Autobiography* (London: Hutchinson, 1944)

Berkeley-Hill, O., *All Too Human: An Unconventional Autobiography* (London: Peter Davies, 1939)

Birrell, A., *Things Past Redress* (London: Faber & Faber, 1937)

Booker, B. Lee, *Yesterday's Child: 1890–1909* (London: Long, 1937)

Brown, L.W., *Suivez Raison and I.T:. Or, A Chap's Chequered Career An Autobiography* (London: Watts & Co., 1933)

Bruce, H.J., *Silken Dalliance* (London: Constable, 1946)

Budge, J., *A Beloved Mother: Life of Hannah S. Allen by her Daughter* (London: Harris & Co., 1884)

Carberry, M., *Happy World: The Story of A Victorian Childhood* (London: Longmans Green, 1941)

Carlile, J.C., *My Life's Little Day* (London: Blackie & Sons, 1935)

Cholmondeley, M., *Under One Roof: A Family Record* (London: John Murray, 1918)

Church, R., *Over the Bridge: An Essay in Autobiography* (London: Heinemann, 1955)

Church, R., *Golden Sovereign: A Conclusion to Over the Bridge* (London: Heinemann, 1951)

Churchill, W.S., *My Early Life: A Roving Commission* (London: Thornton Butterworth Ltd., 1930)

Collingwood, R.G., *An Autobiography* (Oxford: Oxford University Press, 1939)

Collins, H., *My Best Riches: Story of a Stone Rolling Round the World and the Stage* (London: Eyre & Spottiswoode, 1941)

Cust, R. Needham, *Memoirs of Past Years of a Septuagenarian* (Hertford: Stephen Austin and Sons, 1899)

Darlington, W.A., *I Do what I Like* (London: MacDonald & Co., 1947)

Davies, A.M., *A Book with Seven Seals: A Victorian Childhood* (London: Chatto & Windus, 1974)

Davies, C., *Clean Clothes on Sunday* (Suffolk: Terrence Dalton, 1974)

Dawson, W.J., *The Autobiography of a Mind* (London: Century Co., 1925)

Deane, A.C., *Time Remembered* (London: Faber & Faber, 1945)

Easel, J. (pseud. Charles Eastlake), *Our Square and Circle: Or, The Annals of a Little London House* (London: Smith, Elder & Co., 1895)

Farjeon, E., *A Nursery in the Nineties* (London: Victor Gollancz, 1935)

Fisher, H.A.L., *An Unfinished Autobiography* (Oxford: Oxford University Press, 1940)

Fraser, F. (ed.), *The Diaries of Maud Berkeley* (London: Secker and Warburg, 1985)

Furse, K., *Hearts and Pomegranates: The Story of Forty-Five Years 1875–1920* (London: Peter Davies, 1940)

Gardiner, C. Wrey, *The Colonies of Heaven: The Autobiography of a Poet* (Essex: Grey Walls Press, 1941)

Gibbs, P., *The Pageant of the Years: An Autobiography* (London: William Heinemann, 1946)

Gosse, E., *Father and Son: A Study of Two Temperaments* (London: Heinemann, 1907)

Graves, R., *Good-bye to All That: An Autobiography* (London: Jonathan Cape, 1929)

Gray, G., *Vagaries of a Vagabond by 'The Fighting Parson'* (London: Heath Cranton, 1930)

Haggard, L.R., *Too Late for Tears* (Suffolk: Waveney Publications, 1969)

Hare, K., *No Quarrel with Fate* (London: Sampson Low & Co., 1946)

Hodgson, S. (ed.), *Ramsay Muir: An Autobiography and some Essays* (London: Lund Humphries & Co., 1943)

Holland, B. (ed.), *Letters of Mary Sibylla Holland Selected* (London: E. Arnold, 1898)

Hughes, M., *A London Child of the 1870s* (London: Persephone Books, 2005)

Hughes, M., *A London Family 1870–1900* (Oxford: Oxford University Press, 1991)

Hurst, G., *Closed Chapters* (Manchester: Manchester University Press, 1942)

Hutchison, G.S. (Lieutenant-Colonel G.S. Hutchison), *Footslogger: An Autobiography* (London: Hutchinson & Co., 1931)

Jones, E.E. Constance, *As I Remember: An Autobiographical Ramble* (London: A. & C. Black, 1922)

Keppel, S., *Edwardian Daughter* (London: Hamish Hamilton, 1958)

Kendon, F., *The Small Years* (Cambridge: Cambridge University Press, 1930)

Keynes, F.A., *Gathering Up the Threads: A Study in Family Biography* (Cambridge: Heffer & Sons, 1950)

Knight, L., *The Magic of a Line: The Autobiography of Laura Knight* (London: William Kimber, 1965)

Leaf, W., *Walter Leaf 1852–1927 Some Chapters of Autobiography, with a Memoir by C. M. Leaf* (London: John Murray, 1932)

Leighton, C., *Tempestuous Petticoat: The Story of an Invincible Edwardian* (London: Victor Gollancz, 1948)

Lodge, O., *Past Years: An Autobiography* (London: Hodder and Stoughton, 1931)

Lucy, M.E., *Biography of the Lucy Family* (London: E. Faithfull & Co., 1862)

Lumsden, L.I., *Yellow Leaves: Memories of a Long Life* (London: Blackwood & Sons, 1933)

Lunn, B., *Switchback: An Autobiography* (London: Eyre & Spottiswoode, 1948)

Lunn, H.S., *Chapters from My Life: With Special Reference to Reunion* (London: Cassell & Co., 1918)

Lupino, S., *From the Stocks to the Stars: An Unconventional Autobiography* (London: Hutchinson & Co., 1954)

Marett, R.R., *A Jerseyman at Oxford* (Oxford: Oxford University Press, 1941),

Marriott, J., *Memories of Four Score Years: The Autobiography of the late Sir John Marriott* (Blackie & Son, 1946)

Marshall, M. Paley, *What I Remember* (Cambridge: Cambridge University Press, 1947)

Martin-Harvey, J., *The Autobiography of Sir John Martin-Harvey* (London: Sampson Low & Co., 1933)

Milne, A.A., *It's Too Late Now: The Autobiography of a Writer* (London, Methuen & Co, 1939),

Montefiore, D., *From a Victorian to a Modern* (London: E. Archer, 1927)

Mumford, E.E.R., *Through Rose-Coloured Spectacles: The Story of a Life* (Leicester: Edgar Backus, 1952)

Munro, D., *It Passed Too Quickly: An Autobiography* (London: Routledge and Sons, 1941)

Nicholson, H., *Half My Days and Nights: Autobiography of a Reporter* (London: William Heinneman, 1941)

Nickalls, G., *Life's A Pudding: An Autobiography* (London: Faber & Faber, 1939)

Oman, C., *An Oxford Childhood* (London: Hodder & Stoughton, 1976)

Palmer, H.E., *The Mistletoe Child: An of Autobiography of Childhood* (London: J.M. Dent and Sons, 1935)

Panton, J.E., *Leaves from a Garden* (London: Eveleigh Nash, 1910)

Parry, E., *My Own Way* (London: Cassell & Co., 1932)

Peck, W., *A Little Learning or A Victorian Childhood* (Faber & Faber, London, 1952)

Redwood, H., *Bristol Fashion* (London: Latimer House, 1948)

Reilly, C.H., *Scaffolding in the Sky: A Semi-Architectural Autobiography* (London: Routledge & Sons, 1938)

Rentoul, G., *This Is My Case: An Autobiography* (London: Hutchinson & Co, 1944)

Robinson, W. Heath, *My Line of Life* (London: Blackie & Son, 1938)

Rogers, J. Guinness, *An Autobiography* (London: James Clarke & Co., 1903)

Rhys, E., *Wales England Wed* (London: J.M. Dent and Sons, 1940)

Rutherford, M., *Autobiography and Deliverance* (Leicester: Leicester University Press, 1969)

Smithers, J., *The Early Life and Vicissitudes of Jack Smithers: An Autobiography* (London: Martin Secker, 1939)

Streatfeild, N., *A Vicarage Family* (London: Collins, 1963)

Swanwick, H.M., *I Have Been Young* (London: Victor Gollancz, 1935)

Thomas, E., *The Childhood of Edward Thomas: A Fragment of Autobiography* (London: Faber & Faber, 1938)

Thomas, G., *Autobiography: 1891–1941* (London: Chapman and Hall, 1946)

Vansittart, J. (ed.), *Katharine Fry's Book* (London: Hodder & Stoughton, 1966)

Victorian Child [pseudo. Olive Haweis] *Four to Fourteen* (London: Robert Hale, 1939)

Vulliamy, C.E., *Calico Pie* (London: Michael Joseph, 1940)

Watson, E.L.Grant, *But to What Purpose: The Autobiography of a Contemporary* (London: Cresset Press, 1946)

Weymouth, A., *Who'd be a Doctor? An Autobiography* (London: Rich & Cowan, 1937)

Whyte, F., *A Bachelor's London: Memories of the Day Before Yesterday 1889–1914* (London: Grant Richards, 1941)

Williams, E. Crawshay, *Simple Story: An Accidental Autobiography* (London: John Long, 1935)

Woolf, V., 'A Sketch of the Past', in Jeanne Schulkind (ed.), *Moments of Being* (London: Pimlico Press, 2002), pp. 78–160

Woolf, V., 'Old Bloomsbury', in Jeanne Schulkind, *Moments of Being*, pp. 46–47

Wright, T., *Thomas Wright of Olney: An Autobiography* (London: Herbert Jenkins, 1936)

Magazines

English Woman's Review and Drawing Room Journal

The Gentlewoman

The Girl's Own Paper

Heal's Catalogues

Hearth and Home

Home Chat

The House: An Artistic Monthly for Those Who Manage and Beautify the Home

Young Ladies Home Journal

Novels

Bede, C., *The Adventures of Mr Verdant Green, An Oxford Freshman* (London: Nathaniel Cooke, 1853)

Briston, H., *Lottie: Servant and Heroine* (London: Robert Culley, 1898)

Collins, W., *The Moonstone: A Romance* (London: Tinsley Bros., 1868)

Doyle, A. Conan, *The Study in Scarlet* (London: Ward, Lock, Bowden & Co., 1891)

Eliot, G., *The Mill on the Floss* (William Blackwood and Sons, London and Edinburgh, 1860)

Gaskell, E., *Cranford* (London: Chapman and Hall, 1853)

Gaskell, E., *Wives and Daughters: An Everyday Story* (London: Smith, Elder and Co., 1866)

Gissing, G., *New Grub Street* (London: Smith, Elder & Co., 1892)

Gissing, G., *The Odd Women* (London: Lawrence & Bullen, 1893)

Gissing, G., *The Whirlpool* (London: Lawrence & Bullen, 1897)

Hardy, T., *Jude the Obscure* (London: Osgood McIlvain, 1896)

Lawrence, D.H., *Women in Love* (London: William Heinemann Ltd, 1935. first published 1921)

Mayor, F.M., *The Rector's Daughter* (London: The Hogarth Press, 1924)

More, H., *Coelebs In Search of A Wife. Comprehending Observations On Domestic Habits and Manners, Religion and Morals* (London: T. Cadell and W. Davies, 1809)

Poole, Miss, *Without a Character: A Tale of Servant Life* (London: Christian Knowledge Society, 1870)

Thackeray, W. Makepeace, *Vanity Fair: A Novel Without a Hero* (London: Bradbury and Evans, 1848)

Trollope, A., *Can You Forgive Her?* (Leipzig: Bernhard Tauchnitz, 1865)

Trollope, A., *Doctor Thorne* (London: W. Clowes & Sons, 1858)

Wells, H.G., *Ann Veronica* (London: Fisher Unwin, 1909)

Wells, H.G., *The History of Mr Polly* (London: Thomas Nelson & Sons, 1910)

Wood, Mrs H., *East Lynne* (London: Richard Bentley, 1861)

Woolf, V., *Orlando* (London: L & V Woolf, 1928)

Websites and online materials

Old Bailey Database, www.oldbaileyonline.org/ (accessed 12/06/09)

Thompson, P. and Lummis, T., *Family Life and Work Experience Before 1918, 1870–1973* [computer file]. *7th Edition*. Colchester, Essex: UK Data Archive [distributor], May 2009. SN: 2000.

Secondary sources

Books and articles

Adams, A., *Architecture in the Family Way: Doctors, Houses and Women 1870–1900* (London: McGill-Queen's University Press, 1996)

Adams, P., *Somerville for Women: An Oxford College 1879–1993* (Oxford: Oxford University Press, 1996)

Allen, E., 'Culinary Exhibition: Victorian Wedding Cakes and Royal Spectacle', *Victorian Studies*, 45:3 (2003), 457–484

Anderson, G., 'The White Blouse Revolution', in Gregory Anderson (ed.), *The White-Blouse Revolution: Female Office Workers since 1870* (Manchester: Manchester University Press, 1988), pp. 1–26

Anderson, G., *Victorian Clerks* (Manchester: Manchester University Press, 1976)

Anderson, M., *Approaches to the History of the Western Family 1500–1914* (Cambridge: Cambridge University Press, 1995)

Anderson, M., 'The Social Implications of Demographic Change', in F.M.L. Thompson (ed.), *The Cambridge Social History of Britain 1750–1950, Vol. 2, People and their Environment* (Cambridge: Cambridge University Press, 1990), pp. 1–70

Anderson, M., 'The Emergence of the Modern Life Cycle in Britain', *Social History* 10:1 (1985), 69–87

Appadurai, A., 'Introduction: Commodities and the Politics of Value', in A. Appadurai (ed.), *The Social Life of Things: Commodities in Cultural Perspective* (Cambridge: Cambridge University Press, 1986), pp. 3–63

Aries, P., *Western Attitudes Toward Death from the Middle Ages to the Present* (trans. Patricia M. Ranum) (London: Marion Boyars, 1976)

Ash, J., 'Memory and Objects', in Pat Kirkham (ed.), *The Gendered Object* (Manchester: Manchester University Press, 1996), pp. 219–224

Ashmore, S., 'Liberty and Lifestyle: Shopping for Art and Luxury in Nineteenth Century London', in D. Hussey and M. Ponsonby (eds), *Buying for the Home: Shopping for the Domestic from the Seventeenth Century to the Present* (Aldershot: Ashgate, 2008), pp. 73–90

Attar, D., *A Bibliography of Household Books Published in Britain 1800–1914* (London: Prospect Books, 1987)

Attfield, J., 'Barbie and Action Man: Adult Toys for Girls and Boys 1959–93', in Pat Kirkham, *The Gendered Object* (Manchester: Manchester University Press, 1996), pp. 80–89

Attfield, J., *Wild Things: The Material Culture of Everyday Life* (Oxford: Berg, 2000)

Aynsley J., and Grant, C. (eds) *Imagined Interiors: Representing the Domestic Interior since the Renaissance* (London: V&A, 2006)

Bailey, C., 'White Collars, Gray Lives? The Lower Middle Class Revisited', *Journal of British Studies*, 38:1 (1999), 273–290

Bailin, M., *The Sickroom in Victorian Fiction: The Art of Being Ill* (Cambridge: Cambridge University Press, 1994)

Barret-Ducrocq, F., *Love in the Time of Victoria: Sexuality, Class and Gender in Nineteenth-Century London* (London: Verso, 1991)

Beetham, M., 'Of Recipe Books and Reading in the Nineteenth Century: Mrs Beeton and Her Cultural Consequences', in Janet Floyd and Laurel Foster (eds), *The Recipe Reader: Narratives, Contexts, Traditions* (Aldershot: Ashgate, 2003), pp. 15–30

Belk, R.W., 'Of Mice and Men: Gender Identity and Collecting', in K. Martinez and K.L. Ames (eds), *The Material Culture of Gender: The Gender of Material Culture* (New York: Henry Francis du Pont Winterthur Museum, 1997), pp. 7–26

de Bellaigue, C., *Educating Women: Schooling and Identity in England and France 1800–1867* (Oxford: Oxford University Press, 2007)

Bennett, J.M., *History Matters: Patriarchy and the Challenge of Feminism* (Manchester: Manchester University Press, 2006)

Bennett, P., *A Very Desolate Position: The Story of the Birth and Establishment of a Mid-Victorian Public School* (Blackpool: Rossall Archives, 1992)

Berg, M., 'Women's Property and the Industrial Revolution', *Journal of Interdisciplinary History* 24:2 (1993), 233–250

Bermingham, A., 'Introduction The Consumption of Culture: Image, Object, Text', in A. Bermingham and J. Brewer (eds), *The Consumption of Culture 1600–1800: Image, Object, Text* (London: Routledge, 1995), pp. 1–20

Bingham, C., *The History of Royal Holloway College 1886–1986* (London: Constable, 1987)

Bold, J., 'Privacy and the Plan', in J. Bold and E. Chaney (eds), *English Architecture: Public and Private Essays for Kerry Downes* (London: Hambledon, 1993), pp. 107–119

Borden, I., Kerr, J., Rendell. J. with Pivaro, A., 'Things, Flows, Filters, Tactics', in I. Borden et al. (eds), *The Unknown City: Contesting Architecture and Social Space* (Massachusetts: MIT Press, 2001), pp. 2–27

Bourdieu, P., *Distinction: A Social Critique of the Judgement of Taste* (London: Routledge, 1984)

Bourke, J., *Dismembering the Male: Men's Bodies, Britain and the Great War* (London: Reaktion Books, 1996)

Bowden, S. and Offner, A., 'The Technological Revolution That Never Was: Gender, Class and the Diffusion of Household Appliances in Interwar England', in Victoria de Grazia with Ellen Furlough (eds), *The Sex of Things: Gender and Consumption in Historical Perspective* (Berkeley: University of California Press, 1996), pp. 244–274

Boyd, A.K., *The History of Radley College 1847–1947* (Oxford: Basil Blackwell, 1948)

Bradley, A.G., Champneys, A.C. and Baines, J.W., *A History of Marlborough College: During Fifty Years from its Foundation to the Present Time* (London: John Murray, 1893)

Breen, T., 'The Meaning of Things: Interpreting the Consumer Economy in the Eighteenth Century', in J. Brewer and R. Porter (eds), *Consumption and the World of Goods* (London: Routledge, 1993), pp. 249–260

Breward, C., *The Hidden Consumer: Masculinities, Fashion and City Life 1860–1914* (Manchester: Manchester University Press, 1999)

Brewer, J., 'Commercialisation and Politics', in N. McKendrick, J. Brewer and J.H. Plumb (eds), *The Birth of a Consumer Society: The Commercialisation of Eighteenth-Century England* (London: Hutchinson, 1983), pp. 197–262

Briggs, A., *Victorian Cities* (London: Odhams Press, 1963)

Briggs, A., *Victorian Things* (London: Batsford, 1988)

Brock, M.G., 'A Plastic Structure', in M.G. Brock and M.C. Curthoys (eds), *The History of the University of Oxford, Vol. Vii Nineteenth-Century Oxford* (Oxford: Oxford University Press, 2000), part 2, pp. 3–66

Brown, J. Howard., *A Short History of Thame School of the Foundation of Sir John Williams Knight, Lord Williams of Thame* (London: Hazell, Watson & Viney, 1927)

Bryant, P.H.M., *Harrow* (London: Blackie & Sons, 1936)

Burnett, J., *A Social History of Housing 1815–1985* (London: Methuen, 1986)

Burstyn, J.N., *Victorian Education and the Ideal of Womanhood* (London: Croom Helm, 1980)

Bushman, R.L., *The Refinement of America: Persons, Cities, Houses* (New York: Knopff, 1992)

Caine, B., *Destined to be Wives: The Sisters of Beatrice Webb* (Oxford: Clarendon, 1986)

Calloway, S., *Twentieth-Century Decoration: The Domestic Interior from 1900 to the Present Day* (London: Weidenfeld & Nicolson, 1988)

Calvert, K., *Children in the House: The Material Culture of Early Childhood 1600–1900* (Boston: North-Eastern University Press, 1992)

Cannadine, D., *Class in Britain* (London: Yale University Press, 1998)

Cannadine, D., 'War and Death: Grief and Mourning in Modern Britain', in J. Whaley (ed.), *Mirrors of Mortality: Studies in the Social History of Death* (London: Europa, 1981), pp. 187–242

Cavallo, S., 'What did Women Transmit? Ownership and Control of Household Goods and Personal Effects in Early Modern Italy', in M. Donald and L. Hurcombe (eds), *Gender and Material Culture in Historical Perspective* (Basingstoke: Macmillan, 2000), pp. 38–53

Cheshire, J., 'The Railways', in Michael Snodin and John Styles (eds), *Design and the Decorative Arts: Britain 1500–1900* (London: V&A Publications, 2001), pp. 424–425

Chevalier, S., 'The French Two-home Project: The Materialisation of Family Identity', in I. Cieraad, *At Home: An Anthropology of Domestic Space*, pp. 83–94

Cieraad, I., 'Introduction: Anthropology at Home', in I. Cieraad (ed.), *At Home: An Anthropology of Domestic Space* (New York: Syracuse, 1999), pp. 1–12

Clarke, Amy K., *A History of the Cheltenham Ladies College 1851–1953* (London: Faber & Faber, 1953)

Cohen, D., *Household Gods: the British and their Possessions* (London: Yale, 2006)

Collard, F., 'Furniture', in Michael Snodin and John Styles (eds), *Design and the Decorative Arts: Britain 1500–1900* (London: V&A Publications, 2001), pp. 442–443

Colley, A.C., 'Bodies and Mirrors: The Childhood Interiors of Ruskin, Pater and Stevenson', in I. Bryden and J. Floyd (eds), *Domestic Space: Reading the Nineteenth-Century Interior* (Manchester: Manchester University Press, 1999), pp. 40–57

Colley, L., *Britons: Forging the Nation 1707–1837* (London: Yale University Press, 1992)

Colville, Q., 'The Role of the Interior in Constructing Notions of Class and Status: Case Study of Britannia Royal Naval College Dartmouth, 1905–39', in P. Sparke and S. McKellar (eds), *Interior Design and Identity* (Manchester: Manchester University Press, 2004), pp. 114–132

Combs, M.B., 'Wives and Household Wealth: The Impact of the 1870 British Married Women's Property Act on Wealth-holding and Share of Household Resources', *Continuity and Change*, 19:1 (2004), 141–163

Constantine, S., *Social Conditions in Britain 1918–1939* (London: Lancaster Pamphlets, 1939)

Cooper, J., *Victorian and Edwardian Furniture and Interiors: From the Gothic Revival to Art Nouveau* (London: Thames & Hudson, 1987)

Cooper, S. Fagence, 'The Battle of the Styles', in John Snodin and Michael Styles, *Design and the Decorative Arts: Britain 1500–1900* (London: V&A Publications, 2001), pp. 354–355

Corfield, P.J., *Power and the Professions in Britain 1700–1850* (London: Routledge, 1995)

Cox, J. and Cox, N., 'Probate 1500–1800: A System in Transition', in Tom Arkell, Esta Evans and Nigel Goose (eds), *When Death Do Us Part: Understanding and Intepreting the Probate Records of Early Modern England* (Oxford:Leopard's Head, 2000), pp. 14–37

Crook, J. Mordaunt, *The Rise of the Nouveaux Riches: Style and Status in Victorian and Edwardian Architecture* (London: John Murray, 1999)

Crossick, G., 'The Labour Aristocracy and its Values: A Study of Mid-Victorian London Kentish town', *Victorian Studies*, 19:3 (1976), 301–328

Crossick, G. and Jaumain, S., 'The World of the Department Store: Distribution, Culture and Social Change', in G. Crossick and S. Jaumain (eds), *Cathedrals of Consumption: The European Department Store 1850–1939* (Aldershot: Ashgate, 1999), pp. 1–45

Cunningham, G., *The New Woman and the Victorian Novel* (London: Macmillan, 1978)

Curl, J., *The Victorian Celebration of Death* (Stroud: Sutton, 2000)

Curthoys, M.C., and Howarth, J., 'Origins and Destinations: The Social Mobility of Oxford Men and Women', in Brock and Curthoys, *The History of the University of Oxford, Vol. VII*, pp. 581–582

Cust, L., *A History of Eton College* (London: Duckworth & Co., 1899)

Darling, E., and Whitworth, L. (eds), *Women and the Making of Built Space in England, 1870–1950* (Aldershot: Ashgate, 2007)

Davey, P., *Arts and Crafts Architecture: The Search for the Earthly Paradise* (London: Architectural Press, 1980)

Davidoff, L., *The Best Circles: Society, Etiquette and the Season* (London: Croom Helm, 1973)

Davidoff, L., 'The Separation of Home and Work? Landladies and Lodgers in Nineteenth- and Twentieth-Century England', in S. Burman (ed.), *Fit Work for Women* (London: Croom Helm, 1979), pp. 64–97

Davidoff, L., and Hall, C., *Family Fortunes: Men and Women of the English Middle Class 1780–1850* (London: Hutchinson, 1987)

Davidoff, L., Doolittle, M., Fink, J. and Holden, K., *The Family Story: Blood, Contract and Intimacy 1830–1960* (London: Longman, 1999)

DeGroot, G.J., *Blighty: British Society in the Era of the Great War* (London: Longman, 1996)

Delamont, S., 'The Domestic Ideology and Women's Education', in S. Delamont (ed.), *The Nineteenth-Century Woman: Her Cultural and Physical World* (London: Croom Helm, 1978)

De-la-Noy, M., *Queen Victoria at Home* (London: Constable, 2003)

Delap, L., *Domestic Service in Twentieth Century Britain: Memory, Culture, Emotions* (forthcoming, Oxford University Press, 2010)

Deslandes, P.R., *Oxbridge Men: British Masculinity and the Undergraduate Experience* (Bloomington: Indiana University Press, 2005)

Digby, A., and Searby, P., *Children, School and Society in Nineteenth-Century England* (London: Macmillan, 1981)

Dixon, R., and Muthesius, S., *Victorian Architecture* (London: Thames & Hudson, 1978)

Donald, M., 'Tranquil Havens? Critiquing the Idea of Home as a Middle-Class Sanctuary', in I. Bryden and J. Floyd (eds), *Domestic Space: Reading the Nineteenth-Century Interior* (Manchester, 1999), pp. 103–120

Doolittle, M., 'Fatherhood, Religious Belief and the Protection of Children in Nineteenth-Century English Families', in Trev Lynn Broughton and Helen Rogers (eds), *Gender and Fatherhood in the Nineteenth Century* (Basingstoke: Palgrave Macmillan, 2007), pp. 31–42

Douglas, M., and Isherwood, B., *The World of Goods: Towards an Anthropology of Consumption* (London: Routledge, 1996)

Dowling, L., *Hellenism and Homosexuality in Victorian Oxford* (London: Cornell University Press, 1994)

Dyhouse, C., *No Distinction of Sex? Women in the British Universities, 1870–1939* (London: University College London Press, 1995)

Dyhouse, C., *Feminism and the Family in England 1880–1939* (Oxford: Basil Blackwell, 1989)

Dyhouse, C., 'Mothers and Daughters in the Middle-Class Home c.1870–1914', J. Lewis (ed.), *Labour and Love: Women's Experience of Home and Family 1850–1940* (Oxford: Blackwell, 1986), pp. 27–47

Dyos, H.J., *Victorian Suburb: A Study of the Growth of Camberwell* (Leicester University Press: Leicester, 1961)

Dyos, H.J., and Reeder, D.A., 'Slums and Suburbs', in H.J. Dyos and M. Wolff (eds), *The Victorian City* (London: Routledge, 1973), vol. 1, pp. 359–386

Ebery, M., and Preston, B., *Domestic Service in late Victorian and Edwardian England 1871–1914* (Reading: University of Reading, 1976)

Edwards, C., '"Home is Where the Art is": Women, Handicraft and Home Improvements 1750–1900', *Journal of Design History*, 19:1 (2006), 11–21

Edwards, C., *Turning Houses in Homes: A History of the Retailing and Consumption of Domestic Furnishings* (Aldershot: Ashgate, 2005)

Erickson, A.L., *Women and Property in Early Modern England* (London: Routledge, 1993)

Fawdry, K. and Fawdry, M., *Pollock's History of English Dolls and Toys* (London: Benn, 1979)

Ferry, E., '"Decorators May be Compared to Doctors": An Analysis of Rhoda and Agnes Garrett's Suggestions for House Decoration in Painting, Woodwork and Furniture (1876)', *Journal of Design History* 16:1 (2003), 49–61

Field, J., 'Wealth, Styles of Life and Social Tone amongst Portsmouth's Middle Class 1800–75', in R.J. Morris (ed.), *Class, Power and Social Structure in British Nineteenth-Century Towns* (Leicester: Leicester University Press, 1986), pp. 68–106

Fine, A., 'A Consideration of the Trousseau: A Feminine Culture?', in M. Perrot (ed.), *Writing Women's History* (Oxford: Blackwell, 1992), pp. 118–145

Finlay, E., *St Swithun's School, Winchester 1884–1934* (Winchester: Warren & Son Ltd., 1932)

Finn, M., *The Character of Credit: Personal Debt in English Culture 1740–1914* (Cambridge: Cambridge University Press, 2003)

Finn, M., 'Men's Things: Masculine Possession in the Consumer Revolution', *Social History*, 25:2 (2000), 133–155

Finn, M., 'Being in Debt in Dickens' London: Fact, Fictional Representation and the Nineteenth-century Prison', *Journal of Victorian Culture*, 1:2 (1996), 203–226

Finn, M., 'Women, Consumption and Coverture in England *c*.1780–1860', *The Historical Journal*, 39:3 (1996), 703–722

D'e Firth, J., *Winchester College* (London: Winchester Publications, 1949)

Flather, A., *Gender and Space in Early Modern England* (Woodbridge: Boydell Press, 2007)

Flint, K., *The Woman Reader 1837–1914* (Oxford: Oxford University Press, 1993)

Forge, S., *Victorian Splendour: Australian Interior Decoration 1837–1901* (Oxford: Oxford University Press, 1981)

Formanek-Brunell, M., *Made to Play House: Dolls and the Commercialisation of American Girlhood 1830–1930* (London: Yale University Press, 1993)

Forty, A., *Objects of Desire: Design and Society 1750–1980* (London: Thames & Hudson, 1986)

Foucault, M., 'Space, Knowledge and Power', in James D. Faubion (ed.), *Michel Foucault, Power: Essential Works of Foucault 1954–1984*, vol.3 (London: Penguin, 2002), pp. 349–364

Foucault, M., *Discipline and Punish: The Birth of the Prison* (London: Penguin, 1991)

Foyster, E., *Marital Violence: An English Family History 1650–1857* (Cambridge: Cambridge University Press, 2005)

Francis, M., 'The Domestication of the Male? Recent Research on Nineteenth- and Early Twentieth-century British Masculinity', *The Historical Journal*, 45:3 (2002), 637–652

Franklin, J., *The Gentleman's Country House and Its Plan 1835–1914* (London: Routledge & Kegan Paul, 1981)

Franklin, J., 'Troops of Servants: Labour and Planning in the Country House 1840–1914', *Victorian Studies*, 19:2 (1975), 211–239

Fraser, W. Hamish, *The Coming of the Mass Market 1850–1914* (London: Macmillan, 1981)

Freeman, S., *Isabella and Sam: The Story of Mrs Beeton* (London: Victor Gollancz, 1977)

Frost, G.S., *Living in Sin: Cohabiting as Husband and Wife in Nineteenth-Century England* (Manchester: Manchester University Press, 2008)

Frost, G., *Promises Broken: Courtship, Class and Gender in Victorian England* (London: University Press of Virginia, 1995)

Furness, W., *The Centenary History of Rossall School* (Aldershot: Gale & Polden, 1945)

Garrard, J., and Parrott V., 'Craft, Professional and Middle-Class Identity: Solicitors and Gas Engineers c.1850–1914', in Alan Kidd and David Nicholls, *The Making of the British Middle Class? Studies of Regional and Cultural Diversity since the Eighteenth Century* (Sutton: Stroud, 1998), pp. 148–168

Gere, C., *Nineteenth-Century Interiors: An Album of Watercolours* (London: Thames & Hudson, 1992)

Gere, C., *Nineteenth-Century Decoration: The Art of the Interior* (London: Weidenfeld & Nicolson, 1989)

Gere, C., and Hoskins, L., *The House Beautiful: Oscar Wilde and the Aesthetic Interior* (London: Lund Humphries, 2000)

Gernsheim, A., *Victorian and Edwardian Fashion: A Photographic Survey* (London: Dover, 1981)

Giles, J., *The Parlour and the Suburb: Domestic Identities, Class, Femininity and Modernity* (Oxford: Berg, 2004)

Gillis, J., *For Better, For Worse: British Marriages 1600 to the Present* (Oxford: Oxford University Press, 1985)

Girling-Budd, A., 'Comfort and Gentility: Furnishings by Gillows, Lancaster 1840–55', in Sparke and McKellar, *Interior Design*, pp. 27–47

Girouard, M., *Life in the English Country House: A Social and Architectural History* (London: Yale University Press, 1978)

Gittins, D., *The Family in Question: Changing Households and Familiar Ideologies* (London: Macmillan, 1985)

Gleadle, K., '"Our Several Spheres": Middle-Class Women and the Feminisms of Early Victorian Radical Politics', in K. Gleadle and S. Richardson (eds), *Women in British Politics 1760–1860: The Power of the Petticoat* (London: Economic and Social Research Council, 2000), pp. 134–152

Gloag, J., *Victorian Comfort: A Social History of Design 1830–1900* (London: Adam and Charles Black, 1961)

Gordon, E., and Nair, G., *Public Lives: Women, Family and Society in Victorian Britain* (London: Yale University Press, 2003)

Gourlay, A.B., *A History of Sherborne School* (Winchester: Warren and Son, 1951)

Gow, I., *The Scottish Interior: Georgian and Victorian Décor* (Edinburgh: Edinburgh University Press, 1992)

Grant, C., 'Reading the House of Fiction: From Object to Interior 1720–1920', *Home Cultures*, 2 (2005), 233–249

Green, D.R., 'Independent Women, Wealth and Wills in Nineteenth-Century London', in J. Stobart and A. Owens (eds), *Urban Fortunes: Property and Inheritance in the Town 1700–1900* (Aldershot: Ashgate, 2000), pp. 195–222

Grier, K.C., *Culture and Comfort: Parlor Making and Middle-Class Identity 1850–1930* (Massachusetts: Massachusetts University Press, 1997)

Habermas, J., *The Structural Transformation of the Public Sphere: An Inquiry into a Category of Bourgeois Society* (trans. Thomas Burger) (Cambridge: Polity Press, 1996)

Hahn, S., 'Women in Older Ages – "Old" Women?', *The History of the Family*, 7:1 (2002), 33–58

Hall, C., 'The Sweet Delights of Home', in M. Perrot (ed.), *A History of Private Life: From the Fires of Revolution to the Great War* (Massachusetts: Belknap Press, 1990), pp. 47–94

Hall, C., 'Gender Divisions and Class Formation in the Birmingham Middle Class 1780–1850', in R. Samuel (ed.), *People's History and Socialist Theory* (London: Routledge & Kegan Paul, 1981), pp. 164–175

Hallam, E., and Hockey, J., *Death, Memory and Material Culture* (Oxford: Berg, 2000)

Halttunen, K., 'From Parlour to Living Room: Domestic Space, Interior Decoration and the Culture of Personality', in S. J. Bronner (ed.), *Consuming Visions: Accumulation and Display of Goods in America 1880–1920* (New York: Henry Francis du Pont Winterthur Museum, 1989), pp. 157–189

Hamlett, J., '"The Dining Room Should be the Man's Paradise, as the Drawing Room is the Woman's": Gender and Middle-class Domestic Space in England, 1850–1910', *Gender & History*, 21:3 (2009), 576–591

Hammerton, A. James, *Cruelty and Companionship: Conflict in Nineteenth-Century Married Life* (London: Routledge, 1992)

Hammerton, A. James, 'Pooterism or Partnership? Marriage and Masculine Identity in the Lower Middle Class 1870–1920', *Journal of British Studies*, 38:1 (1999) 291–321

Hareven, T.K., 'Recent Research on the History of the Family', in Michael Drake (ed.), *Time, Family and Community: Perspectives on Family and Community History* (Oxford: Blackwell, 1994), pp. 13–43

Harvey, J., *The Art of Piety: The Visual Culture of Nonconformity* (Cardiff: University of Wales Press, 1995)

Hay, I., *The Lighter Side of School Life* (London: T.N. Foulis, 1914)

Heilmann, A., *New Woman Strategies: Sarah Grand, Olive Schreiner, Mona Caird* (Manchester: Manchester University Press, 2004)

Heilmann, A., and Beetham, M. (eds), *New Woman Hybridities: Femininity, Feminism and International Consumer Culture 1880–1930* (London: Routledge, 2004)

Hendershot, H., 'Dolls: Odour, Disgust, Femininity and Toy Design', in Pat Kirkham, *The Gendered Object*, pp. 90–102

Hilton, M., *Smoking in British Popular Culture 1800–2000: Perfect Pleasures* (Manchester: Manchester University Press, 2000)

Hilton, M. and Hirsch, P. (eds), *Practical Visionaries: Women, Education and Social Progress 1790–1930* (London: Longman, 2000)

Hinds, H., 'Together and Apart: Twin beds, Domestic Hygiene and Modern Marriage', *Journal of Design History* (forthcoming, 2010)

Holcombe, L., 'Victorian Wives and Property: Reform of the Married Women's Property Law 1857–1882', in M. Vicinus (ed.), *A Widening Sphere: Changing Roles of Victorian Women* (Bloomington: Indiana University Press, 1977), pp. 3–28

Holdsworth, W., *A History of English Law* (London: Methuen, 1972)

Holland, P., 'Introduction: History, Memory and the Family Album', in J. Spence and P. Holland (eds), *Family Snaps: The Meanings of Domestic Photography* (London: Virago, 1991)

Hollis, P., *Ladies Elect: Women in English Local Government 1865–1914* (Oxford: Clarendon, 1987)

Honey, J.R. de S., *Tom Brown's Universe: The Development of the Victorian Public School* (London: Millington, 1997)

Hoppen, K. Theodore, *The Mid-Victorian Generation 1846–1886* (Oxford: Oxford University Press, 1998)

Horn, P., *The Rise and Fall of the Victorian Servant* (Stroud: Sutton, 1995)

Horstman, A., *Victorian Divorce* (London: Croom Helm, 1985)

Horwood, C., *Keeping up Appearances: Fashion and Class between the Wars* (Stroud: Sutton, 2005)

Hosgood, C.P., '"Doing the Shops" at Christmas: Women, Men and the Department Store in England c.1880–1914', in G. Crossick and S. Jaumain (eds), *Cathedrals of Consumption: The European Department Store 1850–1939* (Aldershot: Ashgate, 1999), 133–145

Hosgood, C.P., 'Mercantile Monasteries: Shops, Shop Assistants and Shop Life in Late Victorian and Edwardian Britain', *Journal of British Studies* 38:3 (1999), 322–352

Houfe, S., *John Leech and the Victorian Scene* (Antique Collectors' Club: Suffolk, 1984)

Howe, B., *Arbiter of Elegance* (London: The Harvill Press, 1967)

Hughes, K., *The Victorian Governess* (London: Hambledon Press, 1993)

Hunt, M.R., *The Middling Sort: Commerce, Gender, and the Family in England 1680–1780* (London: University of California Press, 1996)

Hussey, D., 'Guns, Horses and Stylish Waistcoats? Male Consumer Activity and Domestic Shopping in Late-Eighteenth- and Early-Nineteenth-Century England', in David Hussey and Margaret Ponsonby (eds), *Buying for the Home: Shopping for the Domestic from the Seventeenth Century to the Present* (Aldershot: Ashgate, 2008), pp. 66–67

Jackson, A.A., 'The London Railway Suburb 1850–1914', in A.K.B. Evans and J.V.Gough (eds), *The Impact of the Railway on Society in Britain* (Aldershot: Ashgate, 2003), 169–180

Jalland, P., *Death in the Victorian Family* (Oxford: Oxford University Press, 1996)

Jalland, P., *Women, Marriage and Politics 1860–1914* (Oxford: Oxford University Press, 1988)

Le Jeune, A., *The Gentlemen's Clubs of London* (London: Malcolm and Jane's, 1979)

Kay, A.C., 'A Little Enterprise of Her Own: Lodging-House Keeping and the Accommodation Business in Nineteenth-Century London', *The London Journal* 28:2 (2003), pp. 41–53

Keating, P., *The Haunted Study: A Social History of the English Novel 1875–1914* (London: Fontana, 1991)

Keeble, T., '"Everything Whispers of Wealth and Luxury": Observation, Emulation and Display in the well-to-do-late-Victorian Home', in Darling and Whitworth, *Women and the Making of Built Space*, pp. 69–84

Keep, C., 'The Cultural Work of the Typewriter Girl', *Victorian Studies* 40:3 (1997) 401–426

Kelly, T., For *Advancement of Learning: The University of Liverpool 1881–1981* (Liverpool: Liverpool University Press, 1981)

Kidd, A., *Manchester* (Keele: Keele University Press, 1996)

Kidd, A., and Nicholls, D., 'Introduction: History, Culture and the Middle Classes', in A. Kidd and D. Nicholls (eds), *Gender, Civic Culture and Consumerism: Middle-Class Identity in Britain 1800–1940* (Manchester: Manchester University Press, 1999), pp. xv–xl

Kinchin, J., 'Interiors: Nineteenth-Century Essays on the 'Masculine' and the 'Feminine' Room', in Pat Kirkham (ed.), *The Gendered Object* (Manchester: Manchester University Press, 1996), pp. 12–29

Kingsley Kent, S., *Gender and Power in Britain 1640–1990* (London: Routledge, 1999)

Kingsley Kent, S., *Making Peace: The Reconstruction of Gender in Interwar Britain* (Chichester: Princeton University Press, 1993)

Knight, F., *The Nineteenth-Century Church and English Society* (Cambridge: Cambridge University Press, 1995)

Komter, A.E., 'Women, Gifts and Power', in A.E. Komter (ed.), *The Gift: An Interdisciplinary Perspective* (Amsterdam: Amsterdam University Press, 1996)

Koptytoff, I., 'The Cultural Biography of Things: Commoditization as a Process', in A. Appadurai (ed.), *The Social Life of Things: Commodities in Cultural Perspective* (Cambridge: Cambridge University Press, 1986), pp. 64–91

Laverack, E., *With This Ring: 100 Years of Marriage* (London: Elm Tree Books, 1979)

Lears, J., 'Beyond Veblen: Rethinking Consumer Culture in America', in S.J. Bronner (ed.), *Consuming Visions: Accumulation and Display of Goods in America 1880–1920* (New York: Henry Francis du Pont Winterthur Museum, 1989), pp. 73–99

Ledger, S., *The New Woman: Fiction and Feminism at the Fin de Siecle* (Manchester: Manchester University Press, 1997)

Lee, H., *Reading in Bed: An Inaugural Lecture delivered before the University of Oxford* (Oxford: Oxford University Press, 2002)

Lewis, J. (ed.), *Labour and Love: Women's Experience of Home and Family 1850–1940* (Oxford: Blackwell, 1986)

Lewis, J., *Women in England 1870–1950: Sexual Divisions and Social Change* (Sussex: Wheatsheaf, 1984)

Lewis, J. Schneid, *In the Family Way: Childbearing in the British Aristocracy 1760–1860* (New Brunswick: Rutgers University Press, 1986)

Leyser, H., *Medieval Women: A Social History of Women in England, 450–1500* (London: Phoenix Giant, 1996)

Light, A., *Forever England: Femininity, Literature and Conservatism between the Wars* (London: Routledge, 1991)

Linkman, A., *The Victorians: Photographic Portraits* (London: Tauris Park, 1993)

Linkman, A., 'Taken From Life: Post-Mortem Portraiture in Britain 1860–1910', *History of Photography*, 30: 4 (2006), 309–347

Lipsedge, K., ''Enter into Thy Closet': Women, Closet Culture, and the Eighteenth-Century English Novel', in J. Styles and A. Vickery, *Gender, Taste and Material Culture*, pp. 107–124

Logan, T., *The Victorian Parlour* (Cambridge: Cambridge University Press, 2001)

Logan, T., 'Decorating Domestic Space: Middle-Class Women and Victorian Interiors', in V.D. Dickerson (ed.), *Keeping the Victorian House: A Collection of Essays* (London: Garland Publishing, 1995), pp. 207–234

Long, H., *The Edwardian House: The Middle-Class Home in Britain 1880–1914* (Manchester: Manchester University Press, 1993)

Lubenow, W.C., 'University History and the Histories of Universities in the Nineteenth Century', *Journal of British Studies*, 13:2 (2000), 247–262

Lystra, K., *Searching the Heart: Women, Men and Romantic Love in Nineteenth Century America* (Oxford: Oxford University Press, 1989)

Mackenzie, J.M., 'The Imperial Pioneer and Hunter and the British Masculine Stereotype in Late Victorian and Edwardian Times', in J.A. Mangan and J. Walvin (eds), *Manliness and Morality: Middle-Class Masculinity in Britain and America 1800–1940* (Manchester: Manchester University Press, 1987), pp. 176–198

Mandler, P., 'The Problem with Cultural History', *Cultural and Social History*, 1:1 (2004), 5–28

Mangan, J.A., *Athleticism in the Victorian and Edwardian Public School: The Emergence and Consolidation of an Educational Ideology* (Cambridge: Cambridge University Press, 1981)

Mara, C., 'Divestments', in K. Dunseath (ed.), *A Second Skin: Women Write About Clothes* (London: Women's Press, 1988), pp. 57–60

Marriott, S., *Backstairs to a Degree: Demands for an Open University in Late Victorian England* (Leeds: Leeds Studies in Adult and Continuing Education, 1981)

Marshall, J., and Willox, I., *The Victorian House* (London: Sidgwick & Jackson, 1986)

Martinez, K., and Ames, K.L. (eds), *The Material Culture of Gender: The Gender of Material Culture* (New York: Henry Francis du Pont Winterthur Museum, 1997)

Mason, M., *The Making of Victorian Sexuality* (Oxford: Oxford University Press, 1995)

Massey, D., *Space, Place and Gender* (Cambridge: Polity, 1994)

Mavor, C., 'Collecting Loss', *Cultural Studies*, 11:1 (1997), 111–137

McBride, T., '"As The Twig is Bent": The Victorian Nanny' in A.S. Wohl (ed.), *The Victorian Family: Structure and Stresses* (London: Croom Helm, 1978), pp. 44–58

McBride, T., *The Domestic Revolution: The Modernisation of Household Service in England and France 1820–1920* (London: Croom Helm, 1976)

MacCarthy, F., *William Morris: A Life for Our Time* (London: Faber & Faber, 1994)

McCuskey, B.W., 'The Kitchen Police: Servant Surveillance and Middle-class Transgression', *Victorian Literature and Culture*, 28:2 (2000), 359–375

McKendrick, N., Brewer, J., and Plumb, J.H., *The Birth of a Consumer Society: The Commercialisation of Eighteenth-Century England* (London: Europa, 1982)

McKibbin, R., *Classes and Cultures: England 1918–1951* (Oxford: Oxford University Press, 1998)

Meldrum, T., *Domestic Service and Gender 1660–1750: Life and Work in the London Household* (Harlow: Longman, 2000)

Miller, D., 'Why Some Things Matter', in D. Miller (ed.), *Material Cultures: Why Some Things Matter* (London: UCL Press, 1997), pp. 3–21

Milne-Smith, A., 'A Flight to Domesticity? Making a Home in the Gentleman's Clubs of London, 1880–1914', *Journal of British Studies* 45:4 (2006), 796–818

Moore, J.S., 'Probate Inventories: Problems and Prospects', in Philip Riden (ed.), *Probate Records and the Local Community* (Stroud: Sutton, 1985)

More, C., *Understanding the Industrial Revolution* (London: Routledge, 2000)

Morris, R.J., *Men, Women and Property in England, 1780–1870: A Social and Economic History of Family Strategies Amongst the Leeds Middle Classes* (Cambridge: Cambridge University Press, 2005)

Morris, R.J., 'Men, Women and Property: The Reform of the Married Women's Property Act 1870', in F.M.L. Thompson (ed.), *Landowners, Capitalists and Entrepreneurs: Essays for Sir John Habakkuk* (Oxford: Clarendon, 1994), pp. 171–191

Mullins, S., *Cap and Apron: An Oral History of Domestic Service in the Shires 1880–1950* (Leciester: Leicester Museums Service, 1986)

Munich, A., *Queen Victoria's Secrets* (Chichester: Columbia University Press, 1996)

Muthesius, S., *The English Terraced House* (London:Yale University Press, 1982)

The National Trust, *Tyntesfield* (Swindon: The National Trust, 2003)

Nead, L., *Myths of Sexuality: Representations of Women in Victorian Britain* (Oxford: Basil Blackwell, 1988)

Nead, L., *Victorian Babylon: People, Streets and Images in Nineteenth-Century London* (London: Yale University Press, 2000)

Neiswander, J.A., *The Cosmopolitan Interior: Liberalism and the British Home 1870–1914* (London: Yale University Press, 2008)

Newton, R., 'Exeter 1770–1820', in M.A. Simpson and T.H. Lloyd (eds), *Middle Class Housing in Britain* (Newton Abbot: David and Charles, 1977) pp. 12–43

Hinchcliffe, T., *North Oxford* (London: Yale University Press, 1992)

O'Connell, Sean, *The Car and British Society: Class, Gender and Motoring 1896–1939* (Manchester: Manchester University Press, 1998)

O'Hara, D., *Courtship and Constraint: Rethinking the Making of Marriage in Tudor England* (Manchester: Manchester University Press, 2000)

Olsen, Donald J., 'House upon House', in H.J. Dyos and Michael Wolff (eds), *The Victorian City: Images and Realities* (London: Routledge, 1973), vol. 1, pp. 333–358

Overton, M., J. Whittle, D. Dean and A. Hann, *Production and Consumption in English Households 1600–1750* (London: Routledge, 2004)

Parker, R., *The Subversive Stitch: Embroidery and the Making of the Feminine* (London: The Women's Press, 1984)

Pedersen, J. Senders, *The Reform of Girls' Secondary and Higher Education* (London: Garland, 1987)

Penner, B., '"A Vision of Love and Luxury": The Commercialisation of Nineteenth-century American Weddings', *Winterthur Portfolio*, 29:1 (2004), 1–20

Pepper, S., 'The Garden City', in Boris Ford (ed.), *The Cambridge Cultural History of Britain: Early Twentieth-Century Britain* (Cambridge: Cambridge University Press, 1992)

Peterson, M. Jeanne, *Family, Love and Work in the Lives of Victorian Gentlewomen* (Bloomington: Indiana University Press, 1989)

Pointon, M., 'Materialising Mourning: Hair, Jewellery and the Body', in M. Kwint, C. Breward and Aynsley, J. (eds), *Material Memories: Design and Evocation* (Oxford: Berg, 1999), pp. 39–57

Pollock, L., *A Lasting Relationship: Parents and Children over Three Centuries* (London: Fourth Estate, 1987)

Pollock, L., *Forgotten Children: Parent-Child Relations from 1500 to 1900* (Cambridge: Cambridge University Press, 1983)

Ponsonby, M., *Stories from Home: English Domestic Interiors, 1750–1850* (Aldershot: Ashgate, 2007)

Pooley, C.G., 'Patterns on the Ground: Urban Form, Residential Structure and the Social Construction of Space', in Martin Daunton, *The Cambridge Urban History of Britain*, pp. 429–465

Pooley, C.G., and Turnbull, J., 'Leaving Home: The Experience of Migration from the Parental Home in Britain Since *c*.1770', *Journal of Family History* 22:4 (1997), 390–424

Pooley, Siân, 'Child Care and Neglect: A Comparative Local Study of Late Nineteenth Century Parental Authority', in L. Delap, B. Griffin and A. Wills (eds), *The Politics of Domestic Authority in Britain since 1800* (Basingstoke: Palgrave Macmillan, 2009), pp. 223–242.

Pooley, Siân, 'Domestic Servants and their Urban Employers: A Case Study of Lancaster, 1880–1914', *Economic History Review* 62:2 (2009), 405–429

Porter, R., *The Greatest Benefit to Mankind: A Medical History of Humanity from Antiquity to the Present* (London: HarperCollins, 1997)

Praz, M., *An Illustrated History of Interior Decoration: From Pompeii to Art Nouveau* (London: Thames and Hudson, 1964)

Pugh, M., *We Danced All Night: A Social History of Britain Between the Wars* (London: Vingate Books, 2009)

Purbrick, L., *The Wedding Present: Domestic Life Beyond Consumption* (Aldershot: Ashgate, 2007)

Purbrick, L., 'Wedding Presents: Marriage Gifts and the Limits of Consumption, Britain 1945–2000', *Journal of Design History*, 16:3 (2003), 215–227

Purbrick, L. (ed.), *The Great Exhibition of 1851: New Interdisciplinary Essays* (Manchester: Manchester University Press, 2001)

Rappaport, E.D., *Shopping for Pleasure: Women in the Making of London's West End* (Chichester: Princeton, 2000)

Reid, A., 'Intelligent Artisans and Autocrats of Labour: The Essays of Thomas Wright', in J. Winter (ed.), *The Working Class in Modern British History* (Cambridge: Cambridge University Press, 1983), pp. 171–186

Rendell, J., *The Pursuit of Pleasure: Gender, Space and Architecture in Regency London* (London: Athlone Press, 2002)

Rich, R., 'Designing the Dinner Party: Advice on Dining and Décor in London and Paris 1860–1914', *Journal of Design History*, 16:1 (2003), 49–61

Richardson, A. and Willis, C. (eds), *The New Woman in Fiction and in Fact: Fin-de-Siecle Feminisms* (London: Palgrave, 2001)

Riley, D., *War in the Nursery: Theories of the Child and of the Mother* (London: Virago, 1983)

Robertson, P., 'Home as Nest: Middle Class Childhood in Nineteenth-Century Europe', in L. de Mause (ed.), *The History of Childhood: The Untold Story of Child Abuse* (London: Bellew, 1991), pp. 407–431

Ross, E., *Love and Toil: Motherhood in Outcast London 1870–1918* (Oxford: Oxford University Press, 1993)

Samuel, R., *Theatres of Memory: vol.1 Past and Present Contemporary Culture* (London: Verso, 1994)

Samuel, R., 'Comers and Goers', in H.J. Dyos and Michael Wolff (eds), *The Victorian City: Images and Realities* (London: Routledge, 1973), vol. 1, pp. 123–60

Schofield, A., *Toys in History* (Hove: Wayland, 1978)

Schwarz, L., 'English Servants and their Employers During the Eighteenth and Nineteenth Centuries', *Economic History Review*, 52:2 (1999), 236–256

Seaborne, M., *The English School: Its Architecture and Organisation* (London: Routledge & Kegan Paul, 1971)

Sharp, K., 'Women's Creativity and Display in the Eighteenth-Century British Domestic Interior', in Sparke and McKellar, *Interior Design and Identity*, pp. 10–26

Shonfield, Z., *The Precariously Privileged: A Professional Family in Victorian London* (Oxford: Oxford University Press, 1987)

Shrosbree, C., *Public Schools and Private Education: The Clarendon Commission 1861–64 and the Public School Acts* (Manchester: Manchester University Press, 1988)

Simpson, J.B. Hope, *Rugby since Arnold: A History of Rugby School from 1842* (London: Macmillan, 1967)

Saumarez Smith, C., *Eighteenth-Century Decoration: Design and the Domestic Interior in England* (New York, H.M. Abrams, 1993)

Sparke, P. and McKellar, S. (eds), *Interior Design and Identity* (Manchester: Manchester University Press, 2004)

Spielmann, M.H. and Layard, G.S., *Kate Greenaway* (London: Adam and Charles Black, 1905)

St George, R. Blair, 'Reading Spaces in Eighteenth-Century New England', in John Styles and Amanda Vickery (eds), *Gender, Taste and Material Culture in Britain and North America 1700–1830* (London: Yale, 2006), pp. 81–106

Stabile, S.M., *Memory's Daughters: The Material Culture of Remembrance in Eighteenth-Century America* (London: Cornell University Press, 2004)

Stebbings, C., *The Private Trustee in Victorian England* (Cambridge: Cambridge University Press, 2002)

Steinbach, S., *Women in England 1760–1914: A Social History* (London: Orion Books, 2005)

Stevenson, P., *Bridal Fashions* (London: Ian Allen, 1978)

Stone, L., *Road to Divorce: England 1530–1987* (Oxford: Oxford University Press, 1990)

Stone, L., *The Family, Sex and Marriage in England 1500–1800* (London: Penguin, 1979)

Strange, J., *Death, Grief and Poverty in Britain 1870–1914* (Cambridge: Cambridge University Press, 2005)

Strathern, M., *The Gender of the Gift: Problems with Women and Problems with Society in Melanesia* (London: University of California Press, 1988)

Styles, J., and Vickery, A. (eds), *Gender, Taste and Material Culture in Britain and North America* (London: Yale, 2006)

Styles, J., 'Involuntary Consumers? Servants and their Clothes in Eighteenth-century England', *Textile History*, 33 (2002), 9–21

Styles, J., 'Lodging at the Old Bailey', in J. Styles and A. Vickery, *Gender, Taste and Material Culture*, 61–80

Styles, J., 'Victorian Britain, 1837–1901: What was New', in Michael Snodin and John Styles (eds), *Design and the Decorative Arts: Britain 1500–1900* (London: V&A Publications, 2001), pp. 431–459

Szreter, S., *Fertility, Class and Gender in Britain, 1860–1940* (Cambridge: Cambridge University Press, 1996)

Tadmor, N., *Family and Friends in Eighteenth-century England* (Cambridge: Cambridge University Press, 2000)

Talboys, R. St. C., *A Victorian School: Being the story of Wellington College* (Oxford: Basil Blackwell, 1943)

Taylor, L., *The Study of Dress History* (Manchester: Manchester University Press, 2002)

Thane, P., *Old Age in English History: Past Experience, Present Issues* (Oxford: Oxford University Press, 2000)

Thompson, F.M.L., *Gentrification and Enterprise Culture: Britain 1780–1980* (Oxford: Oxford University Press, 2001)

Thompson, F.M.L., 'Life after Death: How Successful Nineteenth-century Business Men disposed of their Fortunes', *Economic History Review*, 43:1 (1990), 40–61

Thompson, F.M.L., 'Hampstead 1830–1914', in M.A. Simpson and T.H. Lloyd (eds), *Middle Class Housing in Britain* (Newton Abbott: David and Charles, 1977), pp. 87–113

Thompson, T., *Edwardian Childhoods* (London: Routledge, 1981)

Thorburn, G., *Men and Sheds* (London: New Holland Publishers Ltd, 2002)

Thornton, P., *Authentic Décor: The Domestic Interior 1620–1920* (London: Weidenfeld & Nicolson, 1984)

Tosh, J., *A Man's Place: Masculinity and the Middle-Class Home in Victorian England* (London: Yale University Press, 1999)

Tosh, J., 'Domesticity and Manliness in the Victorian Middle Class: The Family of Edward White Benson', in M. Roper and J. Tosh (eds), *Manful Assertions: Masculinities in Britain since 1800* (London: Routledge, 1991), pp. 44–73

Trainor, R., 'The Middle Class', in Martin Daunton (ed.), *The Cambridge Urban History of Britain vol III 1840–1950* (Cambridge: Cambridge University Press, 2000), pp. 673–714

Ulrich, L. Thatcher, 'Hannah Barnard's Cupboard: Female Property and Identity in Eighteenth-Century New England', in R. Hoffman, M. Sobel and F.J. Teute (eds), *Through a Glass Darkly: Reflections on Personal Identity in early America* (Chapel Hill: University of North Carolina Press, 1997), pp. 238–273

Veblen, T., *The Theory of the Leisure Class: An Economic Study in the Evolution of Institutions* (New York: Macmillan Co., 1899)

Vicinus, M., 'Introduction: New Trends in the Study of the Victorian Woman', in M. Vicinus (ed.), *A Widening Sphere: Changing Roles of Victorian Women* (Bloomington: Indiana University Press, 1977), pp.ix–xix

Vicinus, M., 'Introduction: the Perfect Victorian Lady', in M. Vicinus (ed.), *Suffer and be Still: Women in the Victorian Age* (1972), pp.vii–xv

Vickery, A., 'An Englishman's Home is his Castle? Thresholds, Boundaries and Privacies in the Eighteenth-century London House', *Past and Present*, 199 (2008), 147–173

Vickery, A., 'His and Hers: Gender, Consumption and Household Accounting in Eighteenth-century England', *Past and Present*, 1 (supplement 1) (2006), 12–38

Vickery, A., *The Gentleman's Daughter: Women's Lives in Georgian England* (London: Yale University Press, 1998)

Vickery, A., 'Golden Age to Separate Spheres? A Review of the Categories and Chronology of English Women's History', *Historical Journal*, 36:2 (1993), 383–414

Vickery, A., 'Women and the World of Goods: A Lancashire Consumer and her Possessions 1751–81', in J Brewer and R. Porter (eds), *Consumption and the World of Goods* (London: Routledge, 1993), pp. 274–301

Vickery, M. Birney, *Buildings for Bluestockings: The Architecture and Social History of the Women's Colleges in Late Victorian England* (London: Associated University Presses, 1999)

Walker, L., 'Home and Away: The Feminist Remapping of Public and Private Space in Victorian London', in Iain Borden, Joe Kerr, Jane Rendell, with Alicia Pivaro (eds), *The Unknown City: Contesting Architecture and Social Space* (London: Massachusetts Institute of Technology, 2001), pp. 296–311

Walker, L., and Ware, V., 'Political Pincushions: Decorating the Abolitionist Interior 1787–1865', in I. Bryden and J. Floyd (eds), *Domestic Space: Reading the Nineteenth-Century Interior* (Manchester: Manchester University Press, 1999), pp. 58–83

Weatherill, L., *Consumer Behaviour and Material Culture in Britain 1660–1760* (London: Routledge, 1996)

Weatherill, L., 'A Possession of One's Own: Women and Consumer Behaviour in England 1660–1740', *Journal of British Studies*, 25 (1986), 131–156

Weedon, A., *Victorian Publishing: The Economics of Book Production for a Mass Market 1836–1916* (Aldershot: Ashgate, 2003)

White, C., *The World of the Nursery* (London: Herbert, 1984)

White, J., *London in the Nineteenth Century 'A Human Awful Wonder of God'* (London: Jonathan Cape, 2007)

Wilkinson, R.H., *The Prefects: British Leadership and the Public School Tradition* (Oxford: Oxford University Press, 1964)

Willson, F.M.G., *The University of London 1858–1900: The Politics of Senate and Convocation* (Suffolk: The Boydell Press, 2004)

Wolff, J. and Seed, J.(eds), *The Culture of Capital: Art, Power and the Nineteenth-Century Middle Class* (Manchester: Manchester University Press, 1988)

Wrigley, E.A. and Schofield, R.S., *The Population History of England 1541–1871: A Reconstruction* (London: Edward Arnold, 1981)

de Zouche, D.E., *Roedean School 1885–1955* (Brighton: Printed for private circulation, 1955)

Unpublished works

Clewlow, M. (ed.), 'Ammonites and Moabites: The Letters of Dorothea Beale and Esther Burrows 1892–1905' (unpublished edition for MA in Archiving, University College London, 1995),

Ferry, E., 'Advice, Authorship and the Domestic Interior: An Inter-disciplinary Study of Macmillan's 'Art at Home Series' 1876–1833' (PhD thesis, Kingston University, 2004)

Gilhooly, E. (Columbia), 'The Constant Gardener: Or, Nursery Government'. British Association of Victorian Studies/North American Victorian Studies Association Conference, Churchill College Cambridge, 15 July 2009

Hamlett, J., Geffrye Museum Report 3, Jul. 2004. Unpublished Museum Report.

Hamlett, J., Geffrye Museum Report 4, Aug. 2004. Unpublished Museum Report.

Hamlett, J., Geffrye Museum Report 5, Sep. 2004. Unpublished Museum Report.

Keeble, T., 'The Domestic Moment: Design, Taste and Identity in the Late Victorian interior' (PhD Thesis, Royal College of Art, 2004)

Martin, M.C.H., 'Children and Religion in Walthamstow and Leyton *c.*1740–*c.*1870' (PhD thesis, University of London, 2000)

Melville, J. 'The Use and Organisation of Domestic Space in Late Seventeenth-Century London' (PhD Thesis, University of Cambridge, 1999)

O'Connor, S., 'Family and Illness in Eighteenth-century England' (MPhil Thesis, University of London 2007)

Owens, A. J., 'Small Fortunes: Property, Inheritance and the Middling Sort in Stockport 1800–1857' (PhD thesis, University of London, 2000)

Preston, R., 'Home Landscapes: Amateur Gardening and Popular Horticulture in the Making of Personal, National and Imperial Identities 1815–1914' (PhD thesis, University of London, 1999)

Riello, G., '"Things Seen and Unseen": Inventories and the Representation of the Domestic Interior in Early Modern Europe' (Unpublished paper, May 2009)